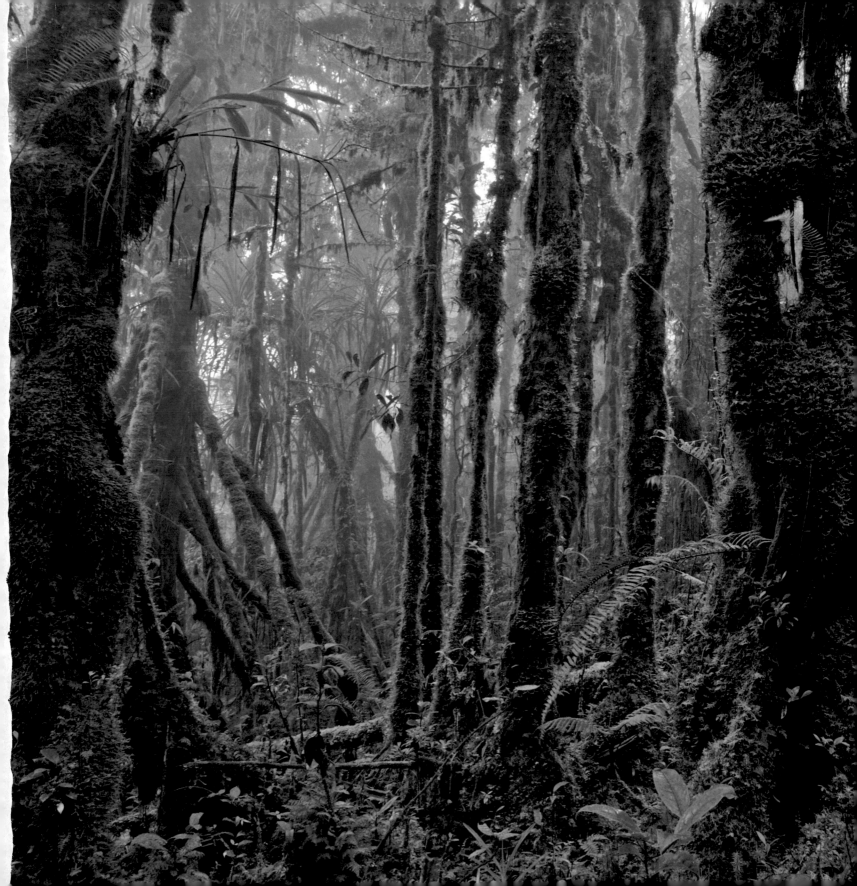

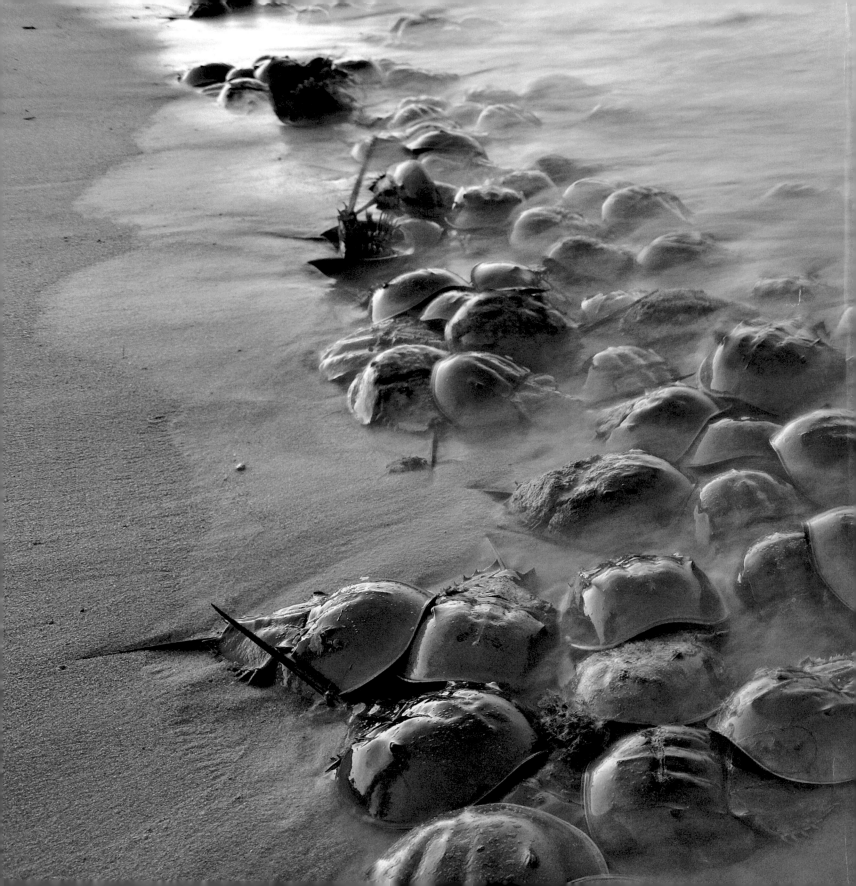

Relics

TEXT AND PHOTOS BY

Piotr Naskrecki

Relics

TRAVELS IN NATURE'S TIME MACHINE

THE UNIVERSITY OF CHICAGO PRESS • CHICAGO AND LONDON

Piotr Naskrecki is an entomologist and a research associate with the Museum of Comparative Zoology at Harvard University. He is the author of *The Smaller Majority*.

The University of Chicago Press, Chicago 60637

The University of Chicago Press, Ltd., London

© 2011 by Piotr Naskrecki

All rights reserved. Published 2011.

Printed in the United States of America

20 19 18 17 16 15 14 13 12 11 1 2 3 4 5

ISBN-13: 978-0-226-56870-6 (cloth)

ISBN-10: 0-226-56870-9 (cloth)

Library of Congress Cataloging-in-Publication Data

Naskrecki, Piotr, author.

 Relics / Piotr Naskrecki.

 p. cm.

 Includes bibliographical references and index.

 ISBN-13: 978-0-226-56870-6 (cloth : alkaline paper)

 ISBN-10: 0-226-56870-9 (cloth : alkaline paper)

 1. Relicts (Biology) 2. Relicts (Biology)—Pictorial works. I. Title.

 QH75.N293 2011

 333.95'16—dc22

 2011004413

♾ This paper meets the requirements of
ANSI/NISO Z39.48–1992 (Permanence of Paper).

For Kristin

CONTENTS

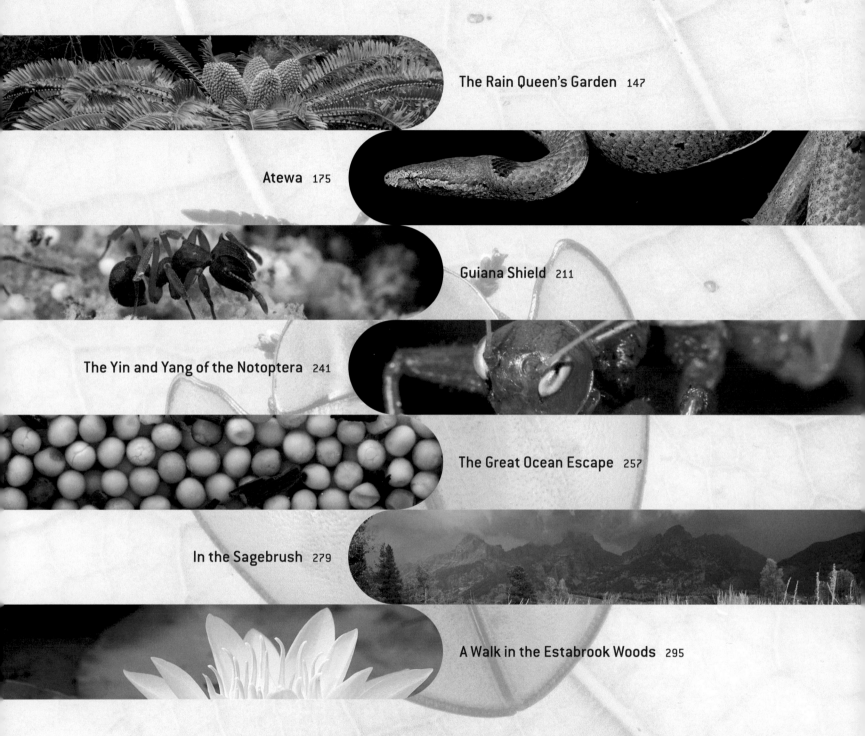

FOREWORD

A book that celebrates the beauty of the natural world through the work of a talented scientist, conservationist, and photographer invites reflection on both purpose and aesthetics. Can images influence the fate of our planet's natural wonders? The answer is a resounding yes. From the creation of the first national parks in America to the establishment of an entirely new protected area system in Gabon, photography has played a pivotal role in showcasing the beauty and uniqueness of wild places, the frailty and irreplaceability of endangered species, and the wonder of indigenous cultures; when paired with scientific understanding it can be a key part of shaping legislation to bring about protection of these special landscapes and species.

Images have always been used as powerful campaign symbols and pictorial calls to action. A photograph made by the late Peter Dombrovskis as an anguished cry for the imminent loss of the mighty Franklin-Gordon Wild Rivers in Tasmania became the lightning rod that inspired an entire nation to oppose a project that would have dammed one of our planet's most beautiful wild rivers. The image worked because it was infused with a sense of purpose. It was crafted with emotion, with urgency, with tears; it was meant to show those who could not see with their own eyes the beauty, the wildness, the incomparable value of what was to be lost.

Just like Dombrovskis's images revealed the beauty of a landscape few people had seen, Piotr Naskrecki's images in this book reveal the existence of a world very few of us know about: that of relict organisms and ecosystems. These organisms are living testimony of our planet's evolutionary history, and they often serve as preservation capsules for genetic diversity and environmental conditions that have otherwise disappeared from our planet, and this alone means they should be targeted as some of our top priorities for conservation. More often than not, however, such relict organisms are little known to the general public or even conservationists, and the images in this book will bring them to light.

Photographs are powerful tools to mold perceptions, to call on our principles, to inspire. As photographers, we have a choice to give our work a higher purpose and to invest it with a fundamental value that goes far beyond the mere beauty of an image.

One may argue that many, if not most, beautiful images are achieved in the absence of purpose. I submit to you, however, the idea that photographs born out of concern for the tragic loss of our natural world carry an intrinsic emotional and spiritual weight that is projected onto those who view them.

The magnificent images in this book will no doubt capture the world's attention. They will find their place in the hands of influential decision-makers and hopefully shape their perceptions. As the photographs travel, they will become ambassadors for a world that is changing fast.

I am proud to work with the talented photographer whose images and words grace this book. I know that his work is not just about capturing beautiful moments but also about how to instill in others a sense of purpose and beauty.

Cristina Goettsch Mittermeier
President
International League of Conservation Photographers

INTRODUCTION

Horsetail fern (*Equisetum fluviatile*)

Few human desires are stronger—and at the same time more unlikely ever to be fulfilled—than our obsession with time travel. I have been fantasizing about time travel all my life, first with a fair amount of hope, fueled by books and movies that seemed to treat it as a remote and difficult-to-achieve possibility, but a possibility nevertheless; later with a wistful resignation, one that nudged me toward the second-best thing: the study of the evolution of life on Earth (or rather a tiny, six-legged fragment of it).

I think that it all might have started with a rock that I found in front of my house in Poland, where I grew up. One day while crossing the street on my way back from school I noticed a beautiful, perfectly preserved shell, somewhat similar to a scallop, embedded in a big, half-buried stone near the curb. I simply had to have it, and so I dug it out surreptitiously one night, a huge piece of rock that I could barely lift, and lugged it home. The first person to spot the new acquisition to my small natural history collection was my grandmother, and when I asked her what she thought about the mystery shell she hesitated for only a second before proclaiming that it was a remnant of the Great Flood, a time when many animals that had not made it into Noah's ark drowned. Good little Catholic boy that I was, I accepted her explanation, but at the same time it struck me as counter-intuitive that an aquatic mollusk would drown in a flood. I went to my father to get some clarification. He, being a man of science, pulled out a book and together we determined that the shell most likely belonged to an extinct brachiopod, a marine animal superficially similar to mollusks, and that it

might be hundreds of millions years old. A drawing of a shell remarkably similar to mine was described as coming from a period called the Cretaceous. There were other drawings there, too: one showed giant dragonflies, apparently as big as birds; another a huge, salamander-like thing with a flat, wide head and short, stumpy legs. I found all this fascinating but could not quite wrap my mind around the fact that these wonderful creatures were gone and would never be seen alive again.

Shortly after, I began reading books on paleontology, most of which were filled with information that went right above my eight- or nine-year-old head, but the descriptions and imagery of trilobites, ammonites, not to mention dinosaurs and surreal calamite forests, filled me with the unfulfillable desire to go back in time. Then I stumbled upon something quite intriguing. It was a description of a living coelacanth caught in the waters of South Africa, a strange fish that scientists thought to have been extinct for over a hundred million years—a living, breathing "fossil" animal. If that contemporary of dinosaurs had survived, then perhaps there were others. Maybe there were still some remote places—pockets of ancient worlds—inhabited by plants and animals hastily written off as already gone, but still hanging on.

Ever since then I have been enthralled by the idea that some organisms might have survived longer than others and that their appearances—perhaps also the behaviors—preserve old snippets of the long, convoluted narrative that is life on Earth; their existence may give us an insight, a tiny keyhole to peek through if you will, into the past ecosystems and interactions among their inhabitants. Barring the invention of an actual time machine (fingers still crossed), they may be our best chance to breathe life into fossilized worlds of the long-gone epochs. Many organisms have been tantalizingly described as "living fossils," and Charles Darwin himself was the first one to support the notion of the existence of animals and plants that have remained unchanged through long geologic periods, preserving in their bodies and functions a record of Earth's past.

"Living fossils" is a concept that has seduced many a scientist and spawned countless arguments that used it as proof, both for and against, the reality of evolutionary change as the force behind the diversity of life. As a young student of biology I wholeheartedly embraced the alluring image of living things that somehow resisted the overwhelming pressure to change alongside their steadily transforming environment; they were my time machine, fossilized remains come alive.

But despite its apparent simplicity and a long list of animals and plants that seem to fit the description of a living fossil, the validity of the concept itself has been steadily eroding and falling out of favor among evolutionary biologists. For one, there is little agreement among biologists as to what a *living fossil* actually is. Is it a single species that has not changed since its first appearance in the fossil record, or is it any surviving representative of a lineage that used to flourish but is now largely gone? Does the organism need to be rare and restricted in its distribution, or can it be common as long as we know that it came from an ancient line? Do we need fossilized remains, or can we just deduce its ancient provenance from its relationships to other organisms? Or does simply having a number of traits that are known to be primitive (plesiomorphic) enough to be considered a living fossil? Do DNA sequences in my cells that go back to the first oxygen-breathing, single-cell protists make me one?

Over time, the concept has become so diluted and has been misapplied so often as to lose almost any meaning, while creationists, in a typical show of infantile literalism, latched onto the term "living fossil" as an argument for the absence of evolution. The confusion has been exacerbated by the misconception that the currently living organisms that resemble species long extinct are the still-surviving ancestors of modern species. This, of course, is not the case. (In all fairness, there exist species that are the result of two species

interbreeding, with both parent species still living, but that's a different story that has little to do with living fossils.) It has also become apparent that many "classic" living fossils (the New Zealand reptile tuatara, for instance) have been evolving at the molecular level faster than many contemporary "young" organisms. Most importantly, we know that all animals and plants that have been labeled living fossils are modern, recently evolved species adapted to the current environments, and not miracle survivors from long time ago, genetically identical to some petrified remains, no matter how superficially similar they might be. For these reasons many biologists now consider the term "living fossil" extinct.

And yet we cannot escape the fact that there are species alive today of extremely ancient ancestry, much older than most other modern organisms. Some are the sole survivors of lineages that once dominated ancient ecosystems before it turned from a river of species into a trickle. The coelacanth, a representative of a once-thriving group of fishes, is such an animal. Others, like the small crustaceans known as the fairy shrimp, are common and belong to groups that are still rich in species, but we also know them from fossils that go back half a billion years. Still others, like sharks, with their cartilaginous skeletons, are modern, successful animals that possess old and primitive traits. Clearly, there must be something we can learn about the ancient worlds from these organisms.

To avoid the ambiguity of the term "living fossil," biologists tend to refer now to such animals and plants as "relicts." As early as 1944, American paleontologist George G. Simpson introduced a system of classification of living relict species that he based on the circumstances that had led to their present status. He noticed that some species had become relicts because of the disappearance of their habitats, confining their survival to rare ecological refugia, tiny remnants of once-expansive ecosystems (ecological relicts). Most other relict species, however, ended up as such due to one or more evolutionary processes, for example, as a re-

sult of being outcompeted by a lineage of more successful relatives (phylogenetic relicts), or by a steady fragmentation and subsequent extinction within most of their former range (biogeographic relicts). After nearly seventy years since its introduction Simpson's system has been only marginally refined by evolutionary biologists, proving its lasting value and validity.

Although we cannot claim that relict species are replicas of living things from former geologic times—they are, after all, organisms perfectly adapted to modern conditions—their morphologies and behaviors can provide us with clues as to what life was like during their former glory. Horseshoe crabs' spawning behavior speaks volumes of the dangers of the Mesozoic seas, which drove them out of the water and onto hostile, but still preferable, dry land. The wing morphology of grigs, relatives of some of the first singing insects, gives us hints about the origin of sound production in these animals. Cycads' toxicity points to a heavy adaptive pressure from ancient grazers, while their pollination biology elucidates the first chapters of the long and successful relationship between plants and insects. The appearance of clumps of horsetail ferns gives us a glimpse of Cretaceous forests, and the maternal devotion of blattodeans helps us understand the evolution of complex societies in insects. Each of these relict organisms sheds a narrow ray of light that illuminates a fragment of the history of life on Earth and contributes to a better understanding of where the amazing variety of forms, including our own species, came from.

Relict organisms can also inform us about what makes one species more successful than others in the never-ending quest to pass on its genes. There is not one unifying feature that all relict organisms share, but some commonalities nevertheless emerge. Some lineages were able to survive by being able to withstand the harsh, cold conditions of high mountains that eliminated most of their competition, while others probably owe their longevity to ingenious and effective defense mechanisms, such as potent toxins or indigest-

ible chemicals in their tissues. A few relict groups have taken advantage of other organisms to get an edge over the competition. Some did it by incorporating them into their own bodies (cycads and their cyanobacterial symbionts are a good example), others by expanding into new niches created by younger, more advanced organisms (like the ferns, which invaded new habitats created by flowering plants). But probably the most common strategy of relics is simply to be an ecological generalist—the quickest way toward extinction is to become too narrowly specialized. The one constant of Earth's ecosystems is the fact that they continually evolve, and if you become too dependent on a single set of conditions you are instantly in trouble when change unavoidably takes place.

Relict organisms, which I prefer to call simply "relics" (there is an added element of priceless inheritance in the word "relic" as opposed to "relict"), are often the last carriers of genes that have otherwise disappeared from the world's genetic pool. For this reason, with the current reality of the escalating demise of global biodiversity, it is more important than ever to put a spotlight on these ancient lineages. Phyletic diversity, the variety of disparate genetic lines and body forms of animals and plants, is more important to protect than a simple richness (high numbers) of species. To illustrate this point, what is more worthy of preservation: five species of parrots, or a parrot, an ostrich, and a hummingbird? While such choices should never become a reality, they tragically often do, and it is critically important that we allocate our limited conservation resources toward the preservation of the greatest genetic diversity possible. Relics, by default, should always be a conservation priority.

Individual species and lineages are not the only relics that still grace the surface of our ancient planet. Entire habitats and ecosystems are sometimes survivors of long-gone

This Atewa dinospider (*Ricinoides atewa*) from West Africa is a member of an ancient group of arachnids that go back over three hundred million years to the Carboniferous period.

conditions, and frequently they shelter unique assemblages of species that can be found nowhere else. They are sanctuaries of biodiversity and, increasingly, sanctuaries of life as it appeared before our kind left the African savannas and spilled over the globe, altering and wiping out countless biological communities and species. Like the organismal relics, these sanctuaries of life must be the first to be considered for preservation and protection from development, and in this book I invite readers to visit a number of them.

In 1858, one year before Charles Darwin sent tectonic waves through the dogma of our understanding of how all living things came to be, an Italian American geographer named Antonio Snider-Pellegrini stirred some controversy by trying to explain the puzzling fact that the eastern contours of the Americas seemed to match perfectly the western edges of Africa and Europe, almost as if they had once been attached to each other. According to his deeply biblical interpretation, Earth's continents were initially created as a single landmass that only later became fragmented, following the Great Flood that separated "Atlantide" (the Americas) from the rest of the world. Had he lived until the present day, Snider-Pellegrini undoubtedly would have been quite confused to learn that his idea of the continental breakup was both true and at the same time seriously at odds with the story of Creation. We now know that Earth's surface is a dynamic, always-in-motion arrangement of tectonic plates, so-called cratons, that endlessly fuse and divide, albeit at rates too slow for us to observe directly. This perpetual reshuffling of the surface of the globe, caused by the movement of the liquid core of the planet, is one of the main forces that drives the diversification and evolution of organisms. Each continental fragment breaking away from a larger landmass invariably carries away animals and plants that from that point forward will be isolated from their ancestral populations and over time will evolve into very different species. We see the results of this process in the unique animals of New Zealand and Australia and the very different plant communities of the Southern and Northern Hemispheres. Although this also means that what we call geography is nothing but a fleeting snapshot of Earth's dynamic state, no more permanent than the arrangement of leaves floating on the surface of a pond, the breakup of old landmasses allowed some lineages and places to retain, by the virtue of their isolation, characteristics that are now gone elsewhere. The older and more remote a place, the more likely it is to preserve fragments of ancient ecosystems as well as organisms that have gone extinct everywhere else.

In the 4.5 billion years of this planet's history, several arrangements of the tectonic plates had particularly profound effects on the history of life. Each major breakup of landmasses led to the emergence of new lineages of organisms, and although we know little about the really old continents such as Nena or Rodinia, we can still witness the results of the breakup of the supercontinent Pangaea, whose massive surface combined most of the world's dry land about a quarter billion years ago. Alfred Wegener, the author of the revolutionary theory of Earth's plate tectonics, was the first to reconstruct the giant formation's shape and its subsequent disintegration. The breakup of Pangaea happened in several protracted stages, with many fragments separating at different times, but the overall pattern that emerged about two hundred million years ago was that of two enormous landmasses—the southern continent of Gondwana, and the northern one known as Laurasia. The effects of this massive rift are clearly reflected in the patterns of today's biodiversity. Areas that were once part of Gondwana—South America, Africa, Australia, New Zealand—share many groups of organisms that cannot be found in places that were once part of Laurasia, which includes much of the land now north of the equator.

In arranging the essays in this book, each of which tells a story of a different relic or a sanctuary, I decided to use this ancient geography as a rough map to guide the reader through time and place. Thus, we will start in some of the

oldest and most isolated fragments of Gondwana—the islands of New Guinea and New Zealand. We will spend some time exploring ancient African ecosystems—the South African fynbos and Succulent Karoo, relics of a dramatic climate change of the Miocene, and in West Africa we will visit Pleistocene forest refugia. Ancient cycads and blattodeans will be our companions there. Then we will move to the Guiana Shield, one of the oldest parts of what is now South America. A chapter on the Notoptera will act as a bridge from the Southern to the Northern Hemisphere, where we will be able to peek into the lives of animals and plants that are now restricted largely to areas once part of the former Laurasian continent. We end our journey near my current hometown in Massachusetts, a place that is still teaming with organisms whose ancestry is older than Pangaea itself.

Over the years I have been exceedingly fortunate to be able to visit some of the most remote, biologically unique parts of the globe, and I used this opportunity to look for and document some of the world's most interesting relics. Being able to see them, alive and in their natural habitats, gave me a taste of that unattainable dream of time travel. Yet this experience—and the several years I spent working for a nongovernmental conservation organization—made me painfully aware of how little time we may have left to still appreciate these ancient organisms and places. While our own species continues its victorious steamroll across the planet, entire ecosystems are vanishing in front of our eyes. As I am writing these words in 2010, the international Year of Biodiversity, it is becoming clear that the world has not achieved, has not even come close to achieving, its goals of significantly reducing or halting the loss of biodiversity, as agreed in a treaty called the Convention on Biological Diversity, signed and ratified in 1992 by virtually all countries of the world (the United States was not, regrettably, one of them). Extinction rates, the speed with which species irreversibly disappear from the planet, are about a thousand times higher now than they were before the appearance of

humans, and the momentum of species loss speeds up with every passing year. According to some scientists, one species of animals or plants disappears permanently from the surface of the planet every twenty minutes. If this is true—and it seems to be—this year alone we will lose about twenty-six thousand species; in a hundred years, half of all the world's species will be gone (there exist even higher, scarier estimates). The truly sad part is that most of the organisms that we are losing in this massive, ongoing extinction event have not yet been discovered and named by science. This tragedy is known as the Centinelan extinction, dubbed so after the Centinela Ridge in Ecuador, where ecologists Alwyn Gentry and Caraway Dodson discovered in 1978 ninety previously unknown plant species. Within a few years, before many of them could be scientifically described, the ridge was converted into a plantation, and all its newly discovered species became extinct. Taxonomists, scientists whose job is to name and classify species, are working as fast as they can, but still they are only able to document about sixteen thousand to twenty thousand species every year, a rate significantly slower than the one at which were are losing species.

Most organisms that we share our planet with have little or no direct impact on our lives, and some may ask why we should care about their survival. I realize that this sounds like the ravings of an incurable optimist, but I am convinced that our concern for their well-being and the efforts that so many people make to protect the natural world are at the core of what makes us human. Compassion, selflessness, responsibility, and curiosity—these are the qualities that our species have evolved while it civilized itself over the last million years, and they, I believe, should be the main reasons for nature conservation. The utilitarian argumentation of pest control, pollination, carbon sequestration, and all other priceless ecosystem services that biodiversity provides us with are fantastic, lifesaving freebies, but they are not the main reason we should care. In the next century, with only half of the species left, if the predictions are true, we humans will

still be able to do just fine, but what a sad life it will be. I really don't want to leave for future generations a planet where most species and all remaining natural ecosystems are relics of the natural world our present generation is still privileged to enjoy. It is my hope that the stories and images in this book will pique readers' interest in both the organisms and ecosystems but also in what can be done to slow down their accelerating loss. There is still a lot we can do, and knowing more about what we are about to lose is the first step toward becoming stewards of the natural world. In the end, let relics be relics, but let's keep other species and habitats from ever joining their ranks.

A group of Atlantic horseshoe crabs (*Limulus polyphemus*) emerging from the ocean to spawn on the shores of Delaware Bay in New Jersey.

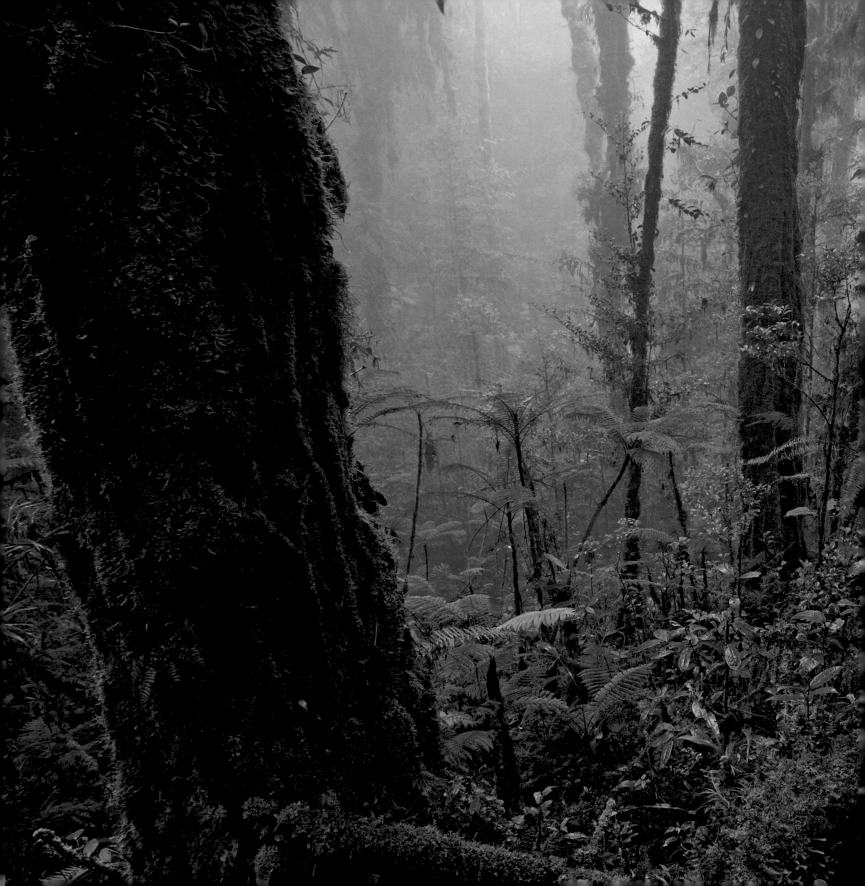

The Land of the Unexpected

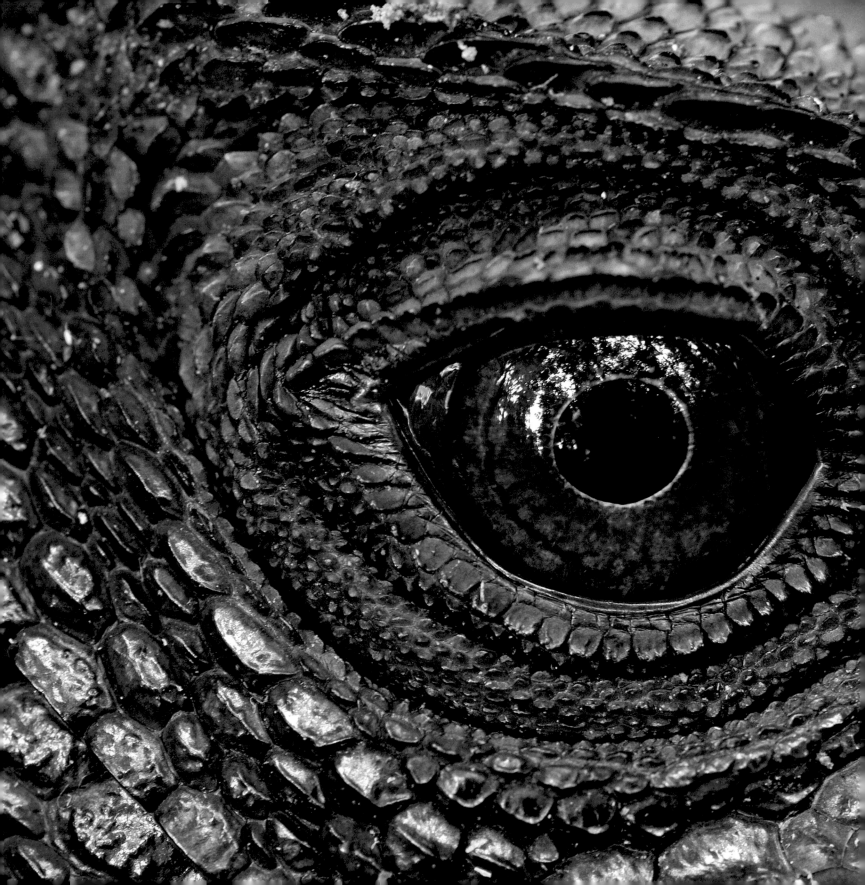

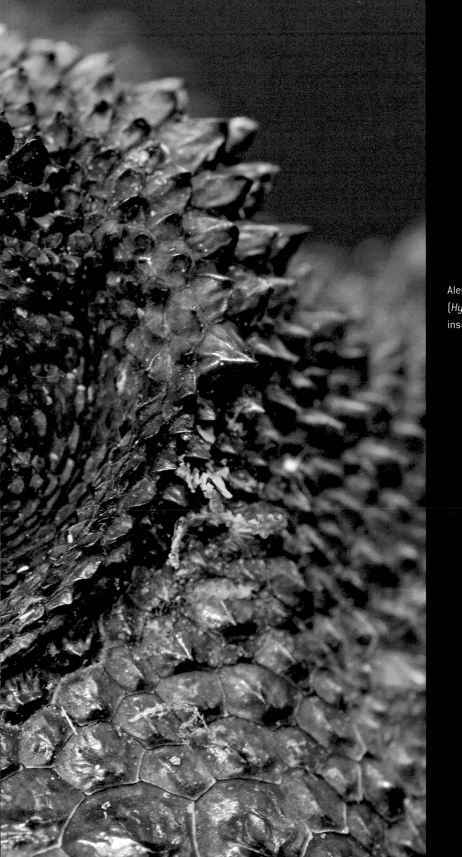

Alert to every movement, the eye of the Papuan forest dragon (*Hypsilurus dilophus*), a sit-and-wait predator, scans the forest f insects and small vertebrates.

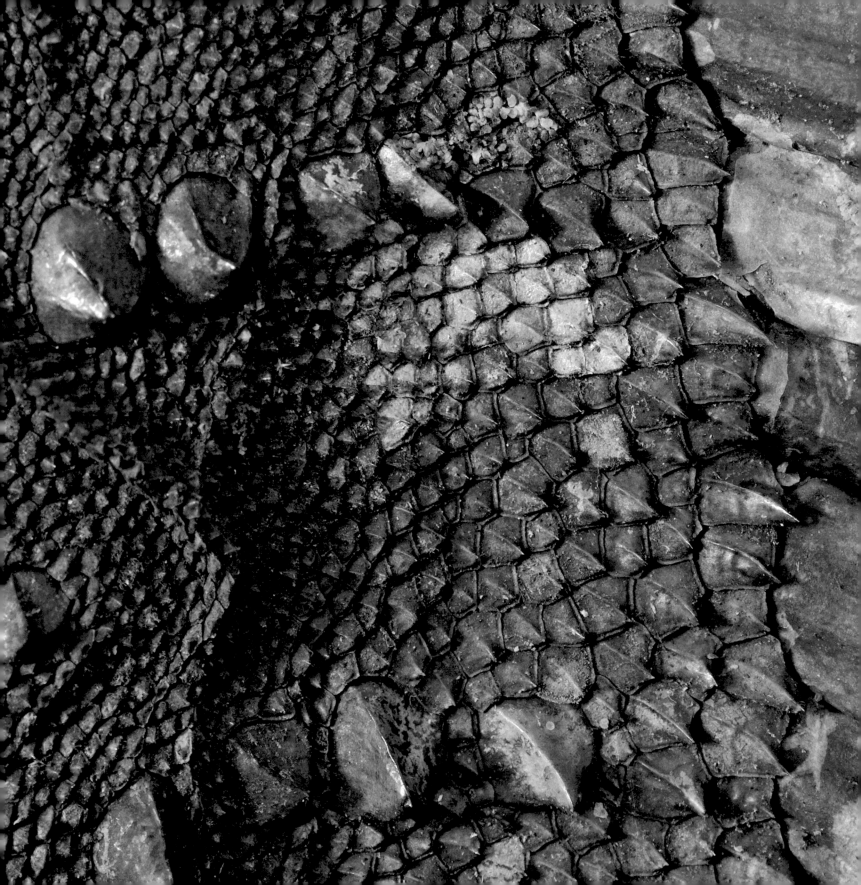

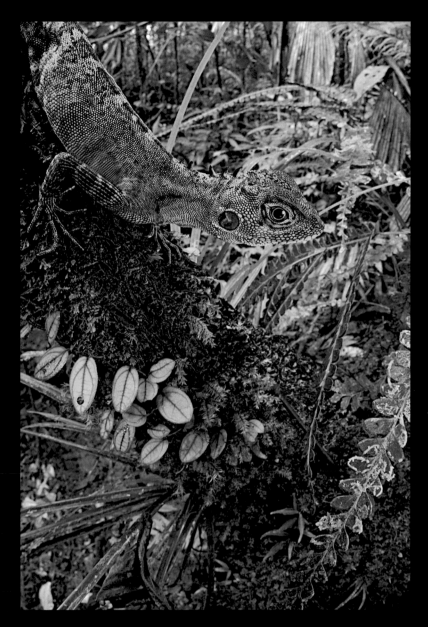

The green forest dragon (*Hypsilurus modestus*) watches me anxiously as I approach him to take a photo. While capable of sprinting at great speeds, these lizards rely primarily on their cryptic coloration to escape the attention of both predators and prey.

Forest dragons (*Hypsilurus*) rarely move from their hunting perches, and in the wet and humid atmosphere of the rainforest algae and minute ferns often begin to grow on the scales that cover their bodies.

Pitchers that develop higher on the plant's climbing stem (opposite, left) have a different shape and color from those that develop on the ground (right), and each targets a different set of insect species.

Beautiful and seductive, carnivorous pitcher plants (*Nepenthes mirabilis*) tempt insects and other small animals with bright colors and sweet nectar. Each pitcher, which develops as an extension on the tip of a leaf, is filled with diluted but sticky biopolymers that trap and drown its victims. Their decomposing bodies provide the plant with necessary nitrogen and phosphorus, elements that are rare in the boggy habitats these plants prefer.

The brightly colored lip, or peristome, of the pitcher is very slippery, and spines on its lower margin prevent insects from being able to climb out. But in an interesting departure from this deadly behavior, one Asian species obtains virtually all of its nutrients from tree shrews, who come to drink the plant's nectar and then promptly defecate into the pitcher.

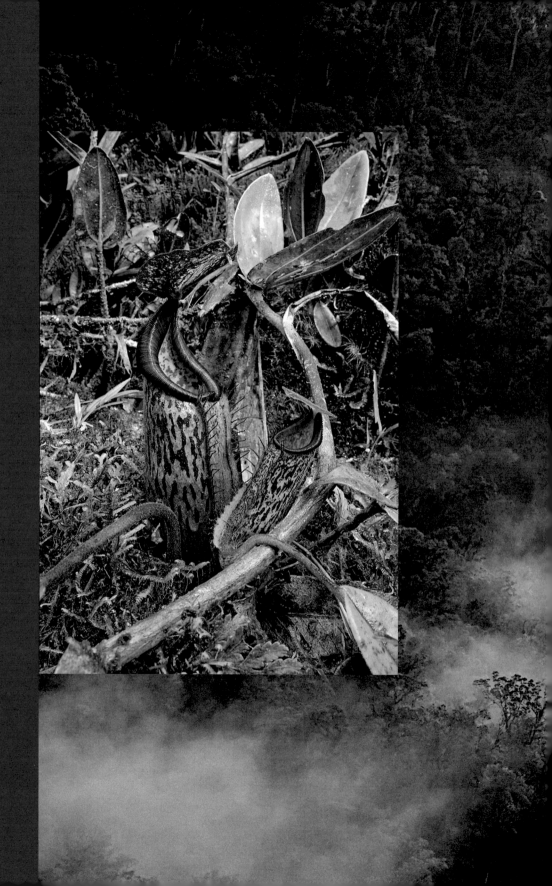

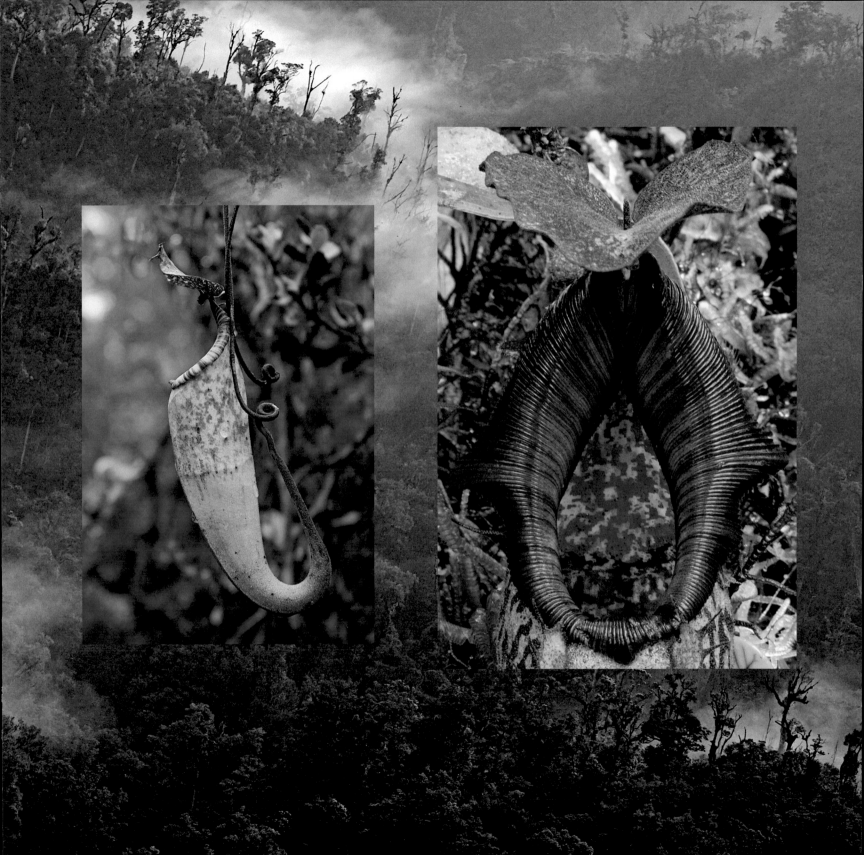

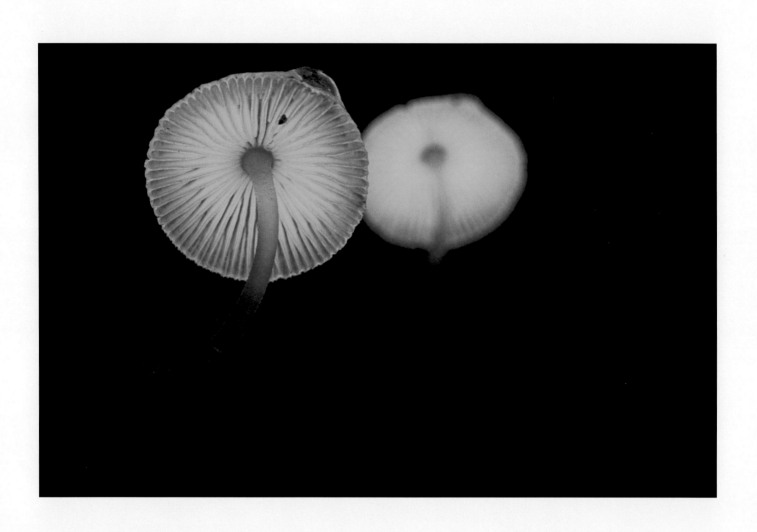

If there ever was a moment in my life when I wished that I could simply close my ears shut, it was when we flew over the foothills of the Nakanai Mountains—the seemingly infinite carpet of thick forest below us, the wisps of the early morning fog clinging to clumps of the tallest trees, the oblique shafts of the still coy sun piercing the darkness below. We skimmed close to the canopy, lifting up only occasionally to avoid hills rising out from the mostly uninterrupted terrain. The view from the helicopter was transcendent of anything that I had seen before, but the roar of the blades held me like claws, not letting me slip into the nearly cataleptic wonderment I was so close to achieving. Never before had I witnessed such raw, undefiled scenery, so primeval, so innocent. I wanted to glide over its surface in silence for hours, breathe in the mist, let my fingers caress the tips of the trees the way I let my hand touch the water when floating slowly in a canoe. I wanted to be marooned in this place, this sanctuary of life still secure in its remoteness and unique for its isolation, but a burst of static in my headphones snapped me out of my reverie. "We found them," said the pilot.

For the last couple of days we had been trying to locate a camp set up by a few members of our group on a high plateau in these mountains covered with nearly impenetrable rainforest, which at this high elevation was obscured by clouds throughout most of each day. We were too late the day before and had to turn back to our lower camp, unwilling to risk flying in poor visibility. But this morning we lifted up right at dawn, and large gaps in the cloud cover allowed us to spot a makeshift landing platform in a small clearing

Bioluminescent mushrooms (*Mycena chlorophos*)

within the thick bamboo and southern beech (*Nothofagus*) forest. The chopper landed on the edge of a plateau with a view so surreally beautiful and primordial that I instantly understood why cryptozoological myths of dinosaurs surviving in the forests of Papua New Guinea persist to this day.

And why wouldn't they? Few places are more remote, less disturbed, and have ecosystems as rich as this part of the planet. The island of New Guinea, its western half a part of Indonesia and the eastern half making up the main portion of the country of Papua New Guinea, still shelters a fragment of the world that would appear very familiar to our long-gone ancestors. It was not until 1938 that a large society of Stone Age people was first contacted on the island of New Guinea by the explorer Richard Archbold, its 50,000 members blissfully unaware of the existence of the outside world. For over a hundred years this island has been a mecca for anthropologists of various extractions attracted by both the "primitiveness" of its tribes and the sheer number of distinct clans inhabiting the island. In an area about thirteen times smaller than Europe, over 1,000 tribes, each with its own unique language, have until recently lived in exactly the same fashion as their forefathers did thousands of years ago, happily dividing their time between foraging in their pristine forests and head-hunting their foes. There is probably no other place in the world, New York City included, more anthropologically heterogeneous, more finely divided among small, isolationist groups of people. Linguists still ponder the origins of the 1,114 languages spoken to this day on New Guinea (albeit some spoken by only a handful of the last survivors of their line), with strong evidence pointing to multiple colonization events by different groups coming from Australia and

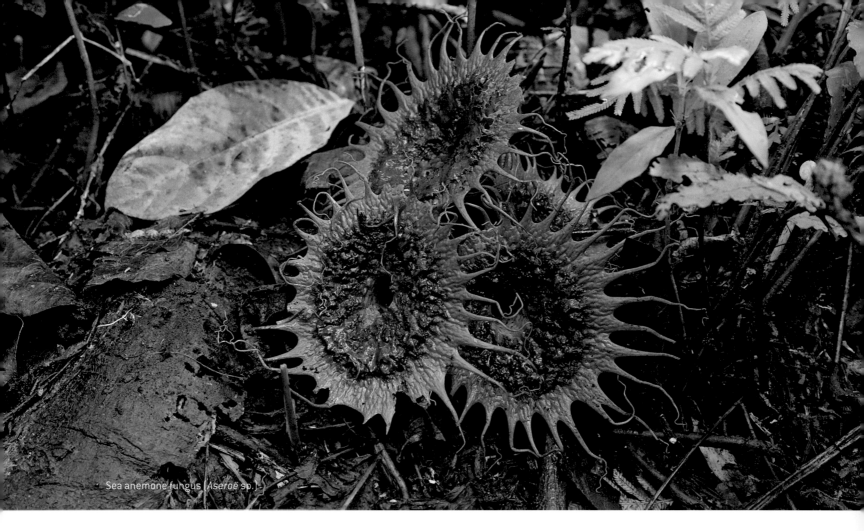
Sea anemone fungus (*Aseroë* sp.)

Southeast Asia that stretch back to at least 40,000—perhaps even 60,000—years ago. Following the time-honored human tradition of distrusting those who are different from us, this multifarious status quo has been maintained by a nearly constant state of war among neighboring tribes, precluding any possible attempts at collaboration toward common goals, such as building roads or developing large-scale trade across the island. It did not help, of course, that New Guinea is one of the most mountainous terrains on Earth, crisscrossed by deep valleys abutted by swampy, malaria-infested lowlands. But the same factors that contributed to the fragmentation of New Guinea's human societies have had remarkably beneficial effects on its nonhuman inhabitants.

Surpassed in their surface area only by the immense forests of the Amazon and Congo basin, the rainforests of New Guinea are the tropical forests probably the least-impacted by human activity. It is still possible to find places there where no human has ever set foot and animals are trusting and unafraid. But even in places where hunting has made a significant dent in the populations of large mammals and birds, the rest of the ecosystem is often in a pretty good shape, thanks largely to the very low population density of humans. Although many tribes still practice slash-and-burn agriculture, the scale on which they do it is low enough for the forest to quickly regenerate. And while there exists ample archeological evidence that some parts of the island's forest

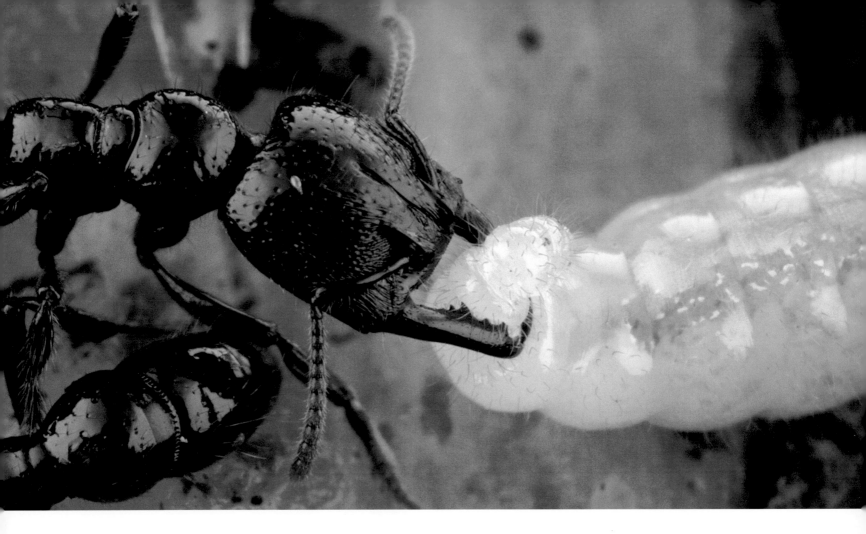

that appear pristine are in fact secondary growth and that slopes of many mountains have been reshaped by ancient agricultural practices, the forests of New Guinea are closer to nature's prehuman condition than virtually any other similar place in the world. For this reason it is not only anthropologists who get positively giddy when talking about New Guinea's diversity. New Guinea, an area legendarily difficult to explore, is renowned for being a place where a biologist is virtually guaranteed to discover new forms of life every time she or he pays a visit. Scientists can only estimate the numbers of species for most groups of organisms that live there, and these estimates are usually higher than those for any comparable area anywhere else on the globe.

Dracula ants (*Amblyopone*) owe their unflattering name to a behavior known as "larval hemolymph feeding," during which adult workers and the queen puncture the skin of a larva and sip its trickling blood. Strangely, this behavior does not seem to harm the larva.

Nearly everything about New Guinea seems ancient and prehistoric, and it often is, but the island itself is surprisingly young. As recently as ten thousand to fifteen thousand years ago, at the end of the last glacial maximum, New Guinea was firmly attached to Australia, forming a large continent known as Sahul. The Gulf of Carpentaria that now separates Australia from New Guinea was just Lake Carpentaria on a massive land bridge connecting the two, and faunas and

floras mixed freely in both directions. At the same time, island arcs slowly drifting from the north and the west steadily pushed closer to New Guinea, allowing Asian elements to colonize it. Nevertheless, the biological composition of today's New Guinea is much closer to that of Australia than Asia. Its current biological communities are probably very similar to the communities of the ancient Sahul continent and give us an impression of what the land now known as northern Australia might have looked like during the last glacial period. Absent from New Guinea are common in Southeast Asian primates (with the potentially disastrous exception of the recently introduced Asian macaques), and there are no cats or any other large carnivores there. The only native placental mammals living on New Guinea are bats and a good selection of rodents. But the group that dominates the mammalian fauna is the marsupials, which includes tree kangaroos, assorted possums, and charming, big-eyed cuscuses. These are complemented by two species of fascinating, egg-laying, spiny mammals known as echidnas. Most of these mammals are nocturnal and, being mostly active at night myself, I ran across a few of them during my nightly foraging for katydids.

One night after coming back to the camp after a stroll in the forest, I saw a small, unbelievably cute possum ambling along our long, improvised workbench. I gave a shout to Ken Aplin, the expedition's mammal specialist, who became very excited, and together we tried to corner the little furry creature. "Catch him if you can," he yelled, "these possums never bite!" Since I was positioned closer to the animal than Ken I grabbed it, and its sharp teeth immediately sank into my hand, and blood poured over my fingers. "Take the bite. Don't let go," said Ken calmly, proving once again that there is no obstacle, moral or otherwise, that will stop a biologist from obtaining the specimen.

It is, of course, impossible to talk about the biodiversity of New Guinea and not to mention birds-of-paradise. This colorful, fluffy offshoot of a lineage comprised mostly of crows and ravens is represented on the island by thirty-eight of its

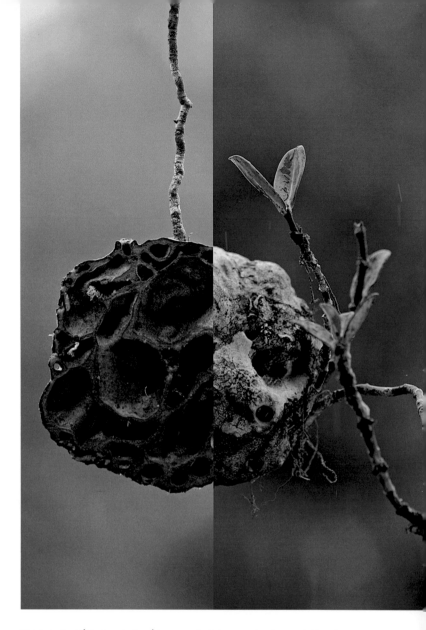

The ant plant (*Hydnophytum*) is a wonderful example of coevolution. A part of this plant's stem, the caudex, forms a large bulb divided inside into multiple smooth-walled chambers. These provide the perfect home for many species of ants that, in exchange for this safe domicile, leave behind their nutrient-rich waste products. Thanks to this rich supply of nitrogen and other elements, the plant is able to reduce the size of its root system and can grow in places with very little soil. Some of the more than forty species known from New Guinea are epiphytes, hanging from branches of rainforest trees.

forty-two known species, and no other group of organisms is considered more emblematic of this part of the world (Raggiana Bird-of-paradise is even depicted on the national flag of Papua New Guinea). I only saw a few glimpses of these birds in the forest, but their calls, especially the otherworldly clacks of the Black Sicklebills delightfully complemented the rich, multilayered, sylvan soundscape during my insect-collecting forays. There is no denying that these birds are as pretty as they come, and their courtship displays are truly spectacular, but to me they were no more than an interesting diversion from the true gemstones hiding in the mossy Eden of New Guinea.

Nobody knows exactly, and it is probably safe to say that nobody ever will, how many species of insects, arachnids, and other invertebrates live on New Guinea and its satellite islands. Interestingly, recent, exquisitely detailed research on insects that feed on rainforest trees in New Guinea, conducted by ecologist Vojtech Novotny and his collaborators, indicate that the numbers of species of these animals might be lower than previously expected—worldwide they seem to be in the range of measly 4 million to 6 million, rather than 30 million, as previously speculated. Their endemism (the degree to which species are restricted to a particular place) also appears to be much lower than initially assumed. It turns out that most plant-eating insects do not like to put all their eggs in one basket; rather than specialize on a single host plant of potentially limited availability, they feed on a plethora of closely related plant species. This means that there is a lot of overlap in insect diversity among various plants, which in turn allows them to disperse over much larger areas. Novotny and his colleagues argue that for the hundreds or even thousands of species of insects associated with a single plant species, no more than 5 are unique to that plant. If this is true, and it probably is, it still means that New Guinea has at least 125,000 species of insects, based on the estimated 25,000 species of vascular plants that can be found there. And this does not include insects that are not associated with plants, nor does it include

Mossy katydids (*Mossula*) usually blend in perfectly among the vegetation. But if all else fails they can defend themselves with their powerfully muscular, spiny legs that they stretch out high in the air and try to jab the attacker.

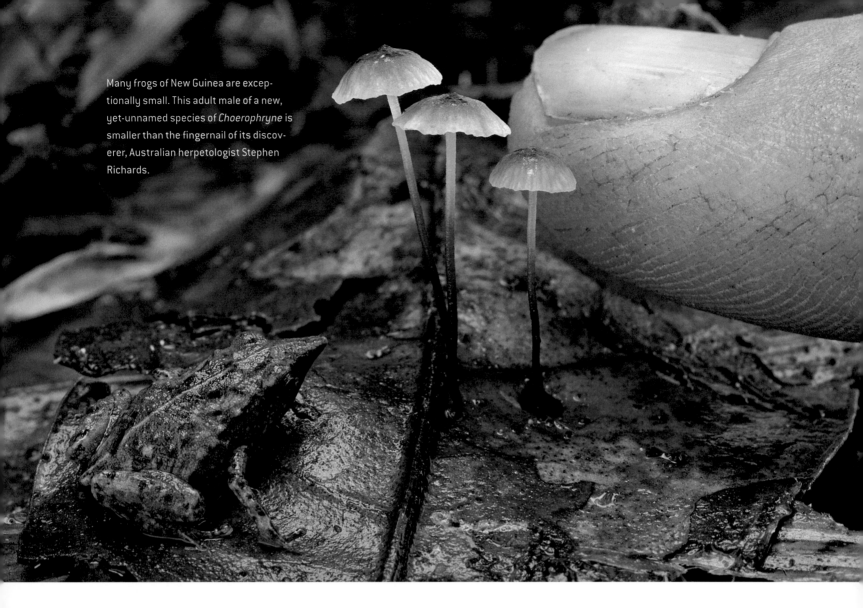

Many frogs of New Guinea are exceptionally small. This adult male of a new, yet-unnamed species of *Choerophryne* is smaller than the fingernail of its discoverer, Australian herpetologist Stephen Richards.

other groups, such as spiders, mites, snails, flatworms, millipedes, and dozens of others. Consequently, the actual richness of New Guinea terrestrial invertebrates is probably closer to half a million, perhaps even higher. Of these, only a very small percentage has been studied by scientists, and most remain unidentified and unnamed. The job of our team of local and international scientists, as we surveyed some of the most remote areas of Papua New Guinea, was to add more detail to the complex map of this country's biodiversity, a map that

for many groups of organisms is still largely blank. We were after new, undiscovered species. But the reasons for our interest in New Guinean biodiversity were not purely academic. Some areas of the country appear to be very good candidates for participation in a new approach to conservation, often referred to as carbon trading. As a part of this scheme, major polluters in developed nations may receive a partial penance for their excessive production of greenhouse gases if they support conservation and reforestation projects in developing

nations. This hopefully will lead to the increase in the number and quality of the so-called carbon sinks, ecosystems that are particularly effective at removing from the atmosphere the excess of carbon dioxide, the main cause of climate change. Our biological survey was one of the preliminary steps in assessing whether New Guinea's forests could indeed benefit from this program.

"It's all a bunch of hippie tree-hugging crap," read a tattered T-shirt, probably donated by some charitable organization, worn by an old woman who was watching me with suspicion from the doorway of her hut. "Well, let's hope that she doesn't really mean it," I thought, as we briskly walked through a small village, trailed by an entourage of surprised and slightly scared children and dogs. Our team counted on the villagers' help in setting up camp and getting fresh food during our stay at the first of several sampling stations in the Nakanai Mountains. We began the survey on the island of New Britain, the largest of the Bismarck Archipelago, which is politically and biologically a part of Papua New Guinea. For several weeks we traversed the increasingly remote and difficult terrain, moving up along the escarpment toward a high, virtually untouched and poorly explored plateau. We departed from the shores of Jacquinot Bay, where the coast was still littered with rusted machine guns and other decaying traces of the Allied campaign against the Japanese forces at the end of World War II. While it felt strange and rather disquieting to trip over corroded weaponry while stalking insects in the forest, its presence was possibly an indication of the state of nature in this part of the world—I hoped that if nobody bothered to remove those chunks of metal, perhaps also nobody bothered to cut down trees.

I had extremely high expectations for these mountains, as literally nothing was known about their fauna of frogs, insects, and related organisms. I was certain that we would find new species there; the only question was how many. Over the following days I slowly acclimated myself to the new environment. There is hardly a more exciting time for

a biologist than when visiting a new geographic area for the first time. New Guinea was such a new place for me, one that I had wanted to see since the time I built a Play-Doh coral reef in my parents' bathtub at the age of seven or eight. Every inch of the ground, every piece of bark, every twig and leaf were potentially hiding some wonderful living treasures. At night, choruses of voices I had never heard before tempted me to go deeper and deeper into the forest. It took me a while to discover that the high-pitched screech coming from among low-lying ferns was a giant cricket, and a buzzing I took for a katydid turned out to be a tiny frog hiding in a clump of mosses. And how I wished that we had with us a specialist who could tell us more about the amazing fungi we were seeing. On a fallen palm frond bioluminescent mushrooms gave off a bluish, ethereal glow, and I brought them back to the camp and placed in front of my tent. For a few nights they helped me find my way back to it in the dark until a big snail came and ate them all. Phantasmagorical *Aseroe* mushrooms looked out of place on the forest floor, their appearance more befitting the depths of tropical seas. Jewel-like *Gasteracantha* spiders hung suspended on orbs spun across low branches on which pygmy grasshoppers nibbled lichens covering their surface, careful to avoid the sticky strands. Large vinegaroons, scorpion-like arachnids that spray attackers with concentrated acetic acid, mingled in the leaf litter with hermit crabs and trap-jawed *Odontomachus* ants. It was heaven.

For the next three weeks, as we moved from site to site, always higher on the slopes of the mountains, I recorded, photographed, and collected every katydid I could find. I sifted amongst fallen leaves in search of small, short-winged predaceous species that were common there and swept my insect net through low branches to catch beautiful, green-leaf mimics. I seduced them with an ultraviolet light I set up at the edge of the camp and stalked them by following their ultrasonic love songs, which I could hear thanks to a wonderful gizmo known as the heterodyne bat detector that translated their high frequencies into something perceivable by my in-

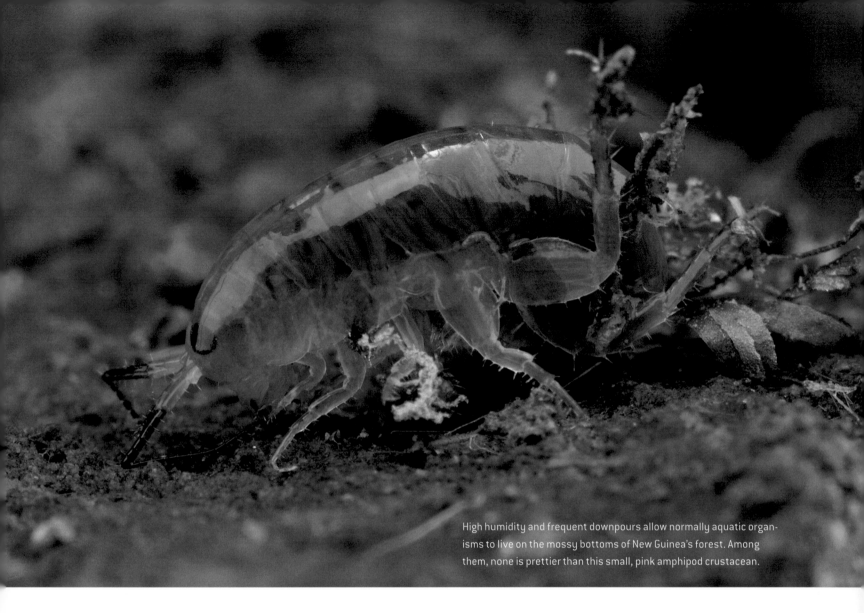

High humidity and frequent downpours allow normally aquatic organisms to live on the mossy bottoms of New Guinea's forest. Among them, none is prettier than this small, pink amphipod crustacean.

ferior human ears. I peeled off giant pandanus leaves to find species adapted to a life in the confines of its tightly packed, stiff foliage, and I split bamboo stalks to capture katydids hiding inside. I was a persistent hunter, and soon all that effort started to pay off. As is always the case, the number of species I found during the first few nights climbed very quickly, and I expected that, after a while, the rate at which new species were added to the list would slow down significantly. But that did not happen. With almost no exceptions,

every night's search added several additional species to the list, while those that were there just a couple of days earlier seemed to vanish without a trace from the forest. To put it simply, my species accumulation curve never approached the asymptote—although I recorded the presence of over sixty species, at least half of them new to science, I wasn't even close to finding all katydids that lived in the forests of the Nakanai Mountains. I strongly suspected that their actual numbers were in the range of a hundred and fifty to

two hundred, but unfortunately this may forever remain a mystery. Even in a place as remote and difficult to access as the Nakanai the tenacious tentacles of the international logging industry are relentlessly probing and testing whether it might be profitable to turn this miracle of nature into more broomsticks and cheap tables. Our second sampling site was located near an abandoned logging camp, with muddy, treeless gaps bearing witness to a narrowly averted destruction. The loggers had left, but the bulldozers and chainsaws may come back—and probably eventually will. For now the one thing that keeps them away from the Nakanai is the general lack of roads and, since these ragged, limestone mountains have no large rivers that could be used to float the logs, a practical way to move timber off site. Although the entirety of traffic on the road that brought us to our site from the village of Marmar consisted of a single car (on account of the bridge that connected the road with the rest of the island having fallen apart a long time ago), some determined investor may eventually make it passable, putting the ancient, old-growth forests of the Nakanai in grave danger.

A few months later our team arrived in the Muller Range, a poorly explored part of the enormous massif of the Central Cordillera that bisects the island of New Guinea from west to east. Like on New Britain, we began our survey at a low elevation in the steamy foothills of the range. I was thrilled that for this expedition we were joined by Australian entomologist David Rentz, who also happened to be the world's most prominent katydid specialist, and I could not wait to begin hunting these animals with him. But as we scouted the untouched, pristine rainforest habitats at night, I was once again surprised by how few individual katydids we were encountering. Sure, almost every one we found was new and different, but we really had to work hard for each collected specimen. Were we there at the wrong time of year? Perhaps the end of the rainy season was not the best time to find these animals. But then again, we were almost on the equator, and seasonality at this latitude is not a major factor

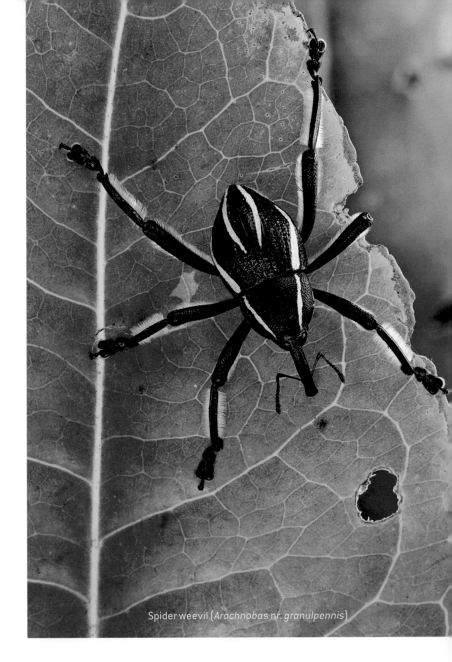

Spider weevil (*Arachnobas* nr. *granulpennis*)

affecting the abundance of insects. As we entered the forest after dusk, David and I could always count on finding a few common species, but each night we also added at least five additional ones to the list. In most cases, however, each was represented by only one animal, a singleton, and we would never see another representative of the same species again.

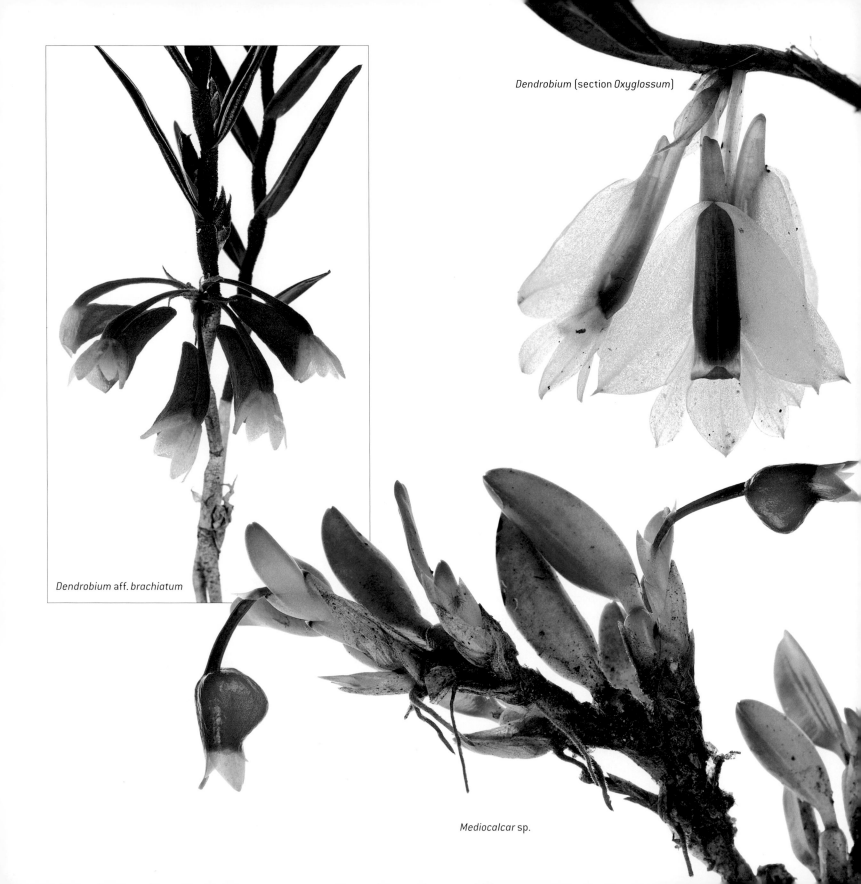

Dendrobium (section *Oxyglossum*)

Dendrobium aff. *brachiatum*

Mediocalcar sp.

Finally, it dawned on us—what we were seeing was a pattern typical of this most diverse of terrestrial ecosystems.

As almost any tropical biologist can attest, it is often easier to find in a rainforest another species of a beetle, a butterfly, or a cricket than another individual of a species already once encountered. The closer to the equator and the less seasonal the forest, the more pronounced this phenomenon seems to be. This apparent low density of insect populations in tropical rainforests, combined with the incredible richness of species found there, is an interesting paradox that has puzzled ecologists for decades. Many explanations have been proposed for the fact that, regardless of the intensity and duration of the sampling protocol, nearly 50 percent of insect species recorded in a tropical rainforest will always be represented by a single individual. Some have attributed this to a simple sampling error, others to genuine rarity of most species of insects. But now many ecologists agree that the main reason for this interesting pattern is the highly dynamic nature of insect communities in the rainforest. While certain species are closely associated with individual species of plants and can always be found in high numbers on them or in their vicinity, most are "tourists"—species that move among many different plants and habitats and never build up large, concentrated populations. Our efforts to get the whole picture of the katydid diversity of New Guinea's rainforests by sampling them, however intently, for a few weeks was about as effective as trying to catch all the fish in a fast-flowing stream while crossing it from shore to shore—you may catch a few, but more will immediately come. Had we stayed in the Muller Range for an entire year, we might have recorded most katydids that occur there, but there would always be some coming for a brief visit from neighboring areas to feed on local plants. To make things even more unpredictable, some equatorial plants flower only once every two to ten years, creating an explosion of flowers simultaneously triggered by a nearly imperceptible but constant drop in the mean temperature of the night, an effect of the capri-

cious El Niño events. This flowering bonanza attracts insects from other places that come in large numbers to feast on the suddenly available nectar and pollen before moving on to a different part of the forest where other species of plants might be flowering. Many katydids feed on flowers, and their distribution and population density across different parts of the vast New Guinea forest is probably influenced by such a periodical but irregular appearance of synchronized blooms.

Although tropical rainforests are not gardens festooned with flowers hanging from every branch all year round, a diligent naturalist will always find there some impressive floral wonders. New Guinea is a place where one of the most resplendent flowering plant families, the orchid, has radiated to the extreme. Rivaled only by the northern reaches of the Andes in South America, the orchid flora of New Guinea is one of the richest in the world. Over 2,800 species have been recorded from the island, which accounts for about 11 percent of the world's composition of the family, and of these 90 percent are endemic to New Guinea. (A quick explanation may be needed here—the word "endemic" has a somewhat pejorative connotation in the popular culture, as in "corruption there is endemic," but to biologists this is an exciting word, indicating organisms that cannot be found anywhere else on the planet, but in one, usually relatively small, region.) The island owes this incredible orchid richness to the perfect combination of environmental conditions that these plants prefer. Most species of orchids are epiphytic—they do not anchor themselves in the soil of the ground but grow suspended from branches and leaves of trees. They are not parasites, however, and must take care of their own water and nutritional needs, and in order for them to survive in the canopy of the forest the atmosphere surrounding the plants must be saturated with water. Due to the highly mountainous nature of its terrain, a large proportion of New Guinea forests is located on the slopes between 500 and 2,500 meters above sea level and maintains extremely high humidity, combined with warm but not exceedingly hot weather, which creates

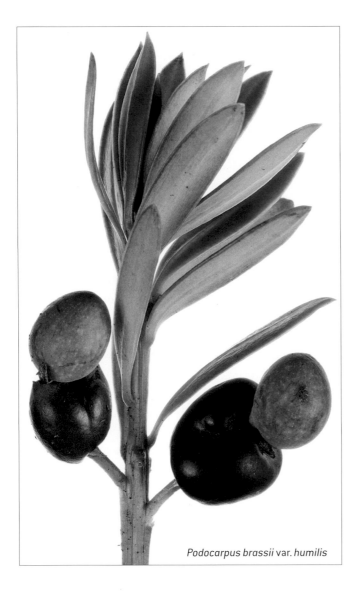
Podocarpus brassii var. *humilis*

pollinators. Some attract insects by turning their flowers into uncanny replicas of female wasps and achieve pollination by repeated visits from confused males who attempt to mate with the flowers. Others produce small amounts of chemical compounds that attract and are collected by male bees, later to be used during these insects' courtship. One New Guinea species, *Bulbophyllum cimicinum*, develops in the center of its flower a perfect, fake "spider," apparent bait that even wiggles convincingly in the slightest breeze. No one knows what pollinates these flowers, but some botanists speculate that it might be spider-hunting wasps.

When our team finally reached Apalu Reke, the last of the planned survey sites on a high-elevation plateau of the Muller Range at nearly 2,900 meters, we found there an unusual plant community, the likes of which had never been seen by a botanist before. Wayne Takeuchi, the expedition's botanist, marveled at the high-elevation meadows composed entirely of tightly packed, stiff-leaved ferns and small shrubs interspersed with patches of mossy forest. To my untrained eye these short, compact bushes looked very much like heathers and blueberries I used to see in the forests of Europe and North America, but Wayne quickly pointed out to me their very different nature. What I took for small red berries hanging from a branch of a heather-like plant turned out to be flowers of an orchid of the genus *Mediocalcar* that weaved its long stems among branches of another plant. A nearby bush, which I thought was a different species of heather, was revealed as a pygmy rhododendron, a plant genus I always associated with large, big-leaved and big-flowered bushes growing in my garden. But this one was only about a foot tall with tiny leaves and flower corollas that looked like small, bright red tubes. Such flowers are typical of plants pollinated by hummingbirds in South America, but these are absent from New Guinea, where their role as pollinators is played by an unrelated family of birds, the honeyeaters. Next to the rhododendron I spotted a very similar plant, with almost identical red, tubular flowers. To my surprise, this turned out

conditions that are perfect for orchids. In some places it is not unusual to see several species of orchids growing on the same tree, and in one instance seven different species of the genus *Bulbophyllum* were found on a thin, approximately foot-long branch. One of the secrets of their ecological success and diversity, despite the fact that most orchids do not produce nectar, is their ability to attract highly motivated, specialized

to be another orchid, an interesting species known as *Dendrobium cuthbertsonii*. Like most orchids, this plant does not produce nectar to attract pollinators to its flowers. Instead, it cheats its way to pollination by mimicking the flowers of the nectar-rich rhododendron and fools birds into dipping their beaks in flowers packed only with worthless, from the bird's point of view, pollen. To avoid the possibility of birds learning to distinguish the faker from rhododendron, flowers of *D. cuthbertsonii* exhibit a remarkable polymorphism and grow in a variety of colors.

Apalu Reke on the high Muller Plateau was a beautiful but very cold place. We shivered in our tents at night when the temperature dropped to below 10°C (50°F), a stark contrast to hot, steamy nights at our earlier campsites. There was not much insect activity at night; in fact, in over a week I recorded the presence of only four species of katydid. My ultraviolet light failed to attract anything, and save for an occasional frog calling from an underground burrow, the place was silent. Days were not much better, and few insects could be seen buzzing around. The role of pollinators of many plants on the plateau had been taken over by birds, whose warm-blooded physiology allowed them to be active even in low temperatures, although this demanded a constant supply of nutrients. One of the most common plants in the open meadows of the plateau was a short shrub covered with large red and blue berries, and I sometimes saw birds feeding on them. I expected this to be a relative of cranberries, but this small plant turned out to be of the genus *Podocarpus*, a close cousin of pines and spruces and an ancient relic of the flora of the old southern supercontinent Gondwana that eventually broke up into several parts, one of which later became today's New Guinea. I knew *Podocarpus* from the cooler regions of South Africa, but there those plants grew in the form of giant trees rather than the stunted, short bushes I was seeing here. Their "berries" had a peculiar structure that revealed the plants' close relationships to conifers. Each consisted of an aril, a brightly colored, fleshy base sought

after by birds, and a green seed that would germinate after passing, undamaged, through the bird's digestive tract.

As the cold days went by, in our desperation to find insects the team's ant specialist, Andrea Lucky, and I decided to sacrifice one of the trees at the edge of the *Nothofagus* forest, hoping to discover something, anything, in the thick mats of epiphytic mosses that wrapped its every branch. Our local helpers swiftly chopped it down with an efficiency that bespoke years of expertise. But several hours later, after combing through every little branch of the fallen tree, and peeling bark off most of its trunk, we failed to locate a single ant, katydid, or beetle. All we found was one small cricket and a few arboreal earthworms. To be certain that we did not miss anything Andrea gathered large samples of mosses and bark from different parts of the tree and placed them in devices known as Winkler extractors that allow entomologists to capture even the tiniest of animals hiding among plant material. Those also produced nothing. It is a well-known fact that the abundance and richness of organisms decrease dramatically with the increase in elevation (if for no other reason than that the area available to them gets smaller the closer they get to the mountaintops), but it was nevertheless stunning to discover that an entire epiphyte-laden tree in the most remote, unspoiled mountains of tropical Papua New Guinea can be virtually devoid of insects. A few years earlier I was surveying insects at a similar elevation in China, in the cold, temperate forests on the eastern flanks of the Himalayas and there, surprisingly, the insect diversity on trees was distinctly more impressive. There had to be an explanation.

In the 1960s ecologist Daniel Janzen came up with an interesting hypothesis that, at the time, was dismissed by many, although now is accepted (with some caveats) by most biologists. He claimed that mountain passes, and thus mountain ranges, were "higher in the tropics." This did not mean, of course, that they were physically higher than in other parts of the world, but rather, that their effect on dispersal abilities of organisms was more pronounced in tropical areas than in

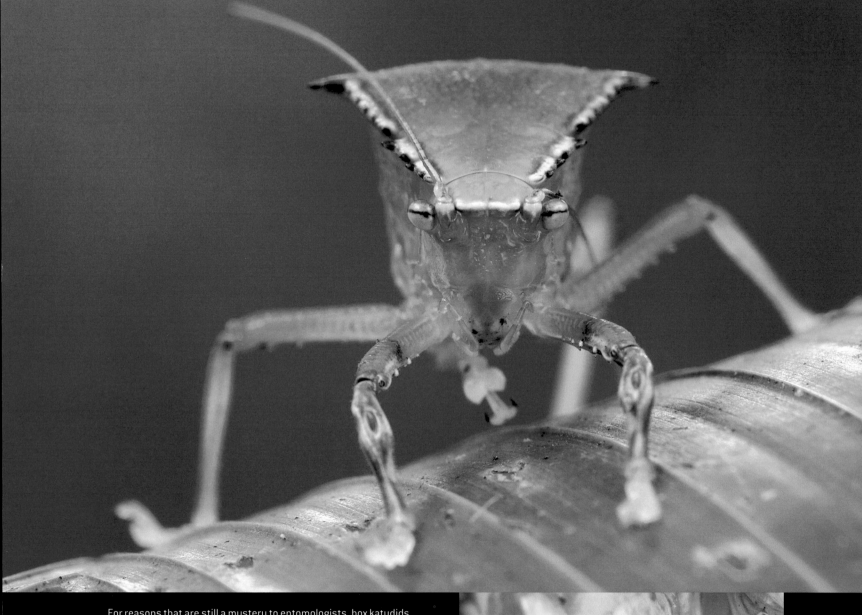

For reasons that are still a mystery to entomologists, box katydids (*Phyllophora*) are some of the very few katydids that do not—and cannot—sing. Their wings do not have the specialized structures that allow other members of their family to produce beautiful courtship calls that resonate through the night in New Guinea's rainforests. But they are not completely silent, either. In an interesting case of evolutionary ingenuity, they have developed sets of dense, parallel ridges on the bases of their legs. If captured by a predator they rub them vigorously against special lobes of the sternum, producing a loud hissing sound, eerily reminiscent of the hiss of a snake. This is probably enough for any bird or other predator to leave the suspect, albeit entirely harmless, insect alone.

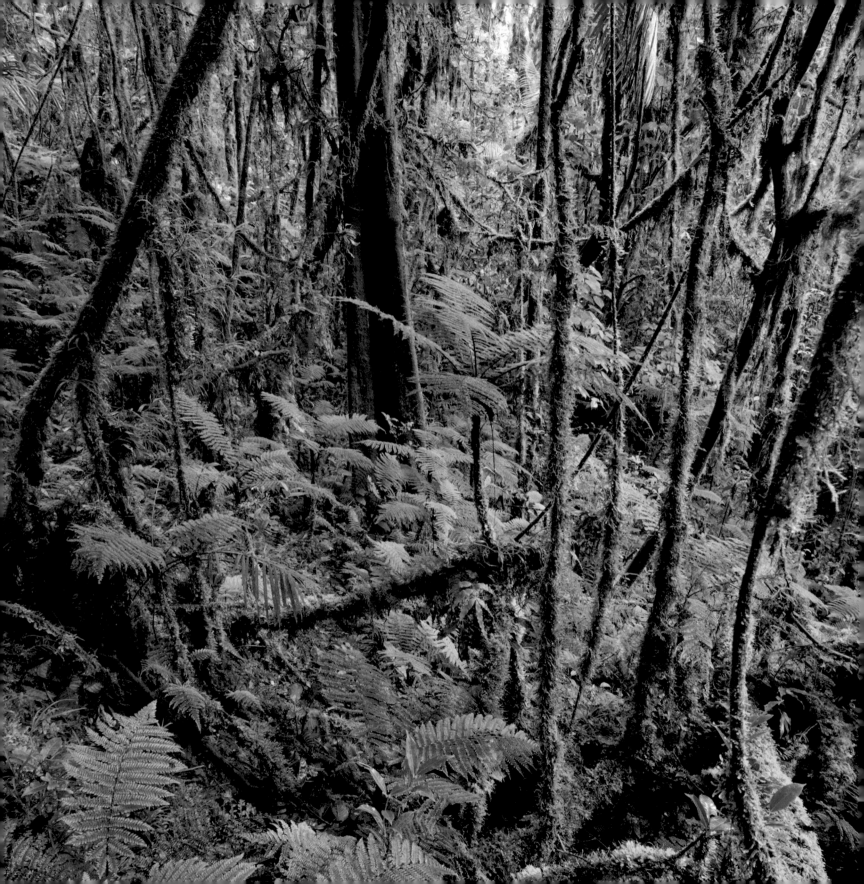

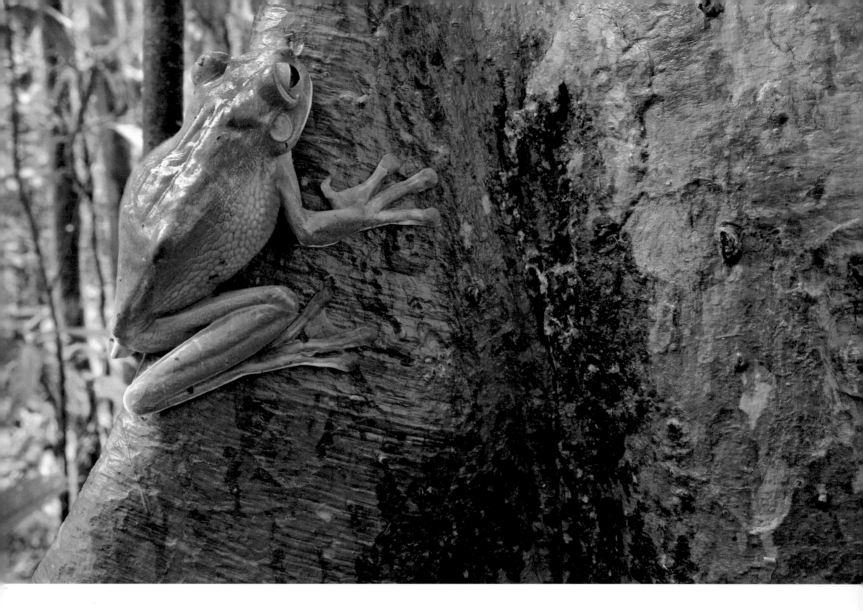

Clinging to a buttress root of a rainforest tree, a giant, newly discovered, yet-unnamed gliding frog (*Litoria* sp. n.) is living proof of how much unexplored biodiversity still hides in the awe-inspiring forest of New Guinea.

temperate regions. Janzen speculated that tropical organisms generally live in more climatically stable conditions than their counterparts in the temperate zones and thus are not as well adapted to dramatic temperature drops typical of the mountains. Therefore, they are less likely to be able to survive a journey across a mountain range, and populations of the same species separated by mountains will quickly become genetically isolated, leading to their transformation into distinct, reproductively isolated species. Perhaps the same principle may explain the general paucity of insects at high elevations in the tropics. The rate of colonization of mountains by organisms that live in the foothills will depend, among other things, on the ability of those organisms to adapt to severe

daily and seasonal shifts in temperatures that characterize alpine habitats. Mountains in temperate zones, by definition, are colonized by species that are already adapted to strong seasonal temperature fluctuations. But in areas closer to the equator there are not many organisms that can withstand harsh, cold conditions typical of the mountains, and consequently, fewer of them will end up living there. In the Himalayas I found ants at the elevation of 5,500 meters, all close relatives of species living in the lowlands. But on New Guinea no ants have ever been seen above approximately half this elevation, despite the fact that species richness of New Guinea ants is orders of magnitude higher than that of the Himalayas. In all likelihood the warmth-loving insects of New Guinea are simply not predisposed to adapt quickly to the alpine conditions of Apalu Reke, and this is why so few of them have so far been able to survive there.

It is puzzles like this that make working on New Guinea such a fascinating experience, and the island is as close to a biologist's paradise as it can get. Every ecosystem is brimming with unanswered questions, and every organism challenges us with the task of untangling its complex behaviors and relationships with other members of biological communities. In each nook and cranny of the island, new, yet-unnamed species of plants and animals await discovery. New Guinea is the home to not only birds-of-paradise and a stunning flora of orchids but also the largest butterflies, the largest katydids, the tallest mosses, and the largest mites in the world. It harbors the planet's third most expansive swath of pristine, tropical rainforest, and the dazzling coral reefs that circle the island are reputably the richest in Earth's oceans. New Guinea offers us a glimpse of the natural world very close to its unal-

tered state, a biological baseline from which the rest of the planet has long since departed. It owes this largely to its remoteness and isolation as well as its dramatic and difficult to access terrain. But like everywhere else, the insatiable appetite of the world for more wood, more gold, and more fossil fuels poses a danger to this spectacular sanctuary of the prehuman world. A recently signed deal between the government of Papua New Guinea and an international consortium of oil companies to extract liquefied natural gas in the highlands on New Guinea, a deal that promises to double (some say, quadruple) the country's gross domestic product, may open a Pandora's box of unchecked industrial exploitation. It is too early to say what net effect the massive extraction operations will have on the biodiversity of the island, but they will certainly result in more roads penetrating the still-inaccessible parts of the country to facilitate the removal of timber; and more products coming in from other parts of the world will carry the risk of unwanted invasive species. Clearly, nobody can deny Papua New Guinea the right to develop and advance its industrial capacities, but in a time like this, when one of the last remaining "arks" of biodiversity sits on the verge of a major change, the international conservation community should offer as much guidance and help to the decision-makers of Papua New Guinea as possible. At the same time, while hoping for the best, biologists from all corners of the world should collaborate with local scientists in their effort to document the incredible richness of New Guinea, this place known as the Land of the Unexpected, which is simply incapable of disappointing a biologist. For my part, I am ready to drop everything I am doing and go back there on a moment's notice.

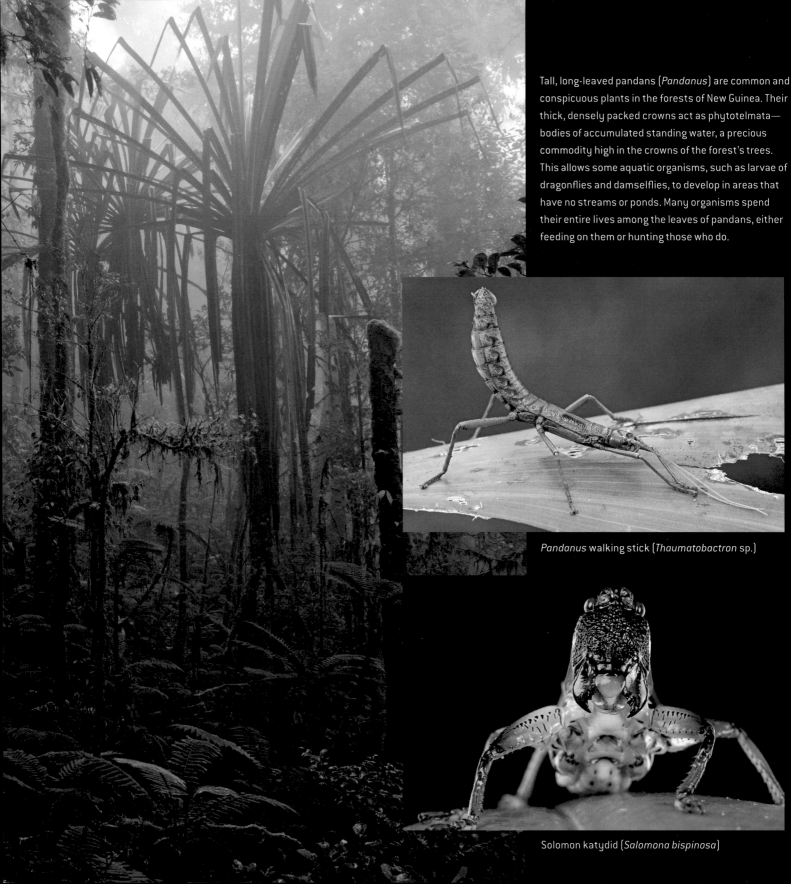

Tall, long-leaved pandans (*Pandanus*) are common and conspicuous plants in the forests of New Guinea. Their thick, densely packed crowns act as phytotelmata— bodies of accumulated standing water, a precious commodity high in the crowns of the forest's trees. This allows some aquatic organisms, such as larvae of dragonflies and damselflies, to develop in areas that have no streams or ponds. Many organisms spend their entire lives among the leaves of pandans, either feeding on them or hunting those who do.

Pandanus walking stick (*Thaumatobactron* sp.)

Solomon katydid (*Salomona bispinosa*)

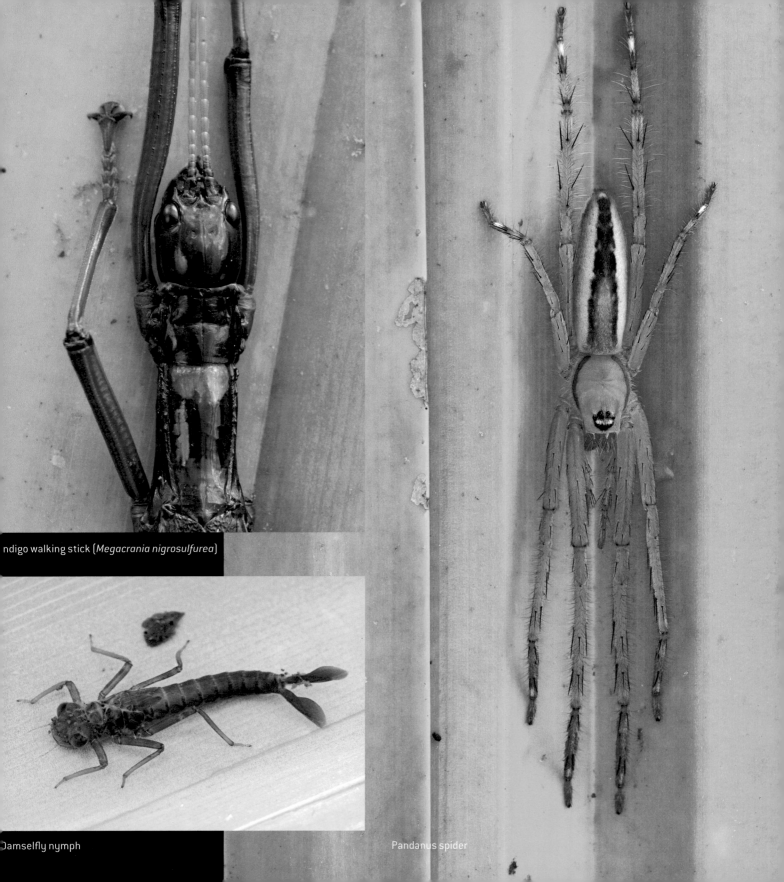

Indigo walking stick (*Megacrania nigrosulfurea*)

Damselfly nymph

Pandanus spider

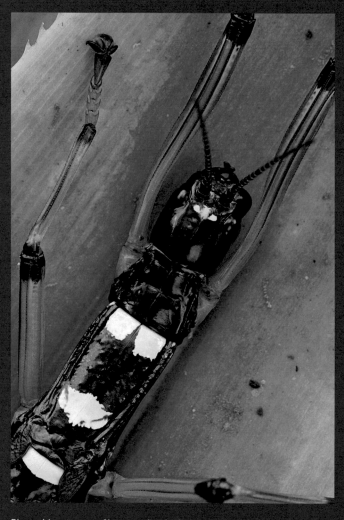

Phasmids, a group of insects that includes some of the best plant mimics of the animal world, is well known for its two extremely effective defense strategies. All species of this group are exclusively herbivorous and thus do not possess sharp teeth or stingers that they could use to protect themselves. Some, like the Indigo walking stick, synthesize exceptionally unpleasant chemicals, which they can spray with surprising accuracy at their attacker. Interestingly, some species of walking sticks produce the compound nepetalactone, found also in catnip. Species that are chemically protected often exhibit bright, contrasting warning coloration.

Other phasmids adopt the opposite approach and turn their bodies into perfect replicas of leaves and stems. None is more convincing than the leaf insect (*Phyllium*), which can be found high among the canopy vegetation of New Guinea's rainforests.

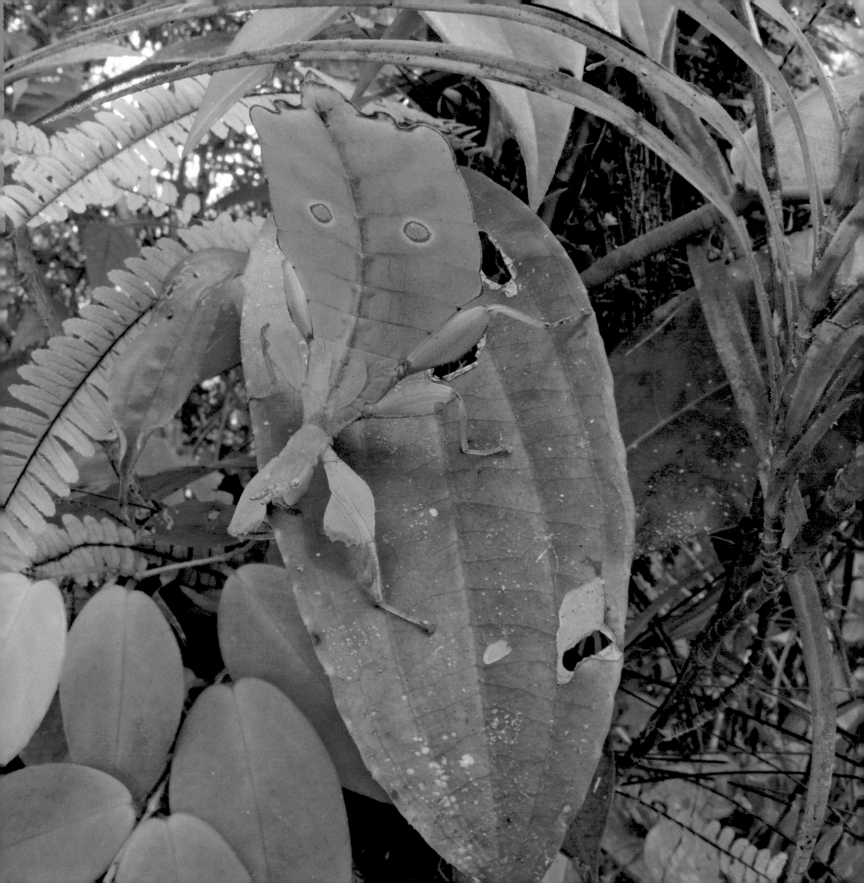

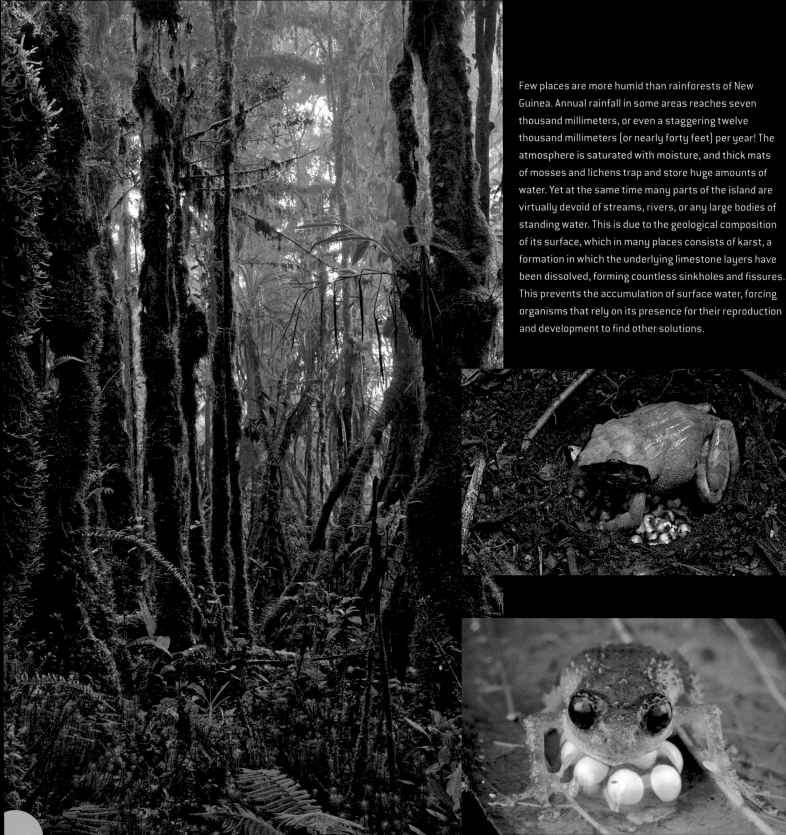

Few places are more humid than rainforests of New Guinea. Annual rainfall in some areas reaches seven thousand millimeters, or even a staggering twelve thousand millimeters (or nearly forty feet) per year! The atmosphere is saturated with moisture, and thick mats of mosses and lichens trap and store huge amounts of water. Yet at the same time many parts of the island are virtually devoid of streams, rivers, or any large bodies of standing water. This is due to the geological composition of its surface, which in many places consists of karst, a formation in which the underlying limestone layers have been dissolved, forming countless sinkholes and fissures. This prevents the accumulation of surface water, forcing organisms that rely on its presence for their reproduction and development to find other solutions.

Frogs are organisms whose early development requires
an aquatic habitat, an inconvenient remnant of their early
evolutionary history. In most species females lay their
eggs in streams and ponds, and developing tadpoles use
their gills to breathe under water. But on New Guinea,
where surface water is scarce, many species have
evolved strategies that allow them to bypass a free-living
tadpole stage entirely. Rather than laying hundreds or
thousands of small eggs and leaving them to their own
devices in the water, they produce a handful of very large
eggs and take care of them until they are ready to hatch.
Each egg contains enough nutrients, in the form of a large
yolk reserve, that allows the embryo inside to complete
its development into a tiny, independent froglet. Unlike
reptile or bird eggs, frog eggs lack a hard, water-imperme-
able shell, and risk their desiccation if not protected and
moistened regularly. For this reason, one of the parents
stays with the eggs and safeguards them throughout
their development. In the large and heavy *Platymantis
boulengeri* the female digs a small hole in the ground,
and sits on the eggs, providing both physical protection
and humidity. In the much smaller frogs of the genus
Oreophryne, it is the male that guards the eggs suspended
in a clutch underside a leaf. He leaves them during the day
to go hunting for insects but comes back every evening
to moisten them with water and shield them from harm.
After a few weeks, young frogs are ready to become in-
dependent, and break the walls of their miniature aquatic
cradles.

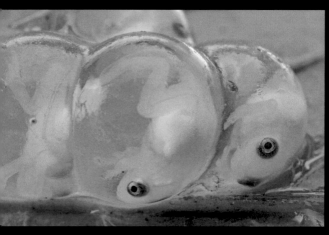

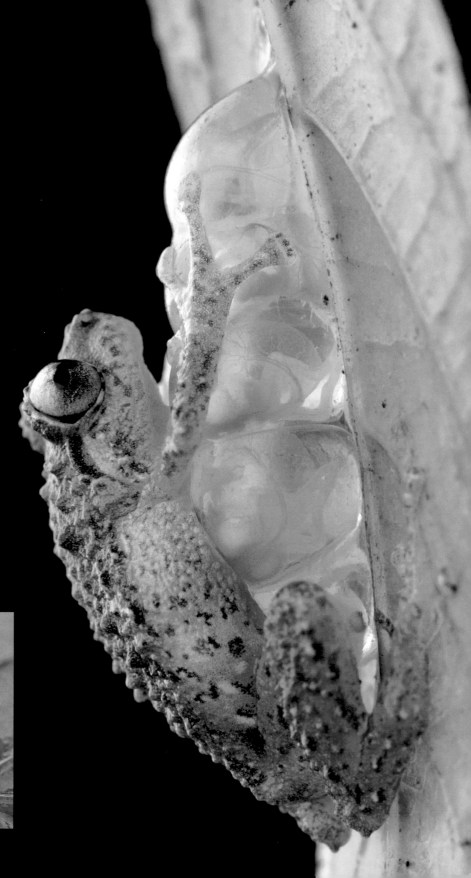

Lechriodus aganoposis

Platymantis mamusiorum

Platymantis nakanaiorum

Giant mouthparts, reminiscent of the antlers of mammals, are a common feature of many New Guinea arthropods. But their disproportional growth, known as allometric hypertrophy, can be shaped by very different forces, depending on the final function of the monstrous organs.

In stag beetles the evolution of enormous mandibles has been driven by sexual selection. Females of these insects preferentially mate with males whose mandibles are larger, and their larger size gives them the advantage in the male-to-male combat. The downside of such huge appendages is that they no longer can be used for feeding, and carrying them around requires a lot of energy. Not surprisingly, within each population of stag beetles a small proportion of males develops regular mouthparts and achieves reproductive success by sneaking up on females when the giant males are preoccupied with jousting.

The mandibles of trap-jawed ants (*Odontomachus papuanus*) are deadly weapons, the development of which is the result of natural selection. These insects feed on small, agile springtails (Collembola), and the faster they are able to close their mandibles around one the greater the chance of a nutritious meal. This has led to the development of the fastest reflex reaction in the entire animal kingdom. A pair of long hairs at the base of the mandibles acts as a sensor, which, if a prey is detected, triggers an instantaneous snap. It takes less than a one-thousandth of a second for the jaws to shut, and the force of this action is so strong that the ants sometimes use it for a very different purpose—if attacked by a predator they bend the head down, snap the jaws, and the energy of this action propels the ant into the air, making them the only organisms known to jump using their jaws.

Long-jawed jumping spiders (*Bathippus*) are unusual in the development of their chelicerae, the spider equivalent of mandibles. Only males have them in such an extraordinary form, but their function is not entirely clear. In all likelihood they are used both for hunting and as a part of

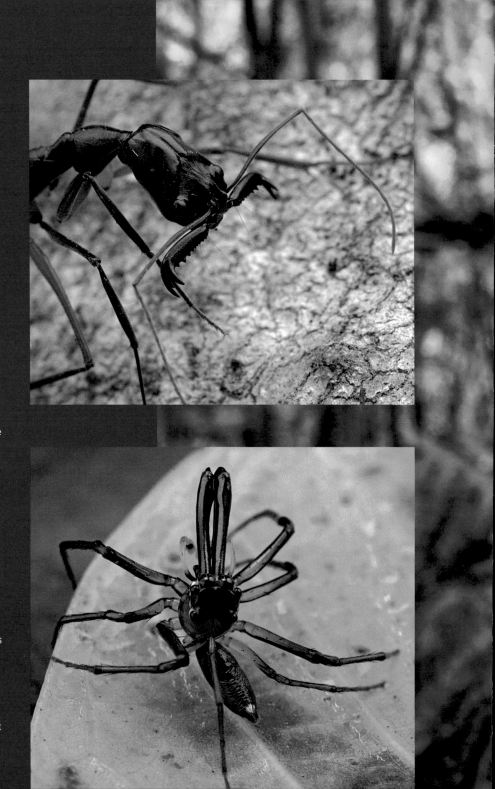

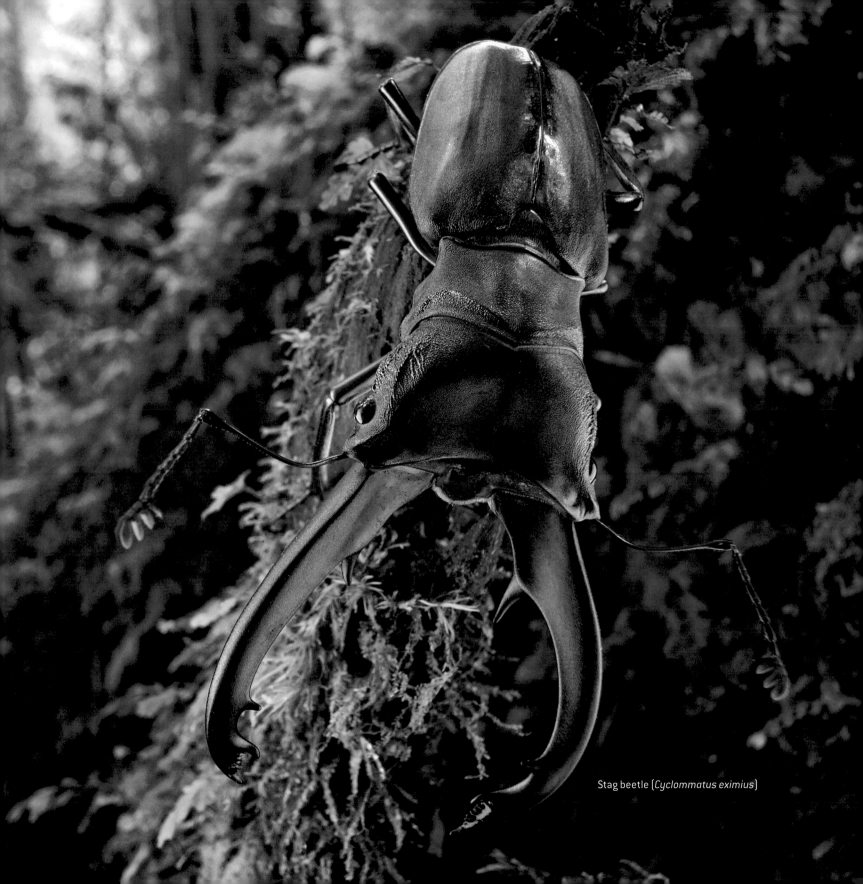

Stag beetle (*Cyclommatus eximius*)

Sexual size dimorphism, a phenomenon where one of the sexes is larger than the other, is quite common among animals. But nowhere is it more pronounced than in spiders, in which the female can be ten times longer and over a hundred times heavier than the male. A good example of sexual dimorphism are spiders of the genus *Gasteracantha*, which are common across New Guinea. The female is large and beautifully adorned, whereas the male is about ten times smaller and rather drab in appearance. The females spin large orb webs on trees or tall bushes, and males look for the females by walking from tree to tree. Recent studies indicate that natural selection favors males of a small size, which is optimal for quickly climbing the vegetation. Larger males simply cannot climb as fast as the small ones and are less likely to find a mating partner. Inconspicuous coloration of the small males also allows them to avoid attracting the attention of birds and other predators.

A male *Gasteracantha taeniata*

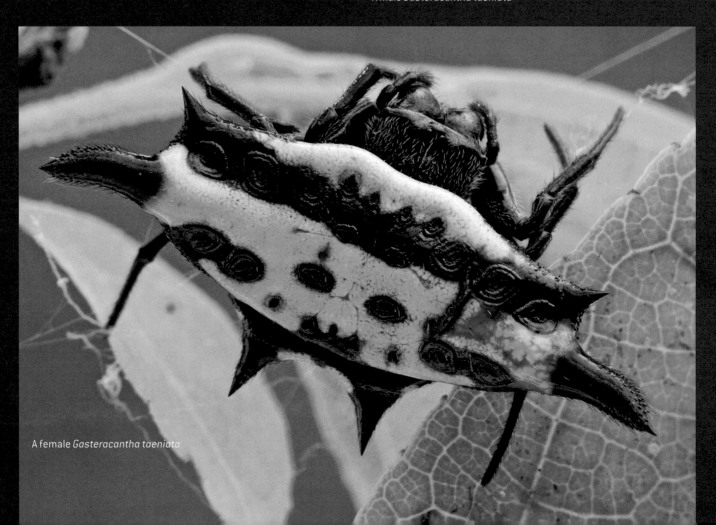

A female *Gasteracantha taeniata*

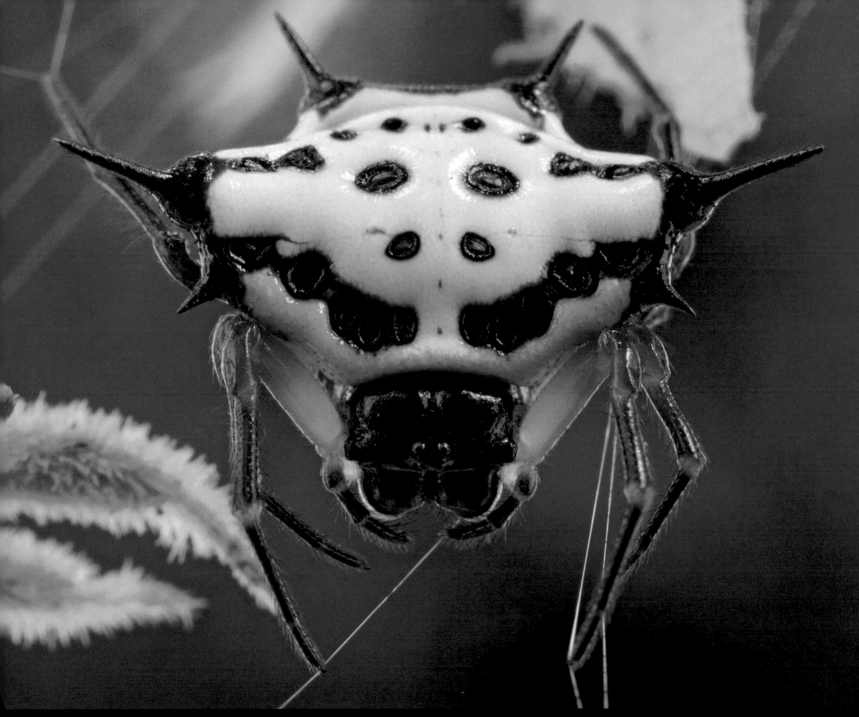

A female *Gasteracantha sapperi*

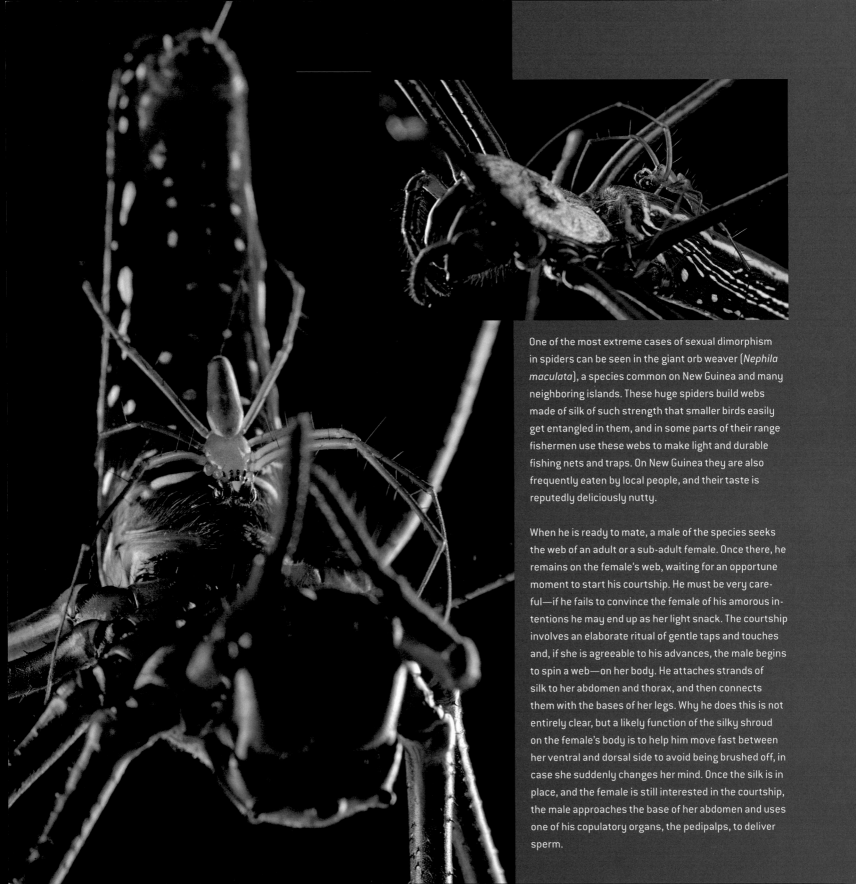

One of the most extreme cases of sexual dimorphism in spiders can be seen in the giant orb weaver (*Nephila maculata*), a species common on New Guinea and many neighboring islands. These huge spiders build webs made of silk of such strength that smaller birds easily get entangled in them, and in some parts of their range fishermen use these webs to make light and durable fishing nets and traps. On New Guinea they are also frequently eaten by local people, and their taste is reputedly deliciously nutty.

When he is ready to mate, a male of the species seeks the web of an adult or a sub-adult female. Once there, he remains on the female's web, waiting for an opportune moment to start his courtship. He must be very careful—if he fails to convince the female of his amorous intentions he may end up as her light snack. The courtship involves an elaborate ritual of gentle taps and touches and, if she is agreeable to his advances, the male begins to spin a web—on her body. He attaches strands of silk to her abdomen and thorax, and then connects them with the bases of her legs. Why he does this is not entirely clear, but a likely function of the silky shroud on the female's body is to help him move fast between her ventral and dorsal side to avoid being brushed off, in case she suddenly changes her mind. Once the silk is in place, and the female is still interested in the courtship, the male approaches the base of her abdomen and uses one of his copulatory organs, the pedipalps, to deliver sperm.

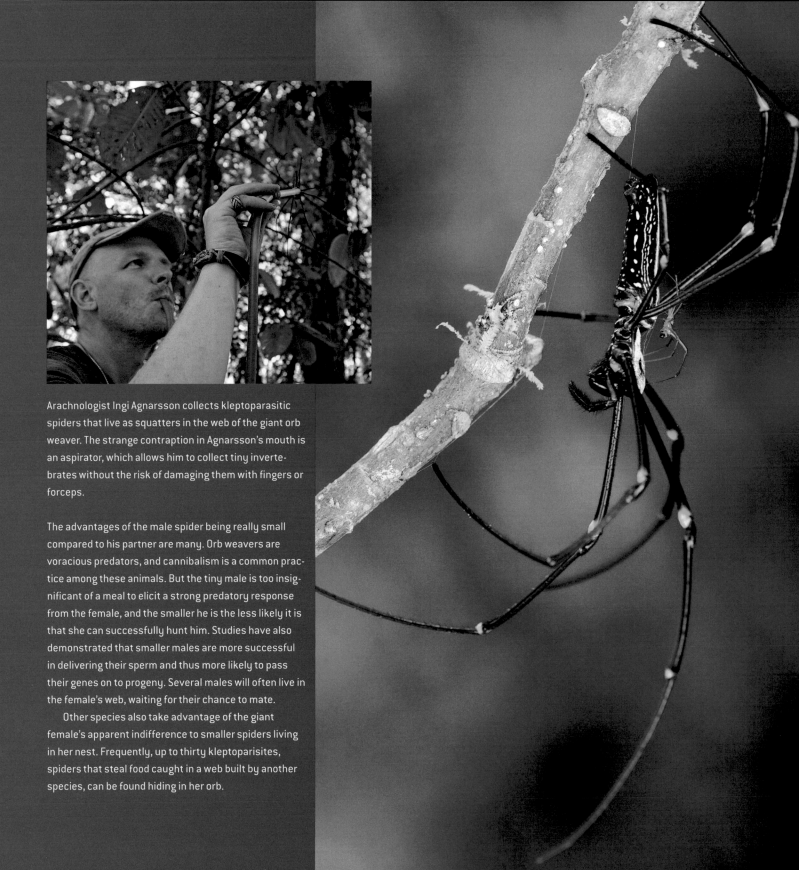

Arachnologist Ingi Agnarsson collects kleptoparasitic spiders that live as squatters in the web of the giant orb weaver. The strange contraption in Agnarsson's mouth is an aspirator, which allows him to collect tiny invertebrates without the risk of damaging them with fingers or forceps.

The advantages of the male spider being really small compared to his partner are many. Orb weavers are voracious predators, and cannibalism is a common practice among these animals. But the tiny male is too insignificant of a meal to elicit a strong predatory response from the female, and the smaller he is the less likely it is that she can successfully hunt him. Studies have also demonstrated that smaller males are more successful in delivering their sperm and thus more likely to pass their genes on to progeny. Several males will often live in the female's web, waiting for their chance to mate.

Other species also take advantage of the giant female's apparent indifference to smaller spiders living in her nest. Frequently, up to thirty kleptoparisites, spiders that steal food caught in a web built by another species, can be found hiding in her orb.

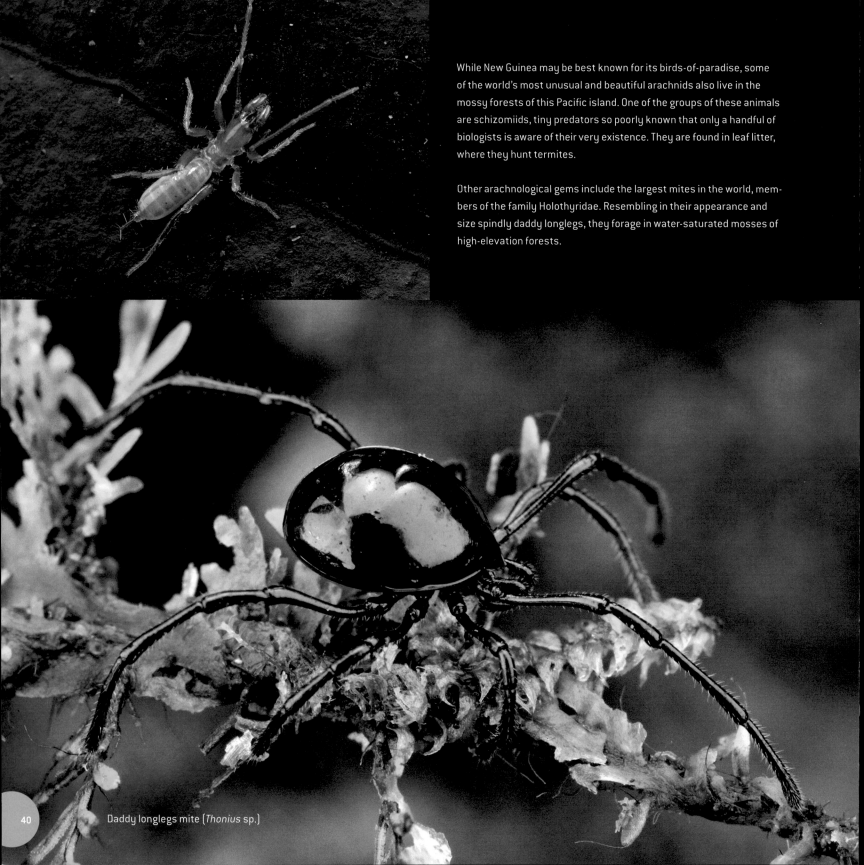

While New Guinea may be best known for its birds-of-paradise, some of the world's most unusual and beautiful arachnids also live in the mossy forests of this Pacific island. One of the groups of these animals are schizomiids, tiny predators so poorly known that only a handful of biologists is aware of their very existence. They are found in leaf litter, where they hunt termites.

Other arachnological gems include the largest mites in the world, members of the family Holothyridae. Resembling in their appearance and size spindly daddy longlegs, they forage in water-saturated mosses of high-elevation forests.

Daddy longlegs mite (*Thonius* sp.)

Jumping spiders (Salticidae) are represented on New Guinea by some of the most interesting members of this family. Shiny, squatty *Coccorchestes* sp. resemble a small black beetles, and probably use their appearance to approach and capture these insects.

The long, spiny front legs of *Diolenius* sp. resemble those of a preying mantis, and possibly these spiders use them for prey capture (both males and females have similarly enlarged legs). Their other function is for the highly choreographed courtship displays for which these jumping spiders are famous.

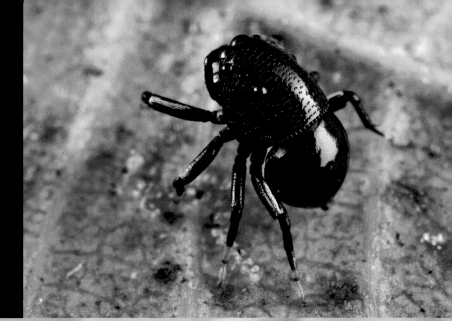

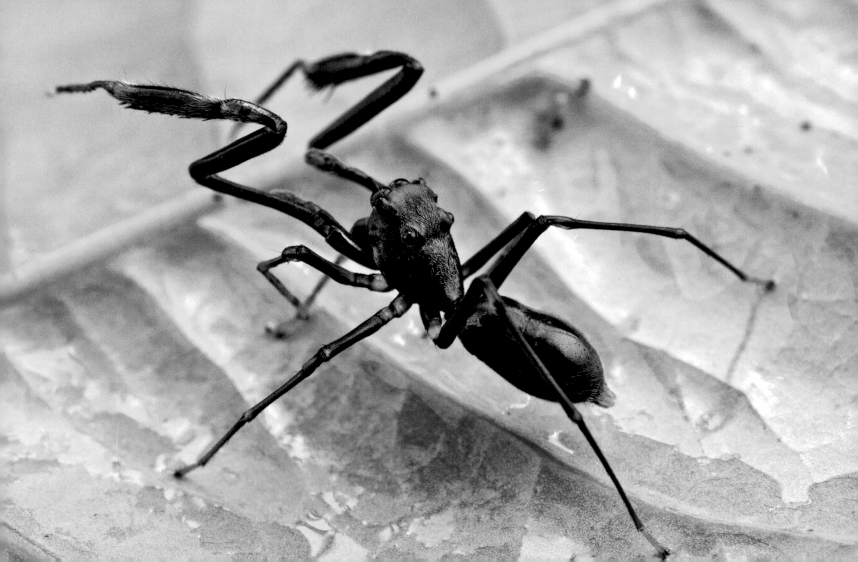

Leaf-nosed bat (*Hipposideros cervinus*)

With nearly a hundred species, bats are the largest group of mammals on New Guinea. More than half of them are insectivorous, hunting their prey with the help of echolocation. Bats that use this method send out short, ultrasonic waves that bounce off their prey, revealing its exact position, even in complete darkness. Some, like the leaf-nosed bats, produce the ultrasonic signals through their noses, which often assume elaborate and strange shapes that help them focus the beam of sound.

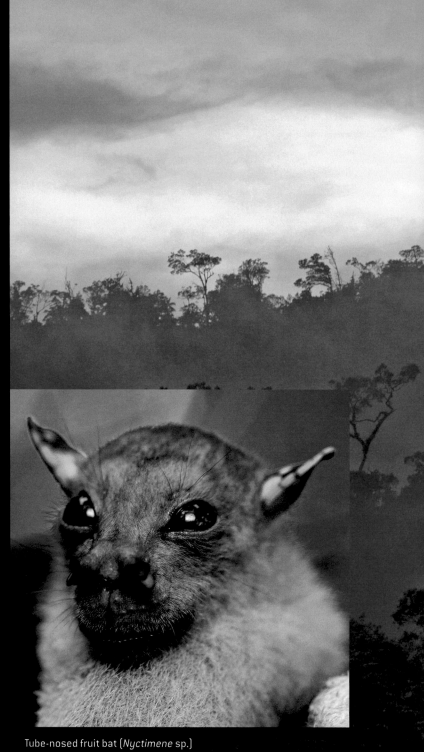

Tube-nosed fruit bat (*Nyctimene* sp.)

Fruit-eating bats are significantly larger than insectivorous bats, and

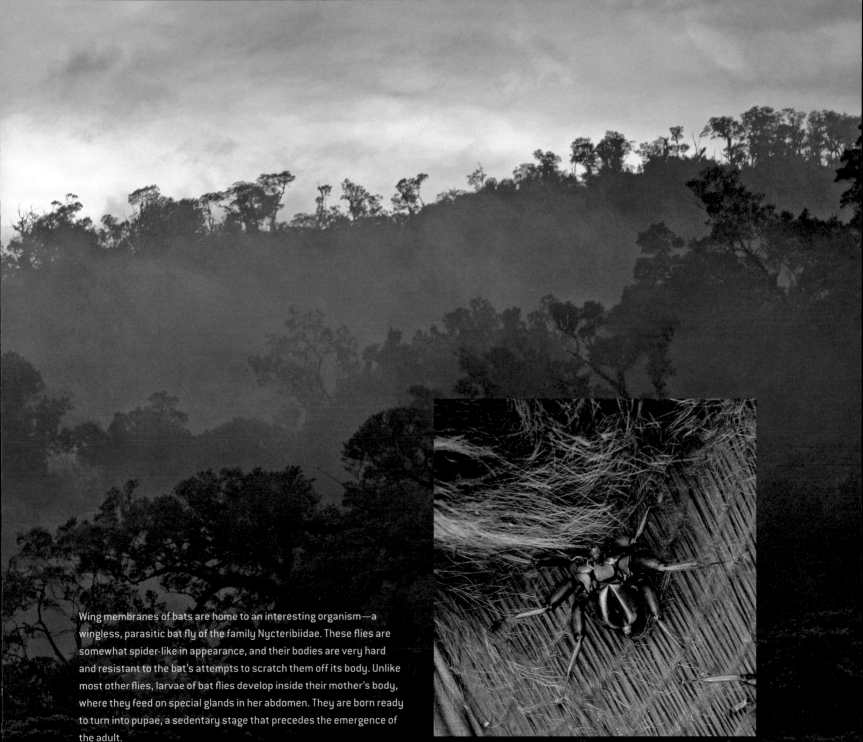

Wing membranes of bats are home to an interesting organism—a wingless, parasitic bat fly of the family Nycteribiidae. These flies are somewhat spider-like in appearance, and their bodies are very hard and resistant to the bat's attempts to scratch them off its body. Unlike most other flies, larvae of bat flies develop inside their mother's body, where they feed on special glands in her abdomen. They are born ready to turn into pupae, a sedentary stage that precedes the emergence of the adult.

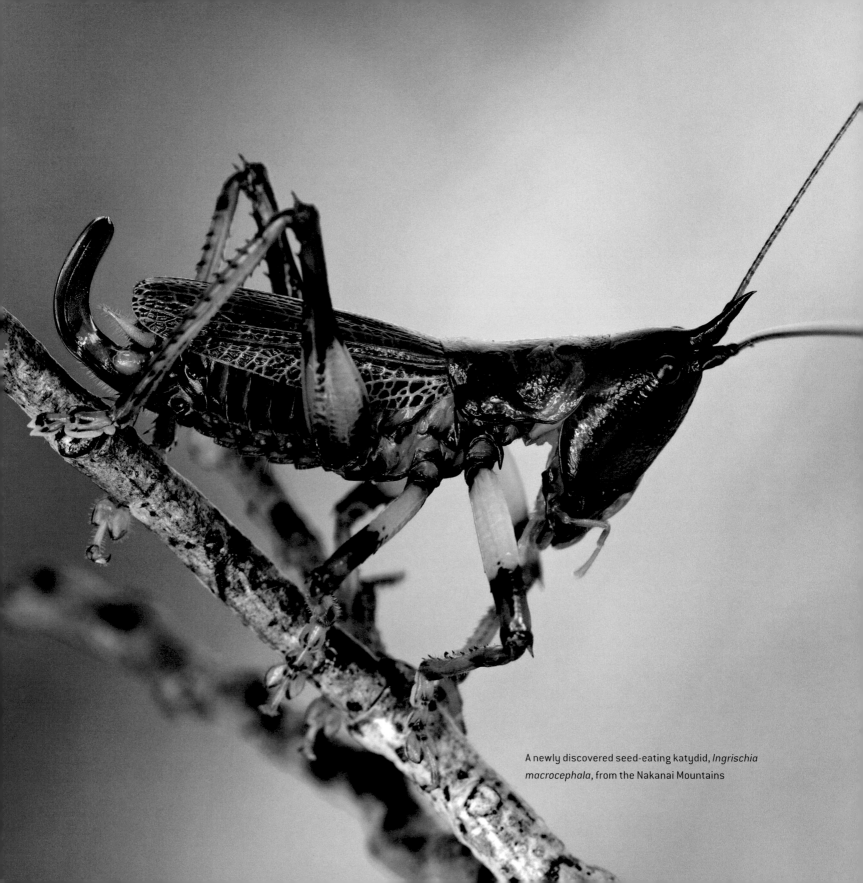

A newly discovered seed-eating katydid, *Ingrischia macrocephala*, from the Nakanai Mountains

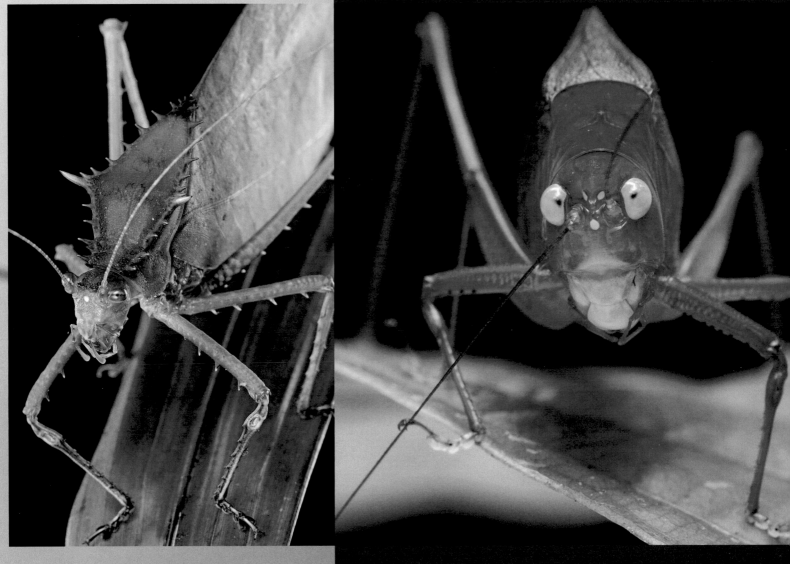

The katydid fauna of New Guinea is truly dazzling. Among the forms that can be found there are the helmeted katydids (Phyllophorinae), the largest katydids in the world. They are easily recognizable by their huge, shield-like pronotum behind the head, which is often armed with sharp spines. Its function is to protect the vulnerable head and thorax from aerial attacks of bats and birds.

Leaf katydids (Phaneropterinae) spend their entire lives in the canopy of the rainforest. Unlike most katydids, females of such species, like this pink-eyed *Caedicia*, never descend to the ground to lay their eggs in the soil but instead deposit them in clutches on the surface of leaves and lianas.

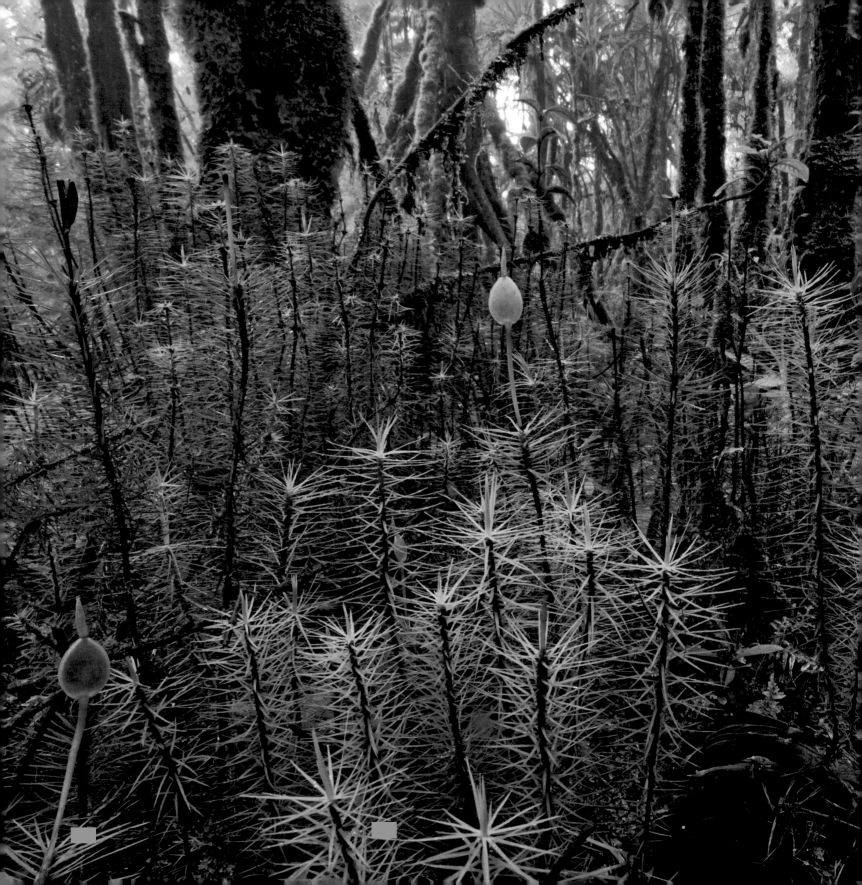

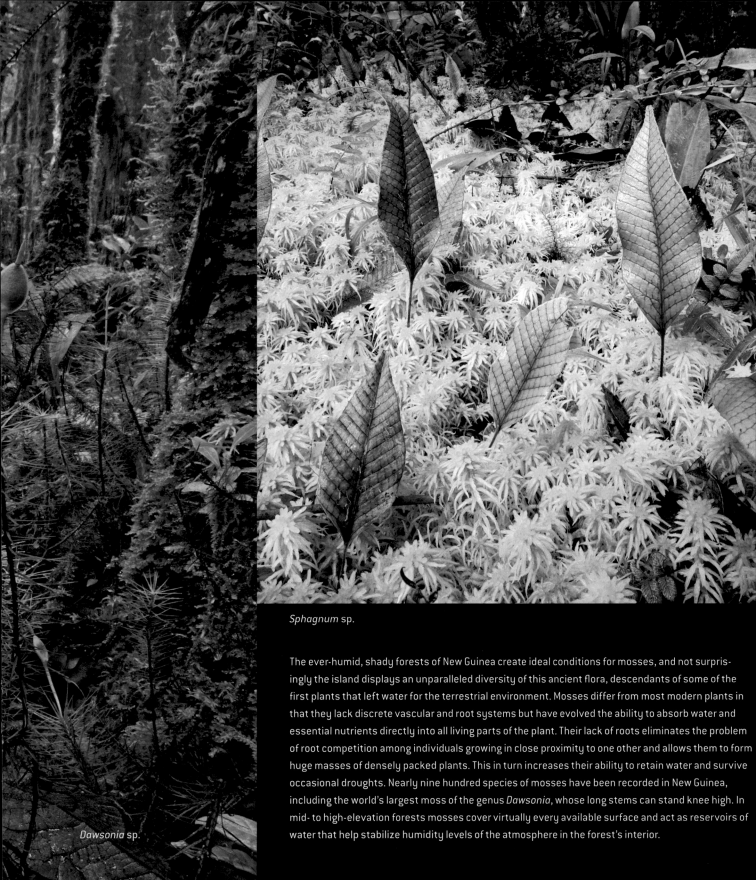

Sphagnum sp.

Dawsonia sp.

The ever-humid, shady forests of New Guinea create ideal conditions for mosses, and not surpris-ingly the island displays an unparalleled diversity of this ancient flora, descendants of some of the first plants that left water for the terrestrial environment. Mosses differ from most modern plants in that they lack discrete vascular and root systems but have evolved the ability to absorb water and essential nutrients directly into all living parts of the plant. Their lack of roots eliminates the problem of root competition among individuals growing in close proximity to one other and allows them to form huge masses of densely packed plants. This in turn increases their ability to retain water and survive occasional droughts. Nearly nine hundred species of mosses have been recorded in New Guinea, including the world's largest moss of the genus *Dawsonia*, whose long stems can stand knee high. In mid- to high-elevation forests mosses cover virtually every available surface and act as reservoirs of water that help stabilize humidity levels of the atmosphere in the forest's interior.

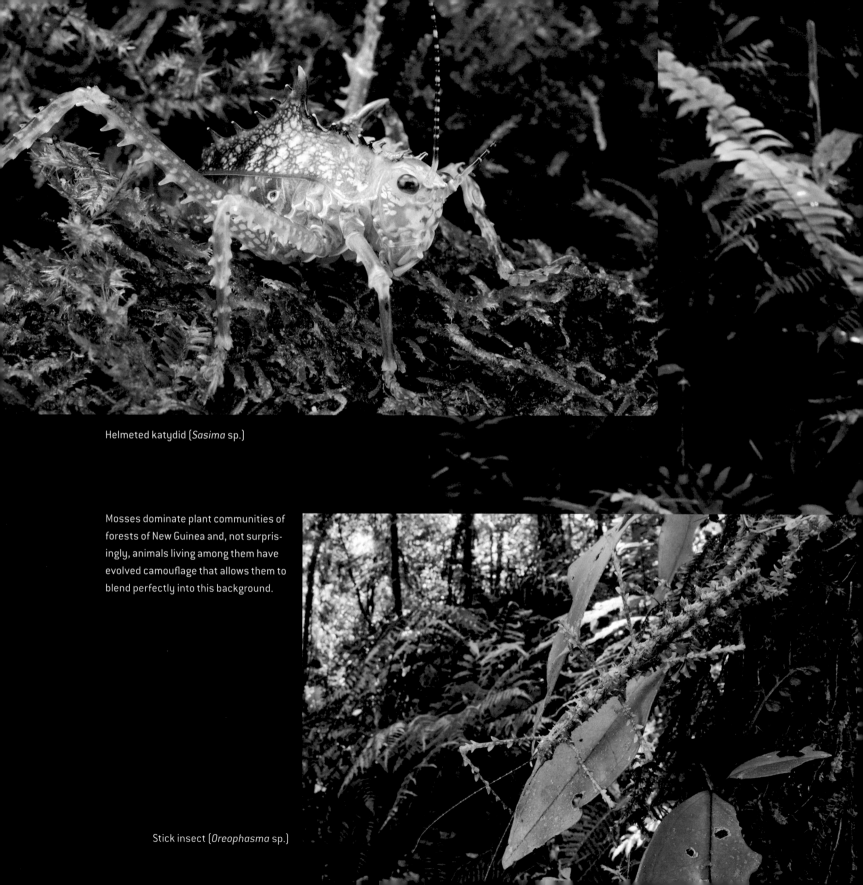

Helmeted katydid (*Sasima* sp.)

Mosses dominate plant communities of forests of New Guinea and, not surprisingly, animals living among them have evolved camouflage that allows them to blend perfectly into this background.

Stick insect (*Oreophasma* sp.)

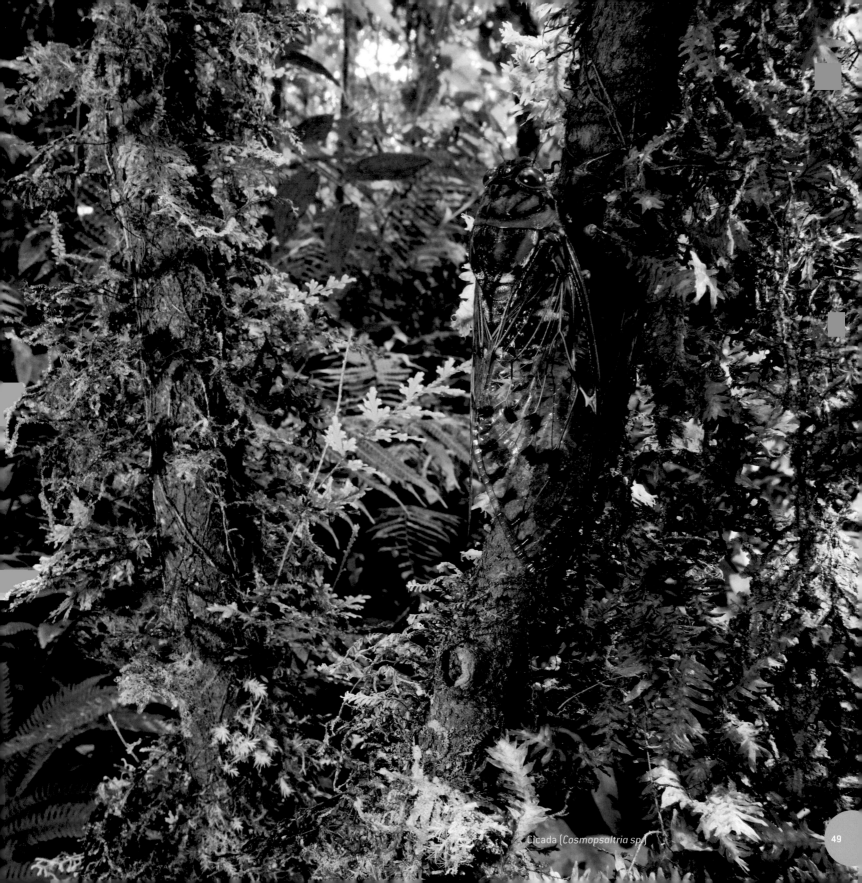

Cicada (*Cosmopsaltria sp.*)

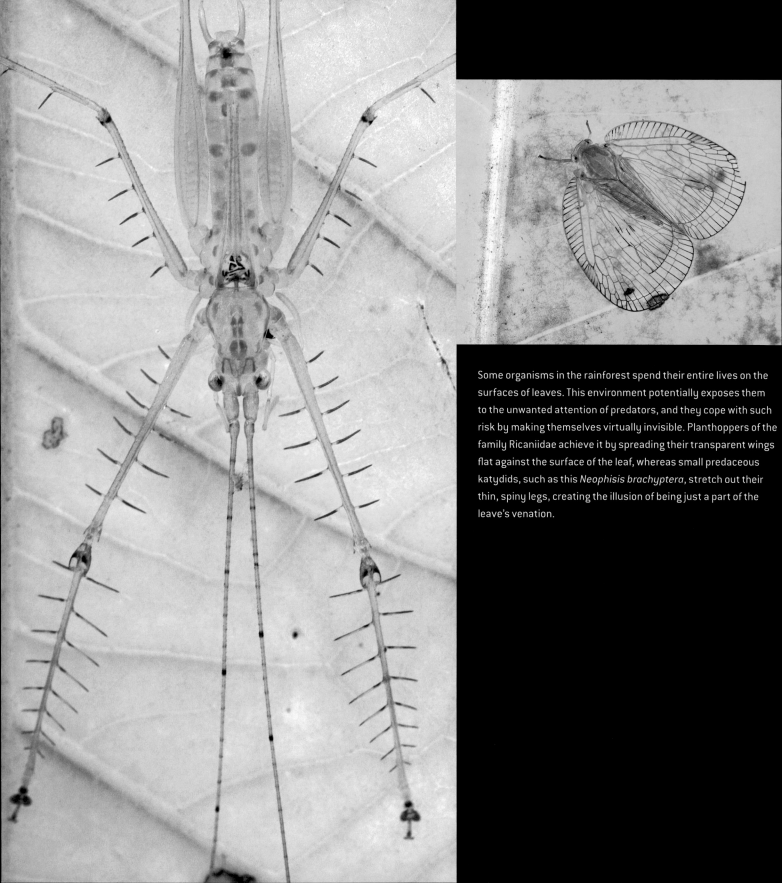

Some organisms in the rainforest spend their entire lives on the surfaces of leaves. This environment potentially exposes them to the unwanted attention of predators, and they cope with such risk by making themselves virtually invisible. Planthoppers of the family Ricaniidae achieve it by spreading their transparent wings flat against the surface of the leaf, whereas small predaceous katydids, such as this *Neophisis brachyptera*, stretch out their thin, spiny legs, creating the illusion of being just a part of the leave's venation.

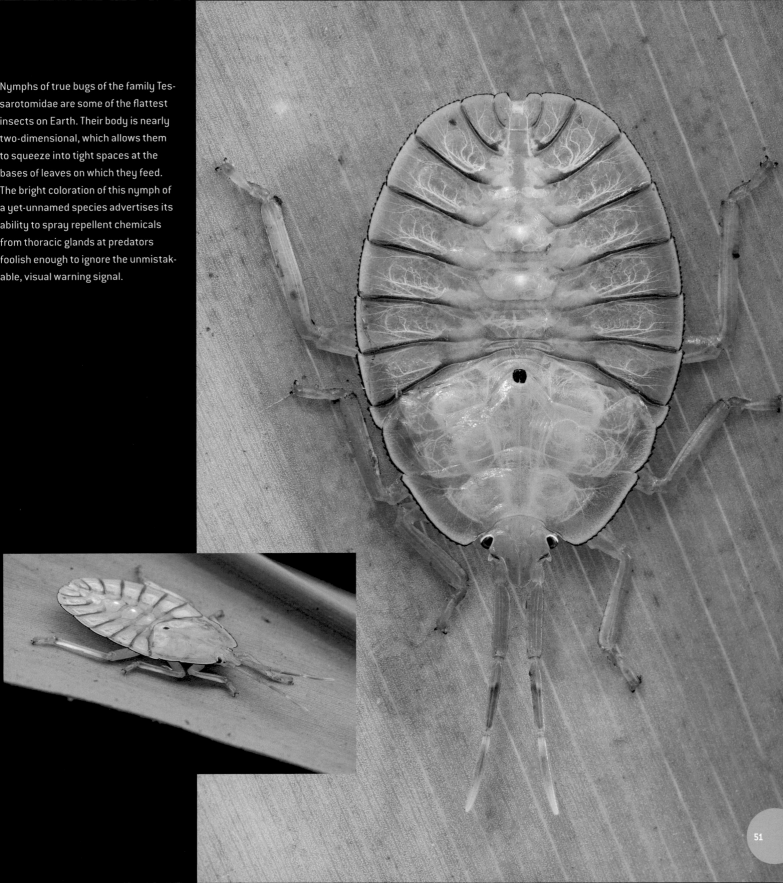

Nymphs of true bugs of the family Tessarotomidae are some of the flattest insects on Earth. Their body is nearly two-dimensional, which allows them to squeeze into tight spaces at the bases of leaves on which they feed. The bright coloration of this nymph of a yet-unnamed species advertises its ability to spray repellent chemicals from thoracic glands at predators foolish enough to ignore the unmistakable, visual warning signal.

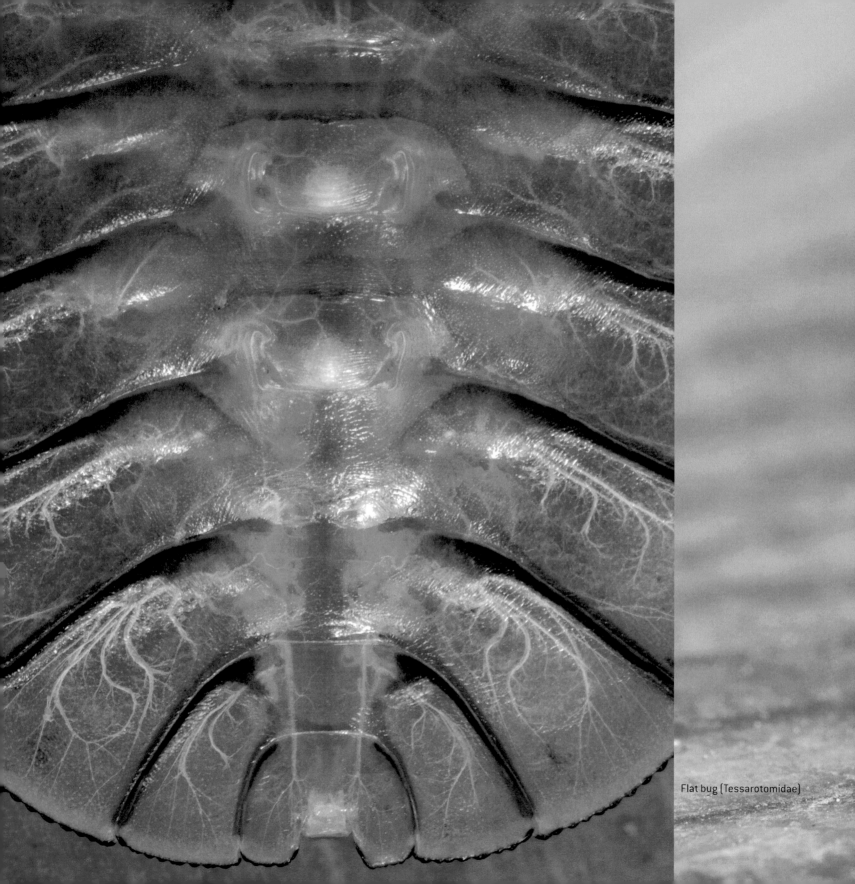

Flat bug (Tessarotomidae)

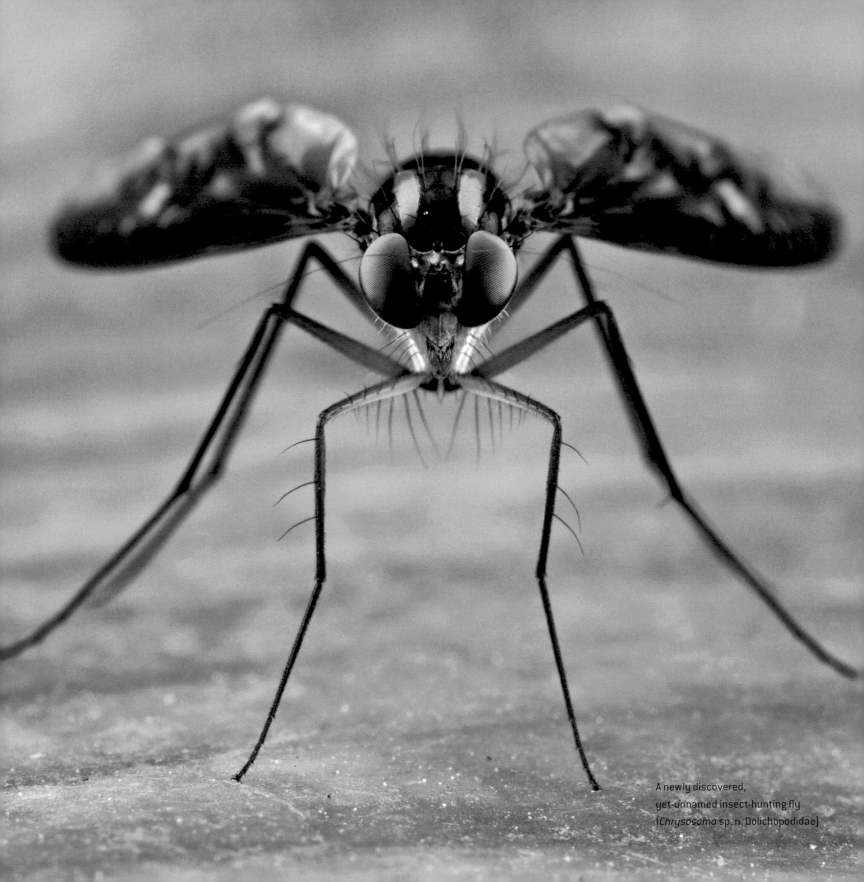

A newly discovered,
yet-unnamed insect-hunting fly
(*Chrysosoma* sp. n. Dolichopodidae)

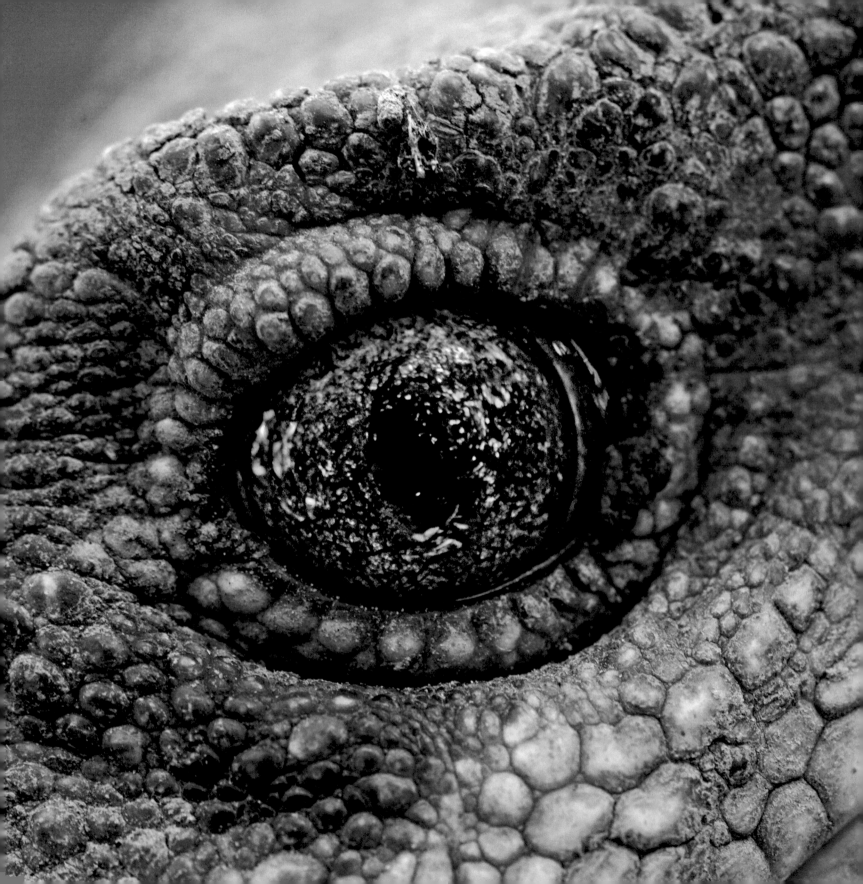

Travels in the Meddle Earth

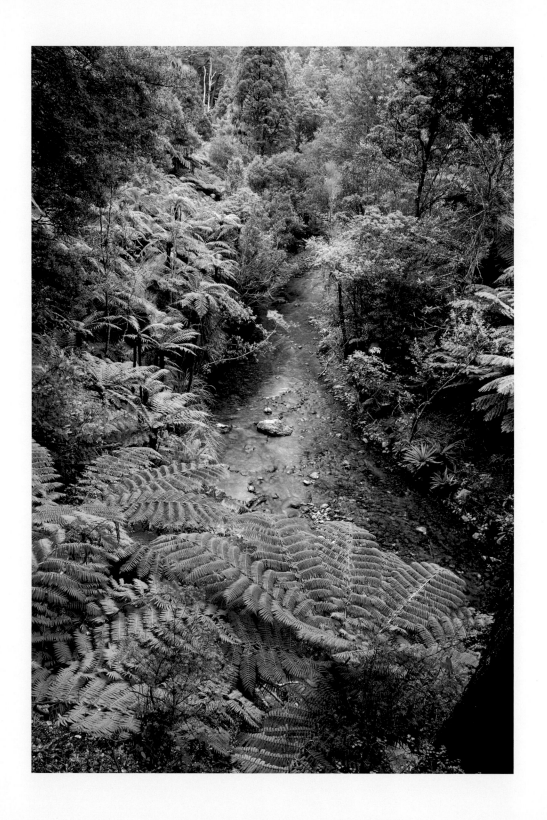

A funny thing about shoes—most of the time they protect our feet from cold and sharp rocks, but they get terribly in the way when you try to use your toes to grab a ledge, the last, feeble attempt to stop the inevitable pull of gravity. I feel a gentle tap on my back, and my feet lose their hold, sending me face first toward the bottom of a deep canyon, the river below so far away that I cannot quite recognize the objects floating on its surface. "Go!" is the last word I hear, and then it's only the swish of air, panic in my heart, and the river getting closer with every nanosecond. Right at the moment I am ready to have my skull crushed, something pulls me up, and I am suddenly flying toward the top of the canyon again. Ah, bungee jumping, the sport of the brave and the insane. But this is New Zealand, home of crazy adrenaline addicts who first inflicted this exercise on the world, and I would have never forgiven myself if I did not make myself try it. "Yeah, it was all right," I say nonchalantly when back on the bridge, hands deep in my pockets to hide the shakes (from the cold, I think). Then I get into the car, and drive away without looking back.

Two things had always attracted me to New Zealand. One was bungee jumping, which I had always seen as a sort of a dry run for a suicide. (Having tried bungee, I know that if I ever decide to cut short my existence I will definitely select a method that does not involve tall bridges.) The other was a burning desire to see a beast that I had first read about when still a young boy in the Old Country. A few years before I was born the government of New Zealand bestowed a rare gift on Poland's oldest university in Kraków. For the occasion of its sixth hundredth anniversary it received a live tuatara, a unique reptile whose pedigree goes back over 230 million

years and is the only surviving member of the reptilian order Sphenodontia, now found only in New Zealand. In books and articles that celebrated this momentous arrival, the animal was portrayed as the closest thing to a living dinosaur the human race would ever have a chance to see. Even its very name sounded mesmerizing—tuatara, a Maori word for "spiny back"—and I envisioned a gargantuan monster, perhaps a real-life dragon. Alas, the Kraków tuatara did not last long; it died of an internal infection after a few years despite the remarkably attentive care it received (it was probably the only inhabitant of the 1960s Communist Poland whose quarters were air conditioned), and thus I never got a chance to see it. Many years later, when I first learned that I would be participating in a series of biological surveys in Papua New Guinea I realized that it was my golden opportunity to visit New Zealand, which, in very relative terms, lies just a stone's throw away from that Melanesian country. I began planning the trip many months ahead, devouring everything that had been published about tuataras and getting in touch with researchers in New Zealand who worked on them.

It quickly becomes apparent to anybody interested in tuataras that the appeal of these remarkable reptiles lies not in their rather underwhelming physique (although I strongly disagree with the assessment presented by an Auckland newspaper in the late 1870s, which called them "the ugliest of all creeping things, with the exception of frogs"). At first glance a tuatara can be confused with a large, thick-legged lizard. Not surprisingly, the first tuatara, in the form of a single skull sent from New Zealand to the Royal College of Surgeons in London, was formally described in 1831 as such. Its descriptor, John Edward Grey, then an assistant in the British Museum's

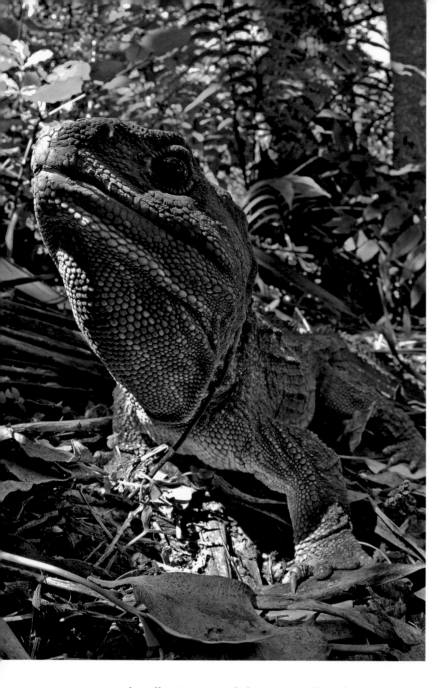

based on a tuatara preserved in alcohol (the name he later changed to the now accepted and "less barbarous" *Sphenodon punctatus*). But it was the paleontologist Sir Richard Owen, the man who famously coined the term "dinosaur," who first noticed a strong similarity of the New Zealand "lizard" to certain Mesozoic reptiles excavated in South Africa. His suspicion of the ancient origin of the tuatara was later confirmed by other zoologists, who placed the species and its fossil relatives in a separate order of reptiles. At the end of his life, after it became clear that tuatara was not a lizard but rather a unique animal close to extinct Mesozoic reptiles Grey published a self-exculpatory paper explaining that he did notice its unusual features, but "it would have required more than usual hardihood in 1831, when the genus was described, to venture to form for it even a family; while an order may now be suggested for the single genus, with every probability of it being adopted—a decided proof of the progress of science in a few years." While Grey's definition of the progress of science may sound antiquated, he was right predicting the fact that nobody now questions the singular status of the tuatara amongst modern reptiles. Its close extinct relatives include Jurassic pleurosaurs (which were long-bodied, aquatic animals) and a number of smaller, lizard-like Mesozoic forms from various places in today's Europe.

Superficially, a modern tuatara's forty-to-seventy-centimeter-long body resembles a chunky iguana, with soft, grey or sometimes greenish skin covered with small, nonoverlapping scales. A low crest runs along its back, eventually turning into stout, conical pegs on the thick, muscular tail. The head is also covered with small scales, but unlike lizards, tuataras do not have external ear openings or even functional tympanic membranes. Nonetheless, they can hear surprisingly well, albeit their sound perception is restricted to low frequencies, such as the low, grumbling noises these animals produce when distressed. Incidentally, their ability to hear only low frequencies makes them strangely intrigued by human voices, which also span the lower registers of the

reptile collection, coined the name *Sphenodon*, and placed it, incorrectly, as it later turned out, among the lizards of the family Agamidae. Eleven years later, not realizing that he was looking at the same, but far more complete, animal Grey described another New Zealand "lizard," *Hatteria punctata*,

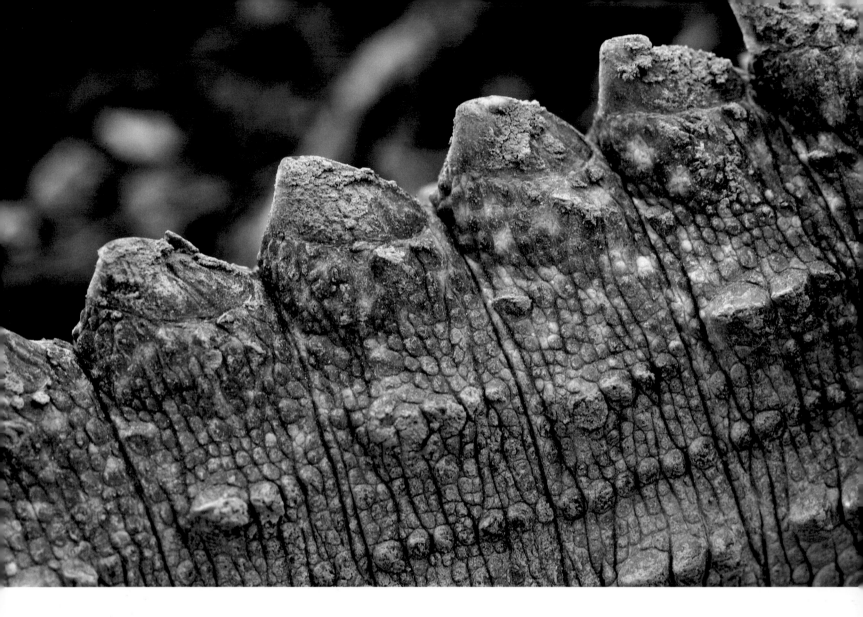

sound spectrum. The strongest indication of tuatara's ancient provenance lies in the structure of their skull, which still bears two pairs of large openings connected by strong, bony arches, features that have long been lost in all modern reptiles (with the exception of turtles, whose ancestors never had those openings to begin with). The upper jaw is fully fused with the rest of the skull, making it inflexible and severely limiting the speed with which tuataras can open their mouth and how wide they can do it. Rather than snatching things directly with their jaws, tuataras must rely on their thick, sticky tongue to catch their prey: "lingual ingestion" is the technical term for this behavior, and ingest they do. Tuataras are known to eat pretty much anything they can catch, and this includes beetles, crickets, earthworms, lizards, other tuataras, and even birds. Once in tuatara's mouth, the prey is quickly cut into pieces by the shearing action of a single

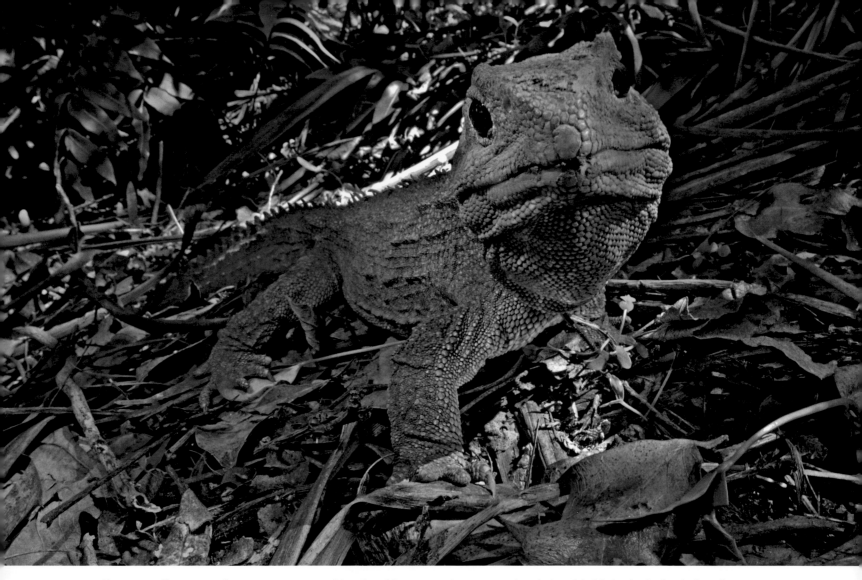

Tuataras, unlike most reptiles, are monogamous, although serial monogamy is a more apt description of their behavior. During the breeding season, a pair remains in close contact, and the male will chase away any potential rivals. But because a female becomes receptive to mating only about every four years, and during that time she may move to a different part of her range, chances are that she will form a bond with a different male the next time she is ready to lay eggs.

row of teeth on the lower jaw against two rows of teeth at the base of the upper one. Contrary to a widely cited misconception that tuataras have only simple, bony processes, these animals have real, enamel-covered teeth, tightly attached to the upper surface of the jaw. And while their disposition is rather docile, if sufficiently annoyed tuataras will bite, and the sensation this produces has been repeatedly described as similar to being gripped by a powerful vise, which will only tighten if one attempts to dislodge it. The rest of the tuatara's skeleton has a number of characteristics that point to its relatedness to ancient, extinct reptiles, such as the structure of its spine (with so-called amphicoelous vertebrae), or the

presence of abdominal ribs, or gastralia, which were found in some dinosaur groups.

Interestingly, their skeletons also show certain characteristics currently found only in birds, such as the presence of long, flat processes on each rib, which increase the rigidity of the ribcage. Although tuataras are not directly related to birds, they also share with them the presence of a simple, common opening of the reproductive and excretory systems (the cloaca) and the lack of a discrete copulatory organ.

Like so many still-surviving relict lineages of organisms, tuataras relish the cold. They are, like all reptiles, ectothermic. This means that their body temperature is dependent on the ambient temperature of the environment, and while they can regulate the amount of energy that reaches their body through basking in the sun or hiding in the shade, they cannot generate their own heat. Unlike most reptiles who prefer warm or truly hot weather, tuataras optimal body temperature is 16–21°C, the lowest of any reptile, and they remain active even when the temperature drops to decidedly nippy 7°C. Although this adaptation to the cool, temperate climate of present-day New Zealand is probably a relatively recent phenomenon, it allowed tuataras to outlive all their Mesozoic relatives from other parts of the globe and withstand the competition from lizards they have been sharing New Zealand with since its separation from the old supercontinent Gondwana. Likely, tuataras' ability to be active in cold weather has evolved out of the need to be able to hunt their favorite food—giant, cricket-like wetas that are active only at night, and this is why they leave their burrows only after dark. During the day they stay underground or sun themselves close to the entrance.

But the more I was learning about tuataras, the more obvious it was becoming that my chances of seeing one in its natural habitat were slim to none. Although recent conservation assessments of tuataras sounded optimistic, the overall picture was far from rosy. The numbers of surviving individuals were impressive, and between thirty thou-

New Zealand is famous for its ferns and has a rich flora of nearly two hundred native, very diverse species. Many are epiphytic, like the beard-like drooping spleenwort (*Asplenium flaccidum*), accompanied by kowaowao (*Microsorum pustulatum*), which are more typical in appearance.

The New Zealand Department of Conservation is doing a truly splendid job working on the restoration of natural habitats around the country, and nearly a third of its surface is at least partially protected. But it may take a long time to reverse the effects of the horrible devastation caused by the original settlers' idea to convert New Zealand into a South Pacific version of England. Thousands of square miles have been turned in "green deserts," where no native plants or animals are able to survive.

sand and fifty thousand individuals are said to live in New Zealand. Unfortunately, most of them are concentrated on the small Stephens Island (also known as Takapourewa), a place completely off-limits to everybody but a handful of researchers. Thirty-four additional tiny islands have tightly monitored populations that vary in size from a few to a few hundred individuals, but mainland New Zealand has not seen free-living tuataras since the arrival of the Maori ancestors and their accompanying menagerie of dogs, rats, and pigs, which quickly did away with the slow, tasty reptiles and their eggs (not to mention the many now-extinct native bird species). By the time the English came in the late 1700s, tuatara (or ngarara, as it was also called) was considered on the mainland an almost mythical creature, remembered only by the oldest of the Maori, and even by them only as something that their grandfathers hunted (and apparently really feared). Luckily, some of the animals survived on a

few small islands in the Bay of Plenty and the Cook Strait where rats and other introduced species never managed to get to. Recognizing its uniqueness and value to science the New Zealand government quickly declared tuataras strictly protected. Yet despite this well-meant gesture, their populations continued to dwindle, and the last century saw the extinction of tuataras on an additional ten of the relatively few islands that still had surviving populations. Only within the last fifteen years, following massive rat eradication efforts and great advances in captive rearing of tuataras, has the downward trend been reversed, and new populations have been reintroduced to several islands. On the mainland, however, tuataras seem to be a lost cause. Nowhere on either the North or South islands, the two large islands that make up "mainland" New Zealand, is there a place free from aggressive, invasive mammals where tuataras could survive and breed. It is a sad possibility that they may never be able to return there—at least not as truly free-living organisms. And yet some people just refuse to give up.

On the outskirts of the capitol Wellington, on the southernmost tip of the North Island, lies a valley called Karori. Until the mid-1800s its entire area was covered with nearly pristine, primeval woods, but after the arrival of English settlers most of the forest was cut down or burned; following the construction of two dams, a lake appeared at the bottom of the valley. But about ten years ago, after both dams were finally decommissioned and nobody really knew what to do next with the place, a group of conservationists came up with an audacious plan to turn Karori into a sanctuary, to recreate a piece of the old fragment of Gondwana known as Zealandia, and return to it its rightful, native inhabitants, including the tuatara. The problem was that like nearly all of the country, Karori was overrun with invasive plants, and introduced mammals and birds thrived there in place of the indigenous fauna. At least 30 mammals, 34 birds, over 2,000 invertebrates, and 2,200 alien plant species are fully naturalized in New Zealand; in fact, the number of exotic invasive

seed plant species now exceeds that of the native ones (and that is only if you count the fully established ones—in a little over a century since the arrival of the English settlers over 25,000 species of alien plant species were brought into New Zealand). And although only a portion of the New Zealand's aliens lived in Karori, their dominance over the natives was overwhelming.

The most serious predicament the Karori project faced was the alien mammals. By a strange bit of luck, the landmass that broke off the eastern part of Gondwana in the late Cretaceous about eighty million years ago to later become New Zealand just happened not to invite any land mammals for its oceanic voyage. The only furry, native inhabitants of New Zealand were a handful of bat and seal species. This left many potential ecological niches vacant—niches that were promptly filled by other, rather unexpected groups. Birds took it upon themselves to become giant grazers (the now-extinct moas), sprightly, flightless insectivores (the mostly extinct wrens), or nocturnal, scent-guided predators of soft-bodied invertebrates (the highly endangered kiwis). In the absence of wily mammalian predators, many lineages of birds forwent flight, as there no longer existed a pressure to quickly take to the air to escape. The role of mice and other rodents was filled by seed-feeding, cricket-like wetas, and since few birds were interested in these insects, they grew huge and sluggish. And so when the mammalian invasion began, probably as early as two thousand years ago with the arrival of the first Polynesian sailors, this vulnerable, insular fauna did not stand a chance. The first to go were flightless moas, massive birds nearly twice the size of present-day ostriches; they fell victim to the worst mammalian offender: man. With the first human settlers came other mammals, most notably pigs, dogs, and the Pacific rat (*Rattus exulans*). The last one was of course brought in accidentally, but that did not diminish the bloodshed this species has caused. Rats are probably the main cause of the extinction of a number of birds, a severe decline in the populations of wetas, and

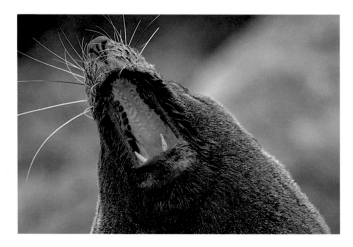

A New Zealand fur seal (*Arctocephalus forsteri*) clearly tells me to back off a little

hedgehogs, cats, and a number of other furry species. Rats and mice, brought by both the Maori and Europeans and lacking competition of any kind, flourished and wreaked havoc among planted crops, which finally attracted the attention of the colonists. In one of the most disastrous decisions in New Zealand's history, stoats, a kind of a weasel, were brought in from Europe to control the outbreaks. But why should stoats bother trying to catch fast and elusive rodents, which over millions of years of coevolution with mammalian predators had developed great skills at avoiding being eaten, when the islands were full of naïve, slow, or flightless birds and their tasty eggs? Unsurprisingly, avian carnage ensued.

It soon became obvious that the only way to keep invasive mammals out of Karori was to surround it with an impenetrable fence and then eliminate all the invaders inside the fence with a combination of traps and poisons. At the cost of slightly over NZ$2 million (approximately US$1.5 million) a tall, metal mesh fence was erected around an area of about one square mile, capped with a wide, slippery metal ledge, impassable to all mammals. Or at least that was the idea—accidental damage to the mesh, designed to be fine enough to prevent even baby mice from slipping through,

the wiping out of tuataras on the mainland. Not to be outdone by the natives, the early English settlers rolled up their sleeves and went about turning this singular exotic land into a South Pacific version of their northern homeland. Deer and foxes were introduced for their hunting pleasure, followed by

In addition to the tuatara, the one group of animals I really wanted to see in New Zealand were the wetas. These distant relatives of crickets and katydids have undergone a remarkable adaptive radiation in this country, and some species are considered ecological equivalents of rodents, of which New Zealand originally had none (now, of course, hundreds of millions of alien rats and mice devastate the native biodiversity). Some wetas have become truly huge and rank as possibly the heaviest insects in the world—the record is held by a seventy-gram female giant weta (*Deinacrida heteracantha*), although some claim that African *Goliath* beetles can get even heavier. Still, this is more than your average sparrow, and three or four times the weight of a mouse.

The fact that wetas are a major source of national pride—and the focus of a significant conservation effort in New Zealand—attests to the remarkable ability of Kiwis to "sell" their biodiversity, a truly admirable and enviable quality. Wetas, members of the insect families Anastostomatidae and Rhaphidophoridae, are by no means unique to New Zealand—they occur in most areas of the globe—but nowhere are they treated with the same degree of fascination and respect.

In the Karori Sanctuary visitors can get a sneak peek at the life of tree wetas (*Hemideina crassipes*) in specially constructed "weta hotels"—dead tree logs that these insects prefer, sawed in half and fitted with small windows. A small, abandoned gold mine in Karori is a place where one can see a colony of cave wetas (*Gymnoplectron edwardsii*). Incidentally, very close relatives of cave wetas are known in North America under the decidedly less glamorous name camel crickets, and are the favorite target of pest exterminators. I decided that I shall start calling the insects in my basement the Boston wetas; let's see if this improves their social standing.

New Zealand is full of ancient, relict lineages of organisms. One of them is velvet worms (Onychophora), strange creatures distantly related to arthropods. Their ancestors lived in the shallow seas of the Cambrian, over five hundred million years ago, before leaving water for humid, warm land environments where all modern species can be found. All species found in New Zealand belong to the family Peripatopsidae, which is restricted in its distribution to areas that were once part of the southern supercontinent Gondwana.

Officially, only five species of velvet worms are known in New Zealand, but recent studies indicate that some of them may consist of complexes of morphologically indistinguishable, but genetically separated so-called cryptic species. One such species is *Peripatoides novaezealandiae*, a common animal in humid forests around Wellington.

allowed some mice to reenter the reserve and establish a population that still seems to be thriving. There was not much that could be done about invasive bird species—even if all alien birds were exterminated in Karori, new ones would simply fly in from surrounding areas—and getting rid of invasive plants turned out to be easier said than done. But, in the end, remarkable progress has been made in replacing some alien plants with native vegetation and a number of indigenous bird species, as well as two hundred tuataras were released in Karori. I decided that if I were ever to see one of these animals living free in something akin to a natural habitat, this was the place.

I took a walk to Karori from downtown Wellington on a cold and windy October morning and was met by a friendly volunteer who gave me a quick introduction to the history and the layout of the sanctuary. The place was undeniably impressive, although my introduction was constantly being interrupted by mallard ducks begging us for food. As we strolled along a wall of tall, imposing pine trees, I tried to spot a plant—any plant—that was not an introduced alien ("No, not that bush," "No, not this either," "No, that's European Plantain," "But look, here is native flax!"). We flushed a group of California quails, and a few European blackbirds flew over our heads as we approached the tuataras' inner sanctum, a smaller area surrounded by another fence, which keeps out wekas—native, flightless birds known to attack and eat the reptiles. Behind it, to my surprise, was yet another, shorter fence. Its purpose was to separate a part of the Karori tuatara population (sixty individuals) from mice that roamed its terrain. The terms "free-living" and "natural" were quickly becoming more and more relative. Unfortunately, by the time I reached the enclosure, freezing rain was pouring, and understandably, no sane tuatara would stick its head out of the burrow in such weather. In the days that followed I visited the sanctuary every day, but the capricious Wellington spring kept tuataras underground. Only after a week, when I stopped there for the last time on my way to the

airport, was I greeted with beautiful sunshine and several tuataras basking in front of their dens.

But for the time being I had no choice but to move to plan B and visit Victoria University in Wellington, which maintains a small colony of the ancient reptiles. One of New Zealand's most knowledgeable tuatara specialists is Dr. Nicky Nelson, who for many years has led the efforts in their conservation and made some remarkable discoveries about their reproduction and sex determination. We met at the university cafeteria, a place with a stunning view of Wellington Harbor and Matiu Island, which has a small population of repatriated tuataras. I had originally planned to visit the island as well but became too entangled in bureaucratic red tape to make it worthwhile. Nicky filled me in on some of the latest research, including a genetic study that unequivocally demonstrated that all tuataras are members of one species rather than two, *Sphenodon punctatus* and *S. guntheri*, as dictated by the traditionally accepted taxonomy. The latter, thought to be restricted in its original distribution to the miniscule North Brother Island in the Cook Strait, appears to be nothing more than a form of the widely distributed species that has been somewhat stunted by limited food availability and marginally differentiated by genetic drift.

After a chat and a cup of coffee I was finally standing in front of a large, glass-walled pen that held the animals. Each pane of glass was connected to a sensitive security system, and the door to the enclosure had two massive locks. None of it surprised me, of course, considering the US$20,000–30,000 asking price for a single tuatara on the black market of exotic pets. Nicky climbed inside and quickly located Spike, a twenty-two-year-old male, a captive-raised youngster (tuataras easily live to be a hundred, although reports of a three hundred-year-old individual could not be substantiated). He was a gorgeous specimen, and I really wanted to spend more time photographing him, preferably in a setting other than an enclosure inside a building. We agreed for Spike to meet me (with a couple of handlers) the next day in

the cemetery adjacent to the university, where some seminatural vegetation could be found. I found the arrangement somewhat peculiar but at the same time strangely symbolic. As I stood on the following day among the graves of early Wellington settlers watching the native New Zealander basking in the specks of early spring sun among seedlings of American maples and clumps of African grasses, his two caretakers vigilant over his every move, I could not help but feel extremely pessimistic about the fate of this island's biodiversity. Tuatara, this magnificent animal, a Mesozoic relic if there ever was one, survives only thanks to the complete devotion of people like Nicky Nelson and is surrounded by one of the greatest biodiversity disasters in the history of the human conquest of nature. If left to their own devices, the entire population of these reptiles would probably disappear within a few decades, devoured by rats or pigs or simply driven to extinction by their vanishing natural habitats. To add insult to injury, since sex in tuataras is not determined genetically, as in it is in mammals or birds, but by the temperature in which their eggs develop, climate change can potentially accelerate their decline (if the temperature of incubation exceeds 21°C, all hatchlings will be male). Recent climatic models developed for the North Brother Island tuatara population suggest that by 2085 no females will be able to develop, thus spelling the end of that group of animals.

Other than apocalyptic annihilation of all life on Earth following an international spat about whether God's word should be read from left to right or the other way around, one of the most frightening possible future scenarios for our planet is the arrival of a period that some scientists chose to call the Homogenocene—the Age of Uniformity. What they envision is a time when, thanks to voluntary and involuntary transfer and exchange of organisms among nearly all possible points of the globe, a feat well nigh impossible a thousand years ago but now trifling, all continents and smaller geographic regions will lose their biological identity. Nearly indistinguishable, relatively small suites of species

will be present across climatically and physically similar areas, whereas the original local ecosystems and associated endemic and native species of those environments will be gone, replaced by more resilient, unfairly advantaged alien invaders (or invitees). Regrettably, as tragically exemplified by New Zealand, it seems that the dawn of this new age is already on the horizon. Global commerce, tourism, migration, biological control, and plain human stupidity have already done a splendid job of mixing things up, shuffling organisms from one continent to the next, opening the gates for barbarians to slaughter the unsuspecting natives. Virtually any place on Earth where humans have ever set foot is left with the trail of our inseparable biological satellites: rats, houseflies, clover . . . the list is thousands of species long. Each of them is likely to displace some local equivalent or, if there is none, carve for itself a deep and permanent niche in the new environment and never without harming the existing balance of things. None rivals our own species in its thirst for destruction, but there are a few impressively accomplished contenders. Mice and rats now feel at home anywhere from polar research stations to equatorial villages, and the list of local species they have extinguished may be even longer than that of species that humans speared and clubbed to extinction (there exists a poor record of plant species we have picked or trampled to death, but there are some known cases). Japanese beetles, Argentine fire ants, European earwigs, German yellow jackets, American cockroaches, Canadian waterweed, their names tellingly prefaced with the (presumed) point of origin, are wreaking havoc in places they would have never gotten to if it wasn't for the convenience of ships and planes. But while these stowaways arrived where they are now without our express consent, most invasive species that now reign supreme were lovingly carried across the oceans, nurtured and cared for upon the arrival, and let loose with a blessing (or at least their cages had locks that needed some work). Goats, foxes, cats, pigs, horses, sparrows, starlings, pigeons, oaks, pines, ivy, kudzu, prickly pear, eucalypts, aloes, carp,

trout, honey bees, bullfrogs, cane toads—the list goes on and on—are all united in their status as legal, consciously invited immigrants in places where they should have never been. In many cases the decision to bring in the alien species was well intentioned, but in the end there were nearly always devastating consequences to the local ecosystems. Alien species, if introduced into an area that matches the physical aspects of their home turf, instantly gain the upper hand over the natives by the simple fact that they left behind an army of predators, parasites, and diseases that over thousands or millions of years had evolved along their side and kept their populations in check. In the new place all these restraints are suddenly gone. The locals, however, still need to deal with their nemeses, but now these limiting factors are combined with the competition from the new arrivals. Not surprisingly, it often takes only one or two generations before local species are completely overwhelmed by the aliens and either undergo a dramatic decline or disappear completely.

New Zealand, because of its geological and biogeographic history, exhibits a notable absence of many taxonomic and functional groups that dominate other lands (snakes, woodpeckers, and mammals, to name just a few). Alien species fill those gaps, and in the process profoundly alter the natural ecosystems. For example, New Zealand had no animals that specialized in stealing bird eggs or chicks. Brushtail possums, introduced to New Zealand 150 years ago to establish fur trade, and now roaming in numbers in excess of 60 million, have become major bird nest predators, although in their native Australia they feed mostly on flowers and other plant material. The saturation with nonnative organisms is now so complete that, according to a recent comprehensive review of New Zealand invasive species, even a small patch of seemingly unmodified native forest in the most remote corner of the country has on average 6 alien mammal herbivores, 5 alien mammal predators, 2 alien fish, numerous alien plants, and an unknown number of alien invertebrates, fungi, and bacteria species.

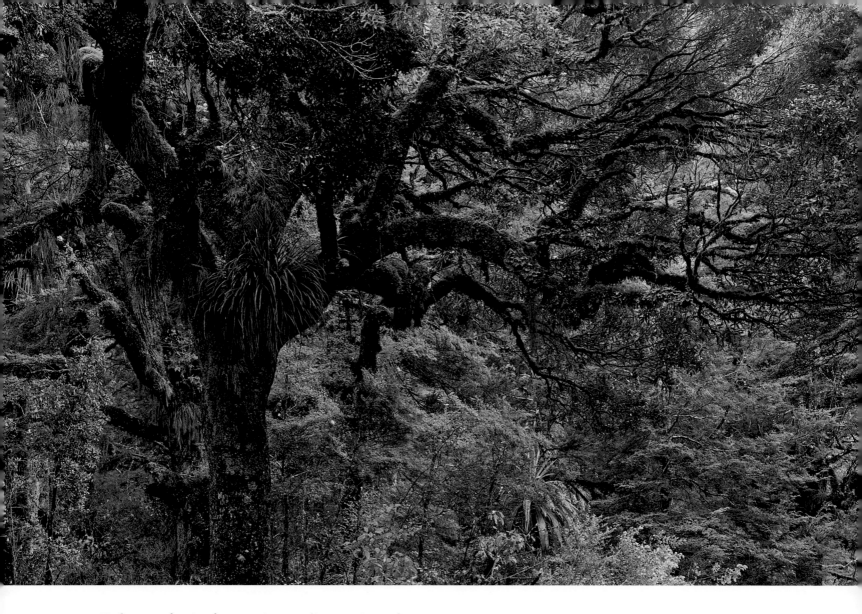

Unfortunately, simply removing an alien species with the hope that everything goes back to the former natural state rarely goes as planned. An endemic New Zealand lizard, Whitaker's skink (*Cyclodina whitakeri*), teeters on the brink of extinction because most of its preferred habitat had been converted to cattle pastures. But the removal of livestock in an attempt to help its population recover had very unintended consequences—the lack of grazing led to proliferation of introduced grasses, which resulted in a dramatic increase

Another group of witnesses to New Zealand's ancient, Gondwanan heritage are the southern beeches (*Nothofagus*), which still form spectacular forests in some areas of the country. Tongariro National Park in the center of the North Island has a particularly beautiful stands of these trees.

in the numbers of introduced rodents, which attracted introduced mammalian predators, who in turn started feeding on the lizards. In the end, the experiment resulted in a

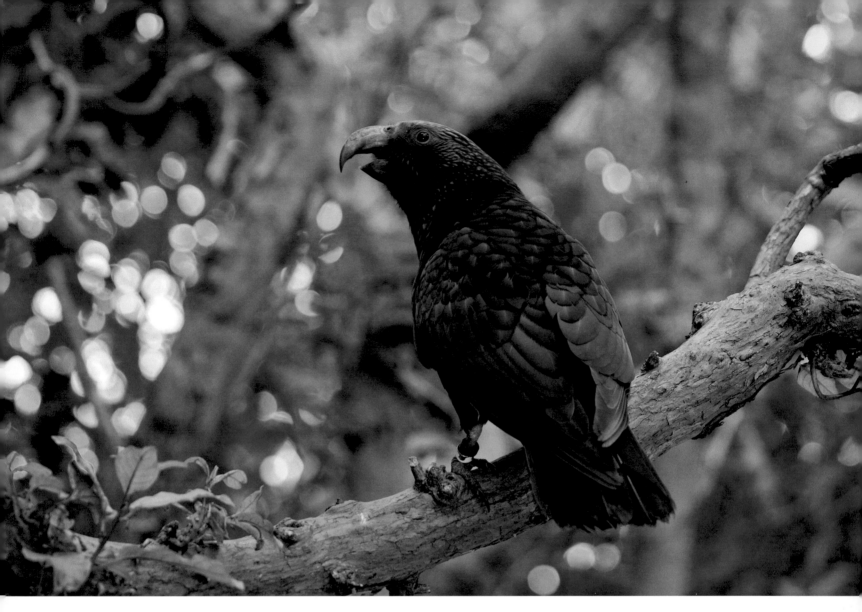

twentyfold reduction of the population size of the already highly threatened reptile.

It is painfully obvious that our understanding of the complexities and multilayered organismal codependencies within even the simplest of ecosystems is not comprehensive enough to predict the outcome of the introduction of even a single foreign species to the mix. One would think that New Zealanders have learned their lesson, and no more alien species will ever be willingly introduced. I was therefore

Kaka (*Nestor meridionalis*), a native parrot still relatively common in some parts of New Zealand

positively shocked to learn that at Karori sanctuary, the very place that epitomizes the most heartfelt attempt to reverse the effects of human meddling with nature, a nonnative Australian plant known as *Banksia integrifolia* is purposefully introduced to the reserve in an effort to increase the availability of nectar to local birds. To add to the mystery, this par-

ticular species is one of the few banksias that do not require fire to disperse and germinate their seeds, which makes it a more likely candidate to escape from Karori and establish itself elsewhere. "Mistakes have been made," the keepers of Karori seem to be saying, "but now we know what we are doing," and let's hope that they are right. Returning Karori to its former prehuman glory is going to be a long process, estimated to take at least five hundred years if everything goes as planned. It is a daring experiment, not unlike trying to keep an iceberg frozen in the middle of a scorching desert, one that will require constant care, significant financial resources, and an army of devotees. And this is for an area of about one square mile, or less than 0.001 percent of New Zealand's surface.

To protect the country from additional invasions, the New Zealand government has created the Ministry of Agriculture and Forestry Biosecurity, one of the most sophisticated and effective biological quarantine systems in the world. It screens all goods and passengers arriving in New Zealand and every day uncovers about 240 cases of high-risk items (potential weed plants, contaminated food, etc.) being brought by people into the country. Unfortunately, for much of the islands' biodiversity this noble effort came too late—42 percent of native New Zealand birds are now extinct, as are numerous amphibians, reptiles, fish, insects, and an unknown number of other invertebrates and many plant species. The survival of the remaining native organisms hinges on the effectiveness of the quarantine and conservation as well as the goodwill of people who devote their lives to saving the remains of the old Zealandia, and it was only thanks to them that I was finally able to meet the tuatara. But with Homogenocene already at the door of this otherwise beautiful island country, the world's attention should probably focus on other places that may soon be met with a similar fate. Other Pacific islands—New Guinea, Fiji, the Solomon Islands—should become the targets of the most stringent quarantine efforts; it is not too late for them to save most of their native fauna and flora from the impact of alien species. And yet if history has taught us anything, it is that we don't need no stinkin' history to teach us anything, thank you very much, and New Zealand's mistakes will be promptly repeated in all those places. I really hope that I am wrong.

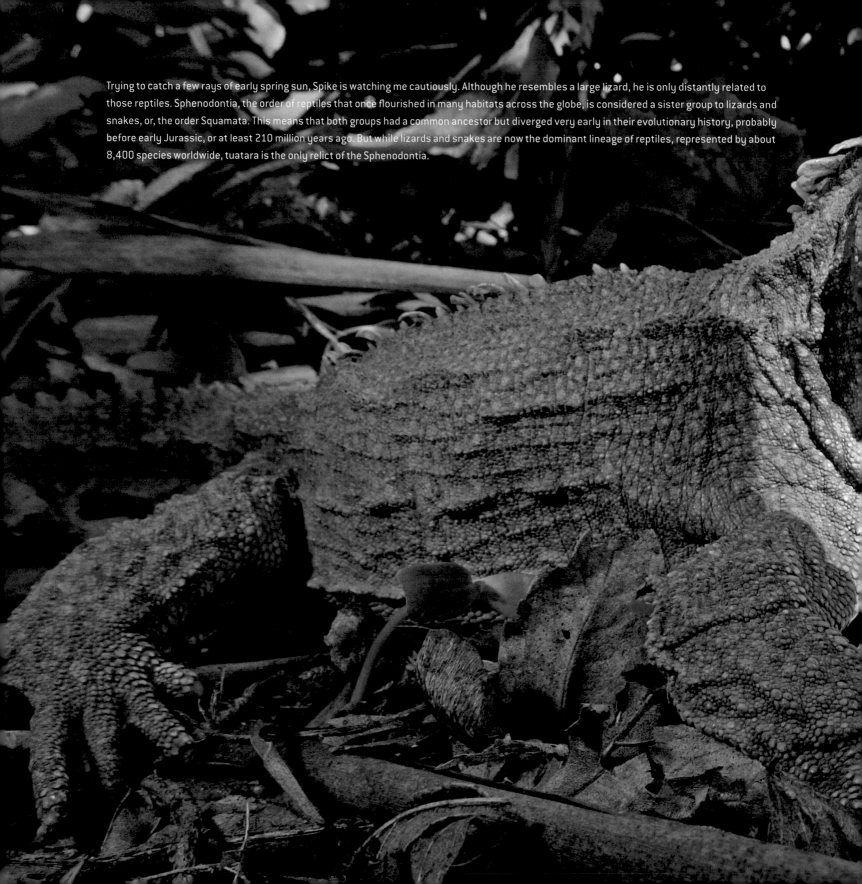

Trying to catch a few rays of early spring sun, Spike is watching me cautiously. Although he resembles a large lizard, he is only distantly related to those reptiles. Sphenodontia, the order of reptiles that once flourished in many habitats across the globe, is considered a sister group to lizards and snakes, or, the order Squamata. This means that both groups had a common ancestor but diverged very early in their evolutionary history, probably before early Jurassic, or at least 210 million years ago. But while lizards and snakes are now the dominant lineage of reptiles, represented by about 8,400 species worldwide, tuatara is the only relict of the Sphenodontia.

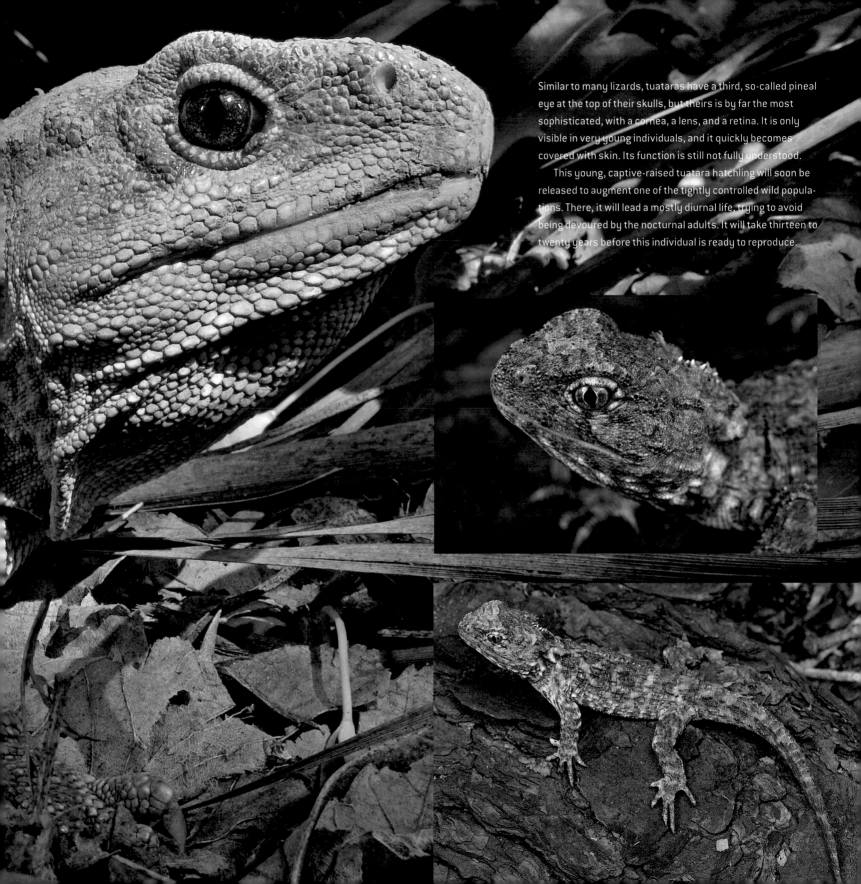

Similar to many lizards, tuataras have a third, so-called pineal eye at the top of their skulls, but theirs is by far the most sophisticated, with a cornea, a lens, and a retina. It is only visible in very young individuals, and it quickly becomes covered with skin. Its function is still not fully understood.

This young, captive-raised tuatara hatchling will soon be released to augment one of the tightly controlled wild populations. There, it will lead a mostly diurnal life, trying to avoid being devoured by the nocturnal adults. It will take thirteen to twenty years before this individual is ready to reproduce.

In 2005 the Karori Sanctuary near Wellington became the first site on mainland New Zealand to see free-living tuataras in over 300 years. Seventy individuals, relocated from Stephens Island in the Cook Strait, were released, 60 of which were placed behind an additional enclosure that protected them from mice that unfortunately still roam in Karori. But as it turned out, animals outside the fence actually did better than the ones inside and gained significantly more weight. A subsequent batch of 130 individuals was released 2 years later outside the mice-proof fence (but still inside a very large enclosure that protects them from wekas, flightless, predatory birds that like to eat the reptiles). After 5 years the survival rate of the released animals was 33 percent, which may seem low, but these cryptic animals are notoriously difficult to spot, and the actual survival rate is almost certainly much higher (within the smaller, mice-proof area the survival rate was 89 percent). But the ultimate proof that the relocation was a success came from the discovery of clutches of viable eggs and, in March 2009, the first freeborn hatching.

To help keep track of the movement of individual tuataras, each animal of the first batch of 70 released in Karori is marked with a unique combination of small color beads. Depending on the size of the animal, they may carry between 2 and 6 beads attached to their crest at the base of the head. Although the presence of beads somehow spoils the illusion of the animal being "wild," a traditional alternative would have been to clip a toe or a combination of toes—a far more painful and risky procedure.

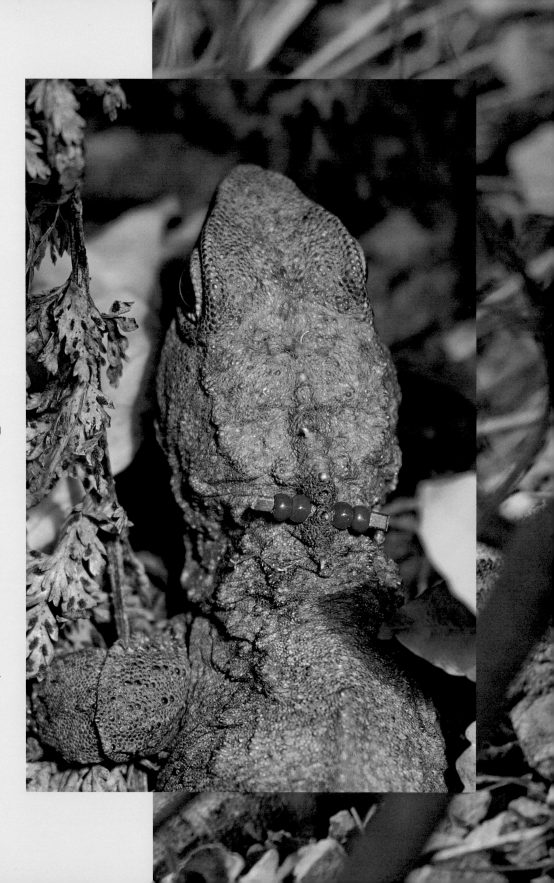

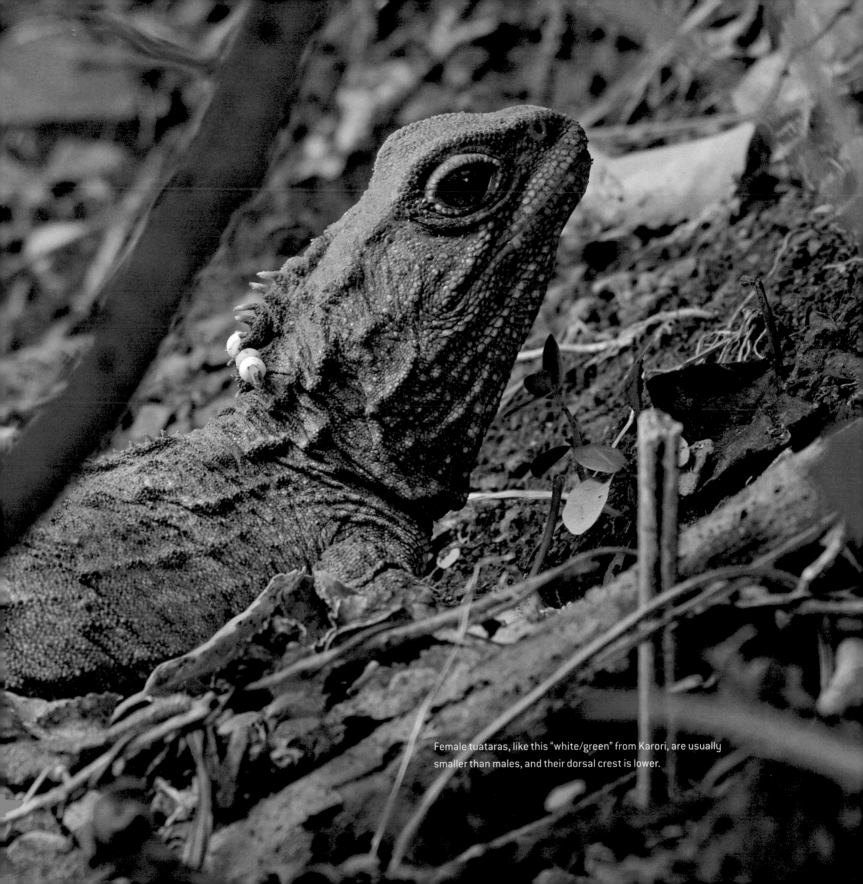

Female tuataras, like this "white/green" from Karori, are usually smaller than males, and their dorsal crest is lower.

New Zealand has a rich, beautiful flora of nearly two hundred species of ferns, most of which are unique to these islands. Not surprisingly, fern-inspired motifs, known as koru patterns, dominate the art of native Maori people, including fantastic designs often tattooed on their skin.

But not all New Zealand ferns have the typical divided leaves seen in most species from temperate regions. The kidney fern (*Trichomanes reniforme*), endemic to New Zealand and surely one of the world's most elegant and unusual ferns, has leaves reminiscent of those found in many flowering plants, whereas the arboreal, epiphytic spleenwort (*Asplenium flaccidum*) sends its long leaves down from branches of large trees and rock cliffs.

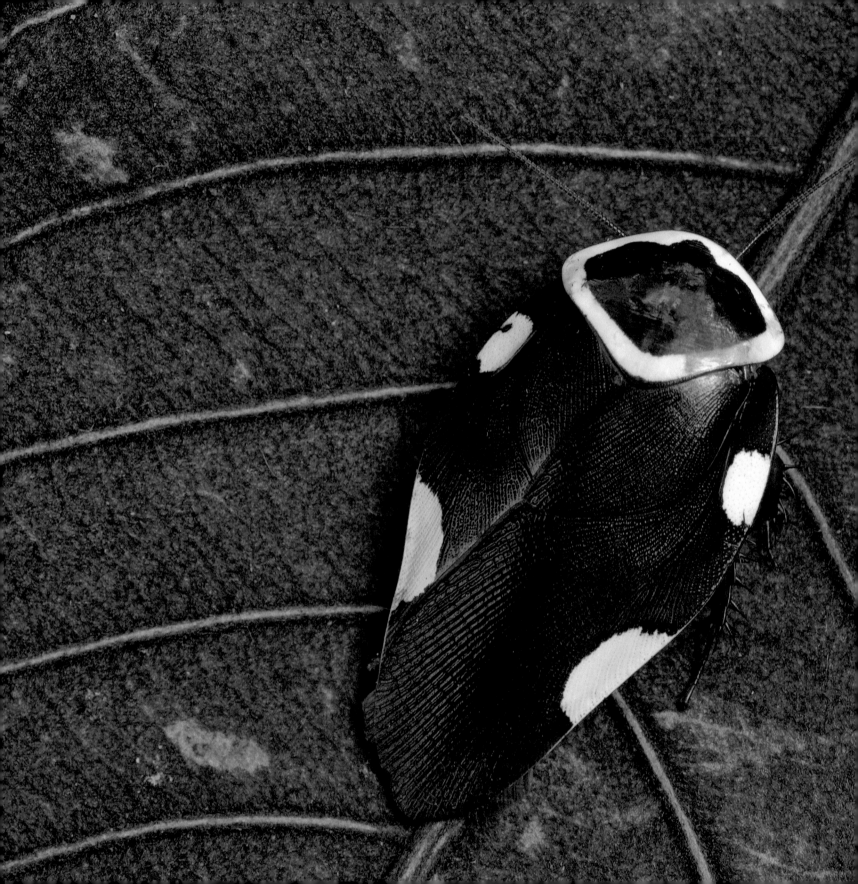

Mother's

The young mother gingerly stepped from under a flat rock and paused, cautious, unsure if the sun was low enough to grant her passage safe from the sharp eyes of her many feathered and scaly enemies. Behind her, cuddled together on a bed of dry leaves and grasses, a small group of her children stirred, for the first time in their short life left without the protective shield of their mother's body. But the smell of ripening berries and fragrant flowers was beguiling her, and she urgently needed to replenish her body with food and water. All of a sudden, the ground below her feet shook, and an enormous dark shape landed with a thud right in front of her, only to lift up and disappear into the air half a second later. Even before the giant object hit the ground, her mechanoreceptors, small sensory organs responsible for detecting movement, had alerted her of the change in the speed of air flowing around her, and in the blink of an eye she turned around and disappeared into her nest. Her young immediately responded to her arrival by hiding under her body, safe again beneath the armored plates of her wide abdomen. She will need to wait a little longer, and perhaps when the sun over Table Mountain is completely gone her chances for an undisturbed meal would be better.

I stopped and swept my headlamp over the vegetation below my feet. I thought I saw some movement near that flat, lichen-covered rock, but then, maybe it was just my imagination. But they surely must be here. It was my first visit to the famed mountain that overlooks the flickering lights of the expansive Cape Town metropolis below, but the gorgeous South African vista barely registered. What I wanted to see was much smaller, but no less interesting: a pretty little animal known as the Table Mountain blattodean (*Aptera fusca*).

Blattodeans, a large, ancient lineage of insects, represented by nearly five thousand mostly tropical species, are a truly fascinating example of the evolution of parental care and social behavior. Within insects, where good parenting usually amounts to not eating your young, blattodeans display levels of devotion and parental sophistication otherwise found only in birds and mammals. When their ancestors first appeared nearly 350 million years ago in the humid forests of the Carboniferous period, they were not much different from other insects at the time, at least not in terms of their reproductive strategies. Females of the Carboniferous blattodeans had a long ovipositor, which suggested that, like most insects, their maternal care was limited to inserting their eggs into the soil or plant tissues, after which the developing young were entirely on their own. But then something happened. Blattodeans lost their long egg-laying device, and some started to live in family groups. With time, the level of parental care and the size of their family groups increased, and one branch of their evolutionary tree eventually blossomed into the most complex example of an animal society, complete with tall buildings and farming communities, unmatched by any other organism until the arrival of our own species. These days, we know this particular branch as termites, but to entomologists they are nothing more than a lineage of highly specialized blattodeans. Strangely, a different lineage of blattodeans went in the exactly opposite direction and turned into solitary, voracious predators, where cannibalism is just another word for lunch. We call them preying mantids, although, just like in termites, their anatomy and genes reveal their undeniable blattodean origin.

Unlike their carnivorous relatives, most blattodeans

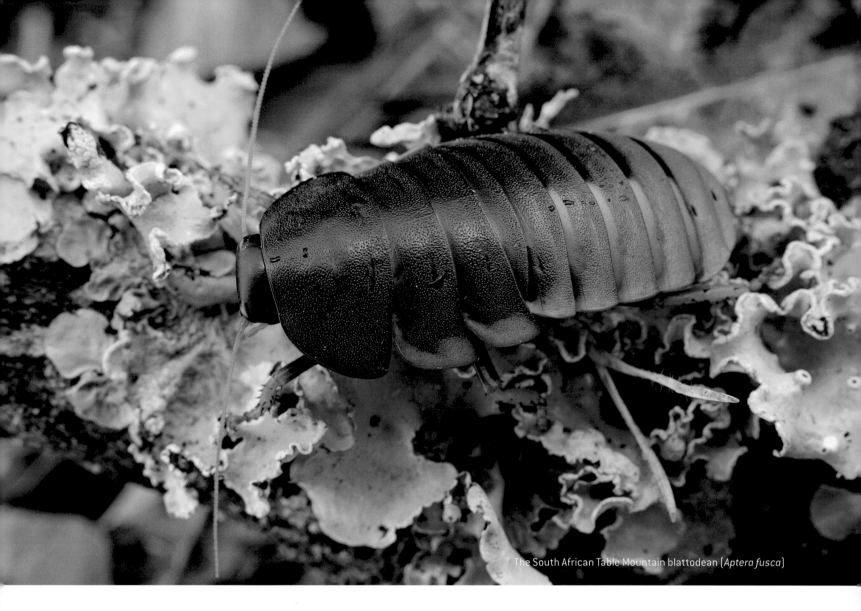

The South African Table Mountain blattodean (*Aptera fusca*)

lead peaceful family lives. They display not only the greatest range of known parental care specializations among insects, but they do so in an astounding array of habitats, ranging from the rainforest canopy to deep caves to fast-flowing streams to the insides of tree trunks. Some "swim" in the constantly shifting sands of the hottest deserts, while others prefer the decidedly cozier setting of bird nests or ant colonies, where their families coexist, apparently unnoticed, with their hosts.

I decided to have another look at that flat rock and gently lifted one of its edges. And there she was. Like a miniature tank, her wingless body covered with overlapping auburn plates, the female Table Mountain blattodean sat motionlessly, shielding a dozen or so small, dark-colored nymphs. I lightly touched her with a finger; she responded by lifting her abdomen and producing an audible squeak. The nymphs started to scatter and, not wanting to disturb this little family anymore, I carefully put the rock back in its original posi-

tion. It all seemed rather simple, but what happened during my uninvited visit to their household was more complex than my eyes could register. The mother not only reacted to my presence by giving me a fair warning about unpleasant, possibly toxic chemicals she could spray me with, she also produced a wave of alarm pheromones that told her children to run away. After a while they would gather back together, guided by her scent and tactile cues detected with their thread-like antennae.

The sensory world blattodeans live in is rather different from ours. Being largely nocturnal, they rely on chemical signals, air and substrate vibrations, and touch far more than on their vision. Aggregation pheromones help keep their family groups together, while mating time is announced by the production of sex pheromones, one of them named, quite appropriately, seducin. Unlike the admittedly more intricate termite or ant societies, blattodean family groups usually do not exhibit food or shelter recruitment—they do not purposefully leave chemical trails leading other members of the family to places of interest—but they nonetheless are known to be able to follow other individuals by their scent. Interestingly, species of blattodeans associated with ant colonies use chemical trails left by their hosts to find the source of food or their way back to the nest. In other words, they love the technology, they just don't know how to produce it, yet.

The body of a blattodean is surely one of the crowning achievements of nature's mechanical engineering. Its main elements are remarkably unspecialized (by insect standards), but this gives these animals a lot of flexibility to adapt to continually evolving environmental conditions, which is also probably one of the reasons why they have hardly changed in their overall appearance since their Carboniferous debut. The head is well protected under a large shield known as the pronotum, which, if need be, can also hide the front legs from harm. The legs are those of a sprinter, long and supple, but are also covered with spines. The spines serve primarily as defense against predators, but those on their front legs

also help to hold their food, such as slippery pieces of fruit. Incidentally, this ability to hold things most likely paved the way for the evolution of powerful, raptorial legs in blattodeans' relatives, the preying mantids.

Most blattodeans have two pairs of large wings, sometimes adorned with beautiful colors and patterns, but in others the wings are reduced to short stumps or are lost altogether. The front wings in some species are quite hard and form convex, protective shields similar to those found in beetles. But their function is not just the protection of their owner. Rather, it appears that they have evolved to protect vulnerable, young nymphs, who in such species climb onto the mother's back right after birth and stay there until they are ready to forage on their own. While there, they feed on nutritious liquids produced by a special gland on the mother's back or, in less refined species, simply pierce their mom's skin and take small sips of her hemolymph (the insect blood), but without really doing her any harm, it appears.

Most blattodeans have flat bodies, well adapted to squeezing into tight spots to avoid being eaten by predators. In extreme cases, as in species living under bark of trees, the body may become so flat that it warrants its own entomological terminology—the pancake syndrome. Being very flat, smooth, and flush with the substrate also has the advantage of not giving predators much to hook their teeth or claws on. But in one group of blattodeans the evolution of self-defense has gone in a different direction.

I was rummaging one day through the leaf litter on the forest floor in northern Cambodia, looking for ants, when suddenly a small, perfectly round ball rolled from a leaf above, bounced off my head, and landed on the ground in front of me. I picked it up to have a closer look, not sure if the object was an animal or a plant. It was about the size of a pea, but black and very hard. It was an animal, as betrayed by the clearly visible segmentation of its body, but several groups (crustaceans, millipedes, and armadillos, to name a few) use a very similar tactic, and I was not sure which one

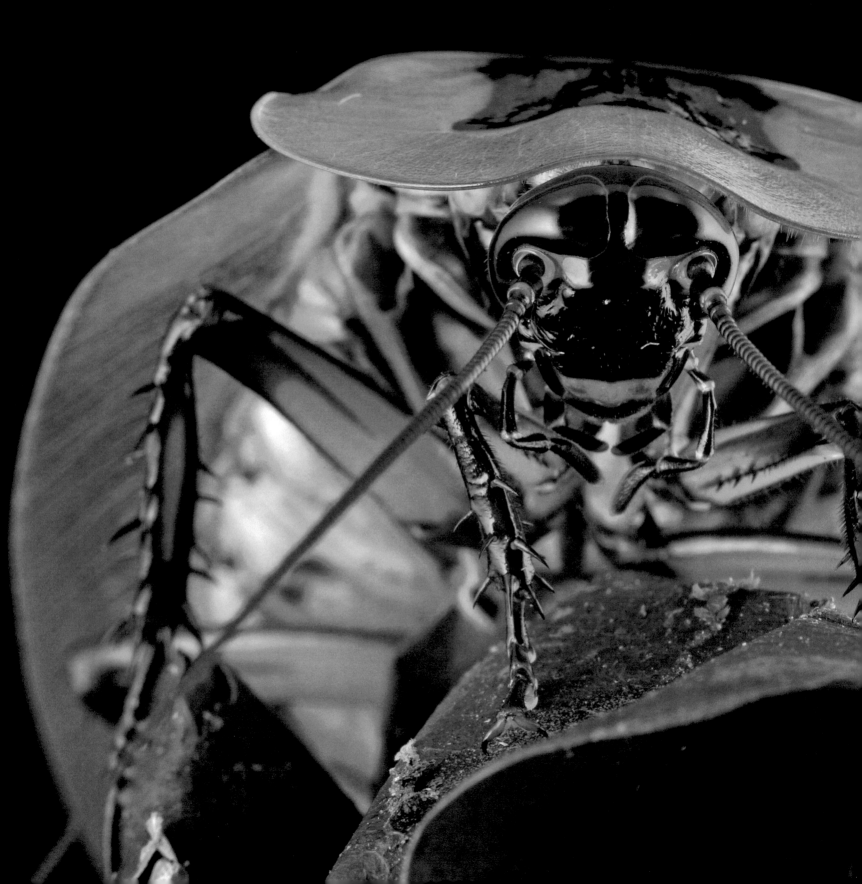

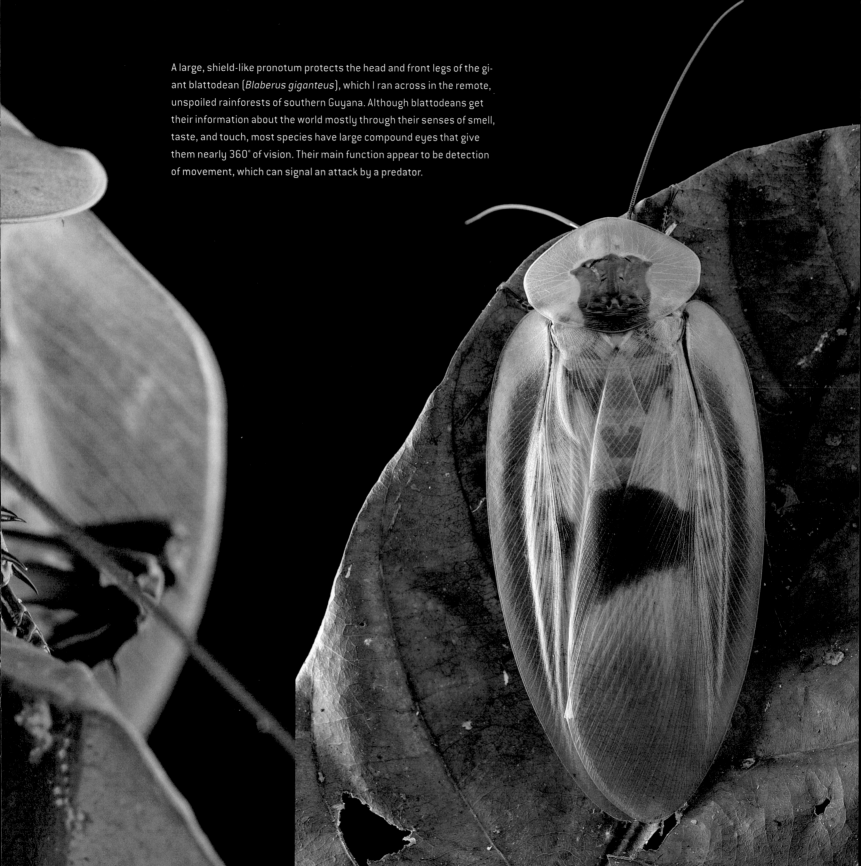

A large, shield-like pronotum protects the head and front legs of the giant blattodean (*Blaberus giganteus*), which I ran across in the remote, unspoiled rainforests of southern Guyana. Although blattodeans get their information about the world mostly through their senses of smell, taste, and touch, most species have large compound eyes that give them nearly 360° of vision. Their main function appear to be detection of movement, which can signal an attack by a predator.

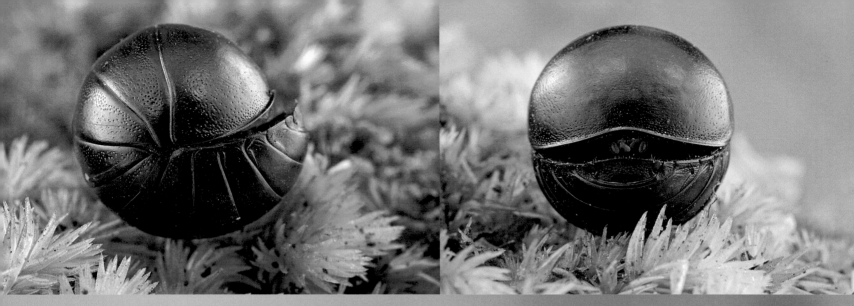

The ball blattodean (*Perisphaerus lunatus*) from northern Cambodia begins to unfurl to reveal long, powerful legs.

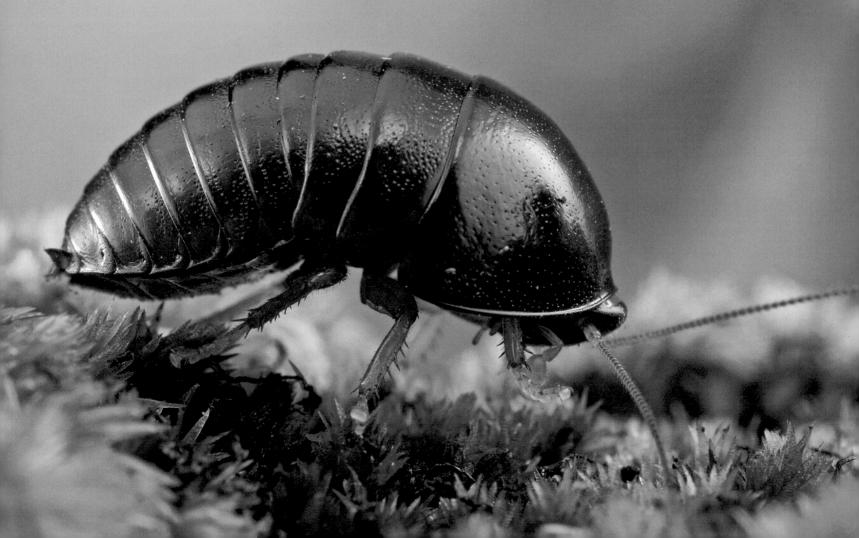

I was holding (I quickly eliminated armadillos from the list of potential suspects). After a few seconds a pair of big eyes with two short antennae between them cautiously peeked from a crack that opened on the mysterious sphere. It was a blattodean, but one I have never seen before. Later I identified it as the ball blattodean (*Perisphaerus*), an interesting animal that experiments revealed to be, thanks to its tight armor, virtually impervious to attacks by ants and other small predators. In fact, the combination of the hard cuticle that forms its exoskeleton with its powerful muscles makes it impossible to unroll the animal without damaging it.

Rolling your body into a tight, hard ball is a neat trick, perfected by only a few other insects, but there is something else about *Perisphaerus* that makes this blattodean unique among not only insects but also almost all other animals. Dr. Louis M. Roth, the late Harvard entomologist who during his long and exceptionally productive life uncovered many secrets of blattodean biology, was the first to realize the unusual nature of *Perisphaerus*. While studying these insects he noticed that females were often accompanied by nymphs clinging to their legs, and some of these youngsters had their heads stuck to the underside of their mother's body. Careful examination revealed something strange: the mouthparts of the nymphs were very long, almost proboscis-like, a trait unknown in blattodeans, whose mouthparts are of a simple, biting type. Looking carefully at the female Roth also noticed that between the bases of her legs were small, glandular openings, and that's where the young ones were sticking their heads. Could it be that the mother were actually suckling her young? Up to that point, only mammals were known to display this type of behavior, but suddenly it appeared that a similar one might have evolved at least one more time in the history of the animal kingdom. The evidence for this is still largely circumstantial, but what we know about blattodeans certainly supports such a possibility. Many species of these insects give birth to live young, and in a few cases the female feeds them until they are ready to start foraging on

their own. In the case of the Pacific blattodean (*Diploptera punctata*), the female develops an equivalent of the mammalian placenta and feeds the embryos growing inside her abdomen with a rich mix of proteins, lipids, and carbohydrates. But a female with "mammary glands" and nymphs with sucking mouthparts take the maternal care among blattodeans to a completely new level.

A couple of years after my first encounter with *Perisphaerus* I found myself, in the middle of the night, following through a bamboo thicket a group of fanatical herpetologists who were intent on catching a particularly elusive frog that was possibly new to science. We were in New Britain, a large island that is a part of Papua New Guinea, and I knew that I had a good chance to run across *Perisphaerus* again. Sure enough, the very moment I heard a triumphant scream that announced the capture of the unfortunate amphibian, I saw the mysterious blattodean scurrying around my feet. And it was a pregnant female. She gave birth to about ten young a few days later, and during the two weeks that I kept her in a small container the nymphs always stayed with her, hidden under her body, their mouthparts firmly between her legs. Every now and then she would have a bite of a fruit, but the young ones never left her side or fed independently. And yet they grew. I separated a couple of nymphs from their mother and offered them the same conditions and food I was providing her with—they were dead within three days while their siblings continued to thrive. Unfortunately, soon thereafter I had to leave the island, and the terms of my research permit did not allow me to take any live specimens with me, thus forcing me to abandon the little family. Yet this short observation convinced me that the female feeds her young with something secreted by her body and that they completely depended on it, just like mammalian offspring does. My admiration for insects ratcheted up yet another notch.

Of course, not all blattodeans display the same degree of nurturing and maternal sacrifice, but there is not a single species in this group that does not at least try to give its

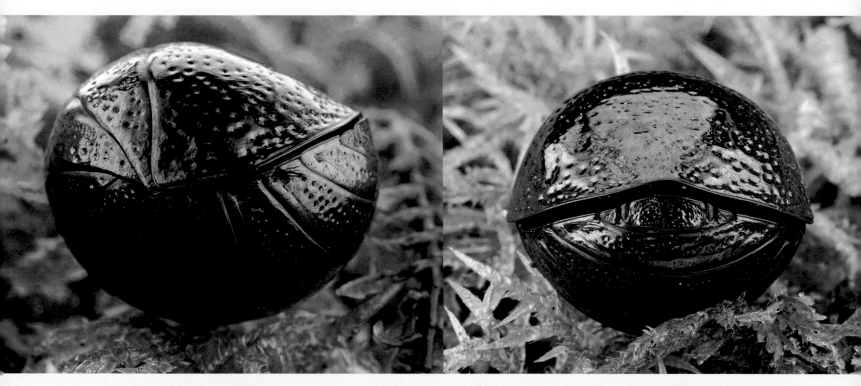

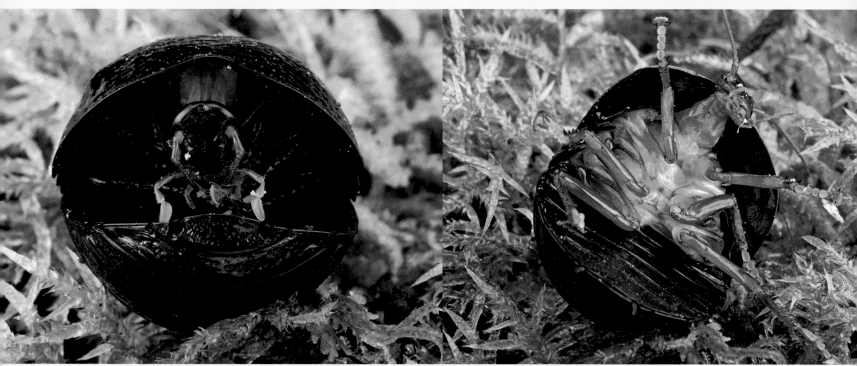

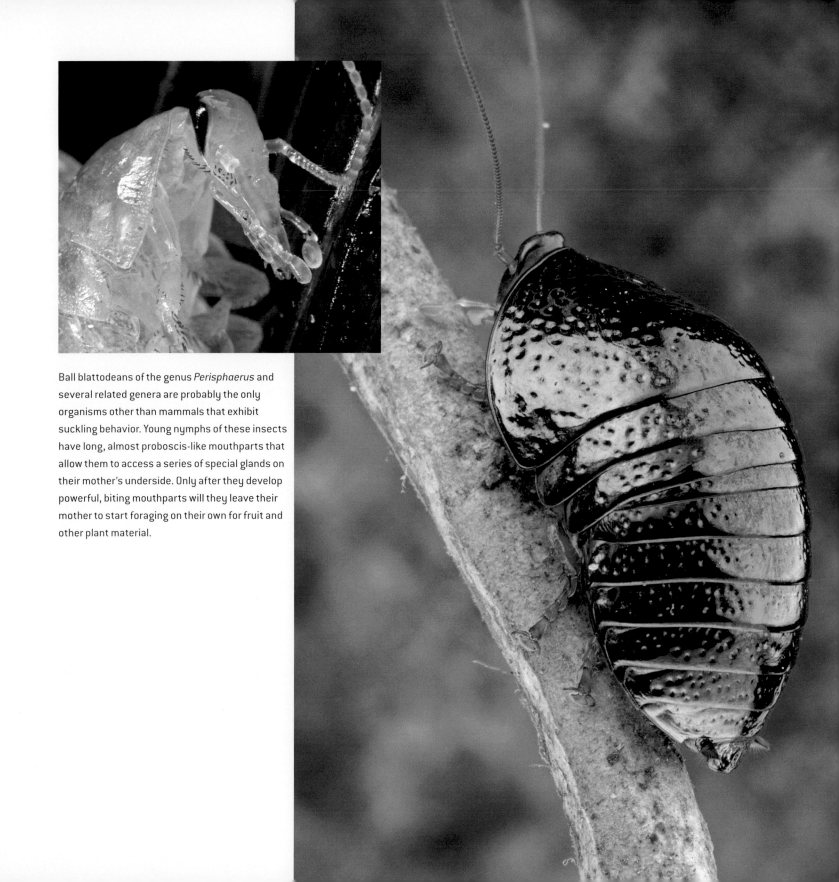

Ball blattodeans of the genus *Perisphaerus* and several related genera are probably the only organisms other than mammals that exhibit suckling behavior. Young nymphs of these insects have long, almost proboscis-like mouthparts that allow them to access a series of special glands on their mother's underside. Only after they develop powerful, biting mouthparts will they leave their mother to start foraging on their own for fruit and other plant material.

children a safe start in life. The least the female blattodean can do for their eggs—and most do—is encase them in a hard, chitinous purse that protects the eggs from physical injuries and desiccation and creates a very effective barrier to predators and parasitoids. Usually such a container, known as the ootheca, is carried by the female until the eggs are almost ready to hatch. She will then bury or glue it close to the source of food, usually a fruit or some particularly tasty leaf, and the young hatch a few days or weeks later, ready to start independent lives. In more advanced species the female never lets her eggs go, and while she still protects them in an ootheca, she carries it until the very day the young ones are going to hatch. Others take it a step further and, after forming the ootheca and filling it with eggs, suck it back into their abdomen. There, protected by both the ootheca and their mother's belly, the young ones complete their development. Their hatching takes place inside the mother's abdomen, giving the impression of live birth (such false live birth is known as ovoviviparity). And finally, there are species, such as the *Diploptera punctata*, that are truly live bearing.

While blattodeans are rarely seen by casual naturalists (they are, after all, mostly nocturnal), the effect of their presence in forests and woodlands of the world is quite significant. A large proportion of blattodean species act as key detrivores—they are principal recyclers of dead organic matter, such as fallen leaves, toppled tree trunks, or carrion. They can process such material thanks in part to a symbiotic rela-

The male of the Table Mountain blattodean (*Aptera fusca*) has long, fully developed wings, while the female (right) is completely wingless.

An ootheca of a blattodean, glued to a leaf, protects the eggs developing inside like a hard, nearly indestructible purse from desiccation and predators.

tionship with a number of protozoan and bacterial guests in their intestines, organisms that supplement the insects' own digestive enzymes with additional compounds that speed up the breakdown of food. At some tropical locations blattodeans constitute 61–84 percent of the invertebrate biomass, well surpassing termites, ants, and other insects that play similar roles. Thus, if it weren't for the blattodeans' garbage removal services, such places could be quickly overwhelmed by organic litter—not the most glorious of occupations, but a critically important one. To balance things out, some blattodeans never descend to the dark bottoms of the forests but spend their life among flowers, feeding on nectar and pollen and pollinating the plants in the process. Such species are often diurnal and beautifully colored. Some mimic gaudily painted, chemically protected beetles, such as ladybugs, others certain diurnal and colorful moths. And, being large, tasty, and virtually harmless, blattodeans can't help but be a major part of the diet of birds, mammals (especially bats), and other predators.

I have always been fascinated by these animals: the simple elegance of their bodies, their devotion as parents, their dominance in tropical ecosystems, their ancient origin, all this made me want to learn more. But for a group so rich in species and so abundant in many terrestrial ecosystems, we know shockingly little about blattodeans. There are probably no more than twenty or thirty scientists worldwide who study the five thousand or so species we already know about (an equal number of new species of blattodeans most likely still awaits discovery). At the same time, thousands of students and researchers around the world work on mammals, a group with a comparable number of species. As it turns out, the two may have a number of astonishing similarities in their reproductive behavior. Perhaps some of the mammal specialists could be enticed to broaden their taxonomic horizons and help us learn more about one of the most intriguing groups of animals that ever walked the earth. Entomologists could really use some help here.

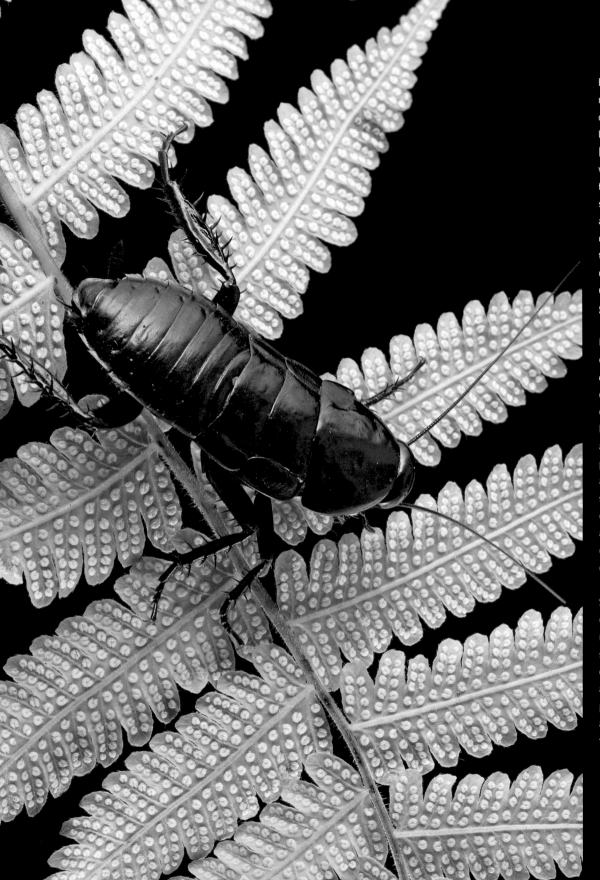

Blattodeans do not bite or sting, but many have evolved unique and very effective defensive strategies. Some, like *Eurycotis* sp. from Costa Rica (left) produce repellant chemicals, which they can spray at an attacker from a distance of nearly a foot. The spray consists of a powerful mix of aldehydes, alcohols, and acids; this combination causes painful irritation to the skin and mucus membranes of the aggressor and has a strong, unpleasant smell, which in itself is a good deterrent.

Brightly colored and active during the day, this Costa Rican *Euphyllodromia angustata* (opposite, top) looks like certain, extremely fast and agile species of flies. The considerably slower blattodean uses behavior known as evasive mimicry, banking on the predators' inability to tell it apart from a fly. Presumably, most predators, such as birds and lizards, will not even try to catch anything as fast as a fly simply because their chances of success are too low to justify the energetic expense of a pursuit.

Some blattodeans, like the Costa Rican *Nyctibora* sp. (opposite, bottom), rely on an extremely sticky, glue-like substance produced by special glands on their abdomen. This effective adhesive quickly immobilizes small predators, such as ants or spiders, and makes it difficult for larger predators to swallow the insect.

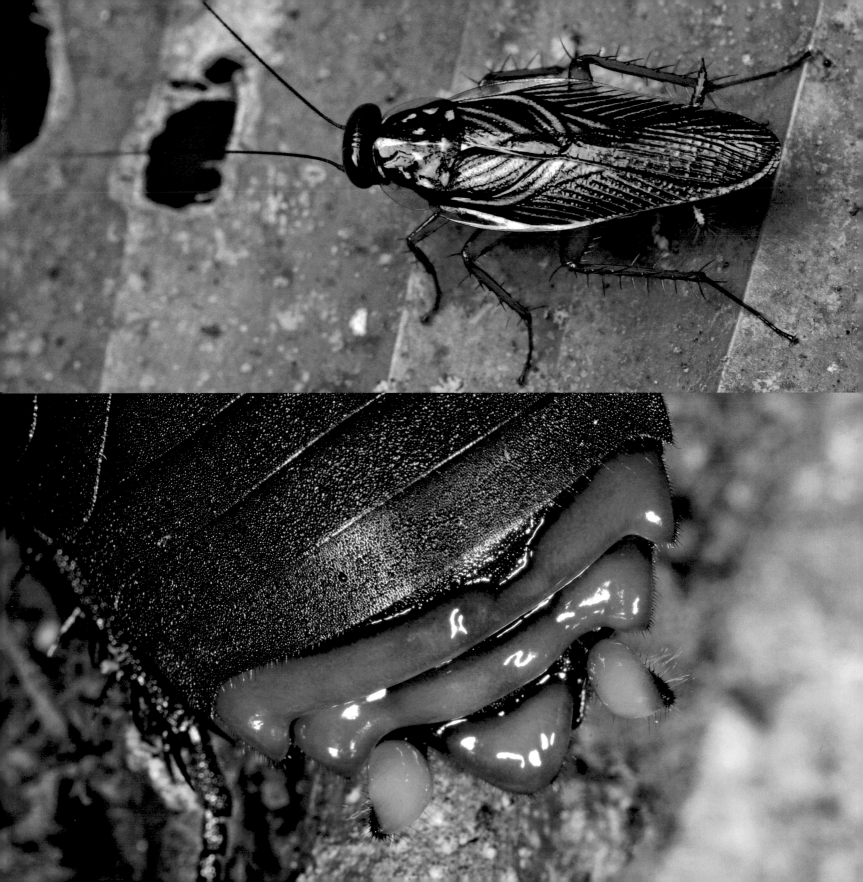

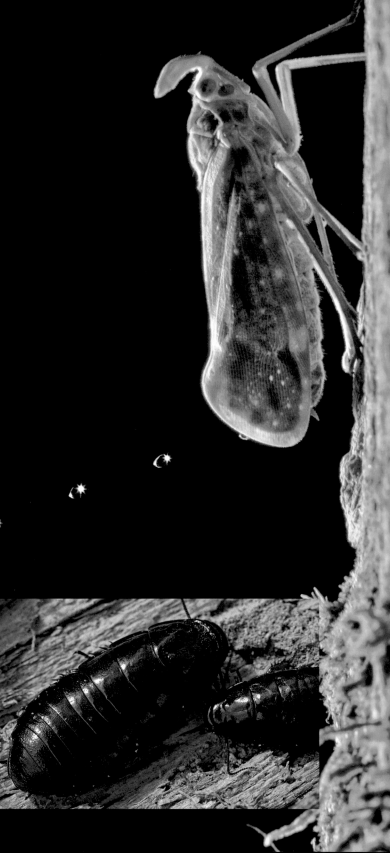

Some blattodeans supplement their plain diet with an occasional trip to the candy store. This Costa Rican blattodean, *Eurycotis* sp., is waiting for a stream of droplets of honeydew, a sugar-saturated excretion produced by certain insects, such as this lantern bug (*Enchophora sanguinea*), that feed on phloem, the vascular tissue in plants that transports sugar and other metabolites from the leaves to other parts of the plant.

Most species of blattodeans are detrivores and scavenger, feeding on dead organic matter, such as leaves, wood, or fallen fruits. Among them the genus *Cryptocercus*, a relict organism found only in northern Asia and the eastern United States, specializes in digestion and decomposition of dead tree trunks. It is one of few animals capable of digesting wood, thanks to its the ability to produce cellulase, an enzyme that breaks down cellulose, the main building block of plants. *Cryptocercus*, such as this *C. relictus* from China, form small, long-lived family groups, and are the closest relatives of termites.

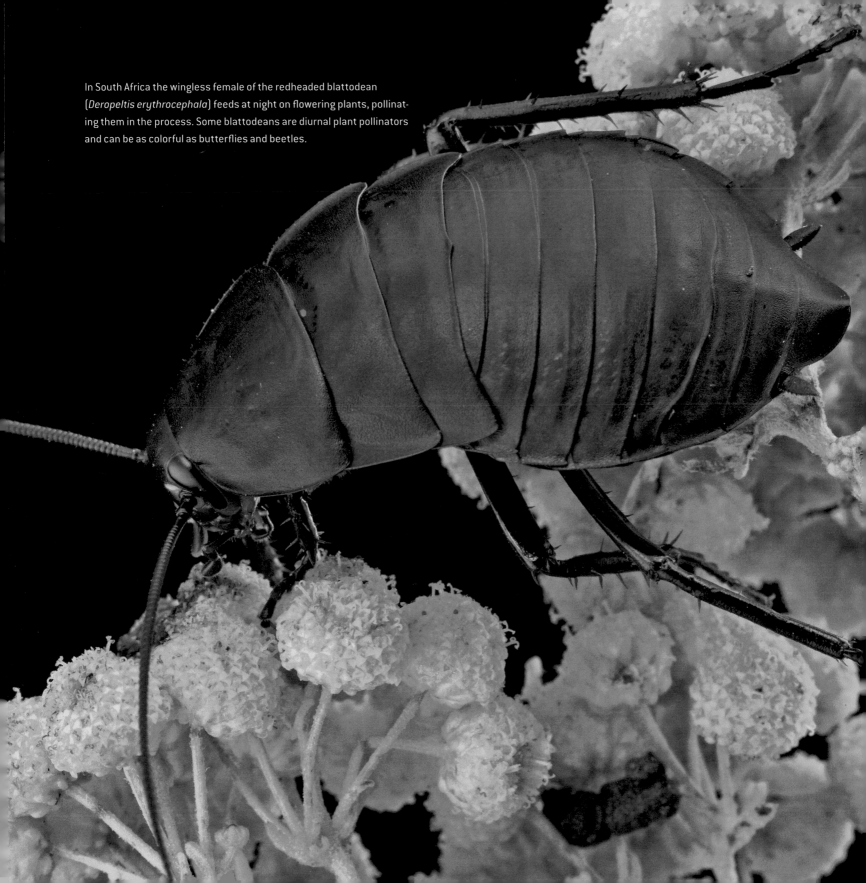

In South Africa the wingless female of the redheaded blattodean (*Deropeltis erythrocephala*) feeds at night on flowering plants, pollinating them in the process. Some blattodeans are diurnal plant pollinators and can be as colorful as butterflies and beetles.

The Southern Kingdom

The trip to South Africa started with a few hiccups. I was about to board a plane in Boston when I heard my name being mispronounced over the PA system. Before I could get to the gate to ask about it, I was intercepted by a couple of serious-looking guys in black fatigues with guns strapped to their hips. Apparently, my ultraviolet lamp, which I use to attract night insects, had a chemical signature similar to some kind of explosive; this triggered a thorough search of my luggage, which led to their finding several boxes full of collecting vials; and these for some reason seemed suspicious. After a series of deeply probing questions the vials were confiscated, but I was allowed to board the plane.

When I deplaned at London's Heathrow to catch a connecting flight to Johannesburg, I was told that of the two carry-on bags I arrived with only one could enter the premises. Call me sentimental, but I felt a certain amount of attachment to both my laptop and my camera equipment and rejected the helpful suggestion from the airport's staff to abandon one of the items. Rather, I stuffed all my pockets with lenses, flashes, and miscellaneous cords and connectors, freeing enough room in my camera bag to cram in the laptop. Constantly pushed and shoved, I had to do all this surrounded by Dantean chaos as hundreds of people who had just arrived and were being channeled through a single, narrow gate faced a similar predicament. Finally, I was allowed to pass and enter the concourse. My internal compass pointed me straight to the food court. I was about to pay for a sandwich when I realized that the familiar and reassuring bulge in my previously zipped up, but now mysteriously open breast pocket was gone, and with it all my cash, my

driver's license, and my credit card. "Huh," I thought, "this is somewhat inconvenient." I had a rental car waiting for me in South Africa, the use of which hinged on the availability of all the missing items. Things needed to be fixed fast. I mentally patted myself on the back for the forethought of placing my passport and a spare credit card on the inside of my vest, and smacked myself on the back of my head (also mentally) for not doing the same with the rest of my valuables. I took out a cell phone and canceled the stolen card, called my wife to ask her to FedEx my old Polish driver's license to South Africa, and finally took a cash advance on my spare credit card. I lost some money, but things were back on track again. Unbeknownst to me, things were going to get much worse later, but for the time being, I felt like nothing could ruin that trip for me.

I was going to South Africa to start a new project, a part of which was an inventory of katydids and grasshoppers of that country. My collaborator, Dr. Daniel Otte, a brilliant entomologist, great painter, and true role model for me, was already there. Together we would cross South Africa and conduct a series of insect surveys in the western part of the country. Dan and I had been planning this for a long time, and finally we were able to secure a generous grant to make our dream come true.

The southwestern tip of Africa has always been a magnet for biologists. A relatively tiny strip of land, a mere ninety thousand square kilometers (less than 0.3 percent of the continent's area), had accumulated such an incredible richness of plant life that it was declared a separate floral kingdom. Capensis, as it is often referred to, is one of only six such units the plant life of the entire world is divided into. By

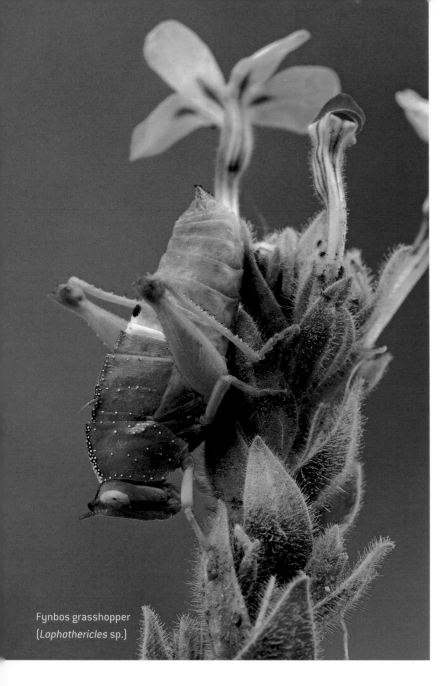

Fynbos grasshopper
(*Lophothericles* sp.)

Ronald D. Good and has since been refined and developed by generations of botanists and biogeographers. Not surprisingly, there is some disagreement about what constitutes a floral kingdom, and many botanists abstain from using this term, choosing instead to refer to Capensis as the Cape Floristic Region, or sometimes as the "fynbos biome." Minutiae of biogeographic classification aside, nobody questions the fact that the Cape region of South Africa is home to such splendid diversity of flowering plants that with every few steps you are likely to encounter a completely different, dazzling array of flora. Over nine thousand species of vascular plants call the Cape Region home, and nearly three-quarters of these are endemic. In fact, the Cape is the mother of all endemic areas, squeezing on a surface smaller than the state of Maine twice as many plant species as there are in the entire northeastern United States and adjacent Canada. Most of these plants are in the fynbos ("fine bush" in Afrikaans), a thick layer of hard-leafed evergreen shrubs, which forms the predominant type of vegetation in the western part of the Cape region. There are no native trees there, and the largest plants growing in fynbos are proteas, thick-branched bushes with magnificent, heavy flowers that attract iridescent sunbirds, Africa's retort to hummingbirds. You can almost sense their desire to grow taller and become real trees in some older, mature proteas that grow among dense patches of low shrubs, but the charred bark of their trunks betrays the work of the dominant force that shapes this ecosystem. Relatively rare but inevitable fires sweep through fynbos vegetation every few years, destroying all plants that might have come near reaching an arboreal size. Sometimes half a century will pass before flames wipe the fynbos' slate clean, but they always do. Not surprisingly, plants of fynbos have evolved an assortment of strategies for coping with these seasonal apocalypses. Many develop underground bulbs, tubers, corms, or rhizomes that act as long-lived reservoirs of nutrients but also—and more importantly—of living tissues that sprout and rebuild the plant following a fire. Botanists

comparison, most of North America, all of Europe, northern Asia, and parts of northern Africa all put together make up another such kingdom, Holarctis. This system of floristic divisions, based largely on the occurrence of unique plant families, was first introduced in 1947 by the British botanist

call these plants geophytes, and the Cape region has a much higher proportion of such forms than most places. Other plants adopt a more defeatist approach to seasonal fires, allowing themselves to be obliterated by flames, save for their heat-resistant, hard-shelled seeds that germinate as soon as the earth cools.

After the spring rains, when most plants are alive and well, the overarching feeling while walking in fynbos is that of being in some enormous, well tended rock garden. I easily recognized some species—there was *Aloe succotrina*, a succulent plant that my grandmother used to concoct her "medicinal" liqueur. I noticed some geraniums and freesias very similar to those I grew up with, and even a morea like the one that flowers in my wife's lovingly tended garden. She would undoubtedly recognize many more species, since a large proportion of common ornamental plants, such as gladiolus, iris, babiana, sparaxis, and watsonia, to name just a few, come from South Africa's fynbos. In places, especially in the more mountainous parts of the Cape, the dominant vegetation resembles heaths and moorlands of the Northern Hemisphere. This is not a coincidence—one of the most successful Cape plant lineages is heather (genus *Erica*), which radiated into astounding 658 distinct species (7 are known from North America). A few other plant groups have undergone similarly expansive diversification—the sunflower family (Asteraceae) is represented there by over 1,000 species, while irises (Iridaceae) have nearly 700 species. Remarkably, about a half of the Cape region flora is made up of just 30 extremely species-rich lineages of plants, as opposed to hundreds of lineages, each with a relatively few species, which is a far more common state of affairs in plant communities around the globe. Clearly, such a heavy bias toward a small number of very successful plant families must have a good reason, as does the overall exceptional species richness of the entire region. Biologists have puzzled over these questions for quite a while, and a consensus of opinions has yet to

be reached, but all agree that some of it certainly has to do with the ancient history of this place.

The geological and climatic history of the Cape region is well known. The surface of the southern tip of the African continent, a place that was once united with the present-day

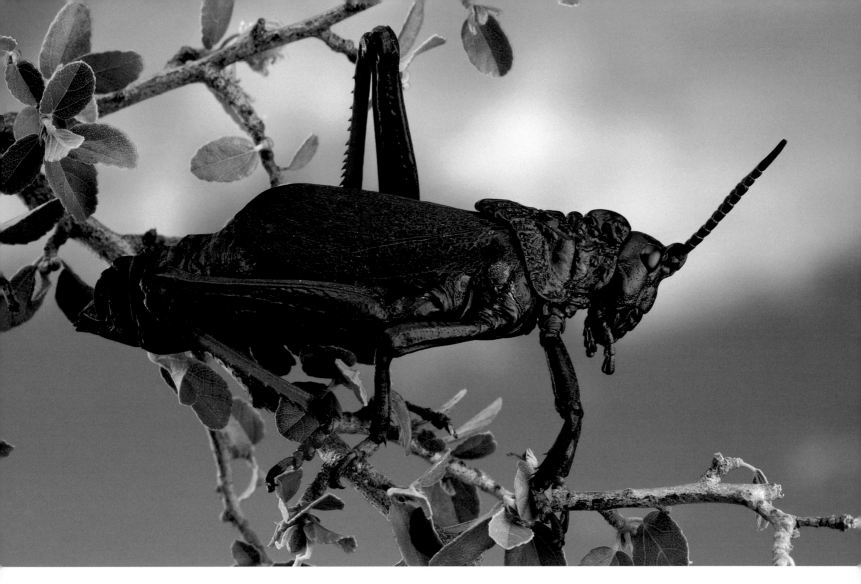

Some plants of fynbos and karoo contain toxic secondary compounds, particularly cardiac glycosides that badly affect the action of the heart muscle of mammals and birds. Insects that feed on such plants often sequester these compounds and use them for their own defense. The body of this foam grasshopper (*Dictyophorus spumans*) is loaded with toxins, and she is not shy about advertising this fact with her warning, black-and-red coloration.

South America, Australia, and Antarctica, is covered with soils derived from ancient, pre-Carboniferous rocks. Layers of sediment, some nearly half a billion years old, have repeatedly warped and folded under the pressure of the movement of the earth's tectonic plates, often pushing older layers of rock on top of younger ones, and each rock type has un-

dergone a different type of weathering and transformation. The result of this remarkably dynamic geological history is the present mosaic of soil types in the Cape; some are fairly nutrient-rich, while others are nearly devoid of essential elements required by plants. This undoubtedly contributes to the existence of an equivalent assortment of plant communi-

ties but does not really explain the through-the-roof numbers of species, especially when one considers how infertile some of the available soil types are in the Cape region.

The current climate of the region is of the Mediterranean variety, highly seasonal and characterized by cool, rainy winters followed by brutally hot and dry summers. Of course, it has not always been like this. Until the Miocene, as recently as six million years ago, the climate of that part of the world was tropical and humid, showered with rains year-round, and without a dry season. The plant life was lush, with extensive forests replete with palms. Pockets of cooler and drier weather existed only near mountaintops, where short, shrubby heaths and rush-like restios (Restionaceae) made their inconspicuous living. But starting in mid-Miocene, a major glacial event began building up enormous amounts of ice in Antarctica. This led to an upwelling of the frigid bottom waters along the Atlantic seaboard of southern Africa, a process that still exists today and is known as the Benguela current. This icy cold current, which makes swimming near Cape Town a very unpleasant experience (that, and the sharks—many, many sharks), resulted in the blocking off of warm, humid air that used to bring summer rainfall to the Cape. Dry seasons ensued, and the luxuriant tropical vegetation, not used to prolonged spells without rain, perished.

Suddenly, the once densely forested areas opened wide to new colonists. But few plants from adjacent areas of Africa could cope with the new, highly seasonal climate of the Cape. Large swaths of land just sat there, free for the taking, but takers were few and far between. There were, however, some plants that never left the area. Those were the plants from the high mountains, where climate had always been cooler and drier, and their alpine biology preadapted them for dealing with long stretches of time without water, followed by downpours of cold rains. No longer forced to compete with fast-growing, large-leafed tropical vegetation, these smaller but hardier plants left the mountaintops and spilled over the new terrain. As they colonized new areas, each place

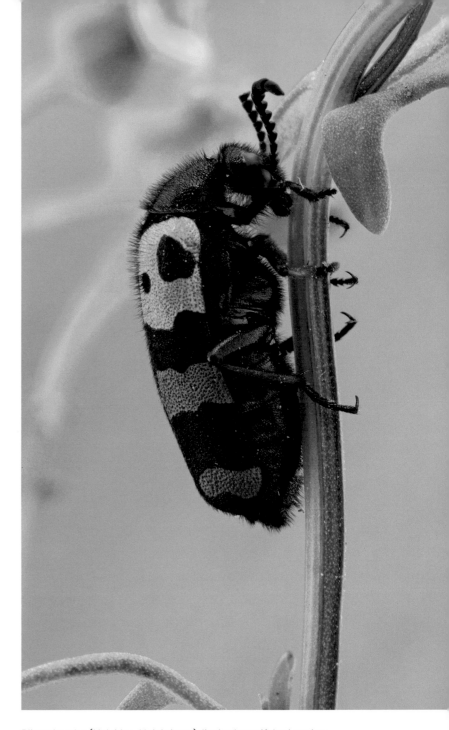

Blister beetles (Meloidae: *Mylabris* sp.) display beautiful colors that spell "look, but don't touch"; their bodies contain cantharadin, a fatal poison that if ingested can easily kill a human.

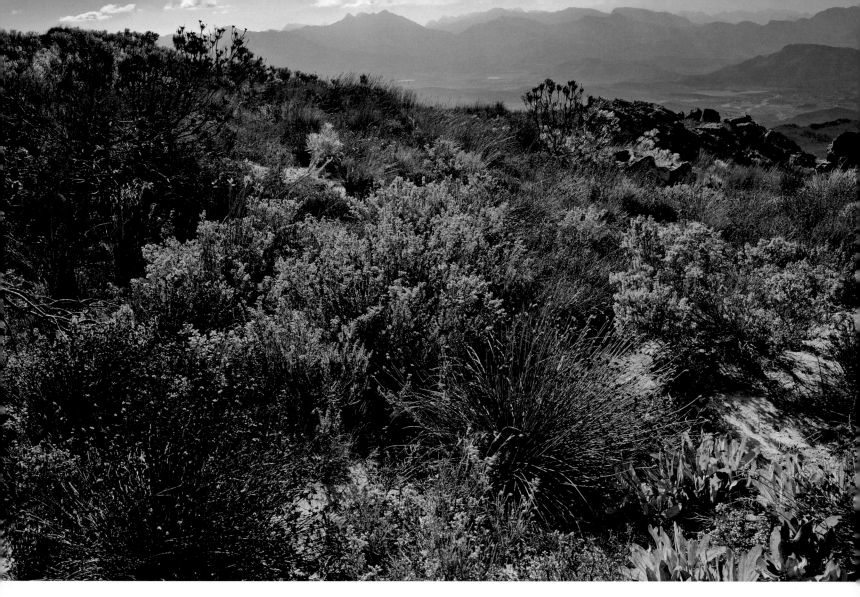

Jonaskop in the Riviersonderend Mountains is a prime example of fynbos vegetation, richly displaying the three dominant plant types of this biome: pink ericoids, grassy clumps of restioids, and shrub-like proteoids, still mostly leafless after a recent fire.

slightly different in its microclimate and trophic character-istics, they began to evolve into a multitude of closely related but uniquely different species. And because the alpine heaths of the Miocene Cape consisted of only a certain, relatively small group of plant families, those were the lineages that were given the head start and a greater opportunity to fill as many niches as they found. This hypothesis of the sudden availability of vacant niches, known as the tabula rasa ("clean slate") model, explains in part the dominance of relatively few families among the current flora of the Cape region. Then again, some biologists question this reasoning and sug-gest instead that fynbos took over the Cape region gradually,

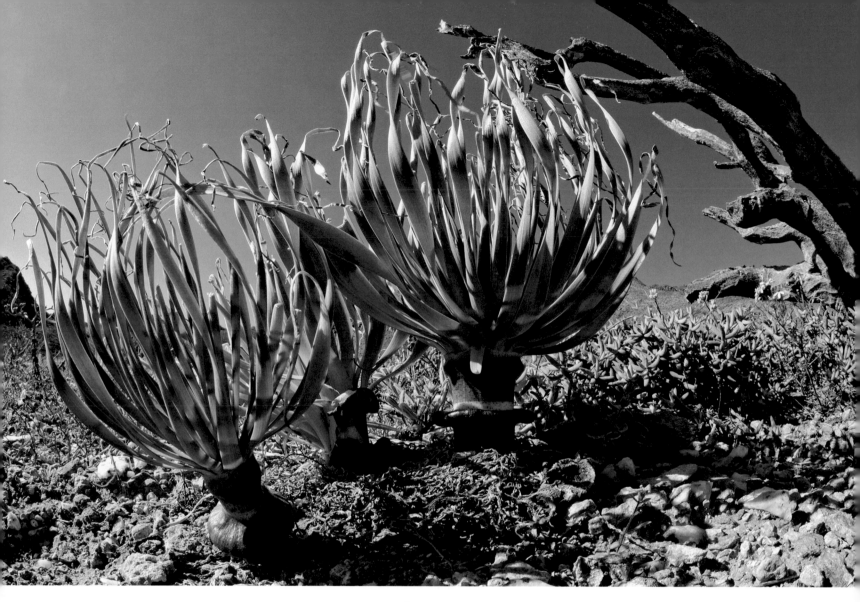

Geophytes, plants that develop underground structures to store water and nutrients, abound in both fynbos and Succulent Karoo.

displacing tropical plants piece by piece, thanks largely to their ability to survive the more and more frequent fires, as well as the prolonged droughts. Regardless of the specifics of the process, the small and nimble heath-like vegetation of fynbos eventually won the competition and now reigns over the Cape region.

But questions remain. Why, for instance, does species composition of plants in the Cape vary so greatly and with very little overlap from one place to another (ecologists call this a "high species turnover")? And why are there so many of them? Could it be that plant species there evolve faster than anywhere else in the world? Several hypotheses have been proposed to explain this phenomenon. Some cite the topographic (shape of the land surface) and edaphic (avail-

ability of nutrients) complexity of the region. Others attribute the incredible species richness to the acts of fire, which frequently wipes out large areas of vegetation, creating gaps between populations within the same species, thus promoting their genetic divergence. Still others put the responsibility on the wings of pollinating insects, which may drive quick specialization of the plants' flowers. An opposite approach tries to explain the high numbers of plant species not by how fast they evolve in the Cape but by how rarely they go extinct. Rather than species being replaced by newly evolved ones, there is some indication that the relative climatic stability in the Cape region within the last 4–5 million years might have allowed older species to survive, while new ones kept appearing. In all likelihood, all these factors have played equal roles in the creation of this incredible floral kingdom. We still need to search for the definite answer, but the end result is unquestionably beautiful and rich.

Quite understandably, the astounding botanical tapestry of the Cape region creates a great environment for insects. Some early studies seemed to suggest that insect diversity in fynbos was lower than expected, but those have since been counterbalanced by research showing a remarkably high insect diversity, at least in some groups. As Dan and I crossed the Western Cape province of South Africa, we stopped frequently to survey insects associated with different types of vegetation. At almost every new place we found different, often completely new species of grasshoppers and katydids, a clear indication that these two groups were well represented in the fynbos. Most of these animals were very small, cryptically colored and shaped, and nearly indistinguishable from leaves and twigs among which they lived. They were often wingless, suggesting that they might be immature, but upon a closer examination they almost always turned out to be fully grown adults who just happened to have lost their wings in the course of their evolutionary adaptation to life in extremely dense, small-leaved vegetation.

Eventually we arrived in Stellenbosch, a small, pictur-esque city not far from Cape Town, famous for its excellent wines and hard cider and for its university, the second oldest in South Africa and one of the few remaining higher educational institutions in this country that still teaches mostly in Afrikaans. There I met with Corey Bazelet, a graduate student whose research focused on the biology and taxonomy of African grasshoppers. A couple days later, Dan left for his home base of Philadelphia, and Corey and I set out north to continue the survey. Our main destination was the majestic Cederberg, an ancient mountain range north of Cape Town that carried a special significance for me.

Thirteen years earlier, when I was still a student in Poland, I received from the South African museum in Cape Town a small collection of insects. Among them were a few strange creatures—large, lightly brown and dark stripped katydids with extremely long legs and other appendages. They had the appearance reminiscent of some pale and peculiar spiders. Not surprisingly, those katydids turned out to be new to science—an always welcome but not unexpected occurrence. The labels attached to the specimens stated that the insects had been collected from rock crevices in Cederberg. Now, that was interesting—no katydids had ever been found in association with rock crevices or caves. Could those be the first such animals? Their morphology certainly seemed to suggest it. Extremely long appendages and pale coloration are the hallmarks of troglophiles, organisms living in caves, and the new katydids fit this pattern. Alas, the insect before me had been collected in the 1930s, and their collector, Mr. Keppel Harcourt Barnard, former director of the South African Museum, died in 1964, thus I could not ask for any additional details. To add to the mystery, all specimens were immature, and I could only speculate about what the adults looked like. I published a formal description of the new katydids, giving them the scientific name *Cedarbergeniana imperfecta* (immature katydid from Cederberg), but ever since I have been dying to find out more about their behavior and biol-

Solpugids, animals harmless to anything larger than a grasshopper, are arachnids devoid of venom glands. Although they present absolutely no danger to humans, myths about the threats they present abound in South Africa. Known there under many names, including red romans, haarskeerders ("hair cutters"), and gift-kankers ("poison cancers"), over 150 species of these interesting animals can be found in dry habitats, where they hunt insects and other small animals. Having no venom, they deal with prey by quickly chopping it with large, heavily muscled mouthparts, or chelicerae. Solpugids themselves are an important prey item for many South African animals, including owls and raptors, as well as foxes, genets, and even jackals.

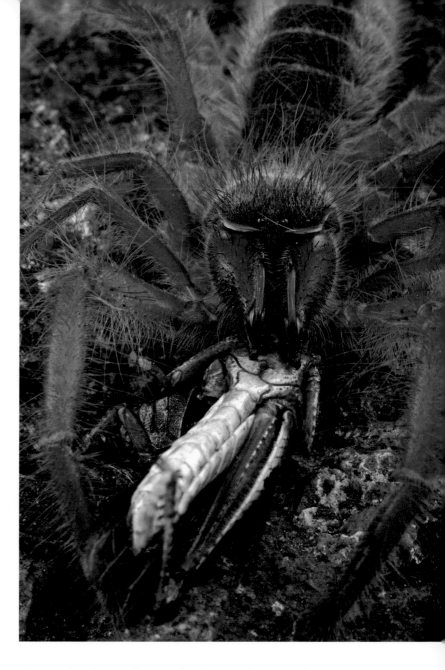

ogy. Do they really live in caves? What do they eat? Can they sing? Are they solitary, like virtually all katydids, or do they live in groups, like cave crickets? At last, I was hoping to find out.

Corey and I left Stellenbosch early in the morning and headed first to a few localities along the coast that seemed particularly promising for possible new species of katydids and grasshoppers. As we drove we chatted about insects, travels, and all this and that you usually talk about to get to know a new acquaintance. Corey grew up on the East Coast of the United States but wanted to move to Israel to reconnect with her Jewish heritage. She really wanted to live there but could not speak Hebrew. In a stroke of genius she came up with the perfect solution—a full immersion treatment that would force her to learn really fast. She enlisted in the Israeli army. "She is one tough cookie," I thought, "probably crazy, too." Who in their right mind would join the army, the most stressful environment imaginable (been there, don't even want to remember it) without being able to understand the commands the drill sergeant spews in your face at the top of his lungs? But, as I learned with time, that was how Corey operated: if the task seemed daunting and difficult, she would willingly put herself in a situation from which she could not back out without first finishing it. That's why she traveled alone across China (without knowing Chinese,

of course) and moved to South Africa without ever having been anywhere on that continent before, and that's why she was traveling with a guy she knew nothing about to remote, potentially dangerous locations to walk in the African wilderness at night. But of course I could not be happier about it. It is very difficult to find a person who is willing to do

The Wolfberg Cracks of Cederberg

hard field work for nothing, never mind one who is actually really interested in it.

The following day we arrived at our final destination. Cederberg is a spectacular place of red and orange sandstone, bizarre spires, jagged cliffs, and deep precipices. And caves. The one I was particularly interested in was called Wolfberg Cracks, an apt name for a series of shallow, open-ended caves, which nonetheless provided a cool, humid environment without light that I hoped was just the kind of place my katydids would choose. To get there one has to hike for a few hours up the mountain, but hiking is not really the right word to describe it, it was more like scaling. Do this in the scorching heat of South African midday, and you can probably be absolved of doing any aerobic exercise for the

next year or so. Corey, a small, lithe woman without a gram of superfluous fat, flew up the mountain. "Just . . . taking . . . some . . . pictures," I breathed heavily in response to her inquires about my considerable lagging behind. But my frequent stops, during which I would just collapse and wait until my heart rate dropped from that of a hummingbird to one closer to that of a large mammal did give me an opportunity to look around. The view from high on the slope was quite stunning, but even more interesting was the vegetation covering the mountain. All around me were neon-pink clumps of *Drosanthemum* flowers; tall, rush-like restios; and huge, tree-size proteas, a clear indication that fire had not swept this slope clean in quite some time (a few years later a massive fire did come and caught up with the vegetation of Cederberg). Below, pristine fynbos and spectacular rock formations created a landscape of prehuman Africa (I pretended that I could not see a farm far in the distance). As far as I could tell, we were the only people on the mountain, and nothing but a pleasant buzz of cicadas broke the silence. At last, a black, vertical hole in the rocks appeared in front of us. We put our headlamps on and started to crawl into the darkness. Before going in I took off my wide-brimmed hat and left it at the entrance.

After the frying pan of the slope, the inside of the cave felt pleasantly chilly. I measured the air temperature, which turned out to be 12°C. There was not much wiggle room in there, and so we had to squeeze one at a time through narrow passages between giant boulders. I slowly scanned the walls of the cave, looking for any signs of insect life, but found nothing. Then Corey said, "They are here," and pointed her light at the ceiling. There, a few feet above our heads, sat a small cluster of Cederberg cave katydids. In that instant I felt a rush of powerful emotions similar to what, a childless man imagines, it must feel to hold for the very first time your own newborn child. Scoff if you like, but I had waited for this moment for thirteen years. I gave those organisms their name and described them, but that was just the beginning,

and now I would learn so much more. They *were* gregarious, and they *did* live in caves! Among the dozen or so animals above us I could see a few adults. They did not seem to be particularly disturbed by our presence but walked away if a beam of light lingered on them for too long. Slowly I crept up to the top of the nearest boulder and scooped up a mature male. What a stunning animal he was. He had tiny, scale-like wings but with well-developed sound-producing structures (so they did sing). His body was slightly smaller than my pinky finger, but with his extremely long legs he was nearly as big as my hand. I expected these katydids to be incredibly agile and fast, but to my surprise they moved at a slow, deliberate pace and hardly jumped. Clearly, the low temperature of their environment put the brakes on their metabolism.

We decided to scope out a few more caves nearby. Our plan was to return to collect more data during the next few days, but first I wanted to get an impression of the size of the katydid population. The first cave opened on its far end to a narrow ledge that curved around a vertical rock wall and led to additional cracks. I went first and began to inch my way slowly around the bend, with Corey a few steps behind me. I sometimes suffer from short pangs of height anxiety, but in my elated state I didn't give a second thought to the jagged rocks that piled way down below the ledge. In fact, it was an unexpectedly easy walk, as the ledge was quite wide. But then I heard behind me a short, muffled cry. I instantly turned and caught a glimpse of Corey tumbling along the face of the cliff toward the rocks beneath. She landed on her knees about twenty-five feet below the ledge, and with the last bit of inertia her head hit a protruding rock at the base of the cliff. She didn't move. A sudden switch from near euphoria to paralyzing fear went through my body like a bolt of electricity. I raced back and slithered through the cave toward the bottom of the cliff, propelled by dread of what I would find below. As I ran toward her I saw her move, and the first flicker of hope lit up in my head. Corey was alive, but I still had no idea what kind of injuries she might

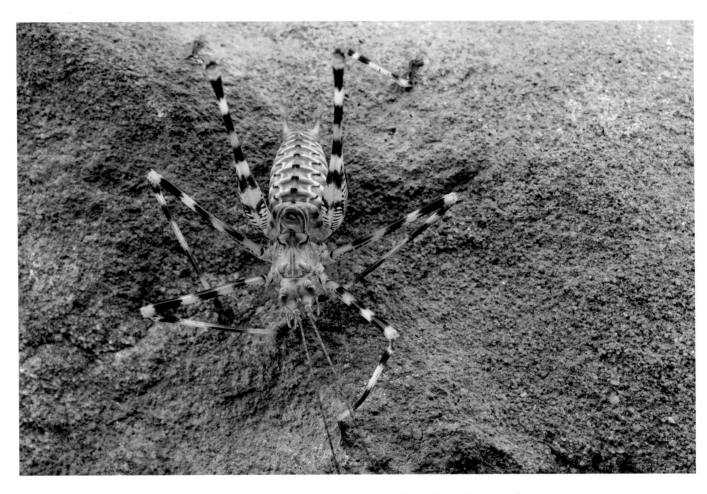

The short, scale-like wings of the Cederberg cave katydid betray his ability to sing, although he no longer can fly.

have suffered. When I got to her and realized that she was conscious I first checked that she could still feel all her appendages, and only after that helped her to sit up. Her head was bleeding, but thankfully it looked only like a superficial scrape, although concussion was a very real possibility. But she could not walk, and though her legs were not broken, something was clearly very wrong with her lower body. Our car was at least two hours away, and the nearest house was even farther. It was clear that Corey could not make it down the slope, thus I had no choice but to leave her and run down

to call for help. I was about to go when I thought I had heard some noise coming from above. I looked up, and then, a miracle: three silhouettes emerged from behind the top of the mountain. Like a setup to a bad joke, an Australian, a French, and an Italian appeared to help the Pole rescue an American. Three young guys, strangers to each other, who just happened to meet and decided to take a hike together, saved the day. What followed was a grueling four hours, during which we took turns carrying Corey in pairs, but finally made it to the car (which, to make things more interesting,

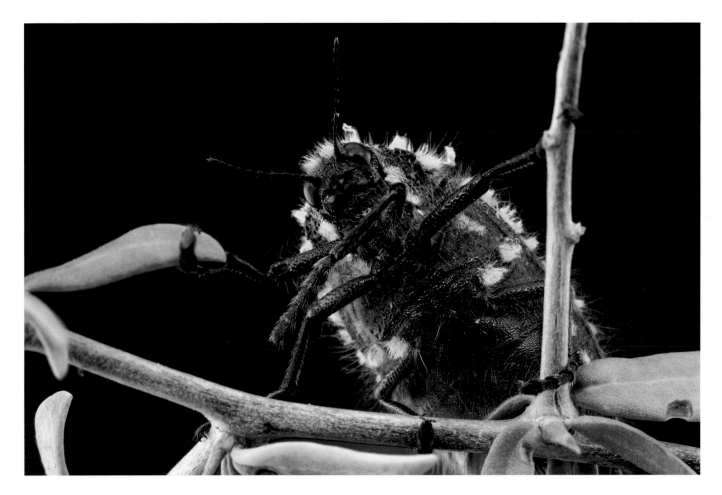

had developed a flat tire during our absence). Throughout this ordeal Corey was unbelievably stoic and never, ever complained about anything. I know I would have screamed like a pig being slaughtered if I had my pelvis broken in three places, a fractured rib, and a collapsed lung. Corey learned the details of her injuries the following day after spending a night in a local hospital, which we finally managed to reach around midnight.

Thankfully, there were no complications in her recovery, and soon Corey was able to walk with crutches; before long, she did not need those anymore. But I felt awful. It was dumb of me to go right into the mountains on our first

trip, although in all honesty I had assumed that if anybody got into trouble it would be me, not an extremely fit person trained by the Israeli army. Guilt was eating me alive—if it weren't for my katydids, she would have been fine—and surely she would never want to work with me again. To my surprise and gratitude, Corey did not hold a grudge, and some months later we picked up where we left off. She admits to being a little more cautious, especially in the mountains, but her resolve is as strong as ever.

As for the cave katydids, since that day I had gone back to Cederberg a few more times, and while I already learned a great deal about their behavior, many aspects of their biol-

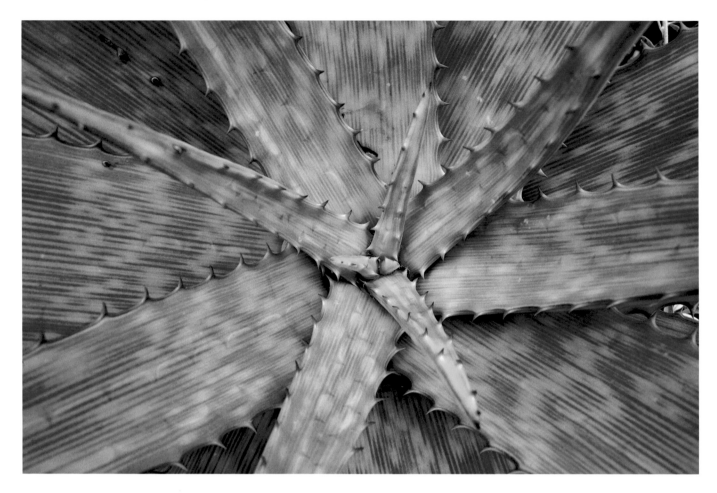

ogy remain shrouded in mystery. I now know their song (a short, ultrasonic chirp) and what they eat (they leave the cave at night to feed on grasses; in technical parlance this makes them trogloxenes); but their breeding behavior, development, and population structure remain to be investigated. Most importantly, I still don't know the reason for their preference of caves, a unique behavior in this group of insects. It is possible that the Cederberg cave katydids are relics of colder conditions from the Pleistocene and survive only thanks to lower temperatures consistently present in caves. If this is the case then their future looks rather bleak, and like many other survivors of cooler time periods they may eventually succumb to rising temperatures. Corey and I have found additional populations of these insects in a different part of the mountain range, which increases slightly the odds of their long-term survival. Every time that I return to South Africa I visit Cederberg to record more data on the katydids, and the bad memories of my first visit are lessened by the exquisite Cederberger, a delightful blend of red wines made from grapes grown there at the highest elevation anywhere in South Africa.

After our unfortunate and unplanned delay, Corey and I continued the insect survey, deciding to move farther north along the west coast of South Africa. The farther we went, the drier it got, and soon the vegetation began to look very

The quiver tree, or kokerboom (*Aloe dichotoma*), got its name from the use of its branches by San people of the Namib region as perfect containers for their arrows. Hollowed-out branches needed only to be capped on one end to make an ideal quiver. Old, thick trunks of dead quiver trees can also be used as a kind of natural refrigerator for water, meat, and other food, and native peoples have long known about the insulating properties of their pithy, spongy stems. Sugar birds are drawn to flower buds and nectar of this species, whereas weaver birds build giant communal nests high in its branches.

Few plants are as emblematic of the Succulent Karoo and Namaqualand as the quiver tree, and almost anywhere you look there is always one or two on the horizon. But this may change in the not-too-distant future. These very slow-growing plants adapt poorly to any alterations of their environment and were some of the very first organisms used to demonstrate unequivocally the negative effect of global climate change on species. As their current habitat becomes even hotter than it already is, their slow metabolism and dependence on animal seed dispersers make these trees poorly suited to make a rapid shift to new areas further away from the increasingly hotter equator. Using rich historical data and photographs spanning over a hundred years, South African biologist Wendy Foden and her colleagues were able to document a dramatic decline of quiver trees in the northern part of their range; at the same time, this loss has not been counterbalanced by gains in its southern part. If things go as predicted, within a century, over three-quarters of quiver trees will disappear from their current range. The really scary part is that these are desert plants, well adapted to the hot climate. If they cannot cope, what chance do other organisms have?

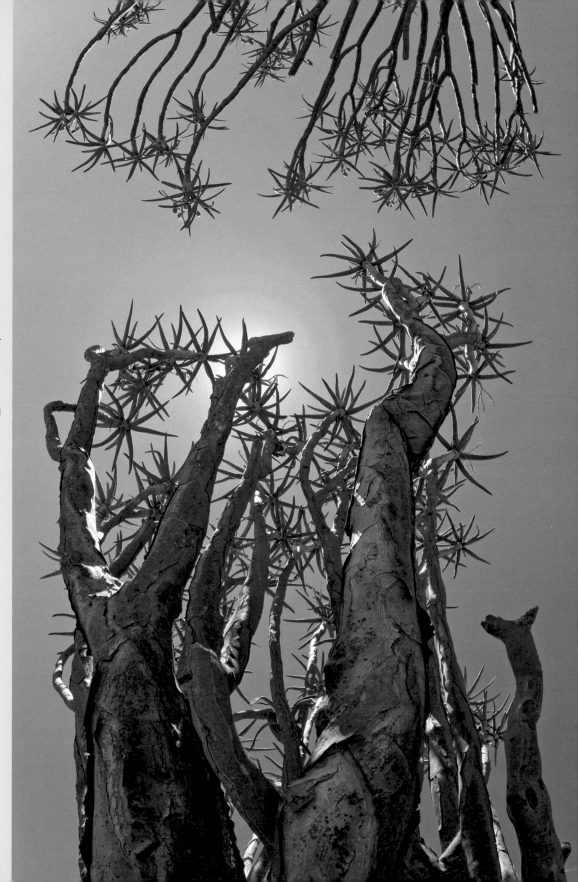

different. Gone were dense, small-leaved bushes and thick clumps of restios. Plants became shorter, and gaps of bare soil between them grew larger. Many had thick, fleshy leaves, often covered with a layer of sticky secretion or wax. Some plants gave the impression of being living, breathing reservoirs of water, so swollen with liquids were their plump stems and modified leaves. There was no mistaking it—we were leaving the domain of fynbos and entering a different ecosystem, known under the exotic name of Succulent Karoo. Like its neighboring ecosystem to the south, Succulent Karoo teems with unique endemic forms of life. Within the flora, the extremely low precipitation and higher temperatures of

this region drove the evolution of thousands of species of succulents, plants capable of storing large amounts of water in their tissues. Largely independent from the scarce, albeit quite regular, availability of water in their environment, the succulents are some of the toughest survivors of the plant world. Over 1,700 species in the Succulent Karoo store water in specially modified leaves, which often resemble small cushions or little green sausages. Additional 200 or so are stem succulents, which often forgo the growth of typical leaves, but instead develop a thick, often barrel-shaped stem that not only stores water but is also the main photosynthetic organ of the plant. Leaves, if any traces of them are at all visible, frequently turn

into spines that protect the juicy and vital stem. A visitor from North America may be fooled into thinking that some of these plants are cacti, but these do not occur in Africa (one species, epiphytic *Rhipsalis baccifera*, can be found in tropical Africa, but likely it was introduced there only recently by migrating South American birds). Rather, members of other families, particularly Euphorbiaceae and Apocynaceae, converge on similar morphologies and physiological adaptations, driven by conditions comparable to those found in the American deserts. But nowhere else has one area evolved such incredible diversity of succulents, and the karoo biome contains nearly a third of the world's species of these plants.

It was September when we first came to the Succulent Karoo, and large stretches of sandy, flat terrain were dotted with thousands of flowers that followed the early spring rains. Like fynbos, Succulent Karoo is the source for many species of plants commonly cultivated in gardens and flowerpots around the globe. If we drove farther north we would have eventually reached Namibia, where the Succulent Karoo turns into the Namaqualand-Namib domain, a strange ecosystem kept alive not by rains, which may not come for years, but by early-morning fog caused by the meeting of the cold Benguela current with hot air coming from the desert. But in the Succulent Karoo, rains

come regularly, if in small quantities, and the spring floral display is an annual event that attracts visitors to Northern Cape in the same way that colorful foliage draws thousands of visitors every fall to New England.

Floras of the Succulent Karoo and fynbos are closely related, and some botanists argue that both biomes should be included within the Cape Floristic Region. Interestingly, a closer look reveals that these two plant communities do not coexist peacefully, but rather are in a constant state of war. Karoo tirelessly sends out its troops to edge into areas rightfully occupied by fynbos and sometimes wins these border skirmishes. Succulents can grow virtually anywhere, their resilience and adaptability having its source in large supplies of water they always maintain. Fynbos plants, on the other hand, are limited in their distribution by water available in the soil and could never survive in the much drier areas of the northwestern part of South Africa. Luckily, they have an unlikely ally that helps them keep the Succulent Karoo at bay. The same fires that wipe out fynbos every few years are not nearly as deadly to its plants as they are to those of the Succulent Karoo. Millions of years of periodical conflagrations have made fynbos plants evolve survival strategies that are lacking in succulents, whose only defense is the extinguishing power of water contained in their tissues. But let the fire burn longer and hotter, and succulent plants inevitably shrivel to nothing, turn into ash, and are gone forever. As long as fynbos can maintain a certain density of its plants that ensures easy passage of flames, it is safe. Dense clumps of rush-like restios are particularly good at supporting hot, lasting fires that eradicate any wandering marauders from the Succulent Karoo.

Humans, in our astounding ability to destroy every natural ecosystem we set foot in, are of course messing up this dynamic equilibrium. Overgrazing by cattle and sheep creates large gaps in fynbos that stop the spread of fire and allows Succulent Karoo plants to establish themselves permanently. At the same time, ironically, overgrazing in the Succulent Karoo proper turns it into an artificial desert. Fynbos suffers greatly from the introduction of alien plants, especially trees, such as pines and eucalypts, which are completely foreign to this ecosystem. Agriculture and urban sprawl also contribute significantly to the shrinking of the fynbos habitat. In the Succulent Karoo mining is a major destructive factor; its underground strata have the misfortune of being particularly rich in diamonds, gypsum, limestone, marble, monazite, kaolin, ilmenite, and titanium, all of which appear to be worth more than the thin coating of life on the surface. Some people disagree with this assessment, and illegal collecting of succulents for ornamental plant trade drives many of their populations to near-extinction. Species that contain pharmaceutically active compounds—or are suspected to—are also targeted, and many had to be formally protected. Once, when trekking through parched expanses of Namaqualand, my Namibian guide suddenly stopped and excitedly pointed to a strange, spiky plant that looked like a large cucumber growing out of the sand. He sliced it into pieces and gave me one to try. It was bitter but strangely quenching. With that piece of tissue I also swallowed a chunk of guilty suspicion that we were destroying a plant that probably took decades to grow. I later learned that we had eaten *Hoodia* plant, something that is now all the rage on the market of dieting aids, and much of the population has been overharvested to nothing.

Fortunately, it is not all gloom along the west coast of southern Africa, and some of the most spectacular examples of effective conservation come from there. A campaign to eradicate invasive plants in South Africa helped reclaim many areas rightfully belonging to native vegetation and sometimes resulted in bringing back organisms thought to have gone extinct; two seemingly vanished species of damselflies have reappeared recently along the streams of the Cape after invasive tree species were removed from along their edges. South Africa has also a fantastic network of reserves and national parks, some of which help preserve the two frail, xeric ecosystems (still, South Africa is a big country, and only 7 percent of its area is protected; a number

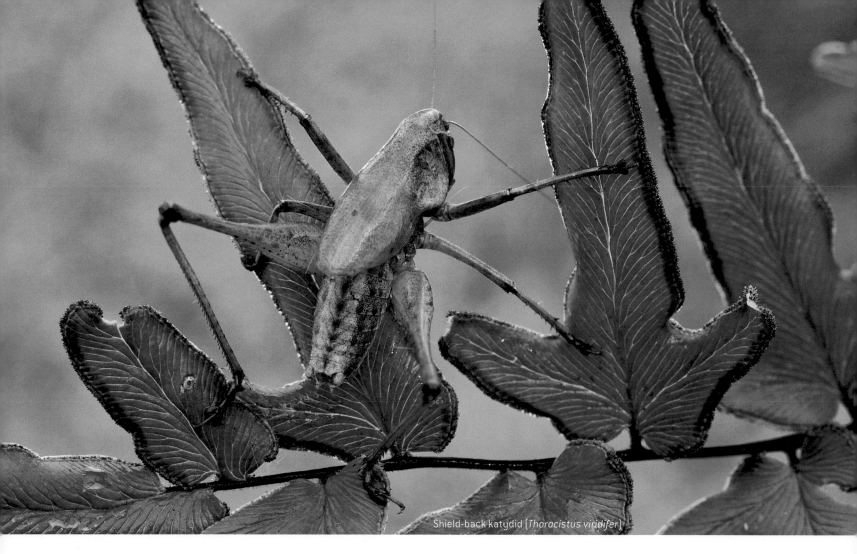

Shield-back katydid (*Thoracistus viridifer*)

closer to 15 percent–20 percent would have been much better). One of them, Richtersveld Transfrontier National Park, protects over six thousand square kilometers of karoo vegetation on both sides of the border with Namibia, although I was a bit disconcerted by the hordes of goats gorging on priceless endemics that I saw there during a recent visit. It turns out that the park is a mosaic of private, communal, and government land, and seminomadic stock farming is still allowed there. Like almost everywhere else, conservation work in South Africa is a tricky balancing act that attempts to respect both the rights of indigenous populations to live according to their traditions and the dire need to protect the last remaining populations of species and irreplaceable habitats. There is no doubt in my mind that nature will lose some of these battles, and many species of plants and animals will go extinct in the next few decades. While protecting as much land as possible from development or overharvesting is the single most effective conservation strategy, I believe that we must put a comparable amount of effort into documenting what is still surviving. The survey of grasshoppers and katydids Dan, Corey, and I were conducting in South Africa may seem insignificant, but in the end our findings may be the only records of the existence of some of these organisms long after we, their habitat, and the very species are gone.

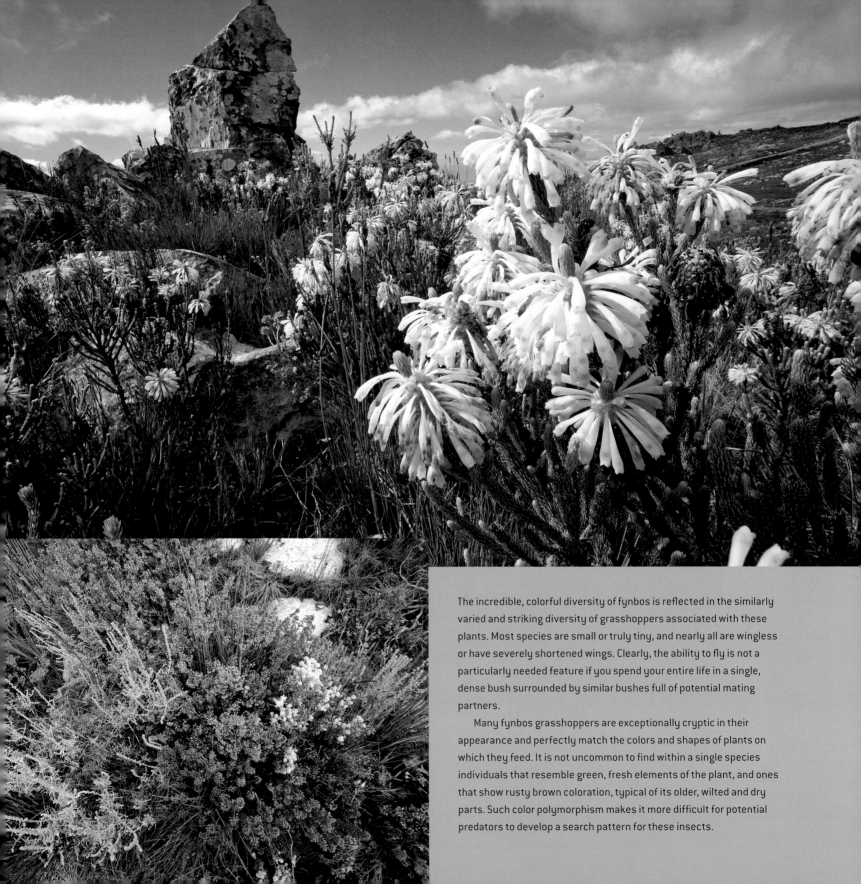

The incredible, colorful diversity of fynbos is reflected in the similarly varied and striking diversity of grasshoppers associated with these plants. Most species are small or truly tiny, and nearly all are wingless or have severely shortened wings. Clearly, the ability to fly is not a particularly needed feature if you spend your entire life in a single, dense bush surrounded by similar bushes full of potential mating partners.

Many fynbos grasshoppers are exceptionally cryptic in their appearance and perfectly match the colors and shapes of plants on which they feed. It is not uncommon to find within a single species individuals that resemble green, fresh elements of the plant, and ones that show rusty brown coloration, typical of its older, wilted and dry parts. Such color polymorphism makes it more difficult for potential predators to develop a search pattern for these insects.

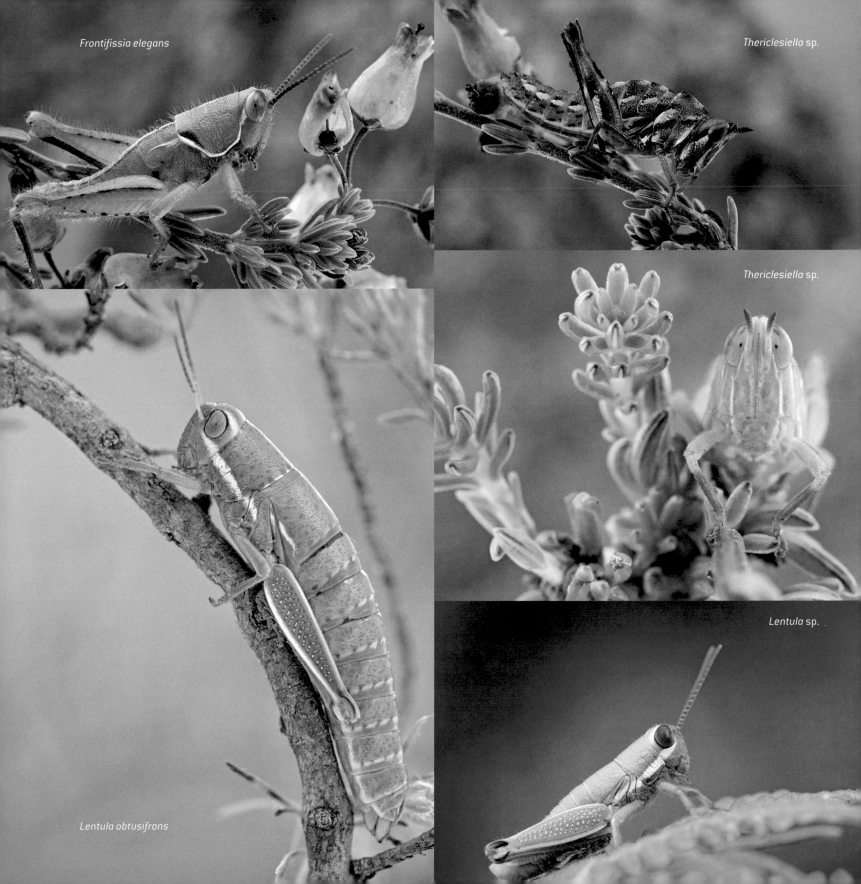

Frontifissia elegans

Thericlesiella sp.

Thericlesiella sp.

Lentula obtusifrons

Lentula sp.

The shallow sandstone caves of Cederberg are home to the world's only cave katydid. The behavior of this species is unlike that of any other member of this group of insects, which tend to spend their lives high in the canopies of trees or in open scrublands and savannas. It is also the only katydid that lives in groups, which consist of five to twenty individuals of various ages.

The appearance and morphological adaptations of the Cederberg cave katydid (*Cedarbergeniana imperfecta*) are typical of insects living in this environment. All its appendages—legs, antennae, and mouthparts—are extremely long, which indicates that touch rather than vision is the main sense this insect uses to find its way in the darkness. Living in groups is also common among cave dwellers, as it facilitates finding mating partners. The wings of this male are reduced to tiny scales, and their only function is to produce short ultrasonic clicks to attract females. Its close relatives living in the open fynbos vegetation of the Cederberg Mountains produce long uninterrupted trills, but in the closed environment of a cave such call would likely produce a lot of overlapping reverb, making it difficult for a female to locate the caller.

But the transition to cave life is not complete in these katydids. While they spend their days inside and court and mate there, there is not much food available to these plant eaters in the darkness under rocks. They must leave the cave every night to feed on seeds and flowers of grasses growing near the entrance to the cave. Occasionally, these katydids can be seen outside even during the day. This type of animal, one that spends most of its life inside but must periodically leave, be it to feed or reproduce, is known as a trogloxene—"a foreigner to the cave."

The long ovipositor in the females of this species suggests that they lay their eggs deep in the soil, most likely outside, close to the entrance to the cave. This would allow the hatching nymphs to find plants they need to feed on before going inside.

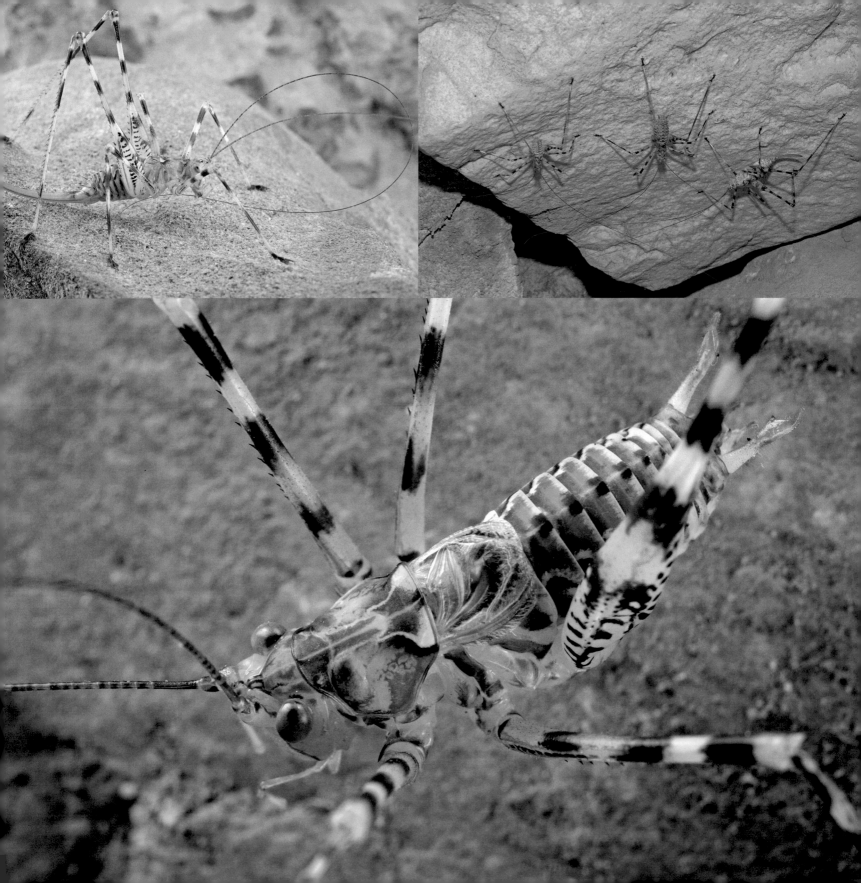

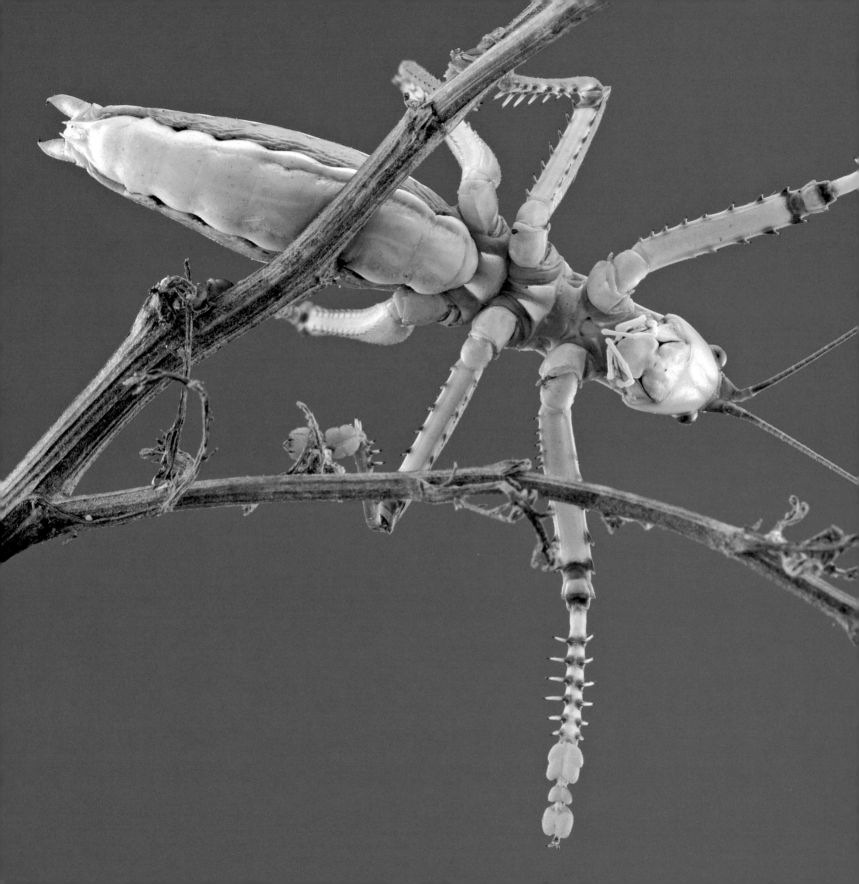

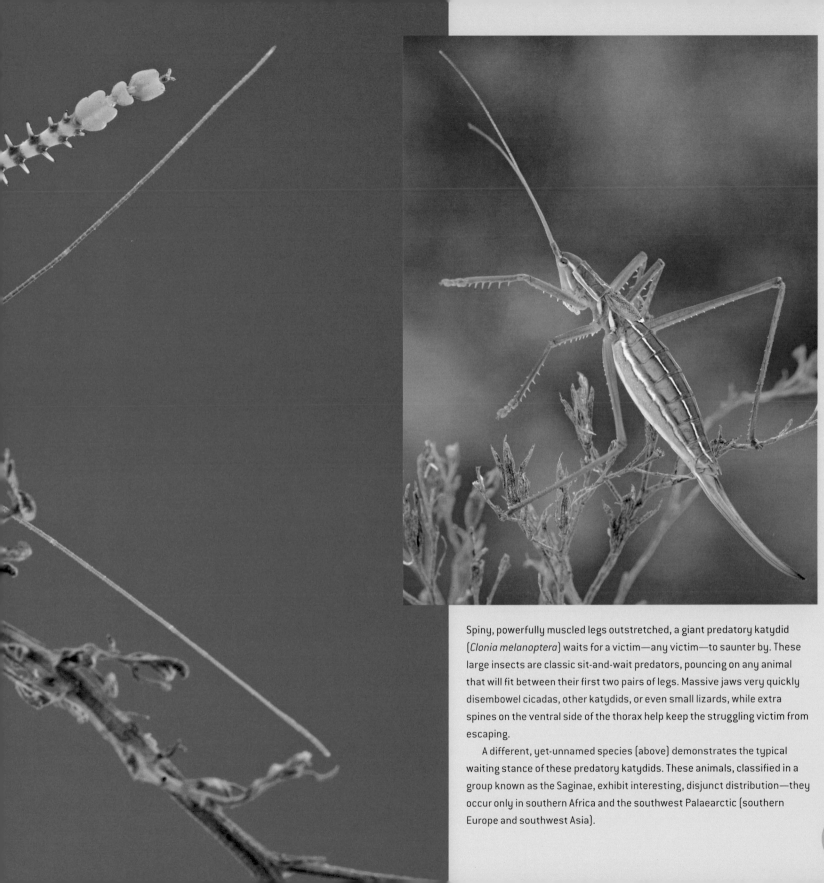

Spiny, powerfully muscled legs outstretched, a giant predatory katydid (*Clonia melanoptera*) waits for a victim—any victim—to saunter by. These large insects are classic sit-and-wait predators, pouncing on any animal that will fit between their first two pairs of legs. Massive jaws very quickly disembowel cicadas, other katydids, or even small lizards, while extra spines on the ventral side of the thorax help keep the struggling victim from escaping.

A different, yet-unnamed species (above) demonstrates the typical waiting stance of these predatory katydids. These animals, classified in a group known as the Saginae, exhibit interesting, disjunct distribution—they occur only in southern Africa and the southwest Palaearctic (southern Europe and southwest Asia).

Annual mass migrations of zebras, wildebeest, Thompson gazelles, and other assorted ungulates on sweeping, dry African plains are the source of some of the most evocative and celebrated images of our world at its finest. Cue the blazing red orb of the setting sun as the endless string of magnificent, heroic silhouettes passes across the horizon and, at the sight of such a pure and epic spectacle of life, your heart is bound to swell with that uplifting feeling of being one with nature. A brief sense of moral outrage may pass through your mind at the recollection of those unscrupulous people who destroy the natural habitats and passageways of the valiant beasts for reasons no other than to plant more crops or graze more cattle. "How selfish we humans are," you muse. "Why can't we leave nature alone?" I, of course, have exactly the same reaction. But at the same time my entomophilous mind can't help but notice a strange disparity in our concern for one group of migratory organisms and a total disregard—a raging abhorrence in fact—for others.

Africa is a place where many animals move en masse in search of greener pastures, and the one that I find particularly interesting is a small, inconspicuous grasshopper known under the scientific name of *Locustana pardalina*. Solitary most of the time, every now and then millions of these insects will band together and, just like the grazing mammals we so admire and love to watch, march across the South African karoo to look for more grass. Wingless at first, they hop across parched terrain in huge reddish waves, but as soon as the animals pass their final molt and grow a pair of sturdy wings, the whole group takes up to the air.

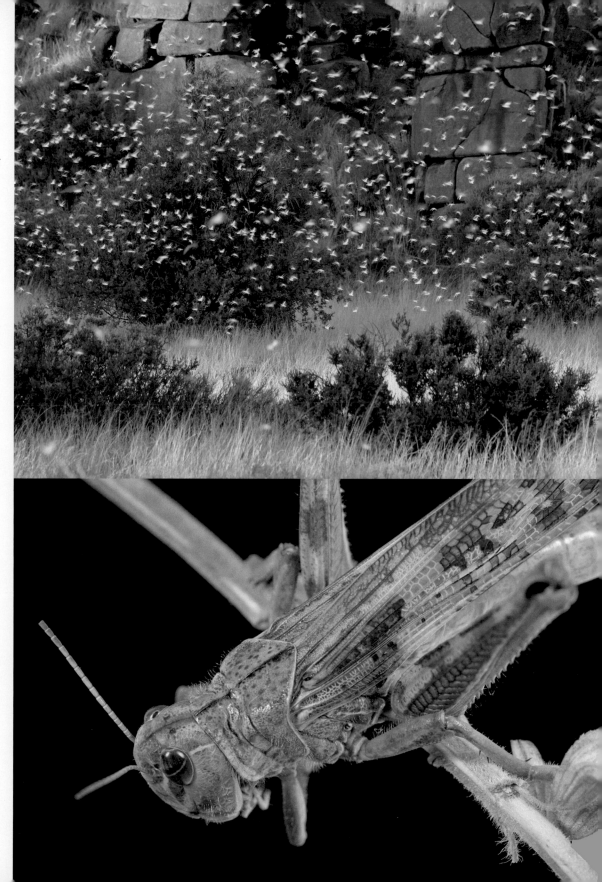

As they flew over my head against the cloudless sky the spectacle was truly breathtaking. The rustling of thousands of wings filled the air, and each animal took on an almost ethereal quality as the light of the sun filtered through their bodies. I saw this scene only twice in my life, and both times the sight felt to me as majestic as the celebrated migrations of the Serengeti plains. After a while the enormous cloud of insects disappeared over the horizon and probably found a good patch of greenery, where they landed and started to feed.

Clearly, I am not a South African farmer, and my description of the swarm of brown locusts is a departure from the traditional depiction of these insects, where words such as "devastation," "tragedy," and "hunger" are frequently evoked. There is no denying that brown locusts cause considerable damages to cereal crops, which to them are no different from grassy plains that used to exist there before the arrival of organized agriculture. The economic losses and human suffering that they cause clearly justify the efforts to control them, but some of the knee-jerk responses to locust swarms may do more harm than good. Broad-spectrum pesticides used to exterminate locusts kill not only the target species but also countless other organisms, such as pollinators or beneficial parasitoids that control outbreaks of other pests. To add to the problem, it is difficult to predict where and when the next outbreak will take place. There is some evidence of their correlation with the El Niño temperature oscillations of Southern Pacific surface waters, on their own difficult-to-predict events.

A lone quiver tree (*Aloe dichotoma*) stands on a hill against the very last rays of the setting sun, surrounded by low, succulent vegetation. Only now, after the air around it has cooled off and the risk of water loss is lower, will the plant open the stomata on its leaves to absorb the carbon dioxide that it needs to grow. This, and many other plants found in the Succulent Karoo, exhibits an interesting type of physiological adaptation to dry conditions, known as the crassulacean acid metabolism (CAM). Most plants around the world exhibit a different type of metabolism, known as the C_3 type, which absorbs carbon very efficiently, but at the same time requires intensive transpiration, leading to the loss of most of the water the plant absorbs from the soil. This works great in humid conditions where water is continually available, but in xeric habitats plants simply cannot afford to lose so much of the precious and scarce resource. CAM plants, such as quiver trees and most other succulents, are extremely good at retaining water, but pay for it by limiting the time during which they can absorb carbon, the main building block of their bodies. This is one of the reasons why plants of the Succulent Karoo grow very slowly. A quiver tree may take up to eighty years to reach its full size.

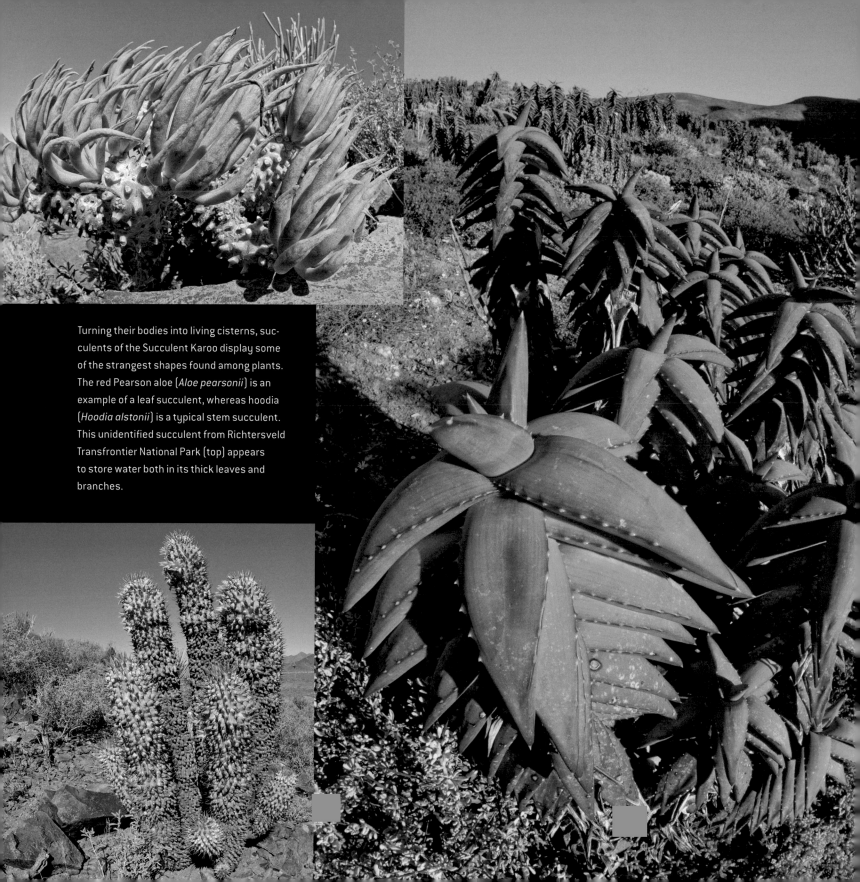

Turning their bodies into living cisterns, succulents of the Succulent Karoo display some of the strangest shapes found among plants. The red Pearson aloe (*Aloe pearsonii*) is an example of a leaf succulent, whereas hoodia (*Hoodia alstonii*) is a typical stem succulent. This unidentified succulent from Richtersveld Transfrontier National Park (top) appears to store water both in its thick leaves and branches.

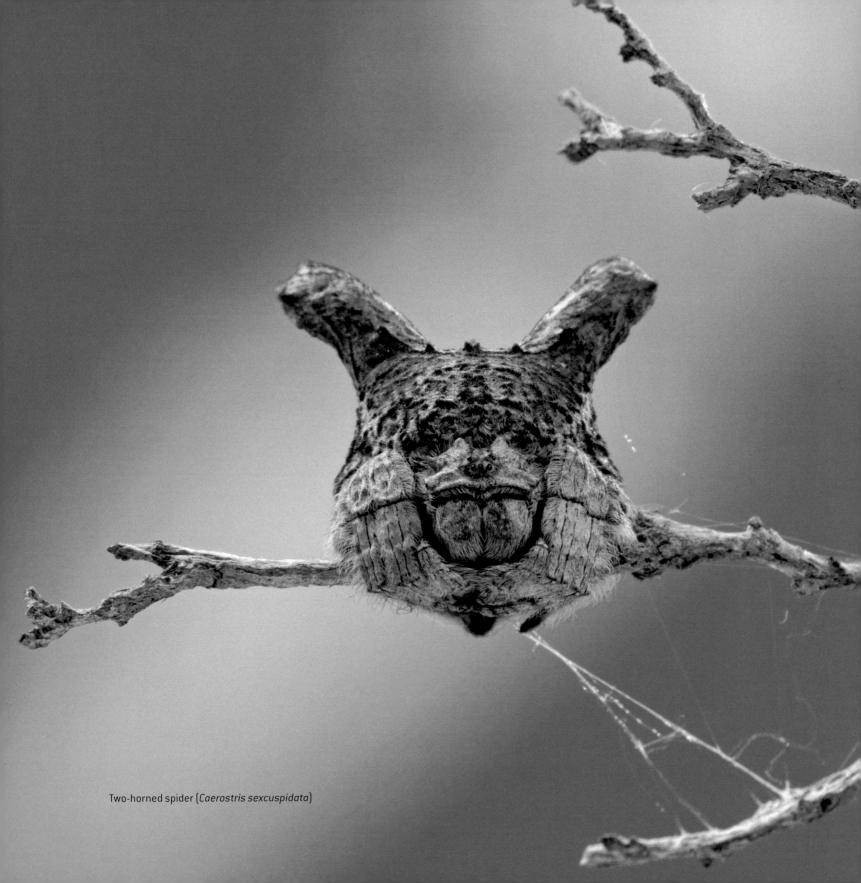

Two-horned spider (*Caerostris sexcuspidata*)

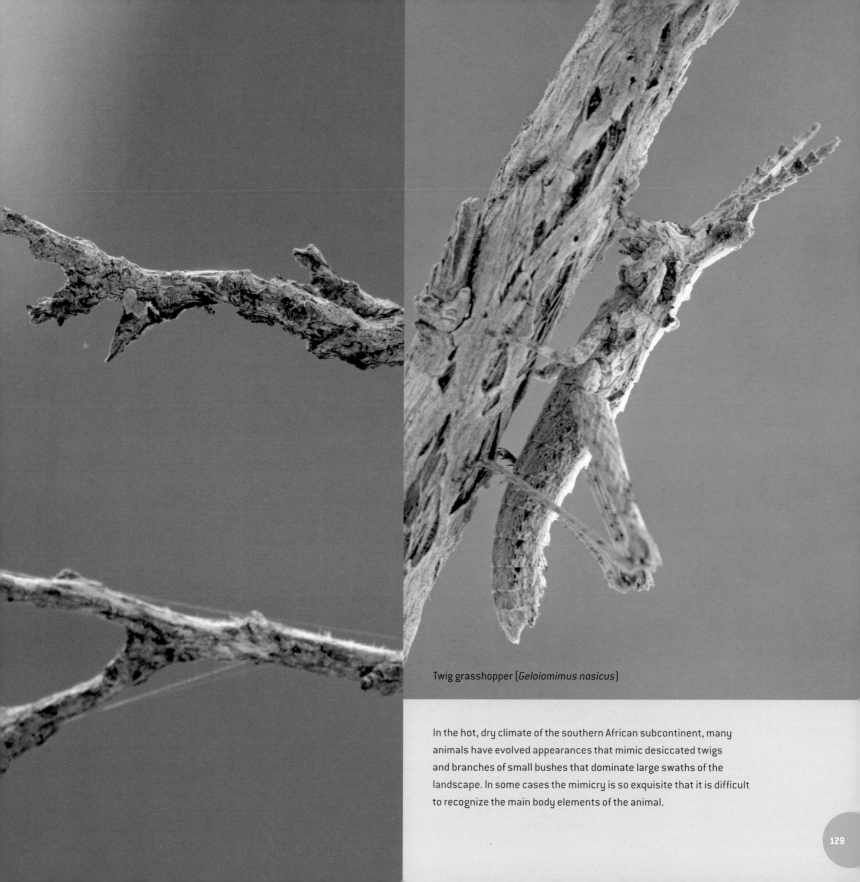

Twig grasshopper (*Geloiomimus nasicus*)

In the hot, dry climate of the southern African subcontinent, many animals have evolved appearances that mimic desiccated twigs and branches of small bushes that dominate large swaths of the landscape. In some cases the mimicry is so exquisite that it is difficult to recognize the main body elements of the animal.

129

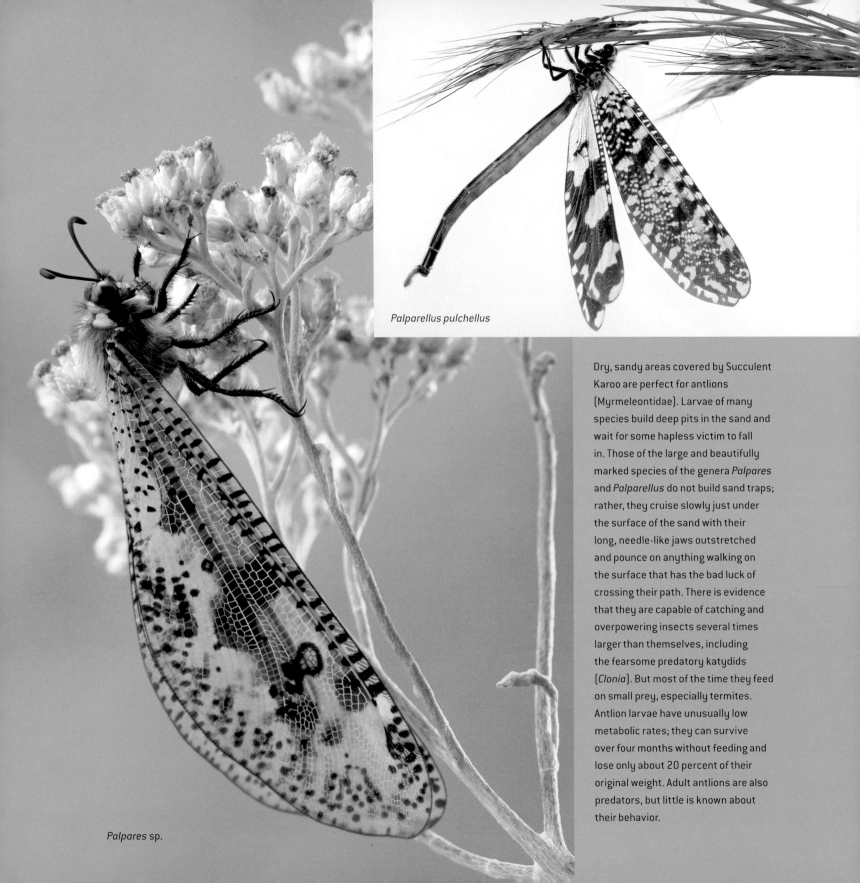

Palparellus pulchellus

Palpares sp.

Dry, sandy areas covered by Succulent Karoo are perfect for antlions (Myrmeleontidae). Larvae of many species build deep pits in the sand and wait for some hapless victim to fall in. Those of the large and beautifully marked species of the genera *Palpares* and *Palparellus* do not build sand traps; rather, they cruise slowly just under the surface of the sand with their long, needle-like jaws outstretched and pounce on anything walking on the surface that has the bad luck of crossing their path. There is evidence that they are capable of catching and overpowering insects several times larger than themselves, including the fearsome predatory katydids (*Clonia*). But most of the time they feed on small prey, especially termites. Antlion larvae have unusually low metabolic rates; they can survive over four months without feeding and lose only about 20 percent of their original weight. Adult antlions are also predators, but little is known about their behavior.

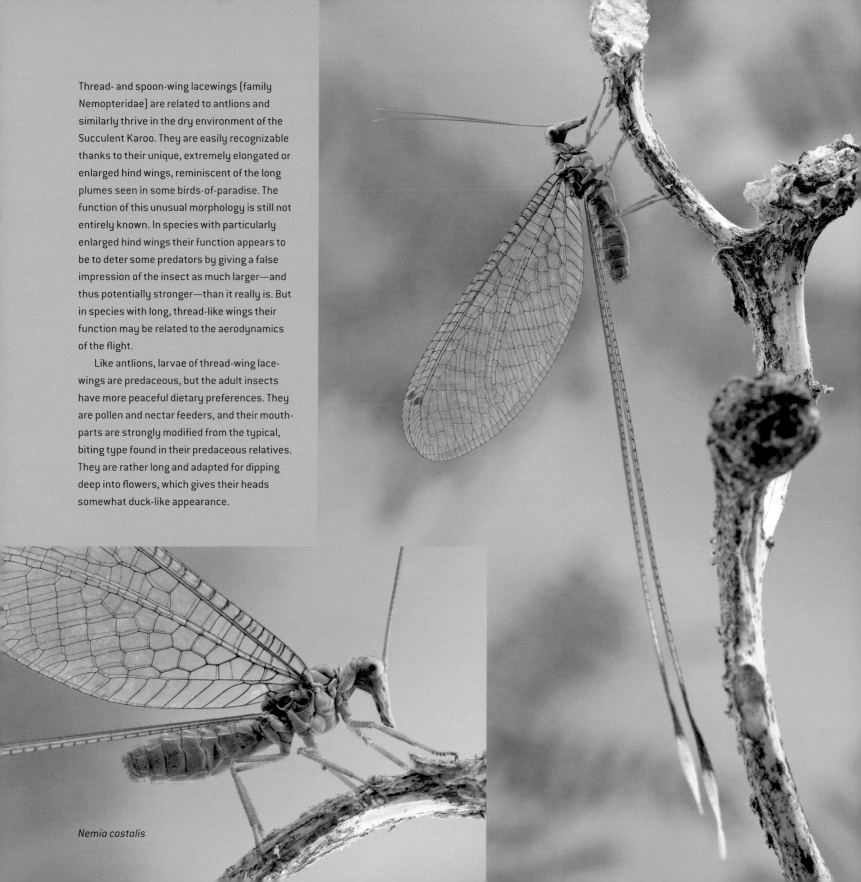

Thread- and spoon-wing lacewings (family Nemopteridae) are related to antlions and similarly thrive in the dry environment of the Succulent Karoo. They are easily recognizable thanks to their unique, extremely elongated or enlarged hind wings, reminiscent of the long plumes seen in some birds-of-paradise. The function of this unusual morphology is still not entirely known. In species with particularly enlarged hind wings their function appears to be to deter some predators by giving a false impression of the insect as much larger—and thus potentially stronger—than it really is. But in species with long, thread-like wings their function may be related to the aerodynamics of the flight.

Like antlions, larvae of thread-wing lacewings are predaceous, but the adult insects have more peaceful dietary preferences. They are pollen and nectar feeders, and their mouthparts are strongly modified from the typical, biting type found in their predaceous relatives. They are rather long and adapted for dipping deep into flowers, which gives their heads somewhat duck-like appearance.

Nemia costalis

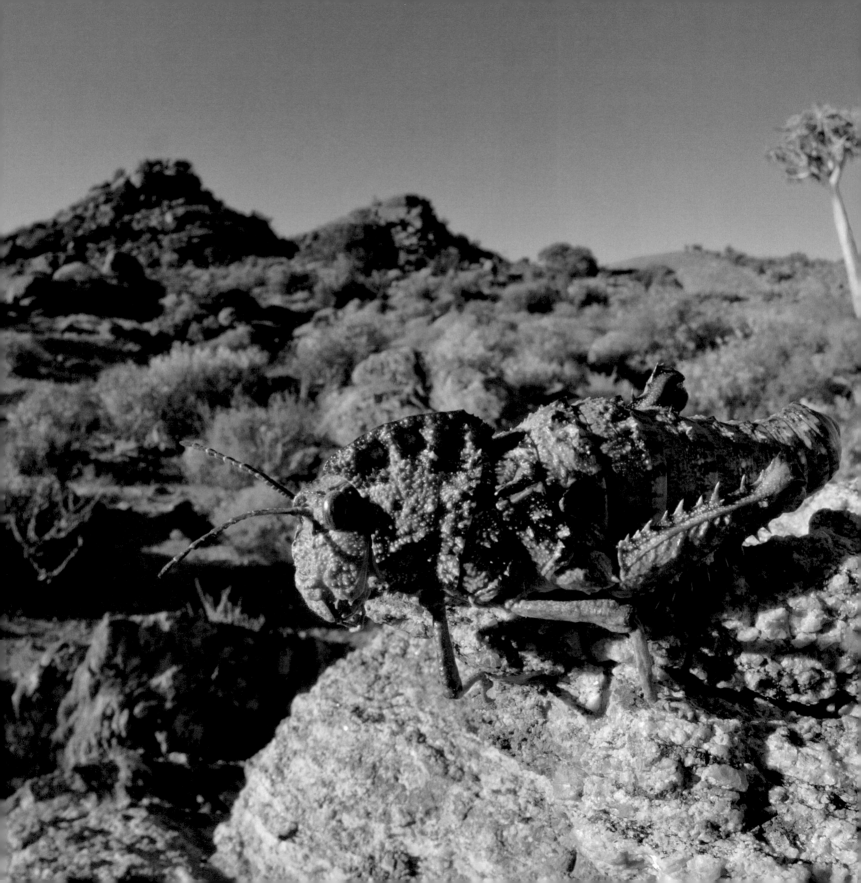

Following brief and stingy spring rains, the normally gray and dusty rock slopes of the Goegap Nature Reserve in the Northern Cape province of South Africa burst into a stunning palette of colors. Only about six inches of rain fall there every year, and plants cling to this precious commodity with all their might. Most have thick, spongy leaves or stems that accumulate as much water as physically possible. To protect it from evaporation, plants of the Succulent Karoo cover all exposed body parts with hairs, spines, or wax—anything to reduce evaporation. Even their stomata, tiny pores on leaves and the stem that allow the plant to breathe, are sunk deep into the tissue so that dry wind cannot suck any extra moisture out of them.

Insects of this unforgiving terrain face very similar challenges. Potentially lethal water loss is as much of a problem for them as it is for the plants, and many have evolved parallel solutions to this threat. A female karoo rockhopper (*Porthetis carinata*), an insect the size of a mouse, protects herself from desiccation with rock-hard, water-impermeable cuticle made of chitin. She can also shut tight her spiracles, small openings arranged in pairs on every segment of her body, which she uses to breathe (unlike mammals and many other vertebrates, insects do not use their mouths to breathe). She, like many other small animals in Goegap, will spend the hottest hours of the day hidden in the shade or partially buried in the sand. Around sunset she emerges to feed on plants, and her slow movements and remarkably rock-like appearance protect her from the sharp eyesight of birds and lizards.

Karoo rockhopper (*Porthetis carinata*)

133

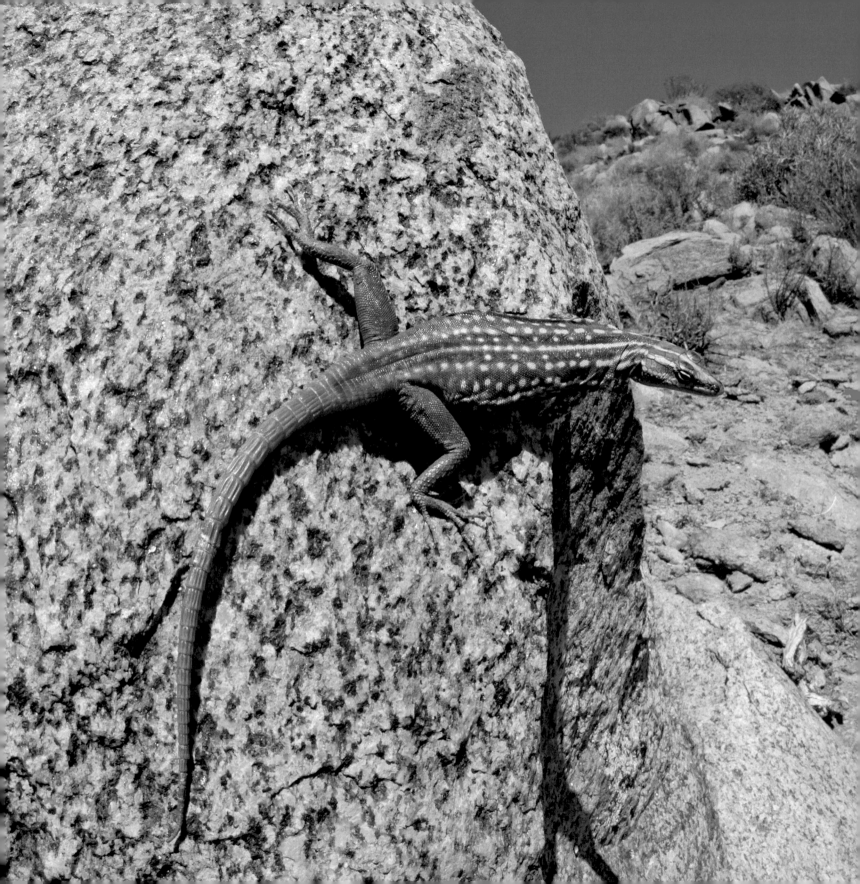

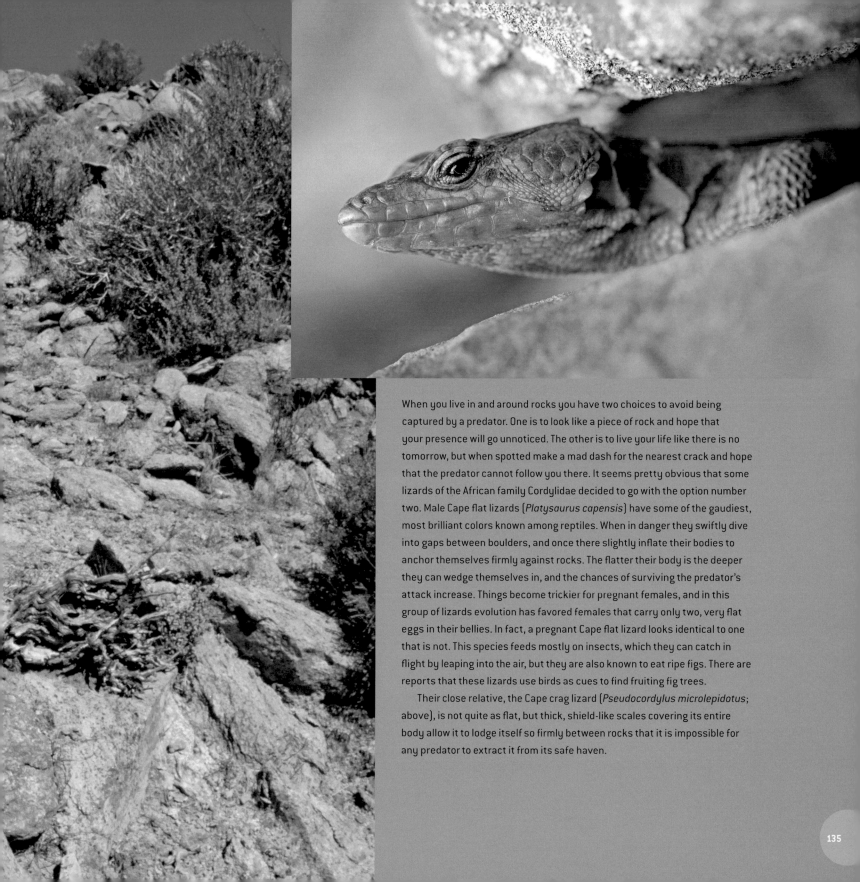

When you live in and around rocks you have two choices to avoid being captured by a predator. One is to look like a piece of rock and hope that your presence will go unnoticed. The other is to live your life like there is no tomorrow, but when spotted make a mad dash for the nearest crack and hope that the predator cannot follow you there. It seems pretty obvious that some lizards of the African family Cordylidae decided to go with the option number two. Male Cape flat lizards (*Platysaurus capensis*) have some of the gaudiest, most brilliant colors known among reptiles. When in danger they swiftly dive into gaps between boulders, and once there slightly inflate their bodies to anchor themselves firmly against rocks. The flatter their body is the deeper they can wedge themselves in, and the chances of surviving the predator's attack increase. Things become trickier for pregnant females, and in this group of lizards evolution has favored females that carry only two, very flat eggs in their bellies. In fact, a pregnant Cape flat lizard looks identical to one that is not. This species feeds mostly on insects, which they can catch in flight by leaping into the air, but they are also known to eat ripe figs. There are reports that these lizards use birds as cues to find fruiting fig trees.

Their close relative, the Cape crag lizard (*Pseudocordylus microlepidotus*; above), is not quite as flat, but thick, shield-like scales covering its entire body allow it to lodge itself so firmly between rocks that it is impossible for any predator to extract it from its safe haven.

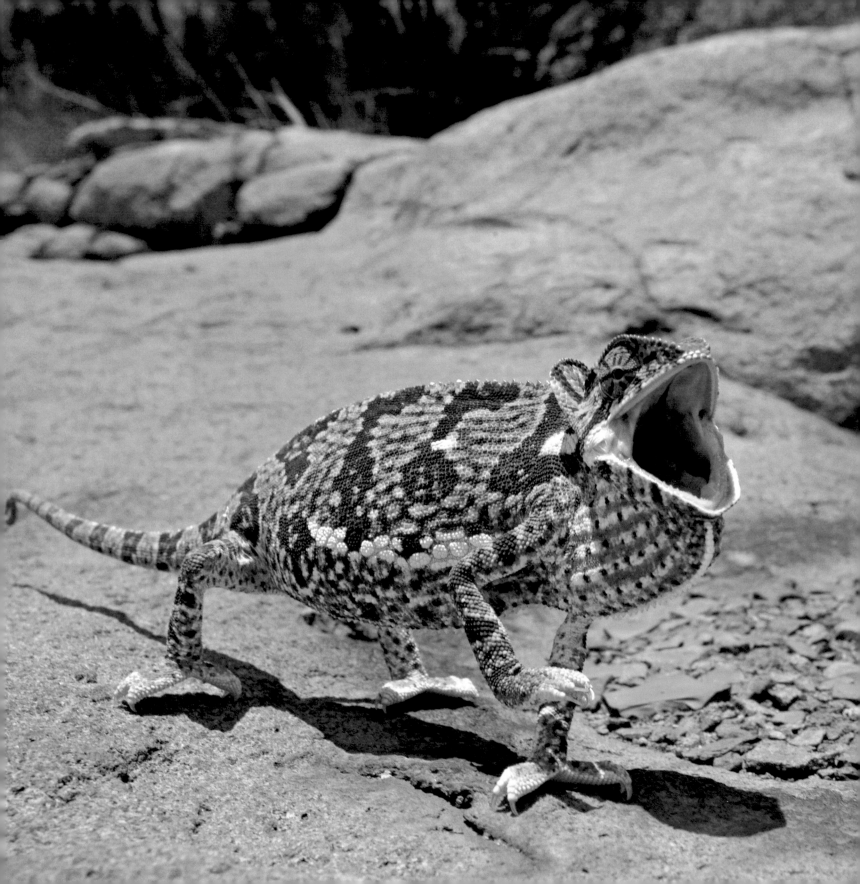

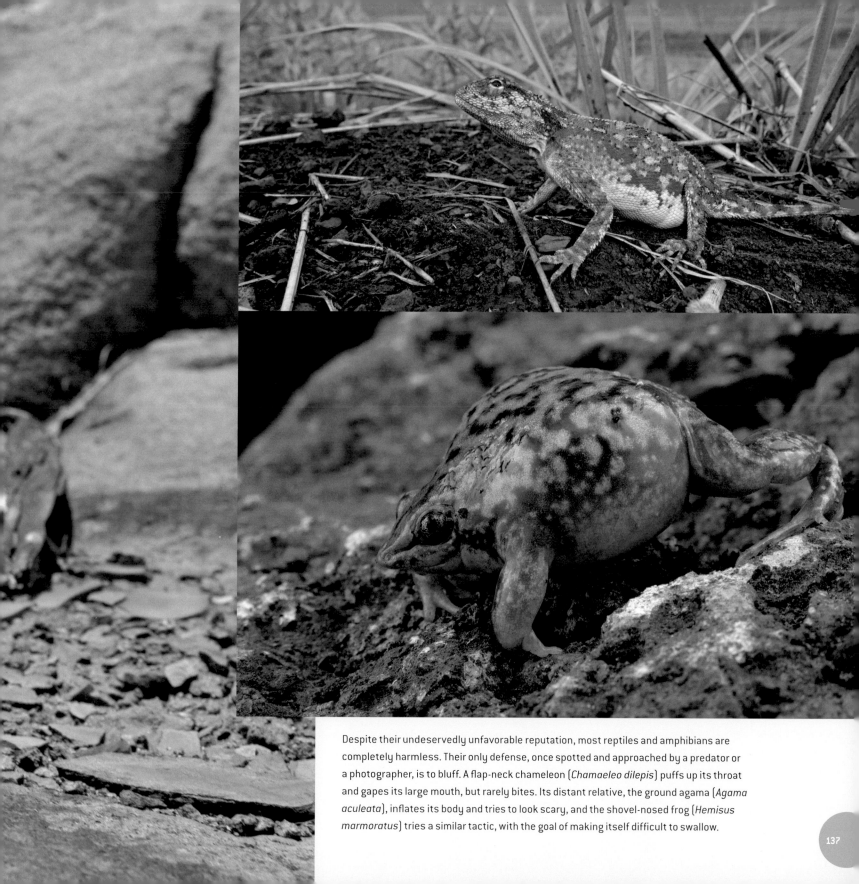

Despite their undeservedly unfavorable reputation, most reptiles and amphibians are completely harmless. Their only defense, once spotted and approached by a predator or a photographer, is to bluff. A flap-neck chameleon (*Chamaeleo dilepis*) puffs up its throat and gapes its large mouth, but rarely bites. Its distant relative, the ground agama (*Agama aculeata*), inflates its body and tries to look scary, and the shovel-nosed frog (*Hemisus marmoratus*) tries a similar tactic, with the goal of making itself difficult to swallow.

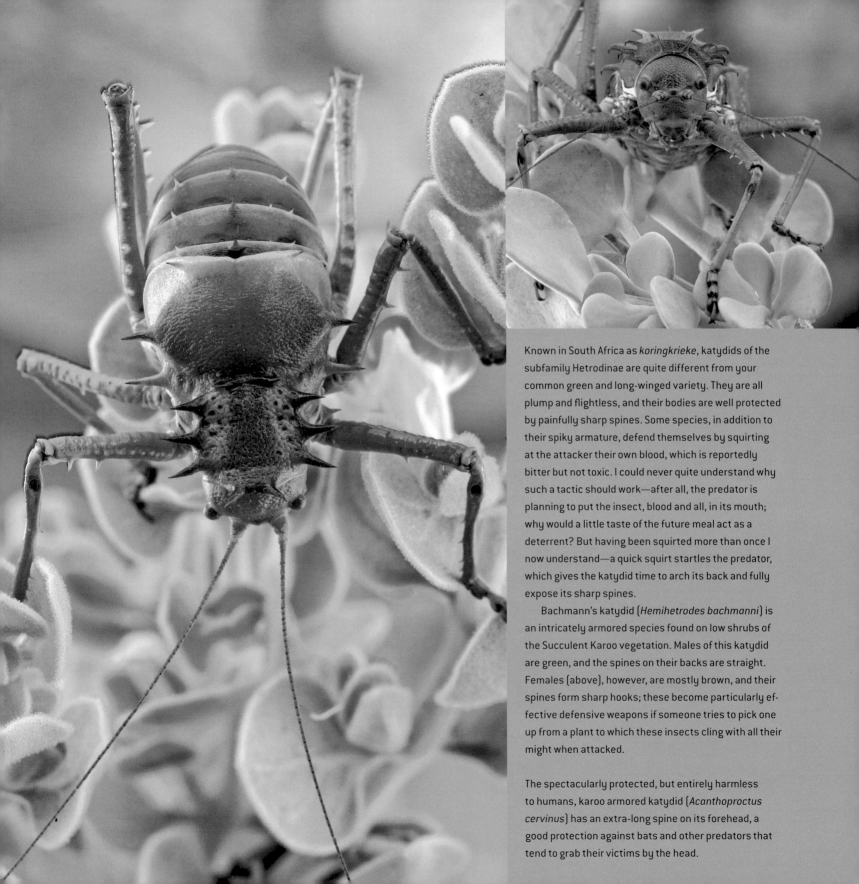

Known in South Africa as *koringkrieke*, katydids of the subfamily Hetrodinae are quite different from your common green and long-winged variety. They are all plump and flightless, and their bodies are well protected by painfully sharp spines. Some species, in addition to their spiky armature, defend themselves by squirting at the attacker their own blood, which is reportedly bitter but not toxic. I could never quite understand why such a tactic should work—after all, the predator is planning to put the insect, blood and all, in its mouth; why would a little taste of the future meal act as a deterrent? But having been squirted more than once I now understand—a quick squirt startles the predator, which gives the katydid time to arch its back and fully expose its sharp spines.

Bachmann's katydid (*Hemihetrodes bachmanni*) is an intricately armored species found on low shrubs of the Succulent Karoo vegetation. Males of this katydid are green, and the spines on their backs are straight. Females (above), however, are mostly brown, and their spines form sharp hooks; these become particularly effective defensive weapons if someone tries to pick one up from a plant to which these insects cling with all their might when attacked.

The spectacularly protected, but entirely harmless to humans, karoo armored katydid (*Acanthoproctus cervinus*) has an extra-long spine on its forehead, a good protection against bats and other predators that tend to grab their victims by the head.

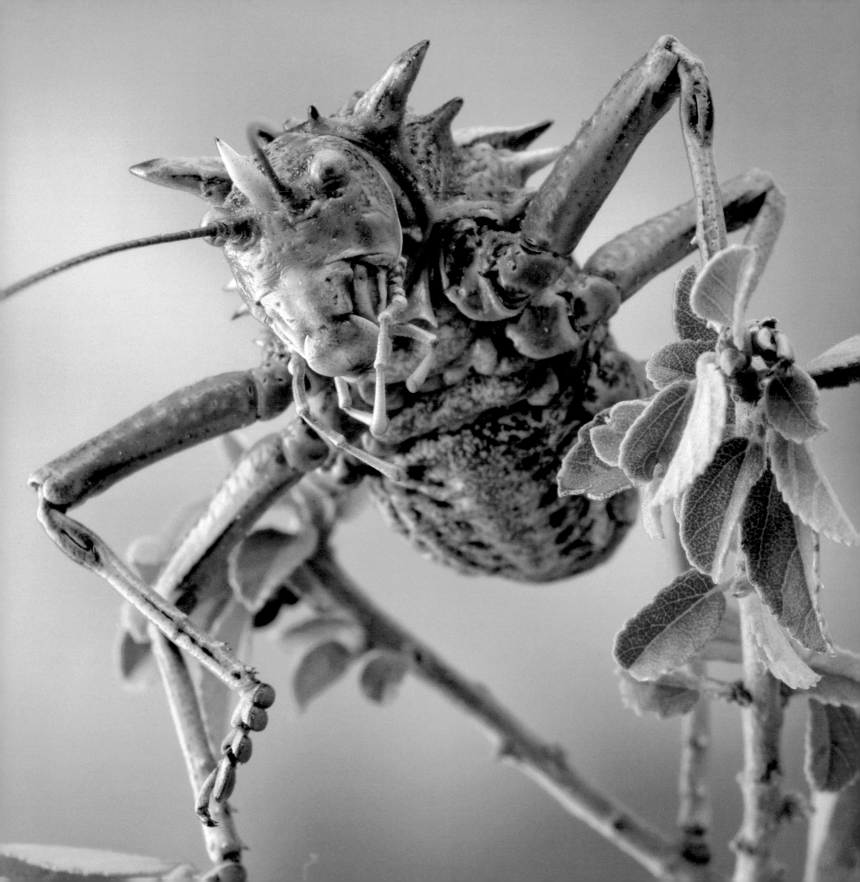

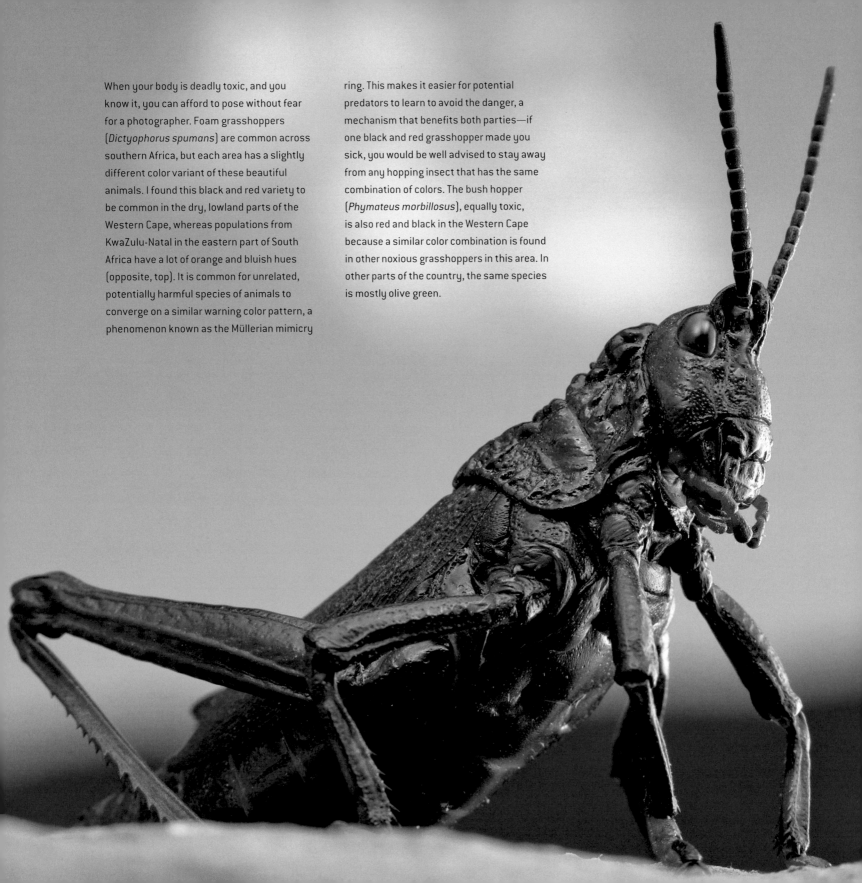

When your body is deadly toxic, and you know it, you can afford to pose without fear for a photographer. Foam grasshoppers (*Dictyophorus spumans*) are common across southern Africa, but each area has a slightly different color variant of these beautiful animals. I found this black and red variety to be common in the dry, lowland parts of the Western Cape, whereas populations from KwaZulu-Natal in the eastern part of South Africa have a lot of orange and bluish hues (opposite, top). It is common for unrelated, potentially harmful species of animals to converge on a similar warning color pattern, a phenomenon known as the Müllerian mimicry ring. This makes it easier for potential predators to learn to avoid the danger, a mechanism that benefits both parties—if one black and red grasshopper made you sick, you would be well advised to stay away from any hopping insect that has the same combination of colors. The bush hopper (*Phymateus morbillosus*), equally toxic, is also red and black in the Western Cape because a similar color combination is found in other noxious grasshoppers in this area. In other parts of the country, the same species is mostly olive green.

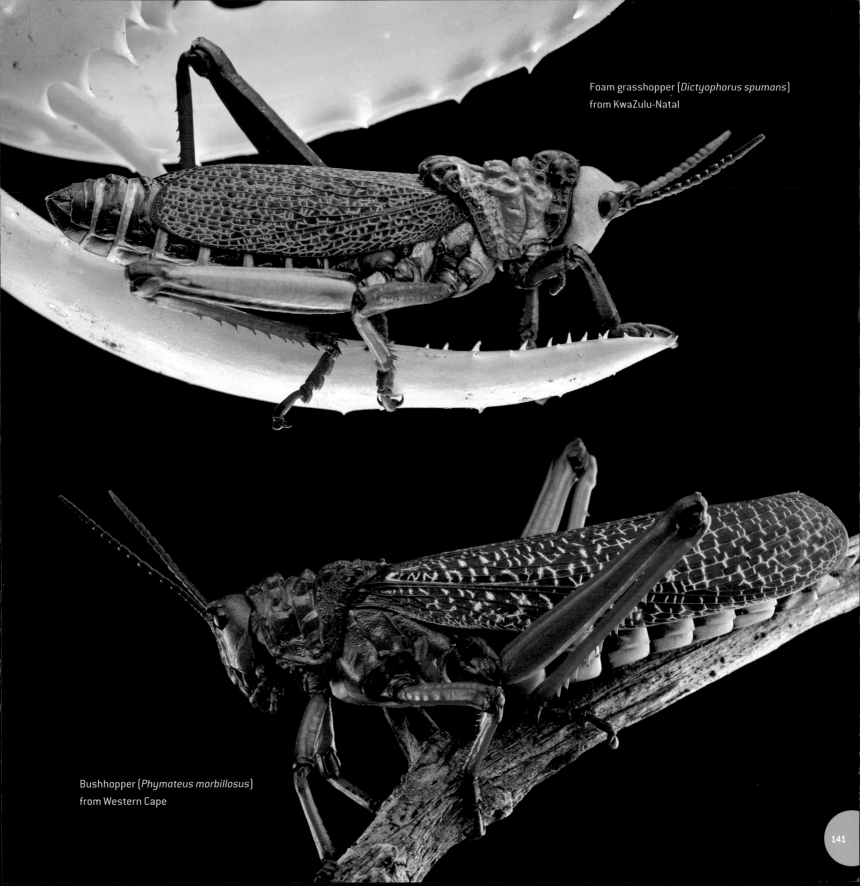

Foam grasshopper (*Dictyophorus spumans*) from KwaZulu-Natal

Bushhopper (*Phymateus morbillosus*) from Western Cape

141

Most insects in southern Africa are completely harmless. Having no toxic compounds in their bodies or sharp teeth or stingers, their best defense is to disappear completely from the view of potential predators, and nobody does it better than the toad hoppers (*Batrachornis perloides*). Common in sandy, open areas of the Succulent Karoo, they blend into their surroundings so perfectly that only after I took the photo shown above did I realize that I had photographed not one, but two individuals (the smaller one is a male courting the larger female).

But even the best disguises sometimes fail. As I was photographing grasshoppers on the plains of the Goegap Nature Reserve, I noticed a Fiscal Shrike (*Lanius collaris*) watching me intently from a nearby bush. The moment I stepped away from my camera, she swooped in and stole the insect I had just photographed. Next time this happened I was ready, and I captured the moment of the kill. She then flew into the bush where her young fledgling received a nice meal from its mother.

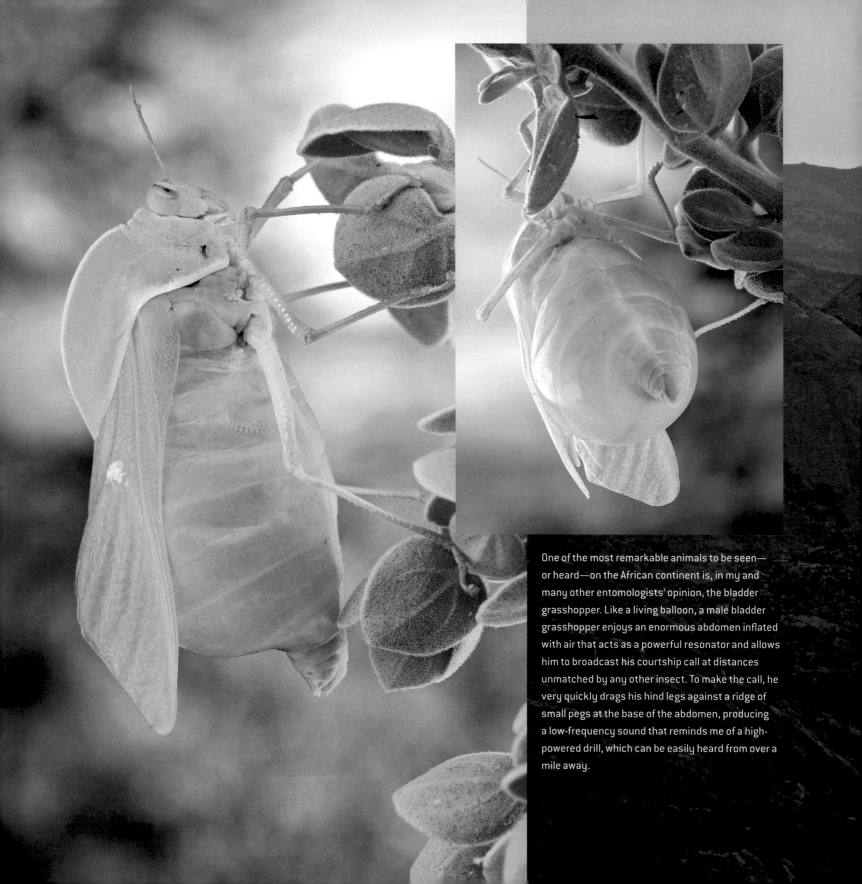

One of the most remarkable animals to be seen—
or heard—on the African continent is, in my and
many other entomologists' opinion, the bladder
grasshopper. Like a living balloon, a male bladder
grasshopper enjoys an enormous abdomen inflated
with air that acts as a powerful resonator and allows
him to broadcast his courtship call at distances
unmatched by any other insect. To make the call, he
very quickly drags his hind legs against a ridge of
small pegs at the base of the abdomen, producing
a low-frequency sound that reminds me of a high-
powered drill, which can be easily heard from over a
mile away.

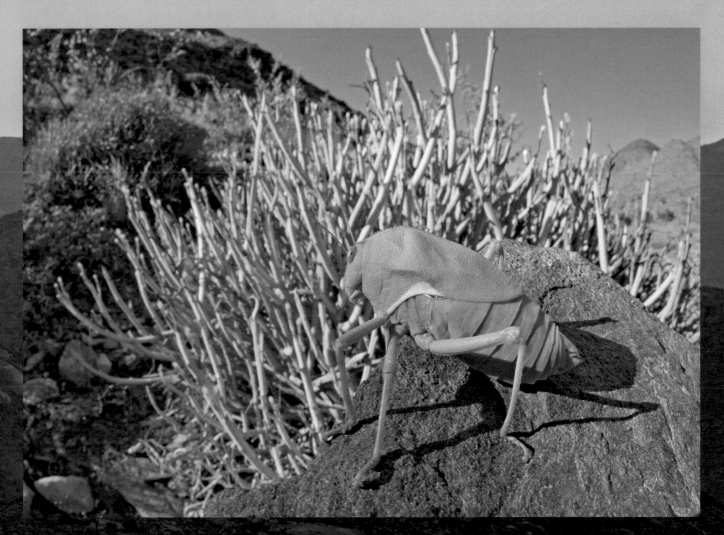

A female bladder grasshopper (*Bullacris* sp.) has tiny wings hidden almost entirely under her shield-like pronotum. Their only function is to produce short clicks in response to the male's call.

Bladder grasshoppers (family Pneumoridae) are found mainly in southern Africa, and only seventeen species are currently recognized. But this small group of animals has received a lot of attention from biologists interested in the evolution of hearing and courtship tactics. It turns out that these grasshoppers have the most sensitive ears among all insects, which at the same time are amazingly unsophisticated, consisting of small bunches of sensory cells attached directly to the walls of the abdomen. But for what they lack in sophistication they make up in number—each animal has twelve separate, simple ears. Females can hear the male's call from a distance of over two kilometers, although the male starts hearing the female's very subdued response when she is only about fifty meters away (which is still

quite remarkable). What follows is a session of back-and-forth chirps between the male and female, which allows the male to find his partners. But because the chubby and defenseless singing male can be as easily located by a predator as by the female, some males resort to cheating. Rather than spending the energy on calling themselves, they wait quietly near a singing male and intercept the female before she can meet the true singer. To avoid being chased away by the singer, these so-called satellite males adopt the appearance of females, lacking both the wings and the conspicuously inflated abdomen of other males. Such "bait-and-switch" sexual parasitism is also known in other singing insects, such as crickets.

The Rain
Queen's
Garden

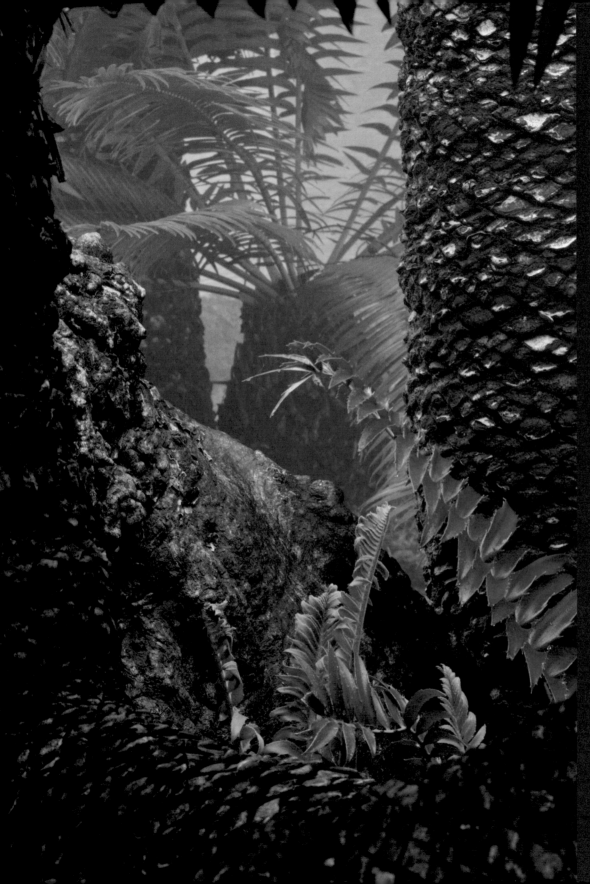

Few places on Earth have a more mystical, ancient atmosphere than the thick stands of the Modjadji cycad (*Encephalartos transvenosus*) in the Limpopo province of South Africa. This species is the largest cycad on the African continent, reaching heights of thirteen meters. Between ten thousand and fifteen thousand of these giant plants make up the world's last surviving cycad forest, and most individuals are thought to be many hundreds of years old.

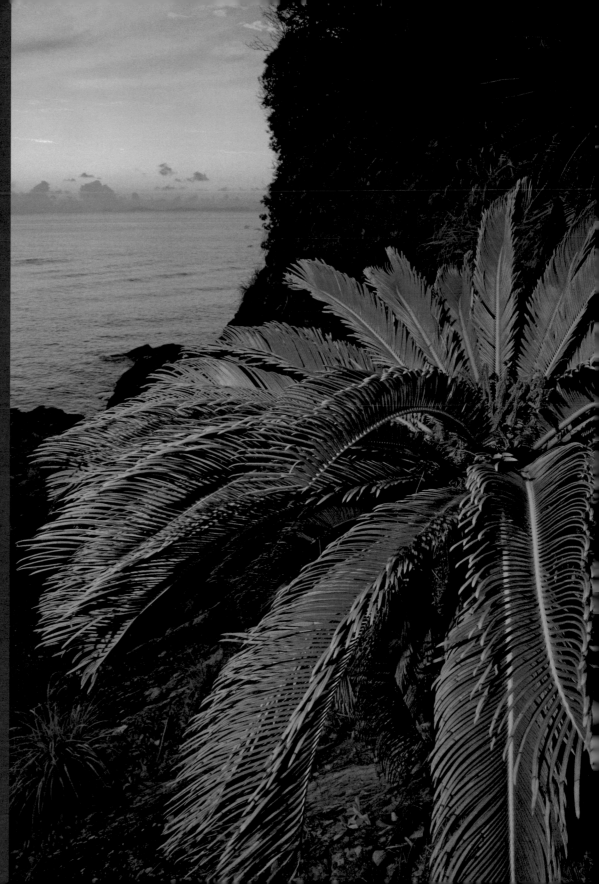

A lone cycad (*Cycas revoluta*) clings to a rock on the northern tip of Japan's island of Okinawa. The island has the largest natural population of these beautiful plants, now common in gardens and greenhouses around the world. The genus *Cycas* is probably the most primitive (basal) of all living cycads and bears many characteristics similar to its extinct relatives, seed ferns of the Paleozoic.

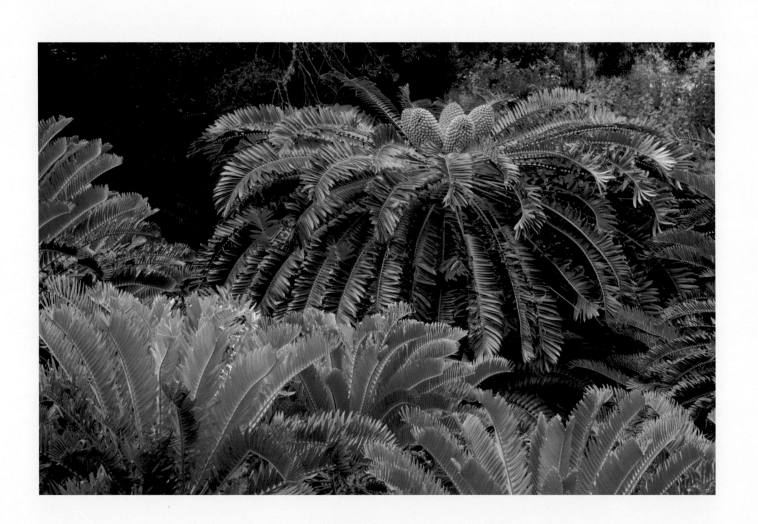

The sprawling town of Kgapane in what is now the eastern part of the Limpopo province of South Africa presents a rather depressing sight. Like many other rural parts of this country, decades of brutal apartheid suppressed its development, and now unemployment is soaring and AIDS ravages the population. The road we traveled was muddy, and I had a feeling that sooner or later our tiny rental car would get stuck forever in some bottomless pothole. We stopped at a gas station to ask for directions and get some supplies. My friends Boni and Corey acted as Zulu and Afrikaans translators, while I tried to get some information using the international language of arm waving and pointing. Luckily, we ran into a guy who knew the place we were looking for. After a surly shopkeeper, separated from us by thick metal bars, reluctantly sold us some bread and canned vegetables, we hit the road with our new guide. Although it seemed impossible at first, the road deteriorated even further, and I quickly discovered that the only way to proceed was to close my eyes, slam the gas, and hope that once I opened them again we still be on the road. Judging from the superficial appearance of towns and roads in this area, one would be forgiven for thinking that we were in some backwater of Limpopo of no particular significance. But in fact we were entering a kingdom, one of the oldest—and most respected—on the African continent.

The Modjadji queen has ruled the Balobedu people of this region for several centuries. She came a few hundred years ago from the Great Zimbabwe, a daughter of the Monomatapa ruler, leaving her land up north to establish a new kingdom in the Molotsi Valley on the northernmost slopes of the Drakensberg Mountains. As a parting gift from her father she was given the power to make rain, a valuable gift indeed in the scorching land of southern Africa. Ever since, the matriarchal monarchy of the immortal Rain Queen (subsequent queens were simply reincarnations of the old one) has ruled the land peacefully, respected by both the likes of Shaka Zulu and Nelson Mandela. The last Rain Queen, Makobo Modjadji, died in 2005 (officially of meningitis, unofficially of broken heart after being denied marriage to her lover, a commoner). Since then the kingdom has had no queen, because the elders still refuse to anoint Makobo's daughter, spawned by a common man and not a member of the royal clan. But when the queen lived, her ability to make rain was undeniable— a highly secretive rainmaking ceremony led by the queen never failed to produce local November downpours, even if the rest of the country was parched. It is probably just a coincidence that the Modjadji kingdom lies in a meteorological oasis, a mountain valley just high enough to catch moist winds off the Indian Ocean and conveniently faces west to intercept the water they carry as they blow inland. Regardless, Modjadji is a humid, subtropical place that shelters a breathtaking botanical phenomenon—the world's last and only natural cycad forest—and I was dying (or just about to, considering the road and the way I was driving) to see it.

We finally reached the Modjadji Forest, the queen's sacred garden (which is a protected reserve), and managed to secure a place to spend a couple of nights. I was instantly impressed, not only by the forest itself but by the straightforward, honest attitude of its keepers, who balked at the very hint of impropriety, say, of letting us stay an extra night if we pay but don't ask for a receipt, the accepted way of conducting business in many parts of the country.

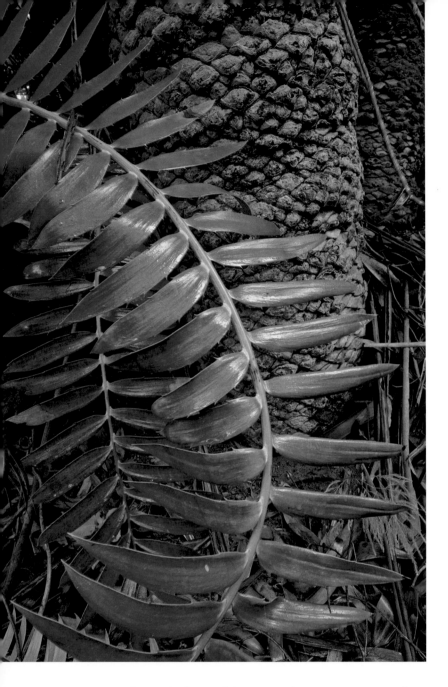

may appear no different from your average palm tree: an adult plant has a thick trunk crowned with an umbrella of giant, frond-like leaves. Like palms, individual leaves can be huge, sometimes seven meters long. But cycads are about as close to palm trees as a *Tyrannosaurus rex* is to a cow. They are the oldest seed-bearing plants, having their roots firmly planted in the Paleozoic, over two hundred and fifty million years ago. They are gymnosperms; unlike flowering plants where the female gametes are safely enclosed in ovaries, cycad ovules develop fully exposed on the surface of specially modified leaves, megasporophylls. Similar to conifers, their distant and equally old relatives, cycads develop pollen- and seed-bearing cones. All cycads are dioecious—each plant is either a male or a female, and the cones they develop are of one sex only. And some cones they are. In a few species, a single cone can weigh over forty kilograms, and in many they can be nearly a meter long. Cycad cones are often spectacularly colorful—bright yellow, orange, or green—and the seeds they bear are similarly striking.

Later that day we climbed the hill in the center of the Modjadji reserve, where some of the largest and oldest individuals were growing. On a good day you can see Kruger National Park from there, but most of the time dense fog obscures the view. Feeling slightly lightheaded, as I often do when the naturalist in me finally fulfills his wildest fantasies, I ran my hand down a dark trunk of a massive Modjadji cycad. It felt almost like caressing the leg of a giant sauropod. There is something reptilian about the appearance of the cycad trunk, which does not have a typical bark but is covered with overlapping scales, remnants of old leaf petioles and special protective leaves, the cataphylls. These scales, which can be very thick and hard, are the main reinforcement of the cycad's stem. It does not contain many woody elements, and is filled mostly with starchy tissue known as parenchyma. Even the thickest cycad stems can be cut with one, powerful swing of a machete, a fact not lost on people living in areas where cycads grow, or used to.

The Modjadji cycad forest is truly an awe-inspiring place. It is estimated that it contains between ten thousand and fifteen thousand fully grown Modjadji cycads (*Encephalartos transvenosus*), with some individuals reaching the astounding height of thirteen meters. At first sight a cycad

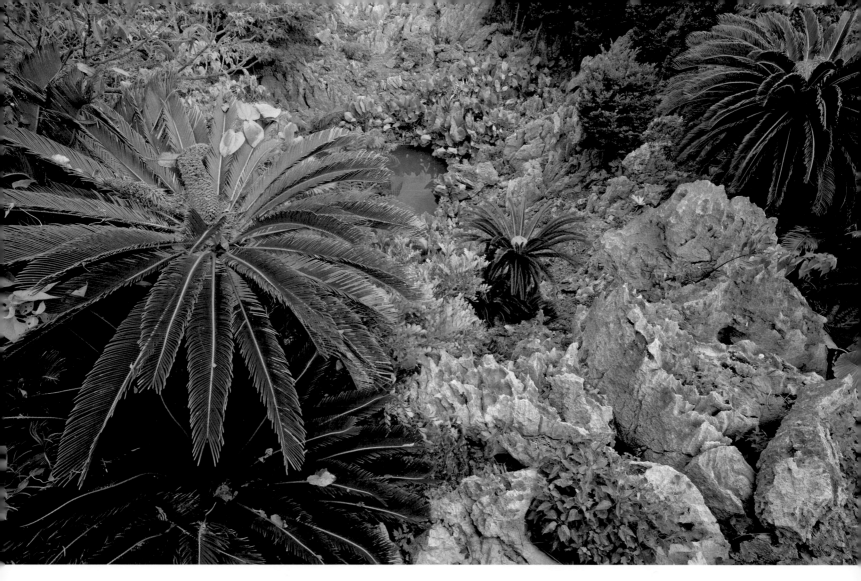

The limestone karsts of Okinawa, ragged rock formations created by the dissolution of some of its layers, provide an ideal habitat for cycads (*Cycas revoluta*). Thanks to their mutualistic relationship with cyanobacteria, cycads are able to use atmospheric nitrogen, which makes them capable of growing on nearly sterile substrates, such as these rocky outcrops. The individual on the left is a male, his pollen-bearing cone already past its prime.

A tall, thick cycad, like the ones growing at Modjadji, can be hundreds of years old; some believe that certain individuals are over a thousand years old. But assessing the precise age of a cycad is a tricky job, as they do not exhibit the annual growth rings in their trunks, typical of familiar trees of seasonal forests. Counting scales on the stem will give you an approximation of the plant's age, but some species go through phases of slowed or accelerated growth, confusing the pattern. But there is no denying that cycads grow very slowly, and it is safe to assume that a plant a meter tall may easily be a century old. The task is even more difficult in species with subterranean trunks. Such species have a unique shrinking

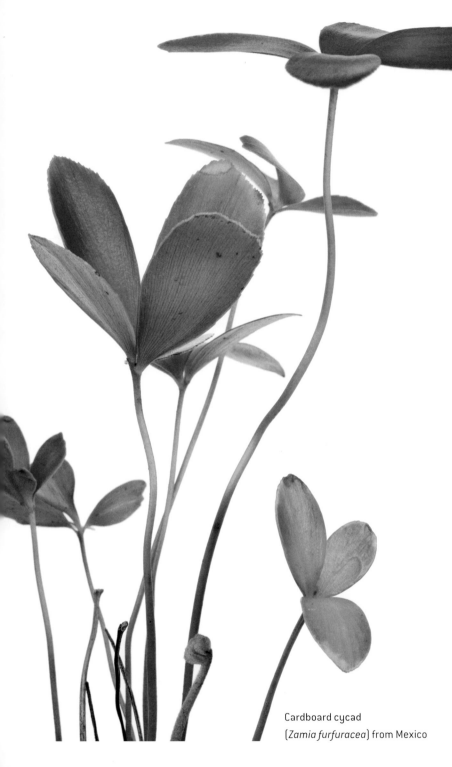

Cardboard cycad
(*Zamia furfuracea*) from Mexico

stem that actually pulls the plant underground as it grows. Even individual leaves of a cycad can last a very long time, two to ten years on average, before being replaced, all at once, by a new "flush" of foliage. It seems that everything in cycads is slow and durable, and their reproduction is no different.

The reproductive cycle starts with the production of giant pollen-bearing cones on male individuals and ovule-bearing ones on females. That is, it starts about thirty years after sprouting from the seed (few species reach sexual maturity in less than ten years). The only exception is the primitive, mostly Southeast Asian genus *Cycas*, in which only the males produce well-defined cones. Females in these plants bear their ovules on loosely aggregated pseudocones, a strong evidence of their close relationship to the long-extinct seed ferns.

The amount of pollen produced by a single male cone is a staggering 500 cubic centimeters or more. In most plants pollination equals insemination. But such haste does not suit cycads. It takes 3 to 7 months before the pollen germinates on the female sporophyll and produces male reproductive cells, the gametes. Cycad gametes are very different from the gametes of other flowering plants—more like those of animals. Known as spermatozoids, each gamete is an individual, microscopic organism propelled by an array of hairs (flagella) that must actively swim its way to a female egg.

For the longest time botanists were convinced that cycads, like conifers, were wind pollinated. That would explain the huge amounts of pollen and the lack of typical insect pollinators, such as bees, butterflies, and moths, buzzing around the cones. And yet it appears now that the old dogma was wrong. New studies on almost every cycad species bring to light exquisite and intricate codependent relationships between cycads and insects. In most known cases, the pollination involves a unique species of a beetle for each species of cycad. It is usually a small weevil, such as the *Rhopalotria mollis*, which pollinates the Mexican cycad *Zamia furfuracea*. Larvae of these beetles develop inside the

male cones, feeding on rich starch deposits (and each other), but they carefully avoid eating the pollen. After emerging from the pupa, the young beetles must squeeze out of the cone through a thick layer of pollen, getting nicely covered with it in the process. The beetles then fly to the female cones, which emit odors chemically quite similar to those that attract bees to orchids, and the pollination takes place.

The Australian cycad *Macrozamia lucida* has evolved an even more sophisticated way of ensuring the production of its progeny: it actively manipulates the behavior of its pollinators. Small insects known as thrips (*Cycadothrips chadwicki*) feed on the pollen of this cycad and are attracted to mature male cones by a couple of very fragrant, volatile compounds produced by the plant once the pollen is ready to be dispersed. This ensures that the pollen is picked up. But now the plant must convince the insects to carry it to the female cone. In a remarkable display of physiological ingenuity, the cycad cones start to heat up. Soon, the cones are positively hot, and like a guy wearing too much aftershave, the once-attractive odors begin to suffocate the insect visitors, forcing them to leave. After a few hours the cones begin to cool off. Female cones, having lower levels of the volatile chemicals than the male plants, reach the reasonable, attractive level of fragrances sooner, and thrips flock to them, squeezing their pollen-covered bodies inside. But the insects, realizing their mistake (there is no nutritious pollen in the female cones), quickly leave for the cool and once-again alluring male cones. The next morning this process, aptly named "push-pull pollination," repeats itself.

The relationship between cycads and their pollinators is a very tight one, and one cannot exist without the other. There is some evidence that these two groups have been co-evolving for at least two hundred million years, although the current species-level relationships between the plants and their pollinators are probably relatively young.

All in all, cycads appear to be really good at forging lasting partnerships. One very important group of organisms

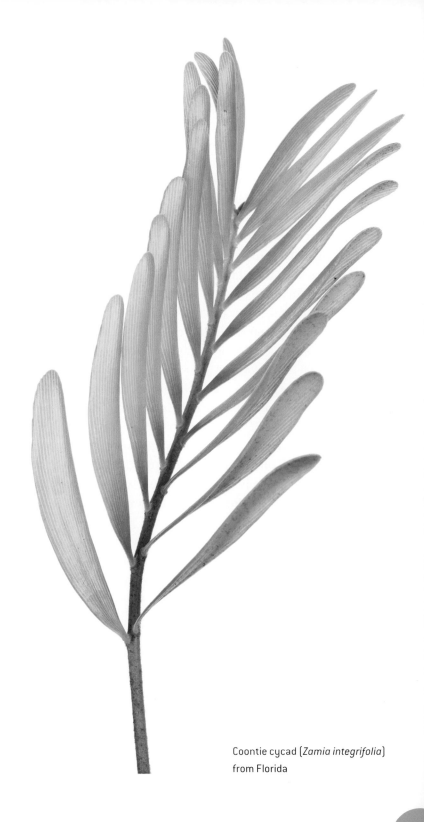

Coontie cycad (*Zamia integrifolia*)
from Florida

that cycads managed to engage in a mutualistic symbiosis is the cyanobacteria, also known as blue-green algae. This symbiotic relationship probably holds the key to cycads' survival over three unimaginably long eras of Earth's history, as well as their individual longevity and the ability to survive in the most inhospitable environments of the planet.

Cycads, like most plants, anchor themselves in the ground with roots. But many cycads don't really need soil, and some species are capable of grooving on virtually bare rock. Their roots can be quite extensive, and it is not rare to see them traveling many meters across nearly sterile, stony terrain before they can reach a pocket of livable earth, from which some water and necessary nutrients may be obtained. One of the nutrients they need—as do all living things—is nitrogen. While Earth's atmosphere is composed mostly of this element (over 78 percent of it, actually), free atmospheric nitrogen appears to be rather difficult to intercept and incorporate into the bodies of living organisms. No animal has ever managed this feat, and very few plants have, and then, only thanks to cyanobacteria. They are the only living things that can convert atmospheric nitrogen into more complex and more easily metabolically available molecules, and any group of plants that managed to get into a symbiotic relationship with cyanobacteria is virtually guaranteed an evolutionary success. Cycads were some of the lucky ones. In addition to the typical roots that keep the plant from flying off when a gust of wind hits it, cycads have special roots, called the coralloid roots, that host cyanobacteria. They are strange, not only because of their bulbous shape but mostly because of their desire to grow up, toward the surface of the soil, where the cyanobacteria can get a glimpse of the sun they still occasionally need. In exchange for the protective housing within the specialized roots, cyanobacteria capture and feed nitrogen into the cycads' tissues, assuring the plant's survival even in the most nutrient-poor habitats.

The ability to fix atmospheric nitrogen definitely helps, but cycads are survivors in more ways than just this one.

Their stem, filled with nutritious carbohydrates, allows them to endure in complete darkness, stripped of leaves and roots, for many years. Even a small fragment of the stem can sprout new leaves and roots if planted, and their thick, scaly stem is quite resistant to fire. Cycads are also very tolerant of salt, and some grow alongside mangrove plants (*Rhizophora*) in coastal swamps. In the nineteenth century, as keeping exotic plants in European gardens and greenhouses became popular, demand for large cycad specimens resulted in many of these plants being brought in from Africa and other places. In order to maintain fresh appearance of their leaves during an oceanic voyage from their native lands, often lasting several weeks, entire plants were dragged behind the ship. And yet upon being planted, they grew vigorously.

Cycads are also quite resistant to injuries and, if wounded, quickly release resin-like mucilage that seals the wounds and helps with the healing process. But probably the best proof that cycads are tougher than most plants is the fact that I, a person who can kill a potted plant by just looking at it, have managed to grow wonderful specimens of cycads in my home near Boston.

The first cycad species was formally described by the father of taxonomy, Carolus Linnaeus, in 1753, who coined the name *Cycas*, after the Greek word *koikas*, a kind of palm tree often used to make bread. We now know, of course, that cycads have nothing in common with palms, but the misnomer persists, even in the current sobriquet often applied to cycads: sago palm. The real sago palm (*Metroxylon sagu*) is a Southeast Asian palm tree widely used to produce bread and other flour-based products. But many cycads also have starchy stems and appetizing-looking seeds, and it didn't take long for people to start using them for food.

In Florida, Calusa and Seminole people had had a long history of using the native species *Zamia integrifolia*, or the coontie, as a rich and plentiful supply of flour. The Florida cycads were so abundant that once the native peoples were

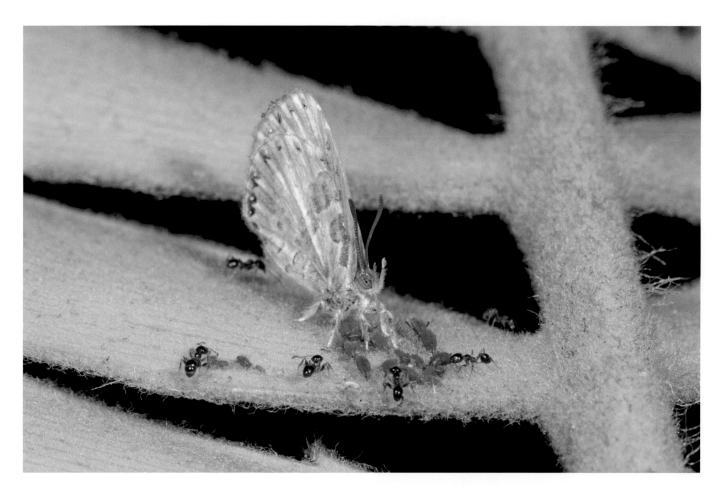

A small butterfly known as a common woolly legs (*Lachnocnema bibulus*) and a group of ants collect honeydew produced by aphids feeding on a Modjadji cycad. It is unclear if the honeydew produced by the aphids is free of toxic secondary compounds or if the guest insects are resistant to their effect.

unceremoniously displaced by white settlers, the new inhabitants of the peninsula promptly tapped into this nutritious resource. From the late 1800s a coontie mill operated in Florida, producing large amounts of starch (used, among other things, to produce baby formula), until the plants were pretty much wiped out by the 1920s, and the mill had to shut down its operations.

Cycad starch has been and still is used in many parts of the world where these plants grow abundantly. On Japan's Ryukyu Islands, *sotetsu miso* (cycad bean paste) is still being made from the starch-rich stems of the native species *Cycas revoluta*. Seeds of the same species are also occasionally used to make Japan's national beverage, sake. Cycad seeds make great sake, except for one thing—sometimes those who drink it suddenly die. Because if there is one thing to know about cycads it is that they are, to put it simply, quite deadly. With no exceptions, all species of cycads are extremely toxic,

Cycad tissues contain a number of nasty secondary compounds with scary names, such as β-methylaminpropionic acid (BMAA), macrozamin, and cycasin. In some species the last one can make up to 4 percent of the plant's dry weight. In itself the compound is quite harmless—after all, the plant does not want to kill itself—but if ingested by an animal it turns into lethal methylazoxymethanol (MAM). For instance, if a sheep eats an entire cycad leaf, the large dose of MAM, will cause almost immediate death due to liver failure. But if the poor sheep just nibbles on the plant, it will live for a few months while the malicious chemical spawns carcinogenic mutations in all major organs of the doomed mammal. "Zamia staggers," an irreversible paralysis of hind legs due to ingestion of native cycad plants, used to be a serious problem for cattle farmers in Australia. Entire herds were lost because of the cattle's desire to feed on the never-before-encountered and, according to some reports, extremely addictive plants. Until very recently cycads were considered noxious weeds in Australia, and the government widely distributed instructions on how to kill cycads using fire, kerosene, or even arsenic.

BMAA, present in almost all parts of the cycad's body, including its seeds and starch, is a particularly unpleasant chemical compound. It is known to cause a wide array of neurodegenerative diseases, which often mimic Parkinson disease, multiple sclerosis, or dementia.

Why in God's name, you will be excused for asking, do people still eat these dreadful plants? The answer is the same as if you asked why people continue to smoke—ignorance combined with the lack of immediate negative effects.

BMAA, the compound that will leave you confused about how to use the two long appendages that dangle from the top of your torso, is a cumulative toxin, often taking years before it reaches levels high enough to cause visible damage to the brain. Those cultures that still produce cycad flour or ferment cycad seeds rely on complicated rituals of multiple washes and peeling before declaring the product edible. But

and if ingested will cause either quick but excruciatingly painful death, or prolonged and progressively debilitating suffering, also ending in kicking the bucket. Cycad leaves are loaded with lethal poisons, and their seeds, or even pollen, if eaten, can kill you in a very short time.

residual amounts of BMAA are always present in the resulting dishes. Furthermore, people who deal with the initial preparation of the cycad meals, even merely washing the seeds, are several orders of magnitude more prone to develop neurological symptoms than those who just eat them. Thus, women in such cultures often fall victim to cycad-induced diseases far more often than their husbands as a result of absorbing the toxins through their skin while handling raw plant material. Cycad seeds are particularly dangerous, and the Bantu people of southern Africa, whose diet still includes these plants, have an extremely high incidence of liver cancer—a direct effect of MAM and similar toxins.

The most famous medical case involving cycads, which reads more like a detective story than research in neurodegenerative etiology, is the case of the Chamorro people of Guam. Chamorros have intrigued the medical community for a very long time because they exhibited a hundredfold greater incidence of certain neurological disorders than the rest of the world's population. In particular, the amyotrophic lateral sclerosis and Parkinsonian dementia complex, known in Guam as lytico-bodig disease, seemed to affect nearly every family on the island. The suspicion immediately fell on cycads, the staple of the Chamorro people's diet. Yet after more than sixty years of medical research, we still don't know what role cycads play in this drama; the pendulum swings between total condemnation and unconditional absolution. Most researchers agreed that the levels of BMAA in cycad-containing meal were too low to cause such severe—yet often very delayed—symptoms. But a few years ago a new theory emerged—in addition to cycads themselves, Chamorros eat giant fruit bats, which in turn apparently feed on cycad seeds. Toxicological studies revealed that bodies of the fruit bats accumulate BMAA at such high levels that consumption of a single animal was equivalent to ingesting several years' worth of cycad dishes. Proponents of this hypothesis have collected a substantial body of evidence in its support, including proof that bats caught in Guam a few decades ago

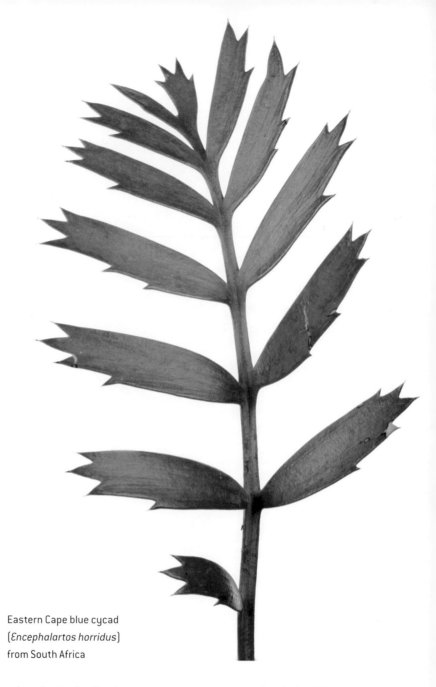

Eastern Cape blue cycad
(*Encephalartos horridus*)
from South Africa

when lytico-bodig disease was rampant were loaded with BMAA. On the other hand, a recent article by Dr. John Steele, who spent his entire life as a physician among the Chamorros, seems to exonerate cycads once again, placing the blame instead on a combination of bad genes, inbreeding, and some

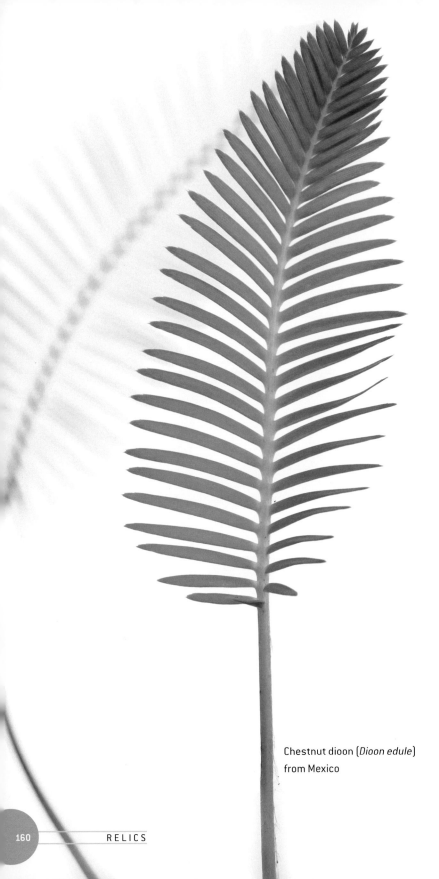

Chestnut dioon (*Dioon edule*)
from Mexico

nebulous environmental conditions. I believe him, but still I would rather eat a plate of live tapeworms in Bolognese sauce than a meal made of cycads.

Not too long ago I read an article about the celebration of Teocinte Day, a festival of the cycad in Honduras where dishes made from various parts of the local species, known as teocinte (*Dioon mejiae*; not to be confused with teosinte, the ancestor of modern corn), including its seeds, were served. The pictures showing the dishes being served to children sent a cold shiver down my spine. On the other hand, is there really a difference between eating a carcinogen and smoking one?

But if you are now planning to stroll casually into your living room and, when it is not looking, push the pot with your cycad plant out the window, do not be alarmed. Cycads are not dangerous as long as you keep them away from your digestive tract. And if your plant is happy enough in your garden to develop male cones, just try not to breathe in its pollen and you will be fine. Thousands of people grow cycads in their homes and gardens with absolutely no ill effects. Rather, it is the cycads themselves who suffer from our fascination with these thrilling plants.

When I first arrived at the Modjadji Forest in South Africa, the guard at the entrance to the reserve was highly skeptical about my motives for visiting the place. I explained in great detail my plans to photograph the plants at dawn and sunset, when the reserve is closed to the public, in order to get the most interesting lighting conditions, and use the photos to promote the message of conservation and education. He listened patiently, nodding in agreement as he clearly had heard it all before. "Look," he finally said, "there is a nursery down the road. Why don't you just buy some plants, instead of stealing them from here?"

I cannot really blame him for being suspicious. Recently poachers stole more than a hundred mature cycads from the reserve, each worth several thousand dollars. Demand for large, fully-grown cycads is so high that some South African

species are now extinct in the wild, the last free-growing individuals having been stolen from their native habitats only to be sold to rich, obsessive cycad collectors. The desire to own the rarest of the rare ratchets the price of some cycads to US$50,000 per individual. And once the reward is this high, the risks and effort the thieves are willing to put in are almost limitless. Cycad poachers sometimes use helicopters to lift giant plants hundreds of years old from national parks and other protected areas. In 2004, as Hurricane Frances was pummeling southern Florida, thieves snuck into the Fairchild Tropical Botanic Garden in Miami and made off with thirty extremely rare cycads from the garden's collection.

To protect the oldest and rarest plants, small electronic identification chips have been installed deep in their trunks. This, in theory, should help identify stolen plants when they are being transported across international borders. But it didn't take long for the poachers to start using X-ray machines to locate and remove the chips. DNA fingerprinting, which allows one to identify individual specimens of cycads, is probably the most effective weapon against cycad smuggling, but the technology is still expensive and not widely available.

People who illegally take the last free-living individuals of these glorious plants from their natural habitats and thus wipe out their last natural populations must be prosecuted to the fullest extent of the law. And yet one persistent thought keeps me awake at night: Are we really attacking the problem at its root or simply going for an easily identifiable, soft target that will make us feel better? After all, when you really think about it, who are these poachers? They are, I believe, the last thieves to arrive at the scene of a crime, grabbing the remaining goods after everything else has been stolen or destroyed by somebody else. Few cycads—or any other threatened or endangered species—are tittering on the brink of extinction because of natural causes. No, they got there because somebody at some point made a concerted effort to destroy their habitat, kill most of the population, and ensure

that there are no places left where these species can find sanctuary. Rota, an island near Guam, which until recently had cycad forests rivaling those of Modjadji in South Africa, is now almost devoid of these plants because of the development of golf courses for tourists. Will their developers, who in the process of building them killed thousands of plants (and millions of other organisms), ever be prosecuted? Somehow I doubt it.

Like bower birds that collect uncommon, shiny objects to attract females, people are drawn to rare, one-of-the-kind collectibles. Sometimes it is stamps or coins, sometimes paintings by old masters, and sometimes endangered species. It is in our genes, and nothing will stop this desire. What we can do instead is to make the desired, rare species undesirable.

Recently, a sting operation conducted by the U.S. Fish and Wildlife Service, working on a budget of $225,000, managed to snag and prosecute three major cycad smugglers, one of whom was otherwise respected as an international authority on cycad biology and horticulture. They were given sentences that amounted to a slap on the wrist and sent back free to their respective countries. It is my firm belief that the amount of our tax dollars spent on this exercise would have been better invested in purchasing a small parcel of land, preferably adjacent to an already existing reserve, and planting several thousand saplings of the plants that those smugglers were trafficking. The best defense against poachers and collectors of rare species is to make these species common. I have yet to hear about a smuggling ring sneaking blue jays into Europe or European pine trees to the United States. No, there is no market for these organisms, not because they are not beautiful (I would argue that blue jays rival most parrots in their intelligence and splendor of their plumage), but because they are so mundane.

Of course it is never this simple. Planting thousands of cycads will help the species survive for a while but not permanently, unless we can also preserve the pollinators and seed dispersers on which they depend. Thus, conservation

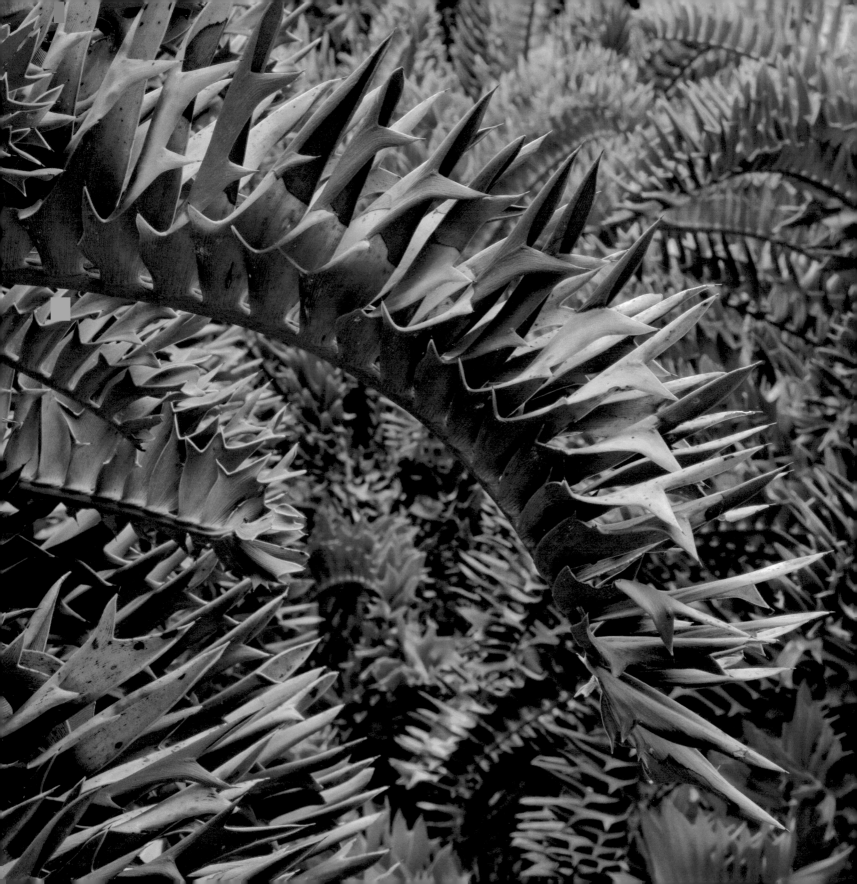

of cycads should focus on keeping their natural habitats intact, and with it other species that need and are needed by these plants. These habitats should be expanded and the plants' natural populations augmented by captive propagation, including the ability to grow even the rarest species by hobbyists. Catching an occasional smuggler will only make the plants more valuable and worth the risk of stealing it.

As I walked among the looming giants of Modjadji I had a distinct feeling of being transported to some long-gone era; I half expected an archaeopteryx to glide from one of the trees. And yet, I realized, this feeling was instilled in me by the common notion of cycads being "living fossils," a vague and confusing term first introduced by Charles Darwin, rather than by what we actually know about the history of these plants. For the first eighty million or so years of their evolution cycads were flimsy, thin-stemmed plants, and not giant trees like the ones I was walking among. The first large, treelike species did not appear until the end of the Cretaceous, about the time dinosaurs were approaching the end of their reign. In addition, the genus of the Modjadji cycad, *Encephalartos*, is likely the youngest of all contemporary cycads, going back no more than two or three million years. Does it matter? No, I still admire these beautiful survivors, which, as a lineage, have endured some of the most dramatic cataclysms in the geological history of Earth and have managed to compete successfully against nimbler, faster growing flowering plants. They have held their own for a long time; let's try and not ruin their chances to live a little longer.

Most cycads have stiff, hard leaves, but few are as well protected as those of the African genus *Encephalartos*. Not only do the leaves contain hard, woody elements, but sometimes individual leaflets end in painfully sharp spines, like in this *E. latifrons*. Some botanists speculate that these defenses might have evolved as protection against grazing dinosaurs.

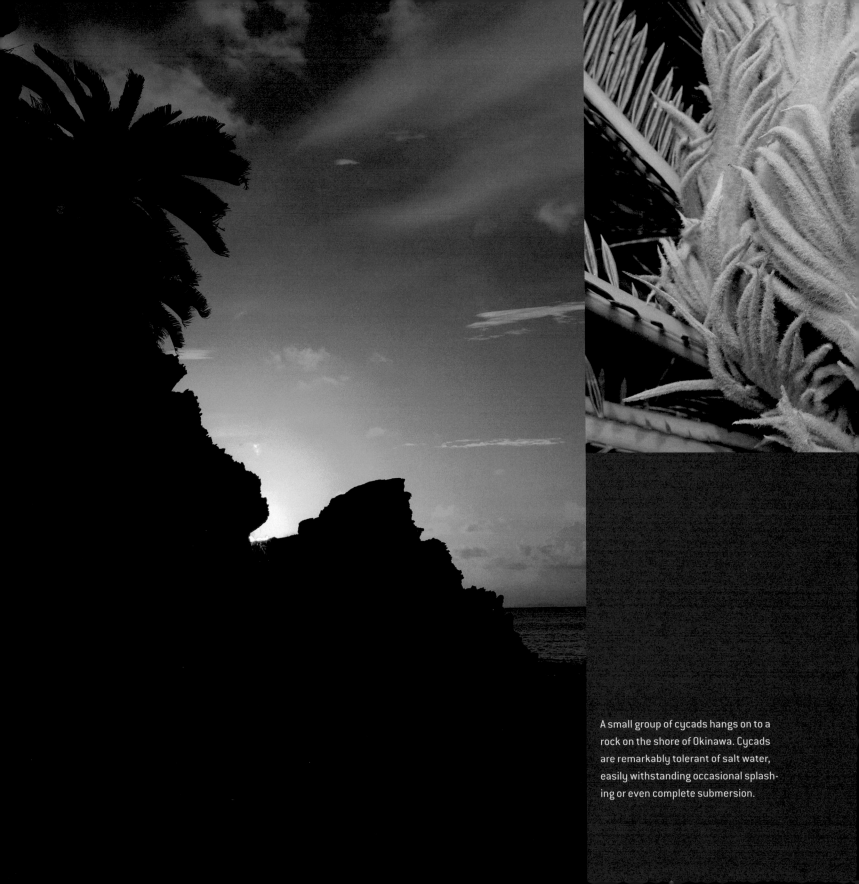

A small group of cycads hangs on to a rock on the shore of Okinawa. Cycads are remarkably tolerant of salt water, easily withstanding occasional splashing or even complete submersion.

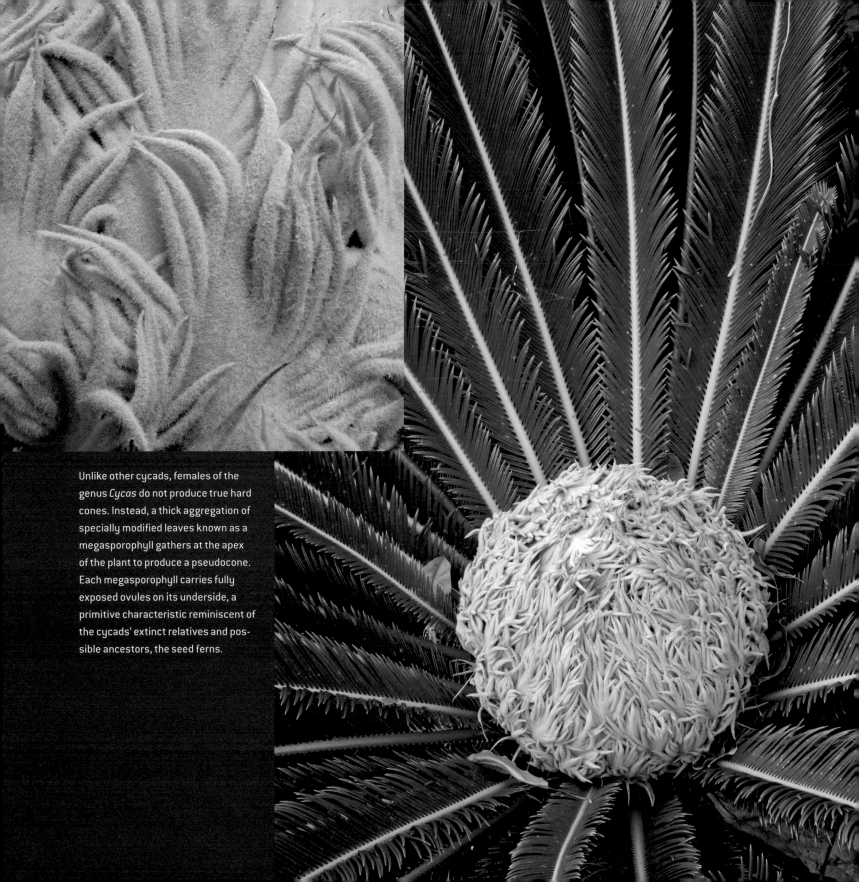

Unlike other cycads, females of the genus *Cycas* do not produce true hard cones. Instead, a thick aggregation of specially modified leaves known as a megasporophyll gathers at the apex of the plant to produce a pseudocone. Each megasporophyll carries fully exposed ovules on its underside, a primitive characteristic reminiscent of the cycads' extinct relatives and possible ancestors, the seed ferns.

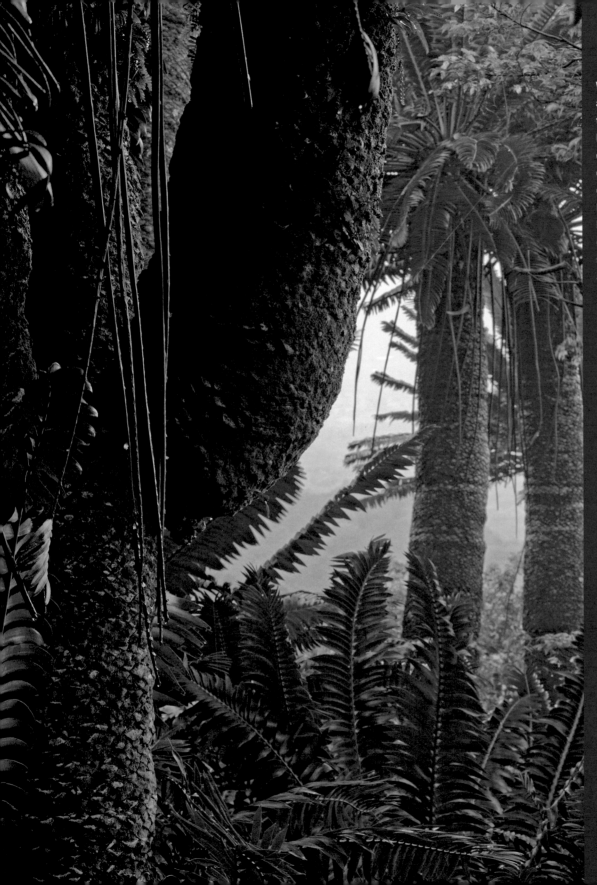

While it is difficult to calculate the exact age of a cycad, individuals as large as those found in the ancient Modjadji Forest are known to be at least several centuries old. The stem of a Modjadji cycad (*Encephalartos transvenosus*) can be sixty-five centimeters thick, but surprisingly is almost devoid of hard, woody elements. Its rigidity is ensured mostly by thick, overlapping scales, remnants of old leaf petioles and cataphylls.

Walking among these giants, it is easy to imagine dinosaurs strolling past similar-looking plants. But giant, treelike cycads did not appear until the end of the Cretaceous, and the genus *Encephalartos* is probably only a few million years old.

The trunk of an old, fully grown cycad resembles the body of some ancient, giant reptile. Each scale is a remnant of the petiole of a single shed leaf. Cycads produce leaves in spurts, so-called flushes, usually once a year. It is therefore possible to count rings of trunk scales and get an approximation of a plant's age. But extended droughts slow down the rate of leaf growth, while seasonal fires often result in accelerated spurts of production of new leaves, disrupting this annual pattern.

In the subtropical humid climate of the Modjadji Forest, epiphytic lichens and algae find homes on the trunks of many old cycads.

167

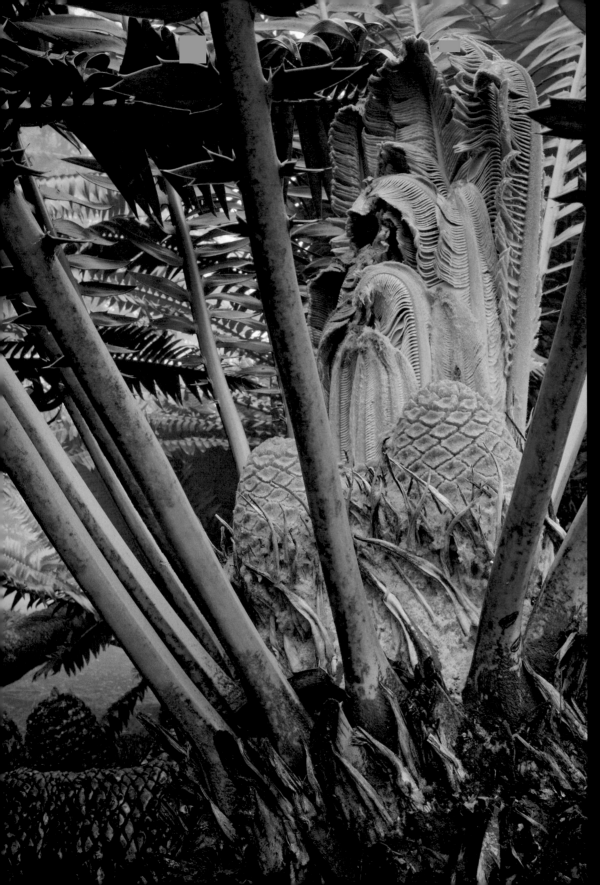

Although it may appear that cycad cones grow at the very tip of the plant, or the apical meristem, they are in fact the result of shallow branching off below the tip. The apical meristem of this individual has just produced a fresh flush of leaves, while young female cones develop slightly to the side. Their bases are still well shielded by special protective leaves known as cataphylls.

Pictured here is an immature female cone of the poor man's cycad (*Encephalartos villosus*), a species still common in the eastern part of South Africa. This species has an entirely subterranean trunk, and thus cones of this species are always produced at the ground level.

The basal parts of young male cones of the Modjadji cycad (*Encephalartos transvenosus*) are protected by cataphylls. The amount of pollen these cones can produce is enormous.

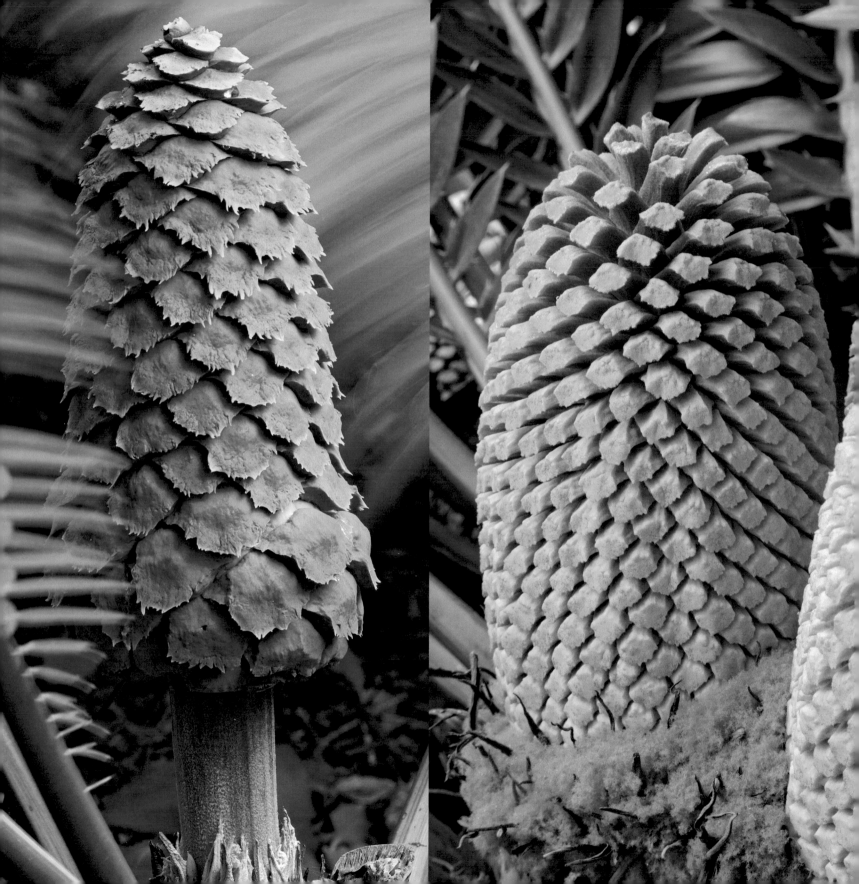

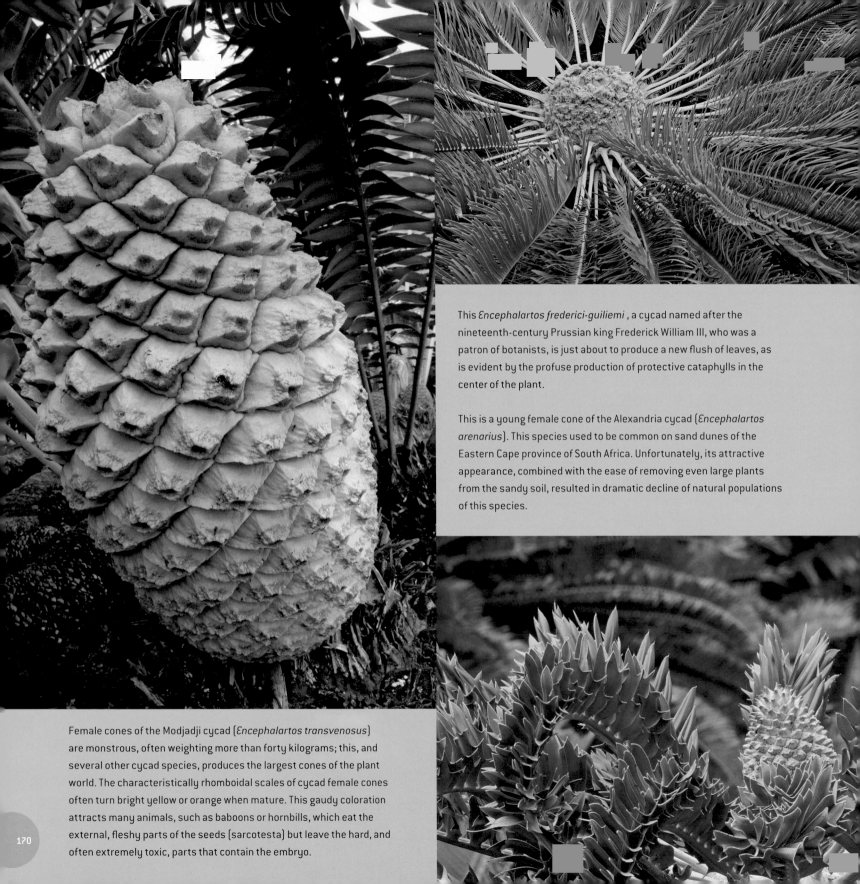

This *Encephalartos frederici-guiliemi* , a cycad named after the nineteenth-century Prussian king Frederick William III, who was a patron of botanists, is just about to produce a new flush of leaves, as is evident by the profuse production of protective cataphylls in the center of the plant.

This is a young female cone of the Alexandria cycad (*Encephalartos arenarius*). This species used to be common on sand dunes of the Eastern Cape province of South Africa. Unfortunately, its attractive appearance, combined with the ease of removing even large plants from the sandy soil, resulted in dramatic decline of natural populations of this species.

Female cones of the Modjadji cycad (*Encephalartos transvenosus*) are monstrous, often weighting more than forty kilograms; this, and several other cycad species, produces the largest cones of the plant world. The characteristically rhomboidal scales of cycad female cones often turn bright yellow or orange when mature. This gaudy coloration attracts many animals, such as baboons or hornbills, which eat the external, fleshy parts of the seeds (sarcotesta) but leave the hard, and often extremely toxic, parts that contain the embryo.

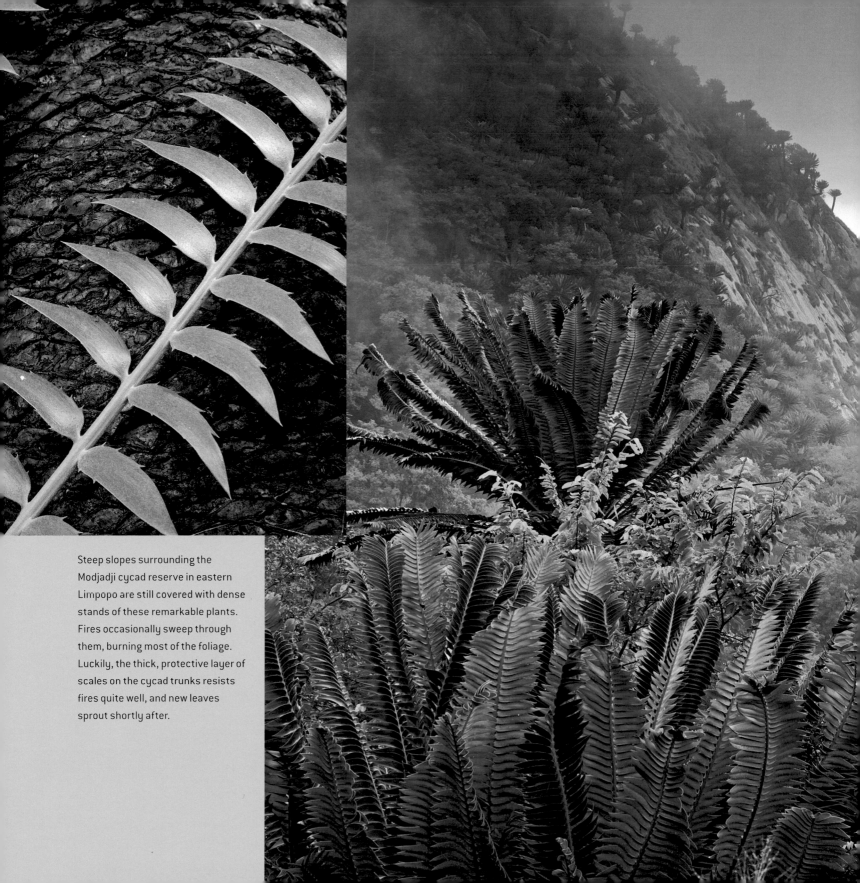

Steep slopes surrounding the
Modjadji cycad reserve in eastern
Limpopo are still covered with dense
stands of these remarkable plants.
Fires occasionally sweep through
them, burning most of the foliage.
Luckily, the thick, protective layer of
scales on the cycad trunks resists
fires quite well, and new leaves
sprout shortly after.

We usually don't think about it in this way, but organisms that became a part of human agricultural or cultural practices are, from an evolutionary point of view, unimaginably more successful than their wild counterparts. The most successful bird is not the charismatic bald eagle (approximately 150,000 individuals worldwide), but the lowly chicken—16 *billion* of these birds share the planet with us. While individual chickens pay for their reproductive success with untimely and often gruesome deaths, there are organisms that take advantage of us and give surprisingly little in return. These include not only my dogs, but also the ancient and lovely ginkgo tree.

Ginkgo (*Ginkgo biloba*) is the last and only survivor of the early seed-bearing plants known as Ginkophyta, which first appeared in the Permian, about 270 million years ago. As it is often the case with very old lineages, ginkgo's relationships are still unclear, but there is strong evidence of its very close affinity with cycads. The first undisputed fossils of the genus *Ginkgo* date to the Early Jurassic (about 200 million years ago), making it the oldest surviving genus of seed-bearing plants. Throughout their very long history, ginkgos have never been particularly diverse, and at any given moment in time only a few, or perhaps only one, species of ginkgo were present on the planet. The genus *Ginkgo* used to be widely distributed across the continents, but a few million years ago it started disappearing from most of its former range, and it was last seen in the fossil record from a small area in central China. There, in the low mountains straddling Yangtze River, the last remaining population of ginkgos was probably found and adopted by Buddhist monks over 2,000 years ago. At least this is how long ginkgos have been cultivated in China, and no truly wild populations of these plants now exist anywhere in the world. From China, the ginkgo was brought to Japan about a thousand years ago, and subsequently it has been spread by gardeners to all corners of the globe.

The appeal of ginkgos is easy to understand—they are beautiful trees that are resistant to frost, pollution, and myriad pests and pathogens that often decimate other plants. This makes them perfect for urban environments, and they have become the tree of choice for many city planners. Ginkgos are exceptionally long-lived; 1,000-year-old individuals are not rare, and some trees in China may be over 3,000 years old. The living proof of ginkgos that survived ground zero at Hiroshima shows that they may be the last things standing after a nuclear war.

In addition, ginkgos have a reputation of being the source of myriad pharmaceutically active, beneficial compounds. Their supposed positive effect on memory as well as their effectiveness in treating dementia and Alzheimer disease is widely known. For the longest time these claims had been believed yet never scientifically tested. Only recently have a number of rigorous studies shown that ginkgo extract is virtually useless in treating dementia or improving our mental capacities. Shortly afterward a new study, funded

by the world's largest maker of ginkgo supplements, claimed (shockingly) that the said supplements did work. In the end, the benefits of using ginkgo to improve the functions of our brains are marginal at best. Some support exists for the positive impact of ginkgo compounds in the treatment of poor circulation, in protection against oxidative cell damage, and as a neuroprotectant. There is also indication that ginkgo may be helpful in treating tinnitus (persistent ear ringing) and vitiligo (loss of skin pigmentation).

For a small amount of leaves collected for some disputable medicinal components, and thanks to being a rather handsome plant, ginkgos have been able to reclaim all their former range on all continents, and now grow in numbers that are probably as high as ever in their history as a lineage. They achieved all this using humans as their tool and distribution agent. In fact, lately I have been feeling strangely compelled to have a ginkgo, and last week had one planted in front of our house.

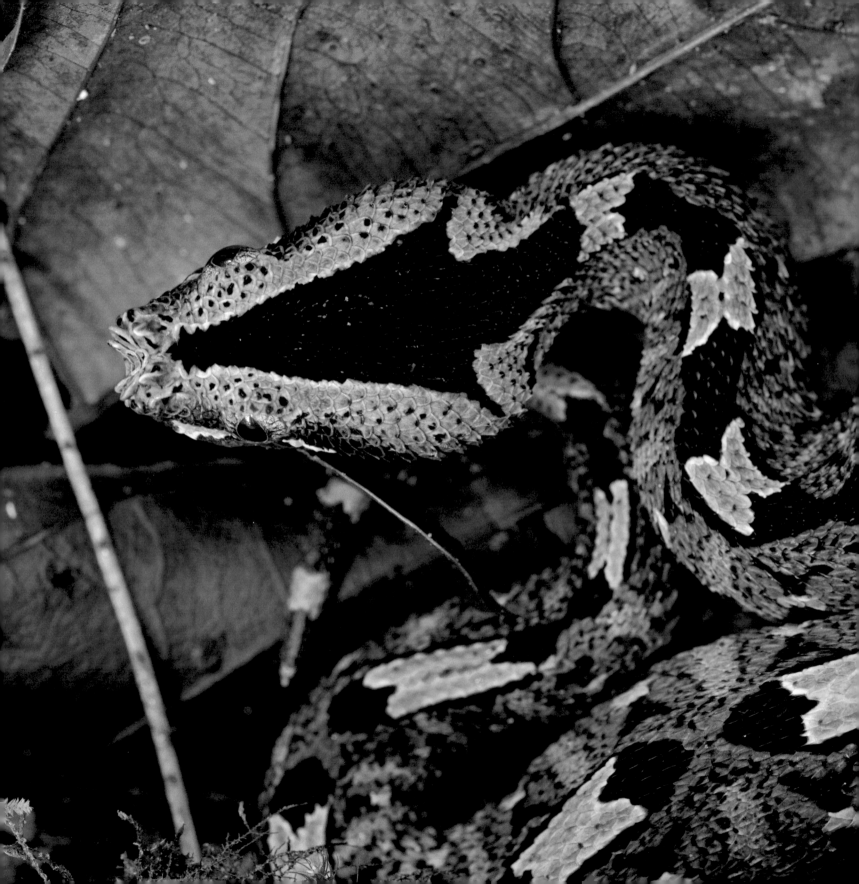

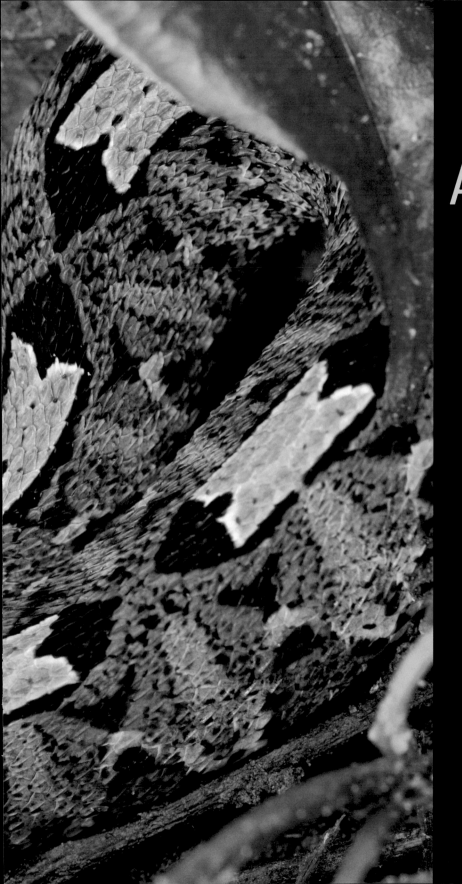

Atewa

The skeleton of a leaf on the floor of Atewa's forest, a reminder of life's mortality, is also an indication of the vitality of this ecosystem. Nothing in the rainforest is wasted—softer tissues and nutrients trapped within dead plant material are quickly decomposed by bacteria and fungi for quick reuse. Woody elements of the leaf, which are harder and more difficult to break down, will also eventually disappear, often thanks to tireless termites and their symbiotic protozoans.

As the old life fades out, new life springs forth. Many tropical trees produce young leaves that are nearly devoid of chlorophyll, giving them beautiful pink and purple coloration. Their priority is to grow as fast as possible, and only after they have achieved the desired size do the leaves develop chloroplasts and begin to photosynthesize. This, of course, does not stop aphids from tapping into nutritious flow of plant juices; here, an ant tends its aphid "herd."

About two billion years ago, Earth was a very different place. Its land surface was still nearly devoid of life, with only cyanobacteria and slime molds clinging to humid nooks and crevices of rocks bombarded by strong ultraviolet radiation. The atmosphere had only a quarter of the current oxygen levels, and the protective ozone layer was virtually nonexistent. The still relatively young Earth seemed to be experimenting with different configurations of its landmasses, and giant earthly crusts, known as cratons, fused and parted, forming enormous supercontinents of strange names. Columbia begat Nena, which became a part of Rodinia, which begat Proto-Laurasia and Proto-Gondwana, and so it went. Volcanoes spewed magma from the earth's mantle and many minerals that now shape the fate of human history and economy were created in those strange days known as the Proterozoic. Gibbsite, boehmite, and diaspore were some of them, and the one thing the three had in common was the presence of the element aluminum. These minerals eventually formed layers of rock and, in time, disappeared under strata of new types of stone and soil. One particularly large deposit of such aluminum-bearing rocks, a part of the so-called Precambrian Shield, spread across Gondwana, the southern supercontinent that formed in the Cambrian about 510 million years ago. Eons of weathering and leaching of more soluble elements of these rocks caused its heavier elements, mostly aluminum- and iron-rich minerals, to concentrate and move closer to the surface. In some places, water and wind carried away most of the surrounding terrain, leaving behind elevated masses of bauxite and iron ore. Like all supercontinents before it, Gondwana eventually began to break up and, at the beginning of the Cretaceous, a crack appeared on its surface. A big landmass we now call South America drifted away, leaving behind the African continent, along with its portion of aluminum-laden rocks.

A hundred and thirty six million years later, I jumped out of a car, straight into the path of an African horned viper. We both froze, me frantically trying to think of a way to catch this gorgeous beast, she flicking her tongue, trying to decide if I was worthy of a quick injection of her lethal hemotoxins. Unfortunately for her, she decided to continue her movement toward a nearby clump of trees. I grabbed her by the tail and quickly tossed her into a bag. "*Bitis nasicornis*, a good sign," said Kuoame, an Ivorian herpetologist, who like me was a member of an international team of biologists surveying Atewa, one of West Africa's most remarkable ecosystem, and a relic of the ancient African forest that once covered most of the continent. Atewa Forest, a small reserve of less than 24,000 hectares located only 50 miles north of Ghana's capital Accra, took my breath away. The lush, dense woods were nothing like anything I had ever seen before. Hundreds of species of plants created a tapestry of raw, vibrant beauty, and the air in the forest was saturated with a rich bouquet of flowers, wet leaves and fallen, decomposing tree trunks. In some places spiky lianas created impenetrable walls where only monkeys and mad botanists would venture. Mushrooms sprang up everywhere, and on the first night I discovered that, thanks to bioluminescent fungi, almost every piece of rotten wood produced a beautiful green glow, turning the forest floor into a mirror of the star-studded sky above. Trees with trunks as thick as a bus spread out enormous buttresses, like fingers on a giant hand. Branches above our heads were heavy with gardens of epiphytic ferns and mosses, and every now

Over the last 20 million years or so Earth has undergone many periods of significant cooling. These periods became particularly intense about 2 million years ago, and each lasted about 41,000 years. Later the cycles became longer, spanning about 100,000 years, and the most recent glacial cycle peaked 18,000 years before present. The effects of these cycles were very different in different parts of the world. As the earth cooled off, polar ice caps got larger, thus removing a huge amount of water from regular circulation. For areas closer to the poles, this meant cold, wintery weather and ice moving in to cover large swaths of land. But for tropical areas located far from the earth's poles glacial periods meant less water in their atmosphere. Following the breakup of Gondwana, the resulting African continent was quite humid, and enormous stretches of uninterrupted rainforest extended north to present-day Egypt, but each glacial period caused less and less water to fall on Africa's surface. Rainforests disappeared from most areas, replaced by savannas and other types of vegetation that did not require constant high humidity. And yet patches of rainforest survived here and there during even the driest spells. Like arks of sylvan biodiversity, they allowed the forest to expand again once the polar ice melted, and water returned to the African atmosphere and ecosystems. Many such refuges were located at higher elevations, humid islands in a xeric sea. Some scientists speculate that these refuges, or Pleistocene refugia, drove the process of allopatric speciation, the appearance of new species during glacial maxima when populations of species were separated and isolated from each other. There is strong evidence for such an effect in South America, although in Africa support for the Pleistocene refugia hypothesis is not quite as evident. Regardless of whether new species evolved or not during the periods of rainforest contraction in Africa, these refuges ensured the survival of the most biodiverse ecosystem on the planet.

As you might have guessed, the forest of Atewa is such a biological sanctuary. Situated on top of a plateau, it rises in some parts to almost eight hundred meters above sea level.

and then we could hear somewhere in the forest a tree tired of its unwanted guests, dropping a branch overloaded with epiphytes seeking free support and access to the light above the canopy. But to truly understand why Atewa is special, we must turn back the clock one more time.

Its high elevation ensures slightly lower temperatures and higher humidity compared to the surrounding lowlands, even during the driest periods. There is evidence that Atewa Forest has remained virtually unchanged since at least the Miocene, ten and a half million years ago, when a major marine regression caused by the expanding polar ice caps wiped out most West African rainforests. But Atewa is a relic in more ways than one. Its forest is one of very few remaining patches of the Upland Evergreen Forest, a very unique community of organisms adapted to life at higher elevations and humidity. Similar forests can be found at the opposite, eastern end of the African continent, evidence of the long-gone continuity of this ecosystem. There are species in Atewa, such as tree ferns (*Cyathea manniana*), that occur nowhere else in West Africa but can be found in Tanzania.

At the beginning of the last century most of southern Ghana was covered with nearly uninterrupted, pristine forest. Since then over 80 percent of it has been logged, burned, or otherwise destroyed. Human actions, mimicking the effect of a glacial event, made Atewa an island, once again turning it into a reservoir for the otherwise-vanished biodiversity. Until recently, Atewa's remarkably rich life was relatively safe. Biologists very early on realized that this forest was exceptional on a continental scale. In 1926, when Ghana was still a British colony, Atewa was declared a forest reserve and was spared the fate of many surrounding woods that have long since disappeared under the assault of saws, axes, and fire. Since then its conservation status has been steadily evolving, becoming a Special Biological Protection Area, then a Globally Significant Biodiversity Area, and also an Important Bird Area—impressive-sounding names that unfortunately carry little actual legal power. And throughout all this time the shadow of its old geological history loomed above Atewa. As it happens, the plateau on top of which its forest has survived for millions of years appears to be made almost entirely of aluminum-rich bauxite, a precious ore that for the last few decades has made mining companies around

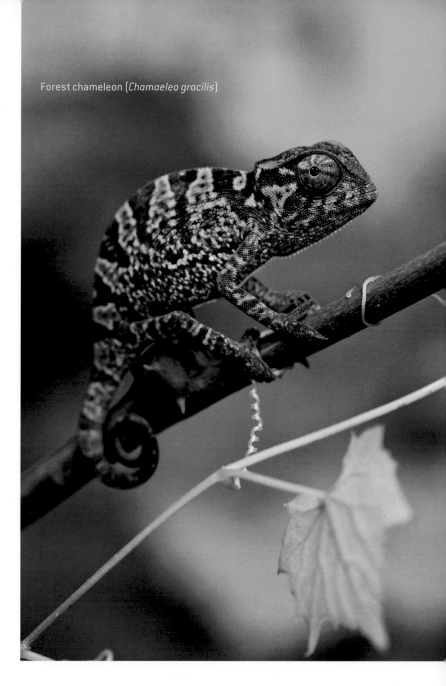

Forest chameleon (*Chamaeleo gracilis*)

the world drool. Different companies have conducted prospecting operations in Atewa, begging the question of what would happen if they decided that the plateau has aluminum deposits rich enough to start stripping away the inconvenient greenery that blocks access to the ore.

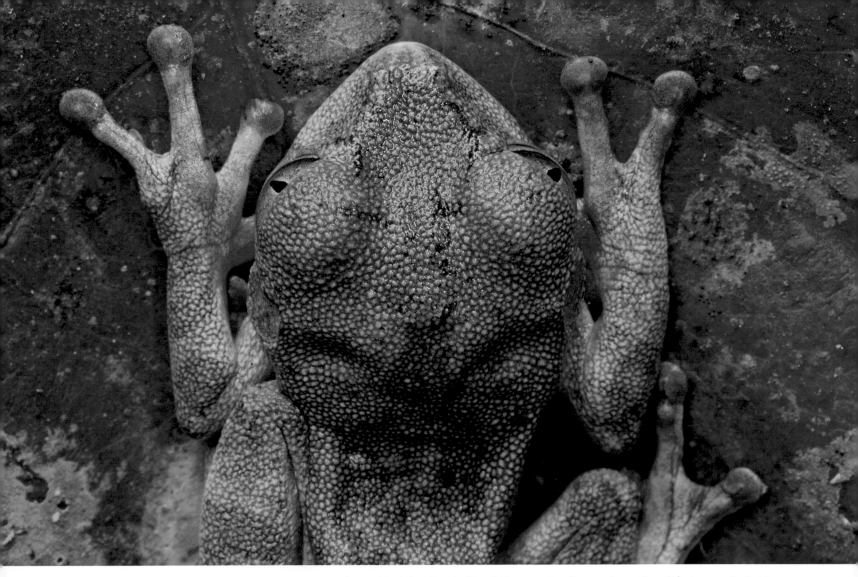

Remarkably similar but completely unrelated to tree frogs of North America, the West African tree frog (*Leptopelis occidentalis*) clings to a leaf with its enlarged toe pads. Its granular skin plays a critical role in gas exchange, being as important for breathing as this frog's lungs. Therefore, high humidity is key to the survival of this species.

When our team of biologists arrived in Atewa, bauxite-prospecting operations were in full swing. A mining company invited us there to create an inventory of plants and animals living within the boundaries of the reserve. The idea was that once the mining operations exhausted all economically profitable deposits of bauxite, after a few decades of exploitation the forest could be put back together. How and where the

lost biodiversity would come from was a mystery to us; but this survey, organized by the Rapid Assessment Program of the nonprofit organization Conservation International, was a unique chance to learn more about this ecosystem and perhaps use this information to convince Ghanaian authorities to put a stop to industrial activities within its borders.

While bauxite mining would almost definitely spell a

quick end to most of the unique life of this upland forest, Atewa had already been robbed of many of its biological resources. As I walked among the thick, gnarly lianas, I kept finding all over the forest floor empty shotgun cartridges discarded by hunters. Even the most remote quarters of Atewa were crisscrossed by nearly invisible hunting trails, and more than once I nearly stepped right into a snare set for duikers, small forest antelopes, prized for their delicious meat. Even before we came we knew that illegal bushmeat hunting was rampant in Atewa. In fact, before setting up a camp in the forest we visited chiefs of several villages in the vicinity to ask them to temporarily halt hunting while we conducted our survey. Quite simply, we did not want to be shot at night by a hunter confusing us with a tastier target. But still, every night, as I silently stalked katydids with my microphone to get recordings of their courtship calls, I could hear gunshots. Along the roads leading from Atewa to surrounding towns, makeshift bushmeat markets offered some of the rarest and most endangered animals as food. All my life I dreamt of seeing and photographing a pangolin, a strange mammal whose entire body is covered with hard, reptilian scales. Fascinating and elusive, these ant and termite feeders have rarely been photographed in Africa. But when I saw one, nearly dead from exhaustion and dehydration after hours of being hung by its tail on the side of the road, I was too saddened to even lift my camera. A friend of mine bought it from the poacher, but the poor animal died before we had a chance to release it back into the forest.

Like the prehistoric layers of bauxite that endanger the existence of the entire Atewa Plateau, the antiquity of Atewa's trees is also their curse. Tall and thick, the oldest trees of Atewa were the first to become the target of illegal loggers. Within the last twenty years most of giant emergents, particularly tall trees that loomed over the canopy of the forest, have been cut down and removed. With them, species of animals that required their presence, such as African Grey Parrots, which needed emergent trees for nesting, also

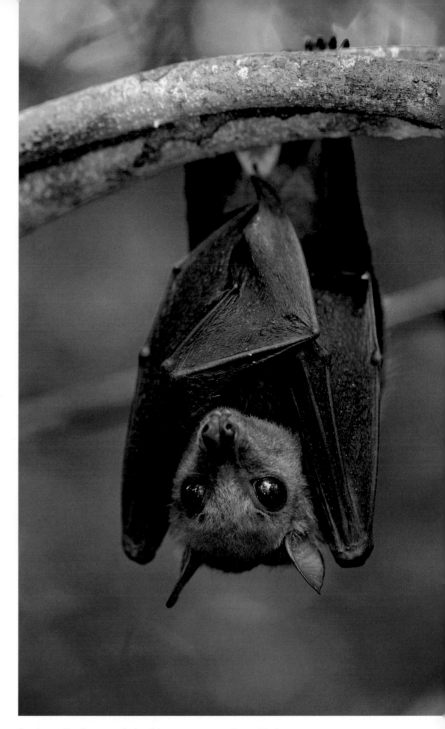

Bats, good indicators of a healthy ecosystem, abound in Atewa. One of the largest species we found there was the collared fruit bat (*Myonycteris torquata*).

disappeared from Atewa. Eventually, illegal logging escalated to the point that the government of Ghana had to take action if anything was to be left of the reserve. In 2001 the Ghanaian army was sent to Atewa to stop loggers from completely destroying the relict forest. Since then illegal logging has subsided, but is by no means eliminated. Nearly every day during our survey we could hear the sound of chainsaws and trees falling somewhere in the distance.

But there may be reasons to be cautiously optimistic about this ancient forest's fate. Its incredible diversity, the result of millions of years of uninterrupted evolution, made it quite resistant to the still relatively minor impact of human actions. Shortly after the completion of our survey, squabbles with the Ghanaian government forced the mining company to abandon their plans to exploit Atewa's bauxite deposits. The company left behind a network of roads that I was afraid could be used by illegal loggers to extract more lumber, but when I visited Atewa again about a year after the bauxite prospecting operations had ceased, I was astounded by the speed of the forest's regeneration. Roads that just a year

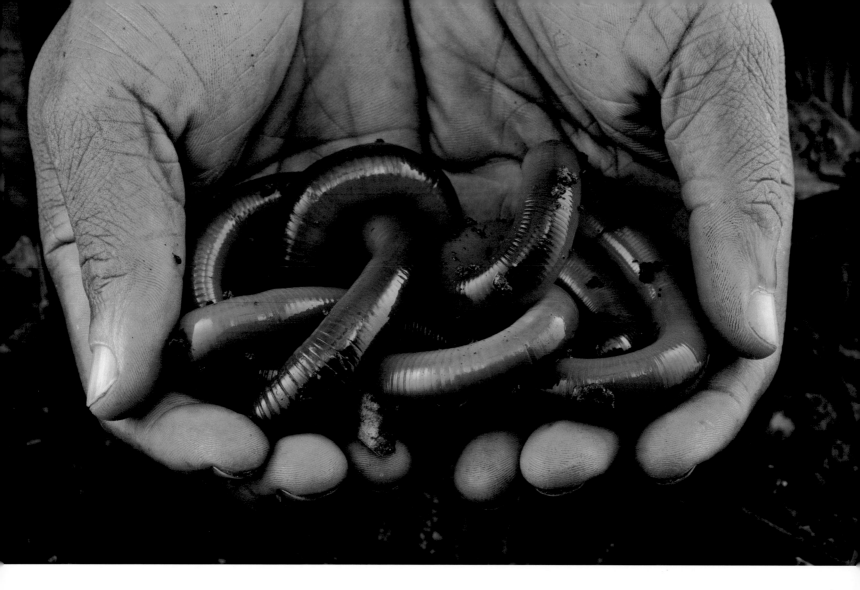

earlier could easily accommodate giant trucks and heavy drilling machinery were nearly completely overgrown with young trees and thick stands of arrowroot plants (Marantaceae). Hornbills and parrots, a rare sight along the roads during our survey, were once again flying above the now-silent edges of the forest. I sat in front of my tent, happy as a clam to be back and see the forest healing its wounds.

The survival of the Atewa forest is incredibly important. In another fifty thousand years or so, probably long after our civilization is gone, another glacier will once again turn

Shallow and poor in nutrients, tropical soils are able to support an unparalleled diversity of plant life thanks to an army of decomposers and recyclers. Countless bacteria, fungi, and invertebrates make sure that no piece of wood or a leaf lingers needlessly, keeping its unneeded nutrients trapped inside. Among them, earthworms are particularly efficient recyclers and soil producers. In Atewa, giant, snake-like earthworms (family Acanthodrilidae) can be seen scouring the forest floor after every rain.

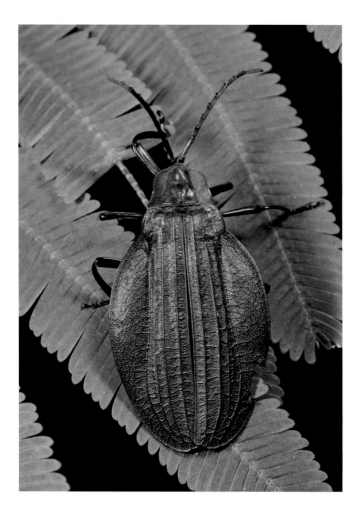

meltdown, our attention shifts even further away from the rather esoteric (or so we think) issues that affect tropical plants or invertebrates. Governments and organizations focus their resources on immediate goals, trying to solve local emergencies as they crop up everywhere with increasing frequency. And it is impossible not to sympathize with people who, forced by hunger and poverty, encroach on protected areas and hunt endangered animals in order to survive another day. A good example of such predicament is Zimbabwe—once a shining beacon of African economy and conservation, now a place where national parks and wildlife are being ransacked by the desperate and famished population, driven to such acts by a greedy and likely insane dictator.

If history has taught us anything, it is that our life depends on the preservation of the critical mass of biological resources that we use daily. The collapse of the Mayan Empire, extinction of the once-thriving civilization of Easter Island, and even the recent, brutal conflicts in Rwanda and Sudan all have their roots in the mismanagement and exhaustion of available natural resources. As much as we like to think of ourselves as being different and special, humans are a part of Earth's biosphere, created within and by it. Ultimately, it is the living, breathing elements of this world that we need more than inanimate supplies, such as coal, gas, or bauxite ore. We can live without cars or beer cans, but we cannot without food and oxygen. As nations around the globe try to band together to attack the problems of greenhouse gas emissions and the shrinking availability of fresh drinking water, in all corners of the world thousands of species quietly go extinct. E. O. Wilson, the renowned Harvard biologist, recently presented the problem our species faces in a succinct law: "If you save the living environment, the biodiversity that we have left, you will also automatically save the physical environment, too. But if you only save the physical environment, you will ultimately lose both."

Few places exemplify this principle better than the Atewa Forest. Its existence not only ensures the survival of count-

most of West Africa into a parched semi-desert (although it is likely that human actions will achieve the same effect much sooner). Throughout Earth's history places like Atewa have acted as safe havens for biodiversity, and hopefully once again it will be able to offer sanctuary to forest wildlife and plants; however, for this to happen we need to stop thinking only about our own well-being and also worry about that of other organisms and the planet as a whole. And this is very, very difficult. Like all organisms, humans always put their own survival first, a natural and understandable behavior. Not surprisingly, in these times of global food crisis and economic

less species already vanished across West African plains, but it also acts as a weather buffer, a carbon sink, an air filter, a water provider, and a source of several ecosystem services to human populations in an area orders of magnitude greater than the reserve itself. Even if bauxite mining never takes place, the destruction of the biological elements of the reserve would have repercussions of an astonishing degree. Aside from the loss of life of organisms that call Atewa home and the end of its role as a glacial refuge, the forest literally keeps the plateau together. There is already ample evidence that the removal of just a small number of trees causes uncontrollable erosion in villages near the reserve, and that many smaller aggregations of bauxite rock are held together by roots of trees growing around them. The removal of the forest would likely lead to an accelerated erosion of the plateau and would affect the headwaters of three major river systems in Atewa that provide water to all surrounding communities and the capital city of Accra. Without the buffering effect of the forest, the weather in the region would likely become more unpredictable and severe, and agriculture would suffer from the lack of pollinators and natural pest control agents that now come from the forest. Unfortunately, Atewa's designation as a forest reserve does not protect it from the possibility of exploitation of its biological resources (after all, this place is also seen as a strategic reserve of lumber), and so far there has been little interest in turning it into a proper national park protected in its entirety by law. So let's be selfish. Let's forget about katydids, orchids, and duikers. Let's save Atewa only for the sake of people who live around it, their children and grandchildren. But when even they are gone, the effect of their forethought will be heard in a quiet, slurping sound of a pangolin's tongue gorging on termites at the base of a giant old tree on the green top of the Atewa Plateau.

Postscript—The very day I finished writing these words I received an e-mail from a friend who had just returned from Atewa. Apparently, a "logging mafia," followed by hundreds of people from surrounding villages, descended on the forest, felling trees and carrying them away. He sent me a few pictures showing giant trees cut down and turned into planks of lumber.

The future survival of the Atewa Forest Reserve is once again in grave danger. In late 2009 another bauxite mining company began scouting the reserve for possible exploration. To make matters worse, Conservation International, the organization that initially championed attempts to turn the reserve into a proper national park, decided to abandon the project and closed its office in Ghana. As far as I am aware, there are currently no organized efforts to protect Atewa from further destruction.

The Upland Evergreen Forest of Atewa is quite different from adjacent forests in Ghana, or what is left of them. Atewa receives between 1,200 and 1,600 millimeters of rain every year, enough to support lush epiphytic flora, which thrives in the foggy, humid atmosphere high in the canopy. The botanical composition of Atewa is quite unique, and although it does not include any strictly endemic plant species it is home to at least 50 species of plants found nowhere else in Ghana. Many epiphytic species thriving here can only be found in montane areas in other parts of tropical Africa, evidence of an ancient connection between these ecosystems. Flora of Atewa includes 765 known species of vascular plants, but entire botanical communities of this forest have never been explored. Its epiphytic flora, including the potentially very species rich flora of orchids, is virtually unknown, and all data on this group of plants are based on what has fallen down incidentally from the forest canopy.

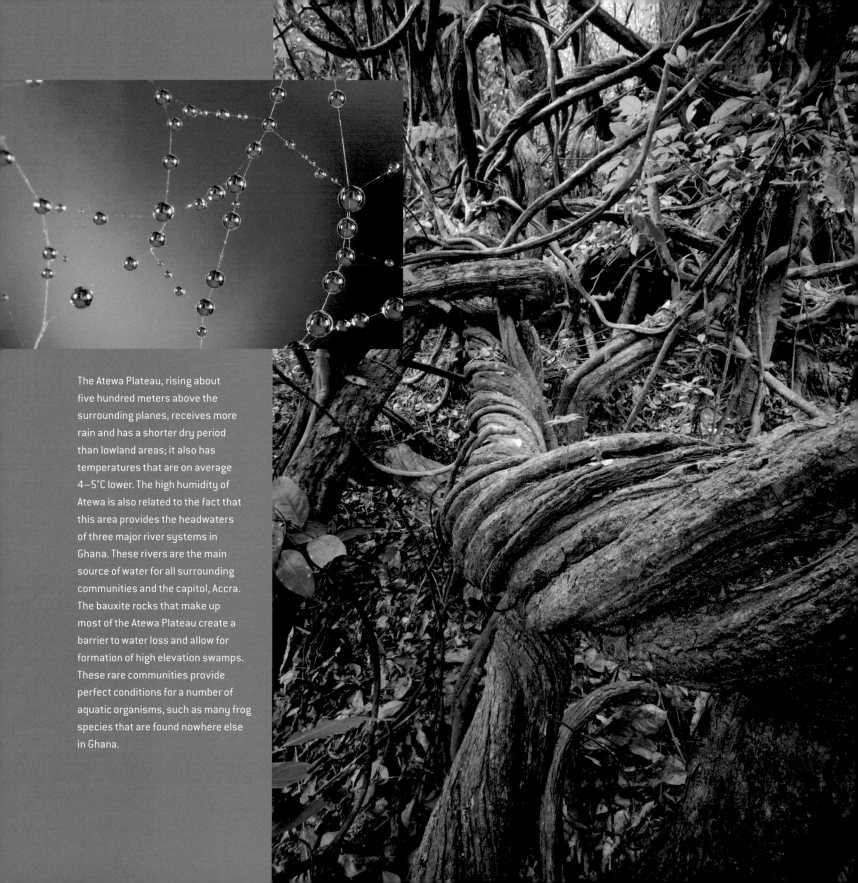

The Atewa Plateau, rising about
five hundred meters above the
surrounding planes, receives more
rain and has a shorter dry period
than lowland areas; it also has
temperatures that are on average
4–5°C lower. The high humidity of
Atewa is also related to the fact that
this area provides the headwaters
of three major river systems in
Ghana. These rivers are the main
source of water for all surrounding
communities and the capitol, Accra.
The bauxite rocks that make up
most of the Atewa Plateau create a
barrier to water loss and allow for
formation of high elevation swamps.
These rare communities provide
perfect conditions for a number of
aquatic organisms, such as many frog
species that are found nowhere else
in Ghana.

Although I had never before seen this beautifully colored inch-worm caterpillar (Geometridae), I instantly knew that it must be quite toxic. An animal must be very sure of its own unpalatability in order to display such gaudy coloration. Later I discovered that this species feeds on lichens scraped from the bark of trees. Some lichens are extremely toxic, and perhaps this caterpillar is able to sequester some of their poisonous compounds to use them for its own defense.

A female flatid planthopper (Flatidae) stays with her children throughout their development. Very little is known about the parental behavior of these interesting animals. Some are known to produce substrate vibrations that may act as a deterrent to some predators or perhaps attract ants that are known to protect some planthoppers in exchange for the honeydew these insects pro-duce. Young nymphs of flatid planthoppers have long, waxy "tails," which they raise in unison if molested by a predator or a photog-rapher. A large group of nymphs with their tails raised resembles a large, fuzzy caterpillar, something that few predators would dare attacking. A similar defensive strategy is known in other groups of insects, such as katydids or stink bugs, which band together when young, mimicking larger, potentially dangerous animals.

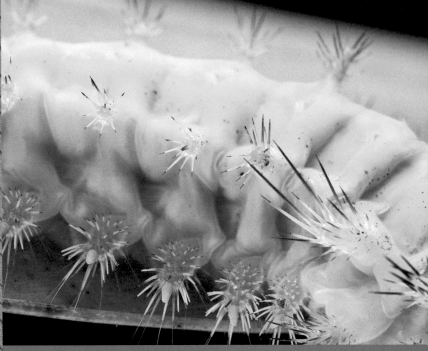

One day, while squeezing through a dense patch of lianas, a sudden blinding bolt of pain paralyzed my right arm. On the verge of panic I anxiously tried to find the viper that I was sure must have bitten me, only to discover that a small, cute and innocent-looking caterpillar had brushed against my skin when I accidentally knocked it off its perch. I have been stung and bitten by many things, but this little larva of a moth of the family Limacodidae delivered the most memorable experience by far. Limacodids, or slug caterpillars, are well known for their defensive strategy. The bodies of many species are covered with sharp, urticating hairs that easily break off if touched. They lodge into the skin of a potential predator, often causing swelling and inflammation, and almost always sharp pain. The hairs of slug caterpillars contain compounds that activate nociceptors, neural cells that cause the perception of pain in the attacker's skin, using neurotransmitters such as histamines and several others. Well protected, slug caterpillars often advertise their very effective defenses with beautiful coloration. There are probably no vertebrate predators who would dare take one of these candies in their mouth.

But slug caterpillars are by no means safe from danger. Anything that can attack the caterpillar between the spines without touching them can overpower these otherwise defenseless animals. Predaceous stink bugs (Pentatomidae) use their long mouthparts like a stiletto to impale and suck dry bodies of these caterpillars.

192

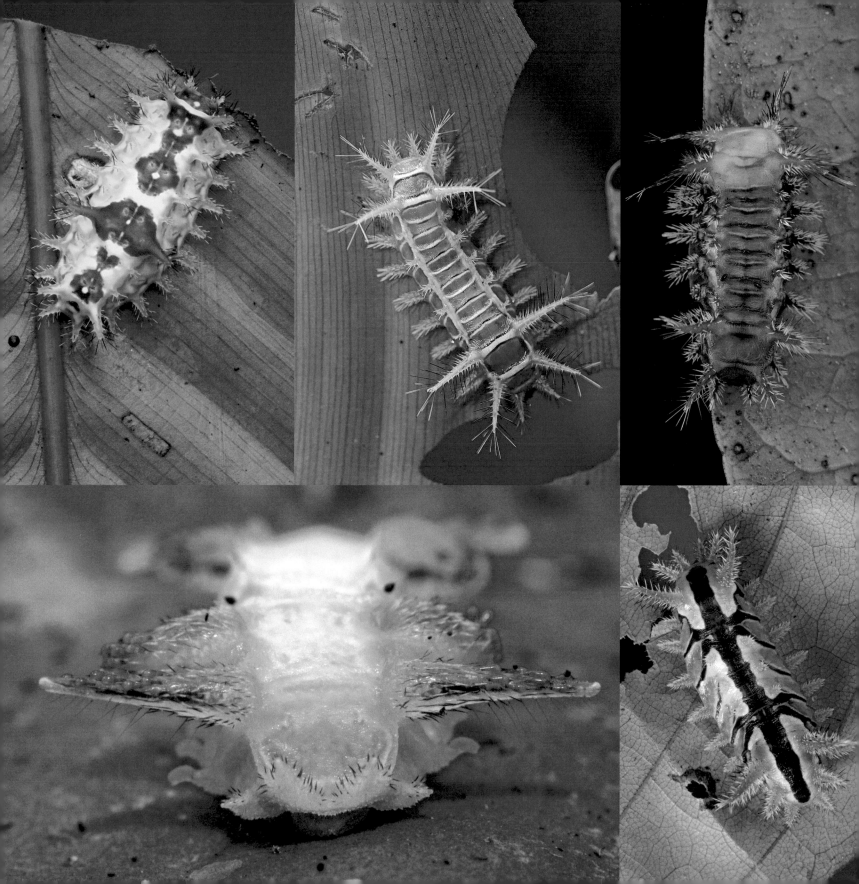

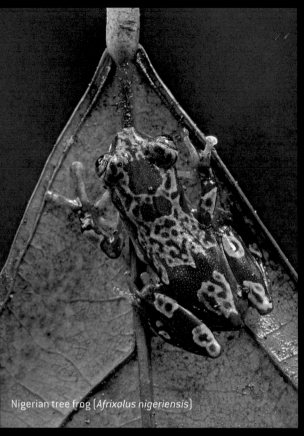

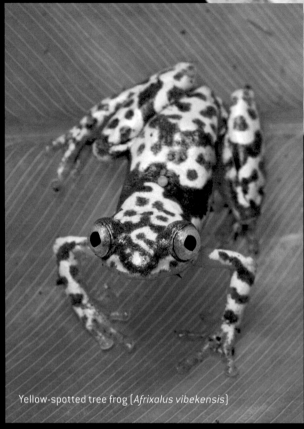
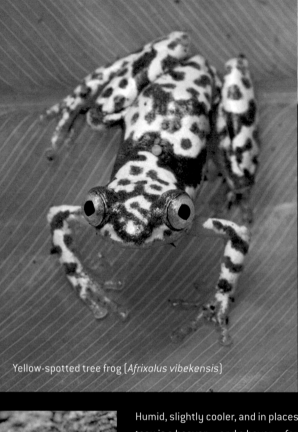

Nigerian tree frog (*Afrixalus nigeriensis*)

Yellow-spotted tree frog (*Afrixalus vibekensis*)

Stream frog (*Conraua derooi*)

Humid, slightly cooler, and in places swampy, the Atewa Plateau is a heaven—and a haven—for frogs. In less than three weeks our survey recorded thirty-two species of these amphibians, but in all likelihood this forest is home to forty to fifty species of frogs—that's about half of the number of all species of frogs known from the United States, an area more than four hundred times as large.

Some of the species found in Atewa, like the critically endangered stream frog (*Conraua derooi*), may already be extinct everywhere else in the world, and nearly a third of the species we recorded is listed by the International Union for Conservation of Nature as threatened. These species, nearly all obligate forest specialists, are particularly sensitive to habitat disturbance, and removal of even a relatively small percentage of Atewa's tree cover can spell their demise.

Tai Forest tree frog (*Leptopelis occidentalis*) 195

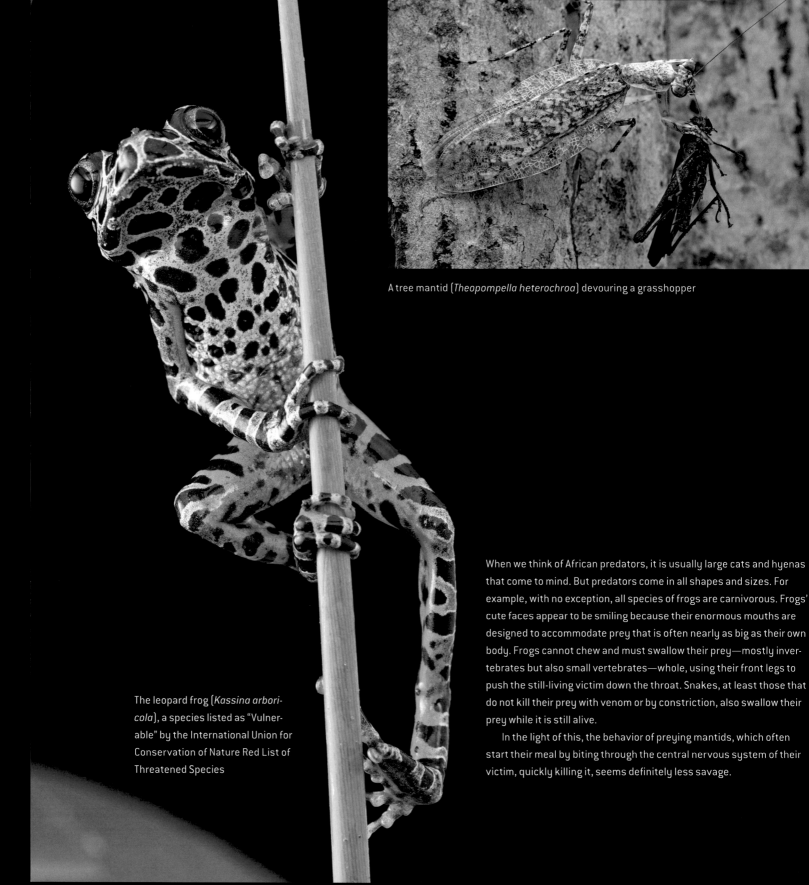

A tree mantid (*Theopompella heterochroa*) devouring a grasshopper

The leopard frog (*Kassina arbori-cola*), a species listed as "Vulner-able" by the International Union for Conservation of Nature Red List of Threatened Species

When we think of African predators, it is usually large cats and hyenas that come to mind. But predators come in all shapes and sizes. For example, with no exception, all species of frogs are carnivorous. Frogs' cute faces appear to be smiling because their enormous mouths are designed to accommodate prey that is often nearly as big as their own body. Frogs cannot chew and must swallow their prey—mostly inver-tebrates but also small vertebrates—whole, using their front legs to push the still-living victim down the throat. Snakes, at least those that do not kill their prey with venom or by constriction, also swallow their prey while it is still alive.

In the light of this, the behavior of preying mantids, which often start their meal by biting through the central nervous system of their victim, quickly killing it, seems definitely less savage.

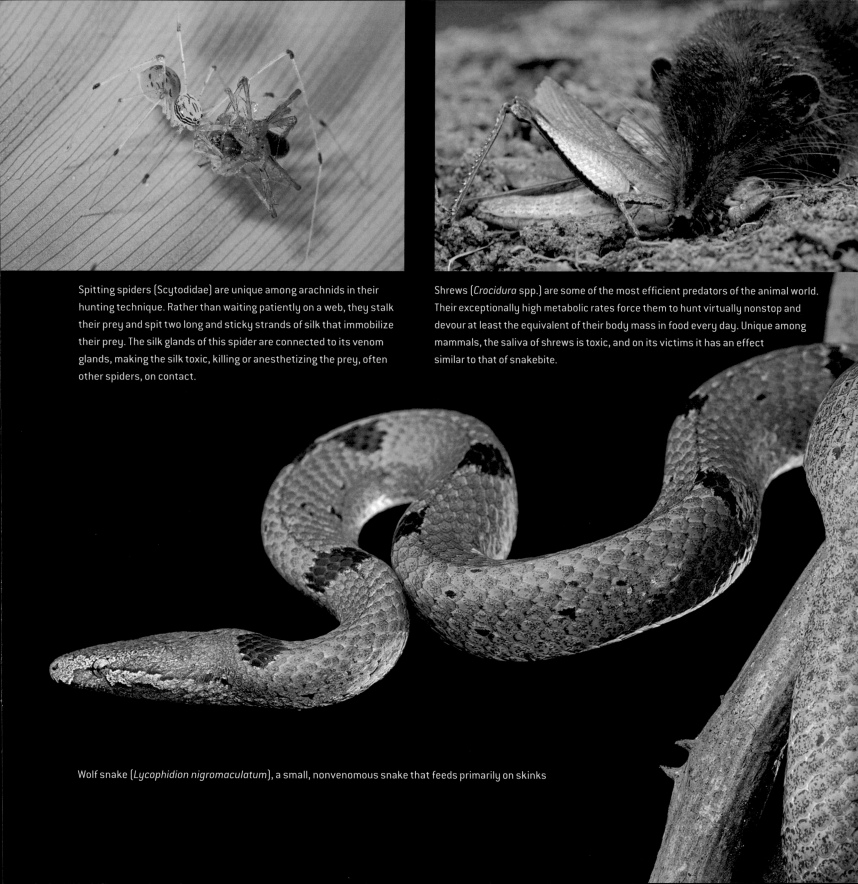

Spitting spiders (Scytodidae) are unique among arachnids in their hunting technique. Rather than waiting patiently on a web, they stalk their prey and spit two long and sticky strands of silk that immobilize their prey. The silk glands of this spider are connected to its venom glands, making the silk toxic, killing or anesthetizing the prey, often other spiders, on contact.

Shrews (*Crocidura* spp.) are some of the most efficient predators of the animal world. Their exceptionally high metabolic rates force them to hunt virtually nonstop and devour at least the equivalent of their body mass in food every day. Unique among mammals, the saliva of shrews is toxic, and on its victims it has an effect similar to that of snakebite.

Wolf snake (*Lycophidion nigromaculatum*), a small, nonvenomous snake that feeds primarily on skinks

Like most tropical forests, Atewa has its fair share of venomous snakes. And like in every other tropical forest, you must be incredibly lucky to run across one. Working mostly at night, when katydids are active, I had a better chance than many members of our team to see these mostly nocturnal animals. Still, in nearly a month of active searching I saw only a handful of snakes. The western bush viper (*Atheris chlorechis*) is one of the most graceful animals I encountered in Atewa. Beautifully adapted to its arboreal lifestyle, these snakes virtually disappear amongst vegetation, hard to notice even when on the move. I spent a good fifteen minutes poking around a small tree, bending branches and turning leaves in search of katydids before I noticed this coiled individual sitting apparently unperturbed, secure in its camouflage, about a foot in front of my face.

Its close cousin, the West African horned viper (*Bitis nasicornis*), is undoubtedly one of the world's most beautiful snakes. The blue, red, and yellow markings of its body are quite striking when seen up close, but in reality form a perfect camouflage on the forest floor among multicolored leaves and speckled lighting where these snakes lie in wait for their prey, which consists primarily of mice and other small mammals. Like all its relatives in the genus *Bitis*, the horned viper can potentially deliver a lethal bite, but human fatalities are very rare. It is not an aggressive species, and before striking often gives a fair warning—a hiss that is reputably the loudest of all African snakes, sometimes even described as a loud shriek.

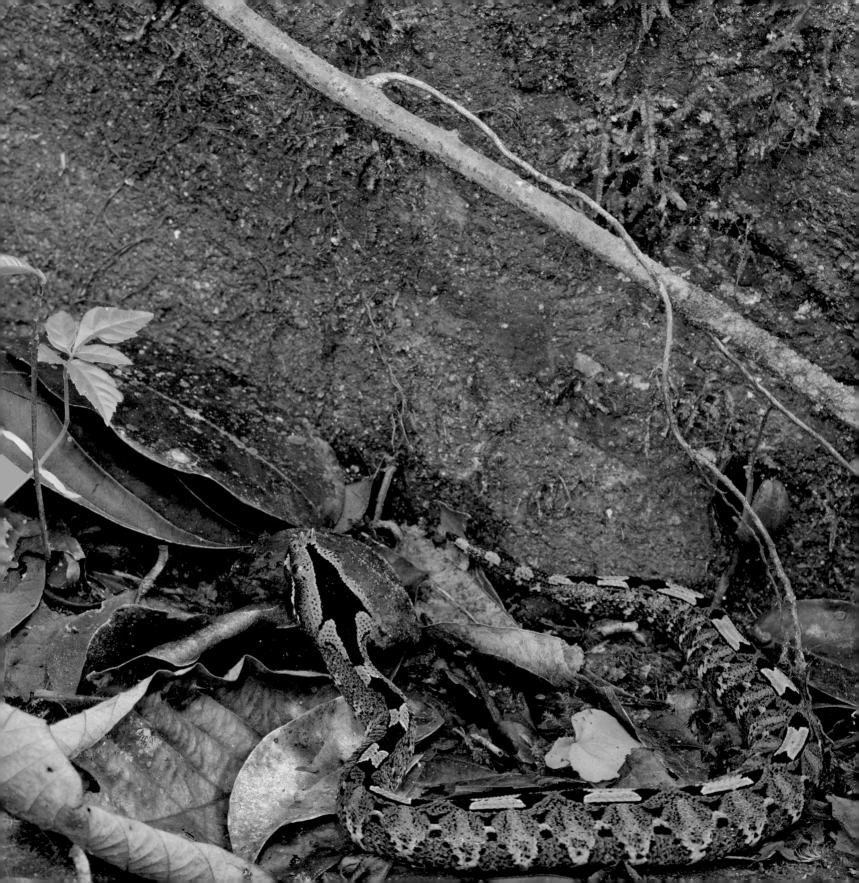

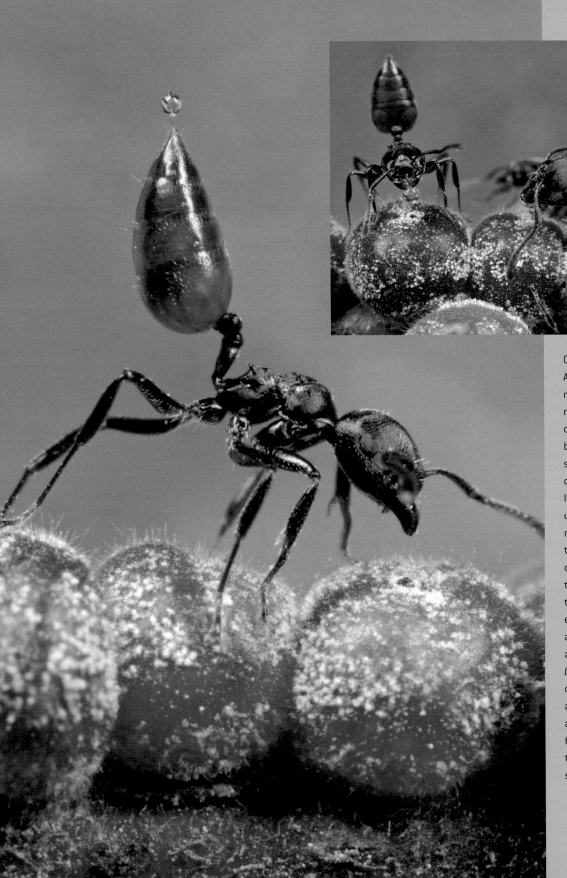

One morning while surveying a drier part of Atewa covered with scrubby vegetation, I noticed what appeared to be clusters of small red fruits on branches of a small tree. On a closer inspection these turned out to be living, breathing animals, strange and completely sedentary insects known as scales, or coccids. Their legs and other typically insect-like body parts were completely hidden under the huge, red scales that comprises most of these insects' bodies. Coccids spend their lives permanently attached to plants, continuously feeding on sugar-rich floem that flows through the vascular system of the plants. The excess of sugar and water is excreted in the form of nutritious honeydew, a substance eagerly sought by ants. These ants, members of the cosmopolitan genus *Crematogaster*, actively defend their herds of coccids; the droplet visible at the tip of this ant's stinger is pure venom. But unlike most ants, these ones do not sting. Instead, their flattened stingers act like tiny spatulas, used to smear their highly irritating venom on the skin of an attacker.

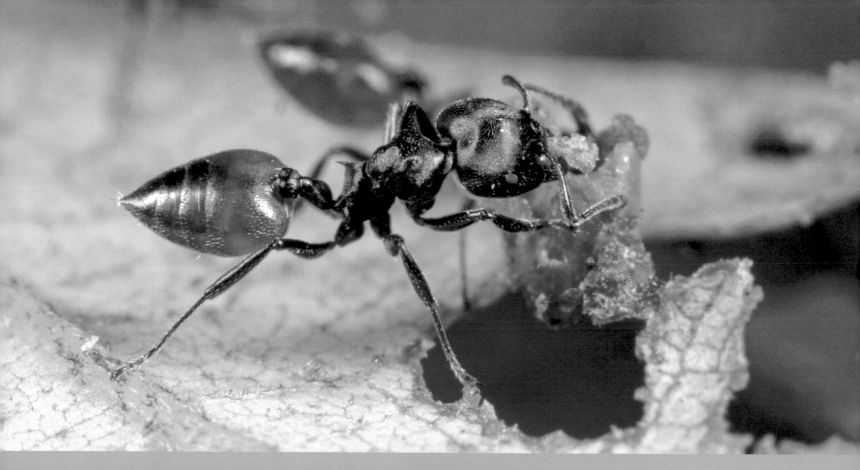

I later discovered that the same species of ants exhibited a behavior that had never been seen in an African ant before—these ants were leaf-cutters. Until now, leaf-cutting behavior has only been documented in Central and South American ants in an unrelated group known as the attines. Attines use freshly cut leaves to feed their underground gardens of fungi, on which the ants then feed. Why the African *Crematogaster* ants cut leaves is still a mystery. Some members of this genus build elaborate nests made of chewed up wood and dry leaves. Perhaps this species uses fresh leaves for the same purpose. It is also possible that *Crematogaster* ants have independently evolved fungus farming, which, if true, would be a truly remarkable example of convergent evolution. But regardless of the application of the fresh leaf material, this behavior gives us an insight into the possible evolutionary path the ants of the New World might have taken to develop their symbiotic relationship with fungi and is another example of how little we still know about the behavior of most tropical invertebrates.

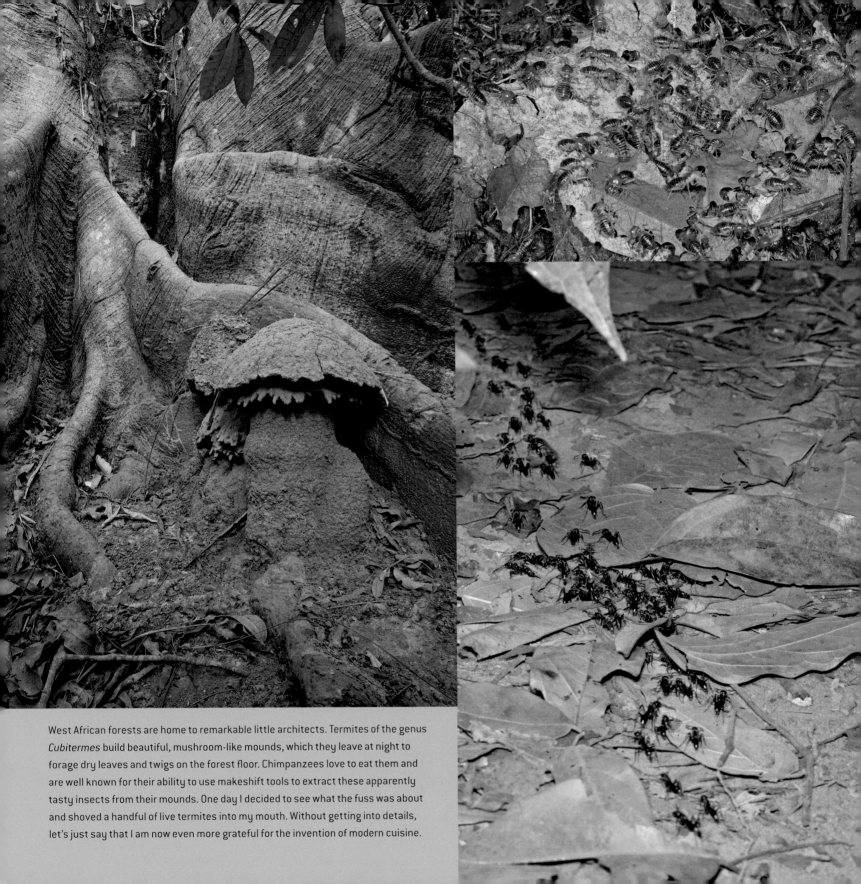

West African forests are home to remarkable little architects. Termites of the genus *Cubitermes* build beautiful, mushroom-like mounds, which they leave at night to forage dry leaves and twigs on the forest floor. Chimpanzees love to eat them and are well known for their ability to use makeshift tools to extract these apparently tasty insects from their mounds. One day I decided to see what the fuss was about and shoved a handful of live termites into my mouth. Without getting into details, let's just say that I am now even more grateful for the invention of modern cuisine.

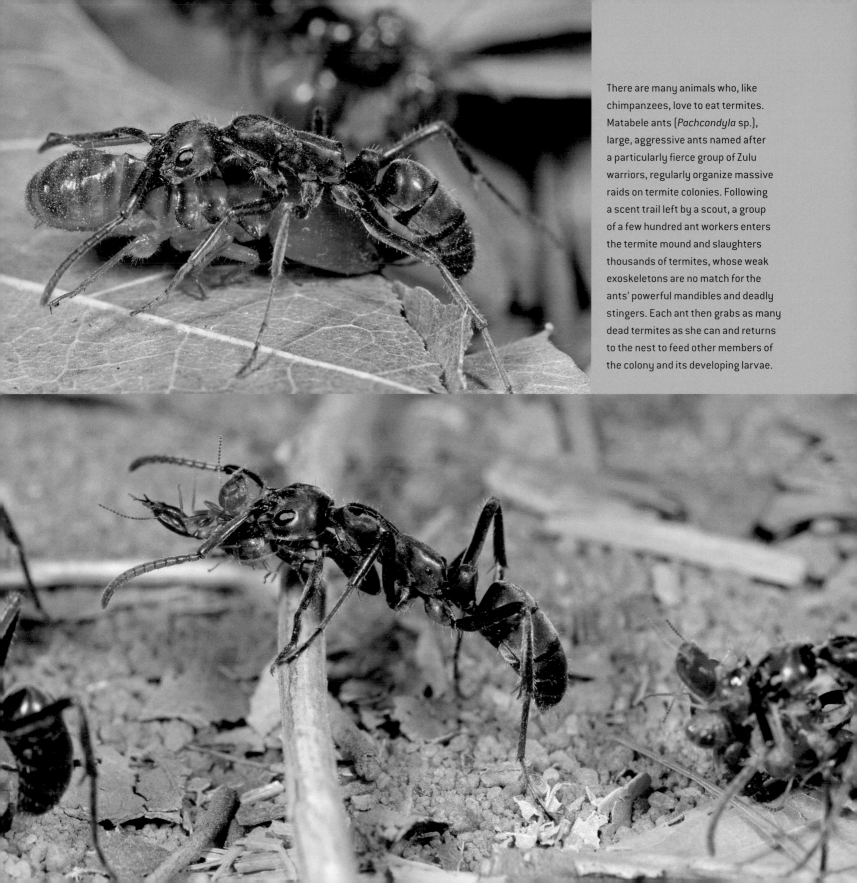

There are many animals who, like chimpanzees, love to eat termites. Matabele ants (*Pachcondyla* sp.), large, aggressive ants named after a particularly fierce group of Zulu warriors, regularly organize massive raids on termite colonies. Following a scent trail left by a scout, a group of a few hundred ant workers enters the termite mound and slaughters thousands of termites, whose weak exoskeletons are no match for the ants' powerful mandibles and deadly stingers. Each ant then grabs as many dead termites as she can and returns to the nest to feed other members of the colony and its developing larvae.

One group of organisms that truly flourish in West Africa is spiders. Nowhere else in the world have I seen similar examples of both spiders that want to disappear and those that want to be seen. The yet-unidentified spider on the right was an impeccable example of a lichen mimic, and it was nearly impossible to identify the different parts of this spider's body.

But the one that impressed me the most was a spider I found one night in Atewa while looking for small arboreal katydids. At first I thought that this quarter-sized animal was either a toy or a piece of jewelry hung by somebody on a branch of a tree. Below it, long, U-shaped strands of exceptionally sticky silk, arranged in a fashion of overlapping curtains, appeared to be very effective for catching flying moths. This animal turned out be an *Aranoethra cambridgei*, one of the rarest and least studied spiders in Africa. Throughout the night I kept running into other rare gems, such as the button spider (*Aetrocantha falkensteini*) and the bola spider (*Cladomelea ornata*). As far as I can tell, none of these spiders has ever been photographed before.

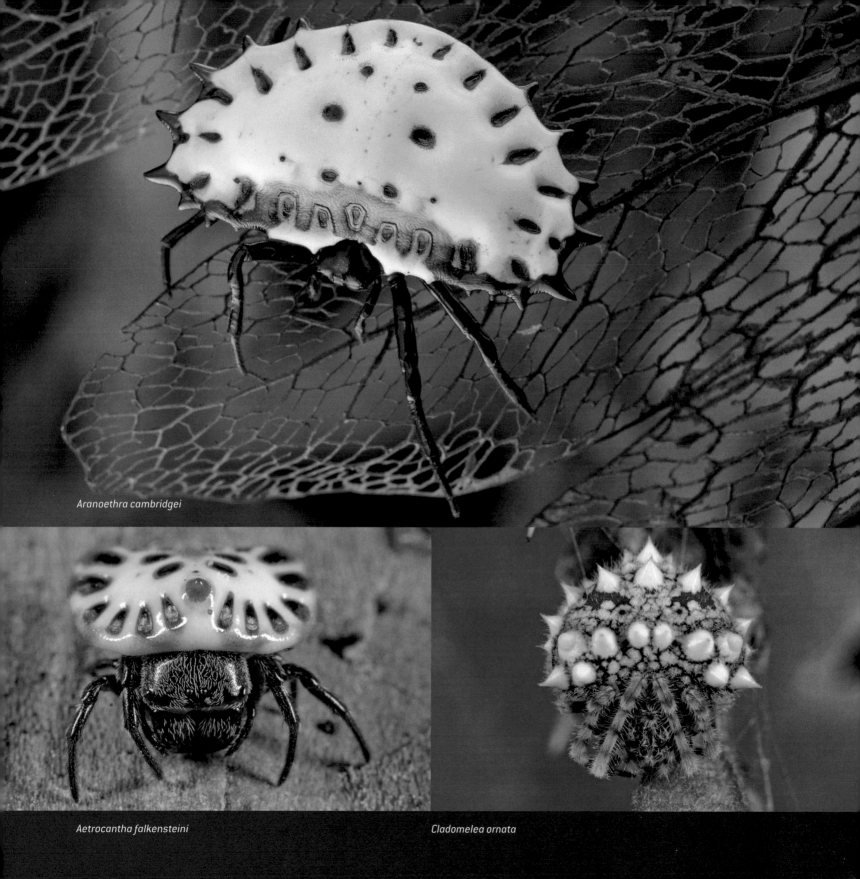

Aranoethra cambridgei

Aetrocantha falkensteini

Cladomelea ornata

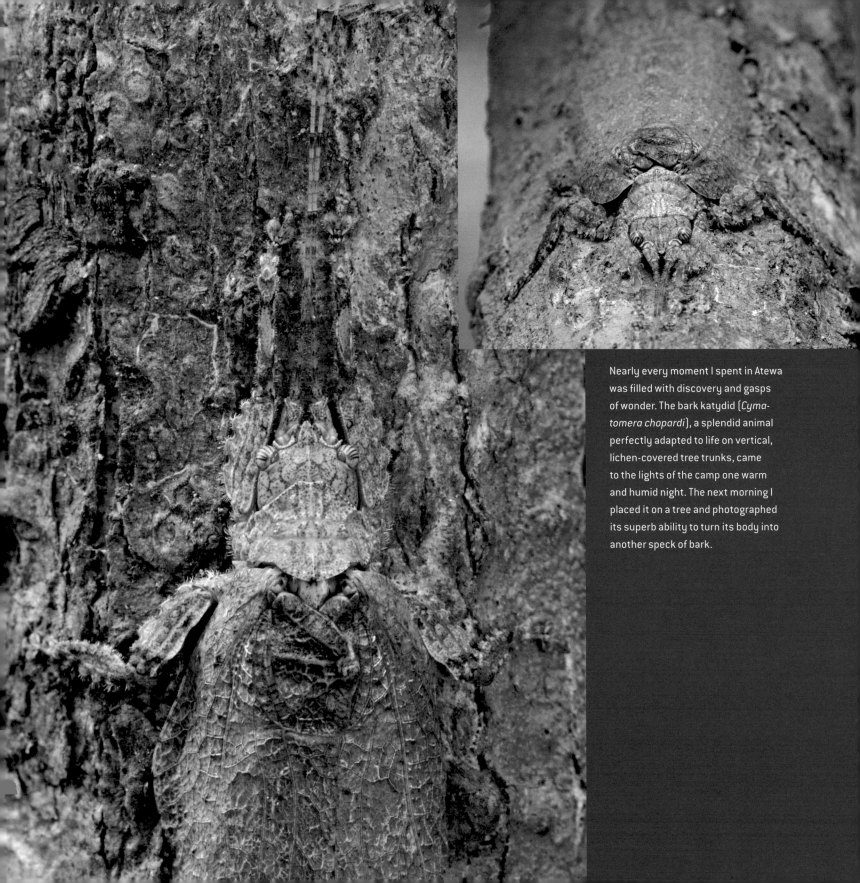

Nearly every moment I spent in Atewa was filled with discovery and gasps of wonder. The bark katydid (*Cymatomera chopardi*), a splendid animal perfectly adapted to life on vertical, lichen-covered tree trunks, came to the lights of the camp one warm and humid night. The next morning I placed it on a tree and photographed its superb ability to turn its body into another speck of bark.

Although I pride myself on knowing African katydids quite well, the Atewa forest left me stumped on more than one occasion. What I initially took for a small green spider turned out to be a nymph of a katydid that to this day I still have not been able to identify. Its spider-mimicking behavior was nothing like anything I have ever seen in this group of insects.

One of the best finds in Atewa was a large, intricately colored leaf mimic, Goete's katydid (*Goetia galbana*). This species has never been recorded in Ghana before, and finding this forest canopy specialist was another piece of evidence for Atewa's nearly pristine condition.

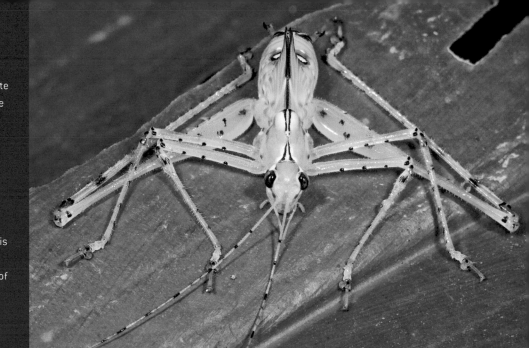

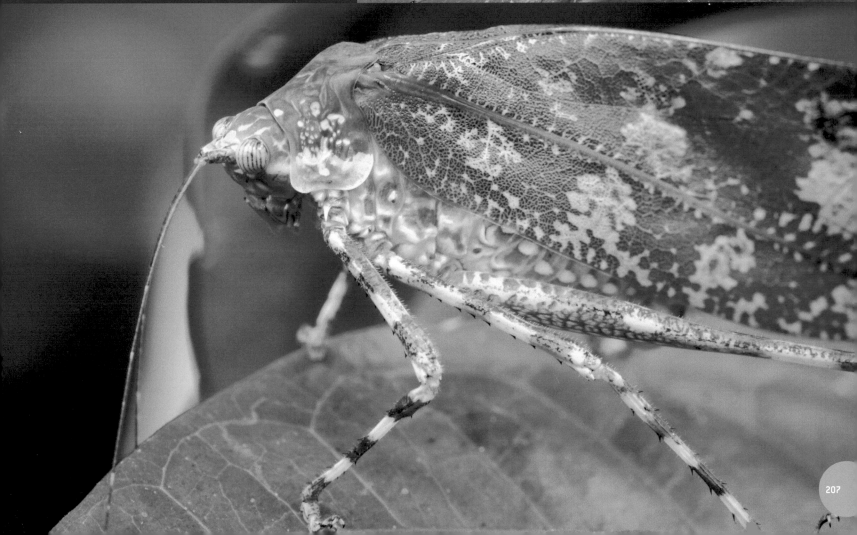

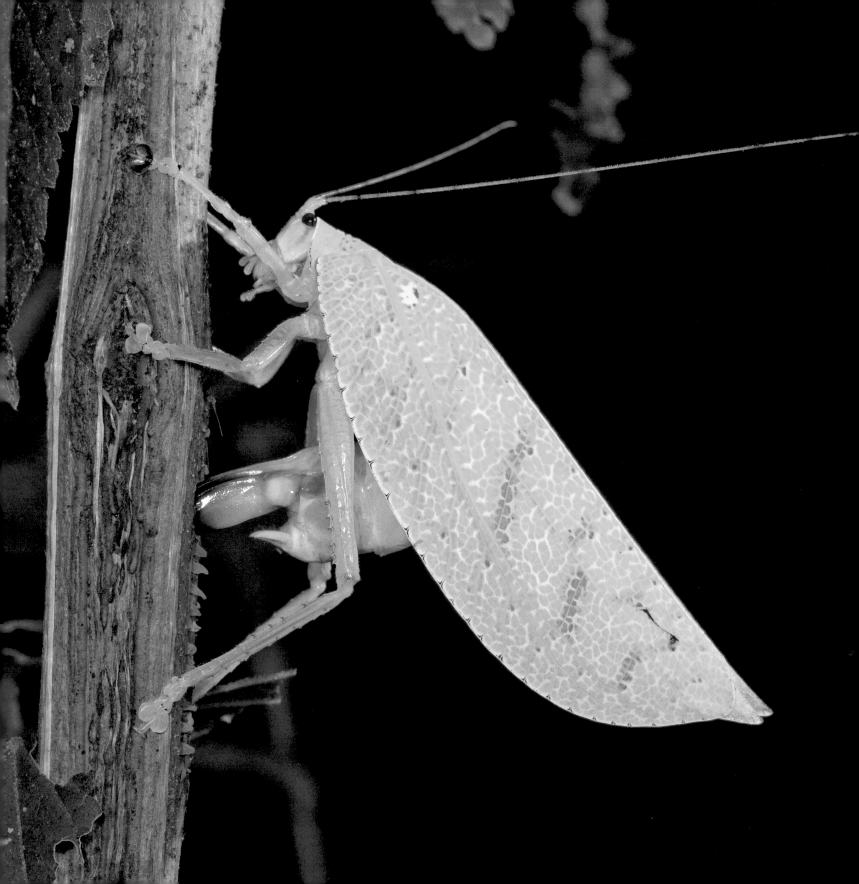

Many arboreal katydids never descend to the ground and complete their entire life cycle high in the canopy. This female of the Afzelius's katydid (*Mustius afzelii*) is using her sturdy, knife-like ovipositor to split the tissues of a liana to deposit her eggs. Here they will be well protected from marauding ants and other predators. Each egg is equipped with a thin collar that protrudes from the stem of the liana, which allows the developing embryo to breathe.

Before the night is over, she returns to the canopy and flattens her body on the underside of a large leaf. Her beautifully reticulate wings blend in perfectly with the venation of the leaf, and as the light shines through the leaf, she completely disappears.

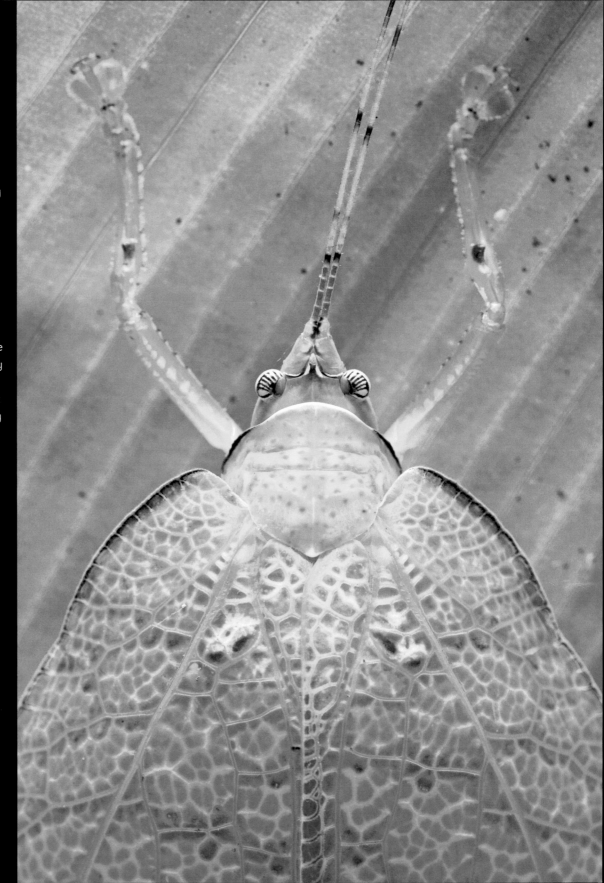

Guiana Shield

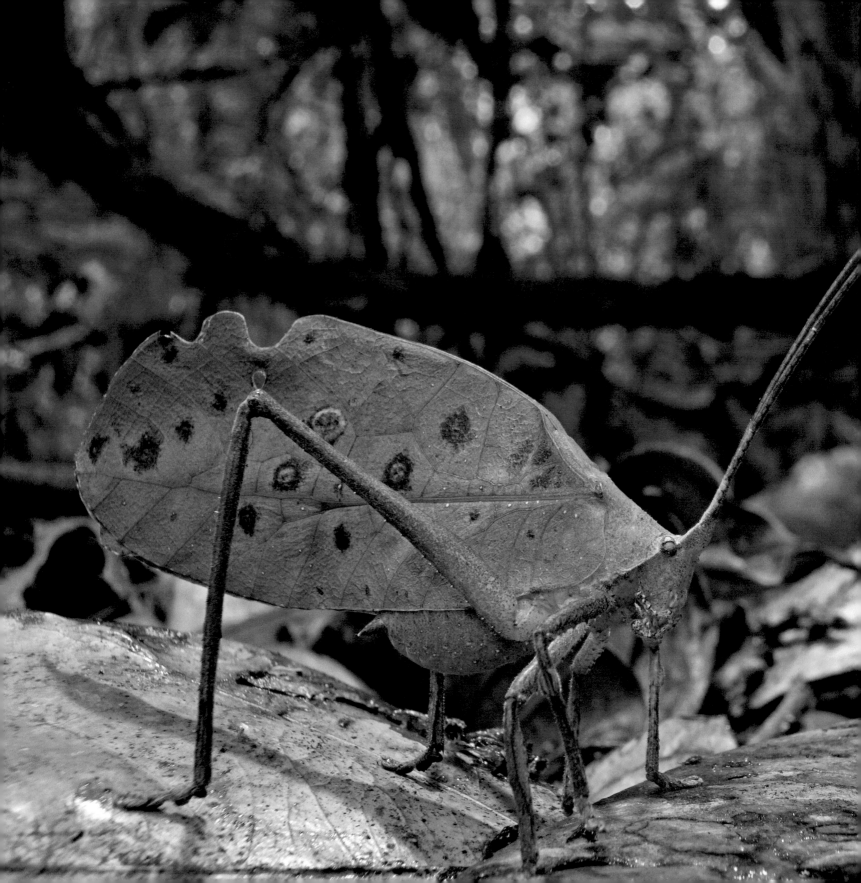

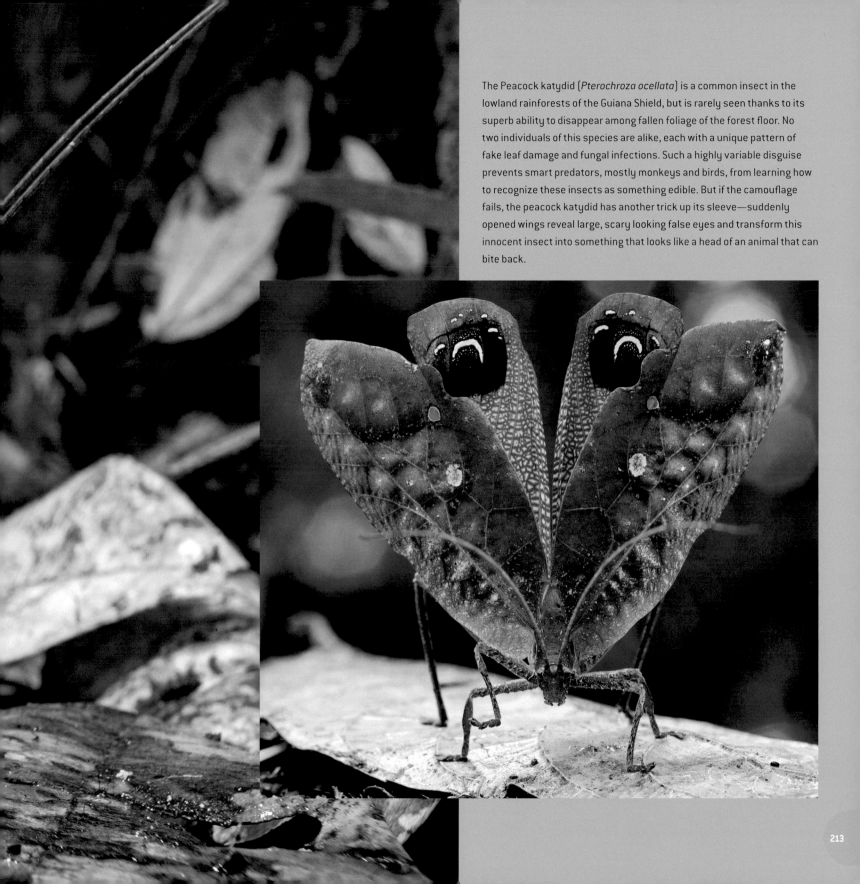

The Peacock katydid (*Pterochroza ocellata*) is a common insect in the lowland rainforests of the Guiana Shield, but is rarely seen thanks to its superb ability to disappear among fallen foliage of the forest floor. No two individuals of this species are alike, each with a unique pattern of fake leaf damage and fungal infections. Such a highly variable disguise prevents smart predators, mostly monkeys and birds, from learning how to recognize these insects as something edible. But if the camouflage fails, the peacock katydid has another trick up its sleeve—suddenly opened wings reveal large, scary looking false eyes and transform this innocent insect into something that looks like a head of an animal that can bite back.

213

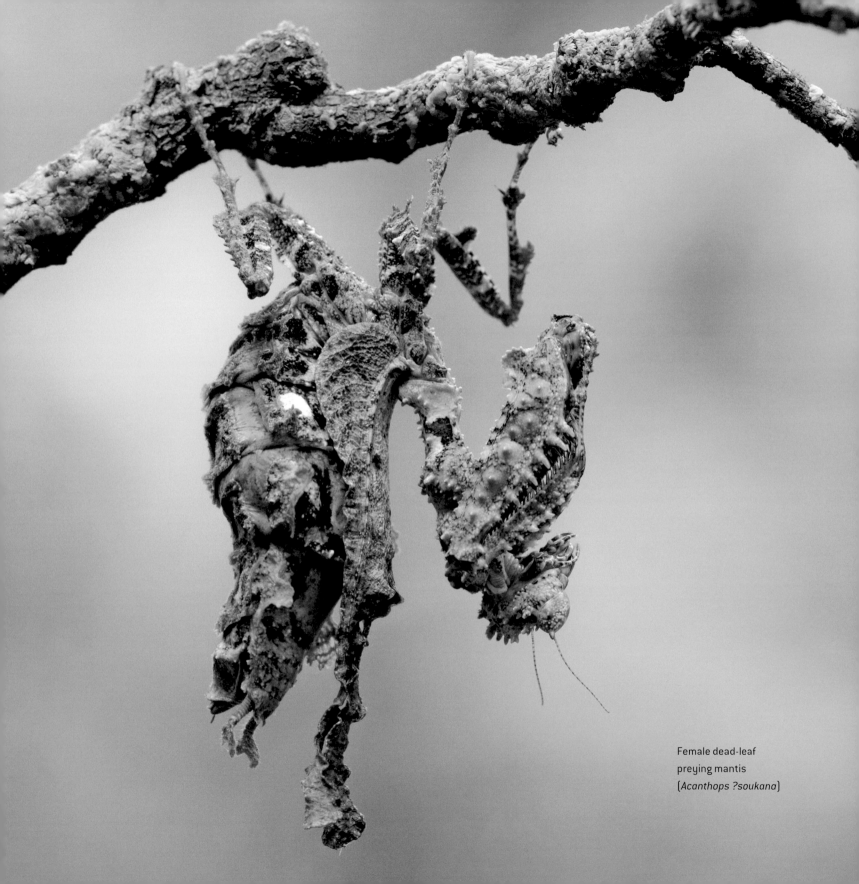

Female dead-leaf
preying mantis
(*Acanthops ?soukana*)

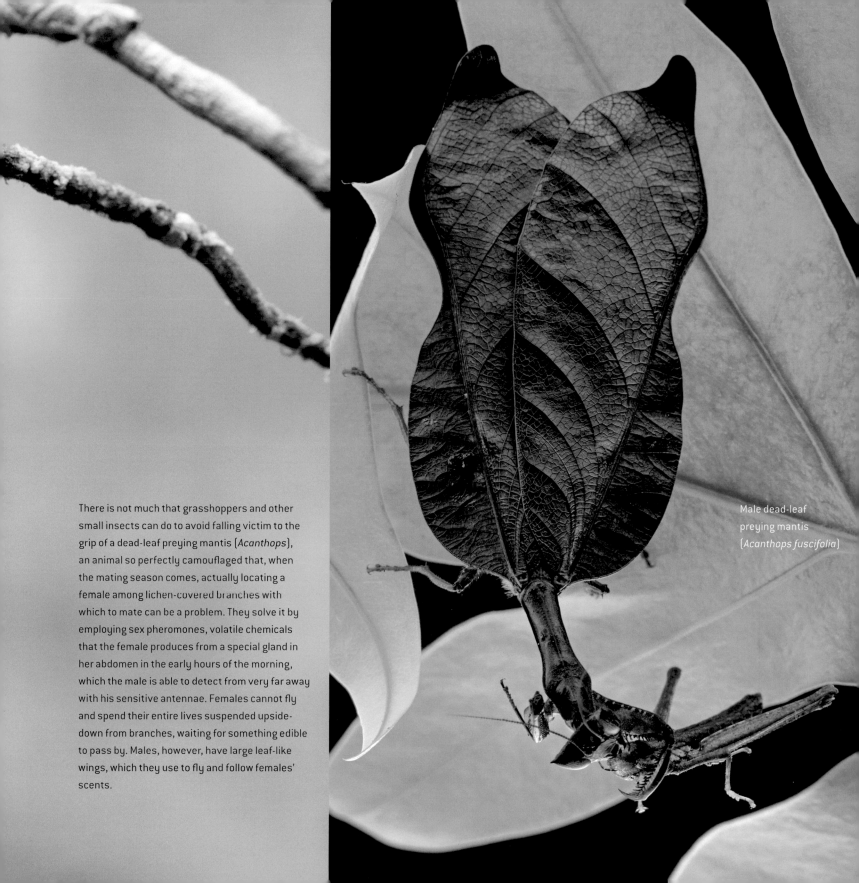

There is not much that grasshoppers and other small insects can do to avoid falling victim to the grip of a dead-leaf preying mantis (*Acanthops*), an animal so perfectly camouflaged that, when the mating season comes, actually locating a female among lichen-covered branches with which to mate can be a problem. They solve it by employing sex pheromones, volatile chemicals that the female produces from a special gland in her abdomen in the early hours of the morning, which the male is able to detect from very far away with his sensitive antennae. Females cannot fly and spend their entire lives suspended upside-down from branches, waiting for something edible to pass by. Males, however, have large leaf-like wings, which they use to fly and follow females' scents.

Male dead-leaf preying mantis (*Acanthops fuscifolia*)

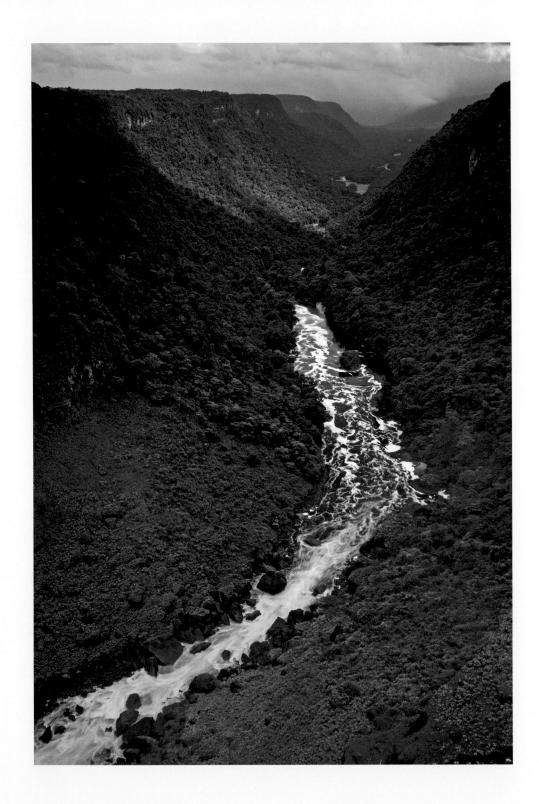

The metallic blue wings of a *Morpho* butterfly moved gracefully up and down with the slow, steady rhythm of a supreme flier confident in its ability to escape out of harm's way with one powerful contraction of its flight muscles. The butterfly slowly circled around the edges of a fire pit in our camp, every minute or so touching the ground for a few seconds at spots where the ash from burnt logs met the soggy ground, releasing precious minerals, sodium mostly, sought after and needed by organisms of the equatorial rainforest. It was a spectacular animal, with the wingspan of a small bird and displaying a cerulean, shimmering gleam unmatched by any other living organism. For centuries these insects have fueled the dreams of butterfly aficionados and have been collected in South America by the thousands to be sold on European markets. But the group of Wai Wai Indians who sat around the fire, chatting and chewing pieces of mystery meat, seemed completely unimpressed by the orbiting marvel of the hexapod evolution. Only one of them, Yaynochi, who in the camp went by his Christian name Reuben, followed it intently with his eyes. He slowly lifted a stick of charred wood, and with a quick swing of his arm threw the piece at the butterfly and hit it with a deadly precision learned from years of hunting with nothing but a flimsy bow and arrow. The insect fell to the ground and fluttered on the wet soil, vainly trying to lift off, its beautiful wings torn, thoracic muscles crushed. Satisfied, Reuben turned away, bored again. Too slow to react, dumbfounded by what I just witnessed, I walked up to the fire and picked up the dying animal. Reuben looked at me and grinned, but when he saw my disappointment a trace of shame flickered on his face. To ask why he destroyed something so graceful and innocent was pointless; I did not think he would have known the answer. His action was a simple test of a physical skill; the butterfly was just a target, and there was no malice in it. He loved the forest he lived in, and the *Morpho* was to him just a common insect, one of thousands of similar butterflies he had seen growing up in the tiny, isolated village of Masakenari in southern Guyana. Rainforests of this area are ecosystems that are some of the biologically richest and least disturbed by human activity in the world, and had I grown up surrounded by such luxuriant exuberance of life my appreciation for a simple butterfly would have probably been similarly dulled. Or maybe not.

The Wai Wai came to the hot, steamy forests of Guyana from nearby Brazil in the late nineteenth century, and by the 1950s almost the entire population of the tribe had concentrated along the upper Essequibo River in the southernmost part of the country, attracted to the Gospel-spreading missionaries who taught them to read and write and helped establish new villages. Later, as the government of the newly independent Guyana became less tolerant of the presence of American evangelists, most of the Wai Wai moved back across the border to Brazil, and all that remained in Guyana were about 150 Wai Wai in a single remote village.

What now surrounds the village, built on a bend of the mighty Essequibo, the third largest river in South America, is an ecosystem so primordial and expansive that to this day many of its parts have remained unexplored. The ancient rainforests that make up the bulk of this environment grow on top of one of the oldest geological formations on the planet, the Precambrian Guiana Shield. Its rocks, which underlie the northern portion of South America, are older than

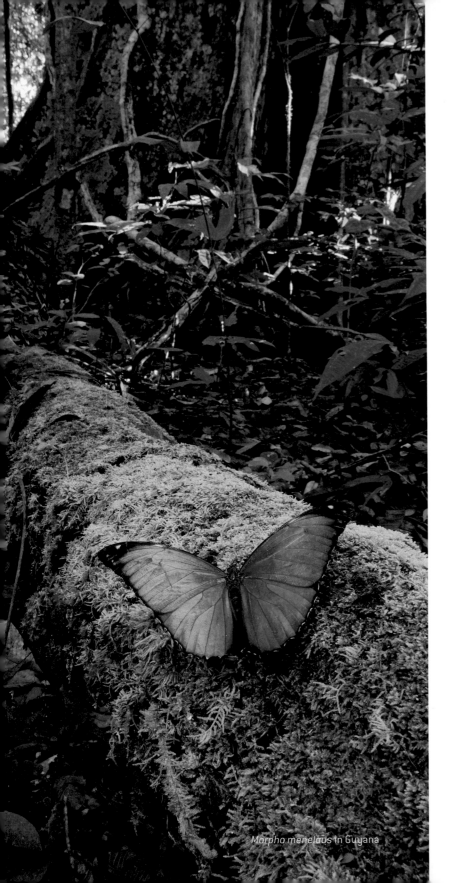

Morpho menelaus in Guyana

life itself, some having originated more than 4 billion years ago, long before the current continents began to take shape. The Guiana Shield was once a part of a larger fragment of the supercontinent Gondwana and carries the memory of being one with West Africa, before a massive rift broke them apart in the Cretaceous, about 135 million years ago. Many parts of the world rest on top of Precambrian rocks, but they are usually buried under thick layers of much younger geologic formations and have little or no effect on what is happening on the surface. But here they are fully exposed, and always have been. Hundreds of millions of years of weathering and leaching has stripped them of anything that can be blown away or dissolved, and in many places their nutrient- and water-holding capacity has largely disappeared. And yet life has found a way of coping with poor or nearly nonexistent soils and has flourished to a degree that has few parallels anywhere else in the world.

Several countries have drawn their borders on top of the Guiana Shield. Suriname, Guyana, and French Guiana are entirely within its area, whereas Venezuela and Brazil incorporate only parts of it into their territories. But despite a long and tumultuous history of colonial conquests (and occasional border disputes that persist between some of its countries to this day), forests of the Guiana Shield have stayed virtually intact and, while supporting enormous biological richness, remain some of the least populated areas of the globe, on par with such inhospitable, frigid places as Nunavut in northern Canada or Siberia. They are, and hopefully always will be, virtually human-free sanctuaries of the New World's pre-Colombian wilderness.

Few areas in South America are less densely populated than Konashen, a southern region of Guyana. Masakenari, the single Wai Wai village located there, is now the only human settlement in an area of more than 625,000 hectares, roughly the size of the state of Delaware. In 2006, when our team arrived to conduct a survey of its fauna, the entire population of the area was 198 people. We came at the invitation

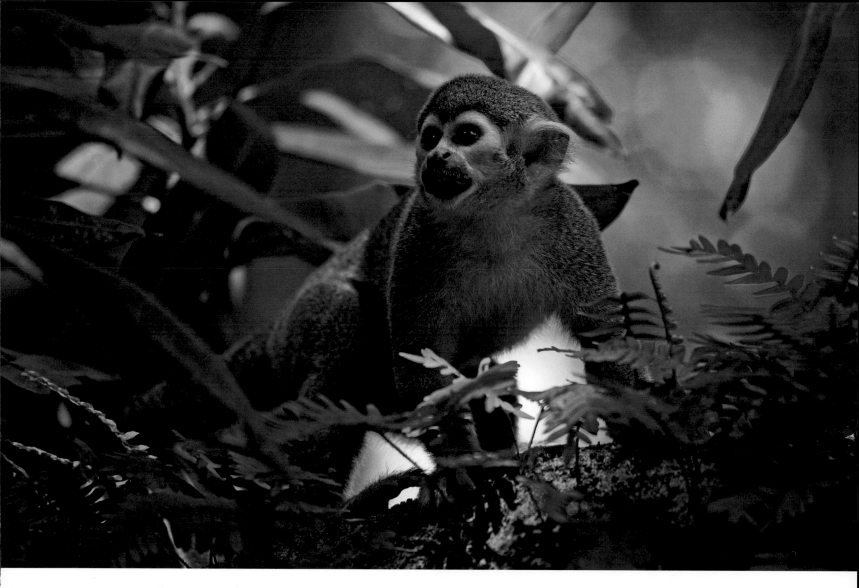

Squirrel monkeys (*Saimiri sciureus*), like this one in French Guiana, are smart, social animals, living in large groups of intricate dominance hierarchy. Their brains are, in proportion to their small bodies, huge. Unfortunately, it appears that mental capacity in primates has a strictly linear relationship with brain mass, which means that only very large species, such as apes and humans, can achieve truly high levels of intelligence.

of the villagers themselves, who had recently been granted by the government of Guyana official ownership of their enormous land and were considering the possibility of developing a small-scale ecotourism industry to generate income needed by their secluded community to purchase medicines and supplies. As the lawful guardians of such enormous bio-logical treasure trove, one hopefully destined to become at some future point a permanently protected area, they also needed to know more about the animals and plants that inhabited its immense forests. In addition, our job was to help them estimate safe hunting and fishing quota for some of their favorite animals, such as caimans, monkeys, and tapirs.

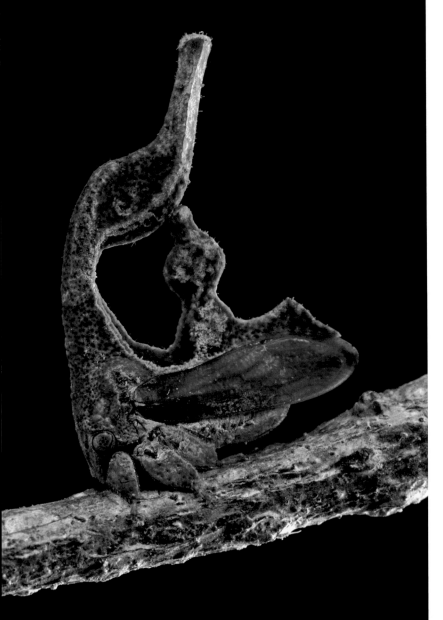

Treehoppers, like this *Cladonota ridicula* in Guyana, may look just like small pieces of debris, but they are insects with complex parental behavior and intricate sound-production mechanisms. Parents often protect their young from predators, and males emit elaborate, low-frequency courtship signals using body vibrations, which are transmitted via the branches of plants on which they feed. This ensures that only nearby females can detect them, and no eavesdropping predators can find the calling males, a significant risk to all insects that produce airborne, audible signals.

We set off in large wooden canoes along the Sipu River, one of Essequibo's tributaries, very early in the morning. Each boat had a small engine, which made moving from one giant fallen tree that blocked the passage on the river to the next one much faster than if we had been using paddles. I don't recall much from the first two days of our river journey. In the excitement of coming to Guyana and flying in a wobbly, tiny plane to Masakenari I forgot to take off my contact lenses for four nights straight, and once the searing pain in my eyeballs finally reminded me to do so, I found myself blind. Luckily, the blindness and the pain lasted for only a day, and when I fully regained my vision a few days later, I found myself in a truly virgin place, the most remote location I had ever been to. We were supposed to set up camp in a place visited once before by a group of botanists from the Smithsonian Institution, but we miscalculated the coordinates and ended up at a site that, as far as we and our Wai Wai hosts knew, had never been visited by modern humans.

The Wai Wai, who spent their lives tracking animals and gathering useful plants, made great, knowledgeable field guides and assistants. They knew which trees were frequently visited by monkeys, how to find a jaguar's hunting trail, or which parts of the river were to be avoided, on the account of the electric eels that made for very memorable, occasionally deadly bathing experiences (not from the electric shock itself, but from drowning following the shock). Alas, I found it difficult to tap into their immense knowledge of the forest. The animals that I was interested in, katydids and their kin, were active mostly at night, when the spirits were out and about, and it took a lot of convincing to get one of the Wai Wais accompany me into the darkness. A couple of days later his headlamp mysteriously died, and he no longer could help me in my nightly hunts. But the Wai Wai did not need to go out at night to find insects; their superb understanding of the forest life and their ability to spot even the most cryptic of sylvan creatures—leaf katydids, stick insects, lichen-mimicking mantids—put my efforts to shame when

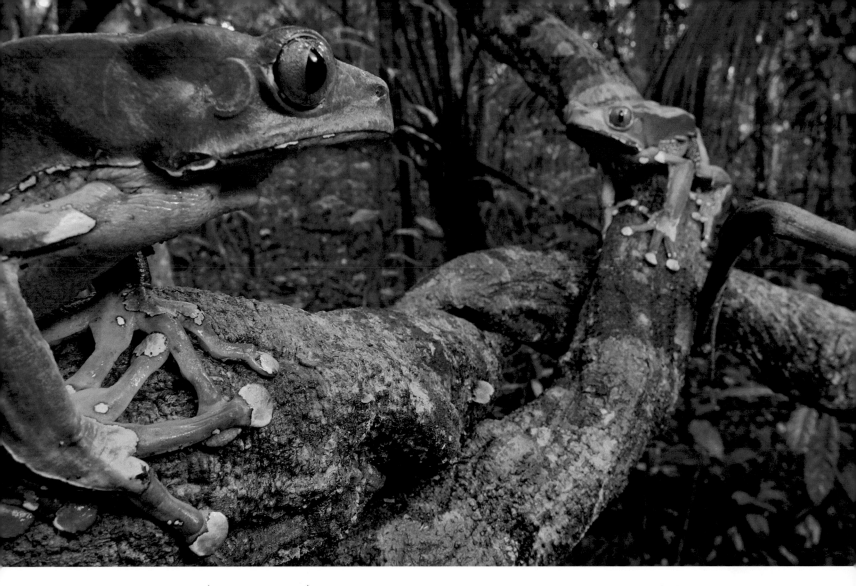

A female of the giant leaf frog (*Phyllomedusa bicolor*) watches the approaching male. Eventually, the pair will produce a big clutch of fertilized eggs, glued to leaves overhanging a forest stream. After eight to ten days, small tadpoles will hatch and fall into the water below to complete their development.

they found these elusive invertebrates during the day. Counterintuitively, finding cryptically colored and shaped animals is easier at night when they are walking and feeding, and the subtle differences in the hue of their bodies versus the surrounding vegetation becomes more pronounced in the light of a flashlight. Spotting them during the day requires a truly superb ability to detect the faintest irregularities in the over-whelming green tapestry of the rainforest. I am also now convinced that their reluctance to be in the forest after dark was a culturally reinforced adaptation that minimized their exposure to the many parasitic and disease-transmitting insects that flourished in the forests of the Guiana Shield. Not that the days were free of them—in some places you had to run to avoid being sucked dry by giant blood-sucking flies—

More terrestrial in its habits than most other crocodilians, the smooth-fronted caiman (*Paleosuchus trigonatus*) can be sometimes found deep in the forest, hunting small land animals. This behavior is particularly common among juvenile individuals, like this one, which I photographed on the forest floor in Guyana.

but nights brought out the really mean ones. Malarial mosquitoes were common, as were tiny sand flies (*Lutzomyia*), carriers of a nasty disease known as leishmaniasis, which eats away at the skin and organs of its victims.

The remoteness of our camp prevented us from bringing enough food to support the combined group of scientists and local field assistants for the entire duration of the survey, but the Wai Wai were more than happy to allow us to use their share of rice and tapioca. Animals in that part of the forest, having never encountered humans, were easy targets for those master hunters, and soon haimaras, caimans, curassows, and pacas—exotic animals I had not thought of

as something edible—became food staples on their plates. Although some of these animals are becoming rare in other parts of South America, southern Guyana still has large, healthy populations of virtually all of its native animals, and the Wai Wai hunting practices were entirely sustainable. Still, it felt wrong to see an endangered turtle on a plate, and our team abstained from partaking of the local cuisine with the exception of the haimara, a giant and very delicious river fish. We also drew the line at tapirs and asked the Wai Wai not to hunt them; I admired their restraint as they watched these huge mammals walk among the tents of the campsite at night, completely unperturbed by our presence. The animals' lack of fear was a good indication of the pristine state of this ecosystem and the minimal footprint the Wai Wai impressed on their landscape. It was also clear that the area had not yet been visited by certain prominent English geologists, who, in the introduction to their monumental treatise on the Guiana Shield geology published in 1993, advised that "the bush cow, or tapir, is not usually savage, and like the hog can make for appetizing meals." And, in case that didn't tickle your fancy, they suggested that "the large constrictors (boa) . . . rarely attack unless disturbed when hungry; indeed, they may themselves be eaten."

But it must be said that our decisions as to what should and should not be hunted by the Wai Wai were often dictated more by the cuteness of their quarry rather than objective, scientific criteria of sustainability or rarity. One late evening, while slowly drifting in a canoe down the river with a team of ornithologists, one of the Wai Wai spotted a male three-toed sloth hanging from a low branch. Sloths are a mammalian equivalent of fruit—immobile, defenseless, tasty—and the Wai Wai quickly picked the ten-pound snack off its branch and tossed it into the boat. Sloths are common in South America and not endangered in any significant way. Unfortunately, the Indians had never encountered Western sensibility, which is heavily skewed toward fuzzy mammals with big, soulful eyes, and the scientists in

the boat protested wildly against turning the animal into a delicious dish (I was not present there, but the term "bawling" was used to describe the reaction of our camp's logistics coordinator). By the time the argument was settled in favor of not eating the sloth, the boat was back at the camp, and we ended up with a big mammal we were not sure what to do with next. Luckily, Chris Marshall, one of the entomologists on our team, realized that sloths were hosts to some unique insects living in their fur, and after a grooming session, which allowed us to collect interesting furtive fauna from the animal's back, we let it climb a large tree at the edge of the camp. Heather, the most vocal proponent of the sloth's release, satisfied with the outcome of her campaign, retreated to her tent, and the whole camp shortly followed. At 9 p.m., a couple of hours after dark, almost everybody was already fast asleep, but for me that was just the beginning of the night. I spent the next few hours in the forest tracing the calls of my beloved katydids (and, as I learned several months later, contracting hideously disfiguring leishmaniasis) and returned to the camp well after midnight. I sat in the silent darkness of the sleeping campsite, enjoying the last sip of water before going to bed, when I heard high above me a strange, crashing sound, followed by a loud thump and a splash in the river. Sloths live in the forest canopy, they have for many millions of years, and are more adept than any other living animal at staying suspended from branches. The last thing you would expect from them is to forget how to do it. But our sloth, for whatever reason, let go of the branch and fell off the tree. He landed in the river and, unfortunately, on his way down he hit one of the boats. When I found him, the sloth was sitting in the shallow water, stunned, his permanent, plaintive smile still on his face. I picked him up, and he wrapped his long, humanoid arms around me, like a child wanting to be comforted. He had a bleeding cut on his back, which I washed with some alcohol. I carried him about a mile from the camp, away from our usual trails and, when I was sure that he was fine, placed him on a trunk of a

tree, and he slowly climbed to the top. I never told Heather what had happened.

About six months later I was back in the Guiana Shield area. I had been invited to lead a group of ecotourists through the countries of the region and was regaling them with tales of natural history, conservation, and survival as we cruised in a well-appointed ship on its rivers, only occasionally stepping ashore to have a leisurely lunch in some swanky, postcard-perfect resort. I really enjoyed this significant upgrade to my usual traveling style, and the trip gave me an opportunity to visit a few places I had not been before. Also, the hideous wounds caused by leishmaniasis on my arms and legs had almost healed, but having just gone through a few weeks of painful chemotherapy to get rid of it I was not quite ready to do any serious fieldwork. To get a bit closer to nature, almost every day we made short forays along smaller rivers and streams in pontoons, and it was during one of those trips that I saw my second sloth in the water. We were moseying up some small tributary of the Amazon in northern Brazil, and the poor thing was tied to a wooden post that supported a fishing platform, clearly destined to become somebody's dinner. It was tethered by its hind leg, and it had been struggling, very slowly, to escape, but each attempt invariably ended in the animal falling off the platform into the water. My heart was breaking, but there was nothing I could do to help. Releasing the animal would amount to stealing somebody's private property, and arguing for its release with its owner would certainly sour the relationship the tour operators had established with the

After a few nights in the rainforests of Guyana it became obvious to me that I would never be able to avoid getting bitten by the ever-present sand flies (*Lutzomyia*), carriers of parasitic protozoans that cause the disease leishmaniasis, and I might as well take some photos of these insects. Not surprisingly, a couple of months after these pictures were taken I developed symptoms of the disease, and only after weeks of painful chemotherapy was I able to regain my health.

Dawn hours in many areas of the Guiana Shield reverberate with loud roars and howls of the red howler monkey (*Alouatta seniculus*). The main purpose of these amazing acoustic displays is to establish territorial boundaries of individual troops of these leaf- and fruit-eating primates, which helps them avoid the need for physical confrontations. Red howlers generally refrain from direct, physical violence, and, interestingly, the only known case of this species using tools is an observation of one the monkeys gently poking with a stick a sloth that occupied the same tree, apparently trying to make it move somewhere else. In the end, the sloth stayed, and the monkeys left the tree. (Venezuela)

local people; we had been sternly warned not to interfere with their affairs. I anticipated trouble—surely, this group of sensitive, nature-loving people I was leading would be even more concerned for the cute mammal's well-being than a bunch of rational, cold-hearted scientists. I glanced apprehensively at my eco-conscious passengers; somebody yawned, another person took a photo then lifted the binoculars to look at a bird above. An older lady in a wide-brimmed hat looked at me with a worried expression on her face: "How much longer till lunch?" she asked.

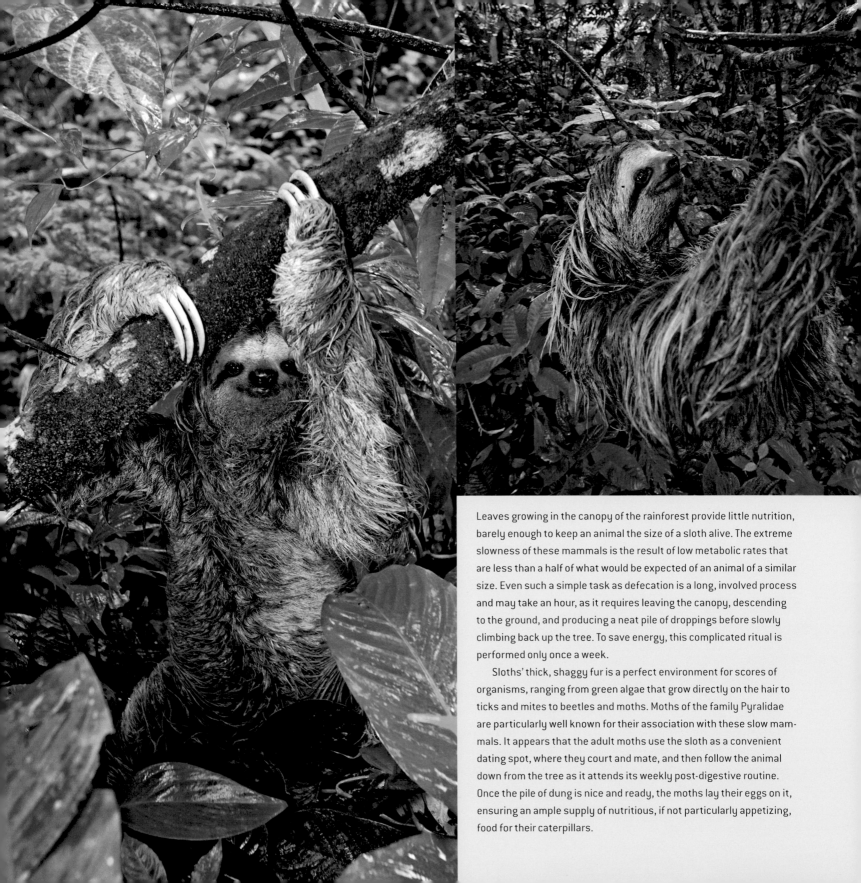

Leaves growing in the canopy of the rainforest provide little nutrition, barely enough to keep an animal the size of a sloth alive. The extreme slowness of these mammals is the result of low metabolic rates that are less than a half of what would be expected of an animal of a similar size. Even such a simple task as defecation is a long, involved process and may take an hour, as it requires leaving the canopy, descending to the ground, and producing a neat pile of droppings before slowly climbing back up the tree. To save energy, this complicated ritual is performed only once a week.

Sloths' thick, shaggy fur is a perfect environment for scores of organisms, ranging from green algae that grow directly on the hair to ticks and mites to beetles and moths. Moths of the family Pyralidae are particularly well known for their association with these slow mammals. It appears that the adult moths use the sloth as a convenient dating spot, where they court and mate, and then follow the animal down from the tree as it attends its weekly post-digestive routine. Once the pile of dung is nice and ready, the moths lay their eggs on it, ensuring an ample supply of nutritious, if not particularly appetizing, food for their caterpillars.

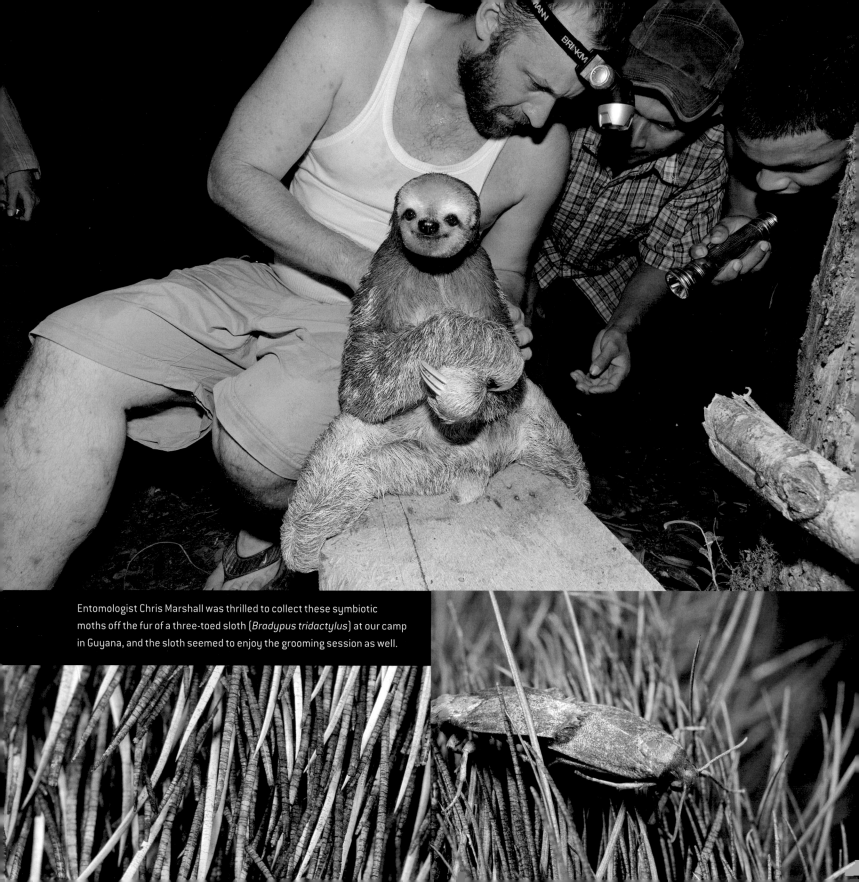

Entomologist Chris Marshall was thrilled to collect these symbiotic moths off the fur of a three-toed sloth (*Bradypus tridactylus*) at our camp in Guyana, and the sloth seemed to enjoy the grooming session as well.

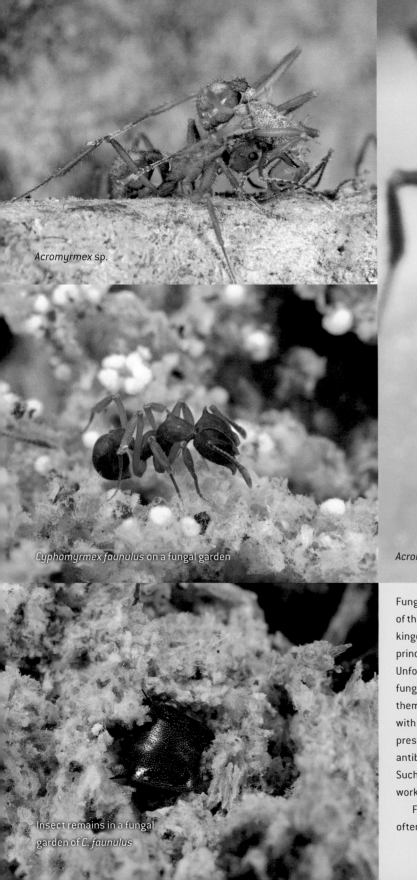

Acromyrmex sp.

Cyphomyrmex faunulus on a fungal garden

Insect remains in a fungal garden of *C. faunulus*

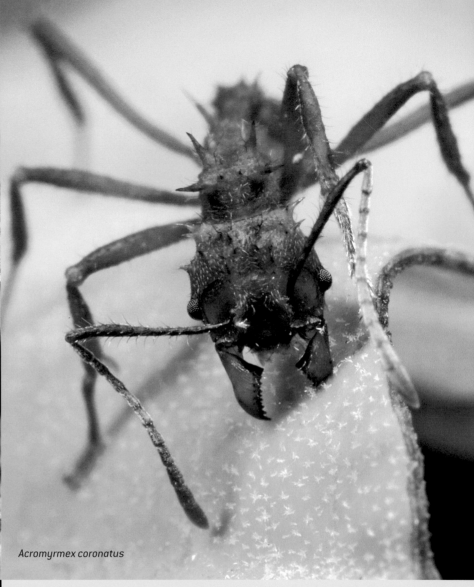

Acromyrmex coronatus

Fungus-growing ants (Attini), one of the dominant groups of insects in the forests of the Guiana Shield, build some of the most complex societies known in the animal kingdom. Deep in their underground colonies they grow and harvest fungi, their principal source of food, collecting leaves or detritus to fuel the growing mycelia. Unfortunately, their fungal gardens sometimes fall victim to the parasitic micro-fungus *Escovopsis*, which may lead to the collapse of the entire colony. To protect themselves against the parasite, the ants have evolved a mutualistic relationship with a bacterium of the genus *Pseudoncardia*, which produces antibiotics that suppress the growth of the parasitic *Escovopsis*. Some workers in the colony carry the antibiotic-producing bacterium on their bodies, seen as a white, powdery coating. Such medicine-carrying individuals are carefully protected and transported by other workers if the colony needs to relocate (upper left).

Fungus-growing ants display a finely developed polyethism—a division of labor often accompanied by extreme differences in body size.

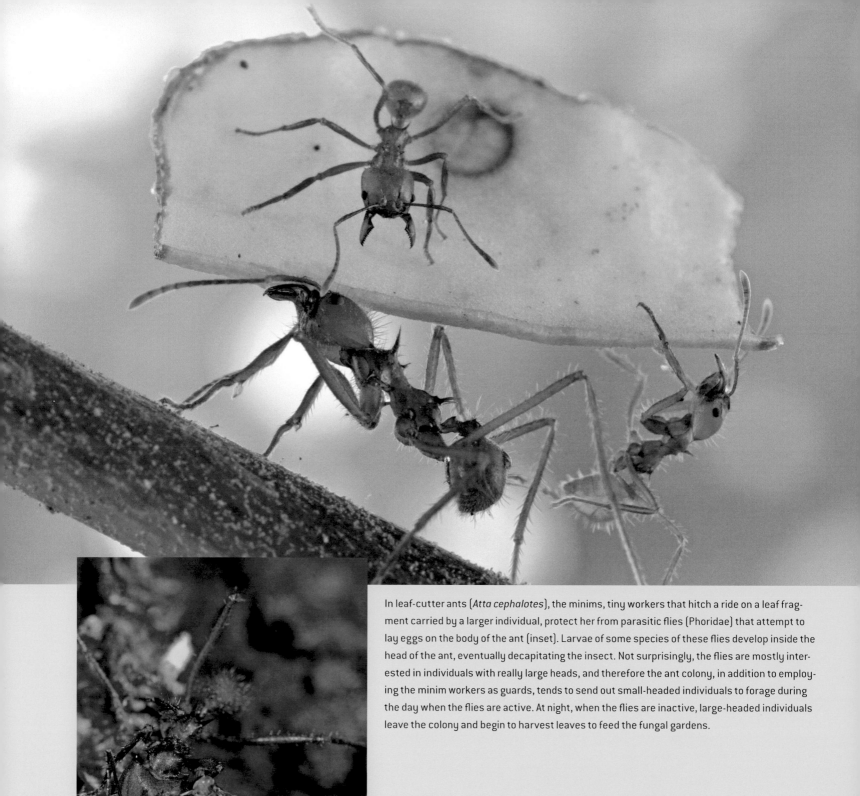

In leaf-cutter ants (*Atta cephalotes*), the minims, tiny workers that hitch a ride on a leaf fragment carried by a larger individual, protect her from parasitic flies (Phoridae) that attempt to lay eggs on the body of the ant (inset). Larvae of some species of these flies develop inside the head of the ant, eventually decapitating the insect. Not surprisingly, the flies are mostly interested in individuals with really large heads, and therefore the ant colony, in addition to employing the minim workers as guards, tends to send out small-headed individuals to forage during the day when the flies are active. At night, when the flies are inactive, large-headed individuals leave the colony and begin to harvest leaves to feed the fungal gardens.

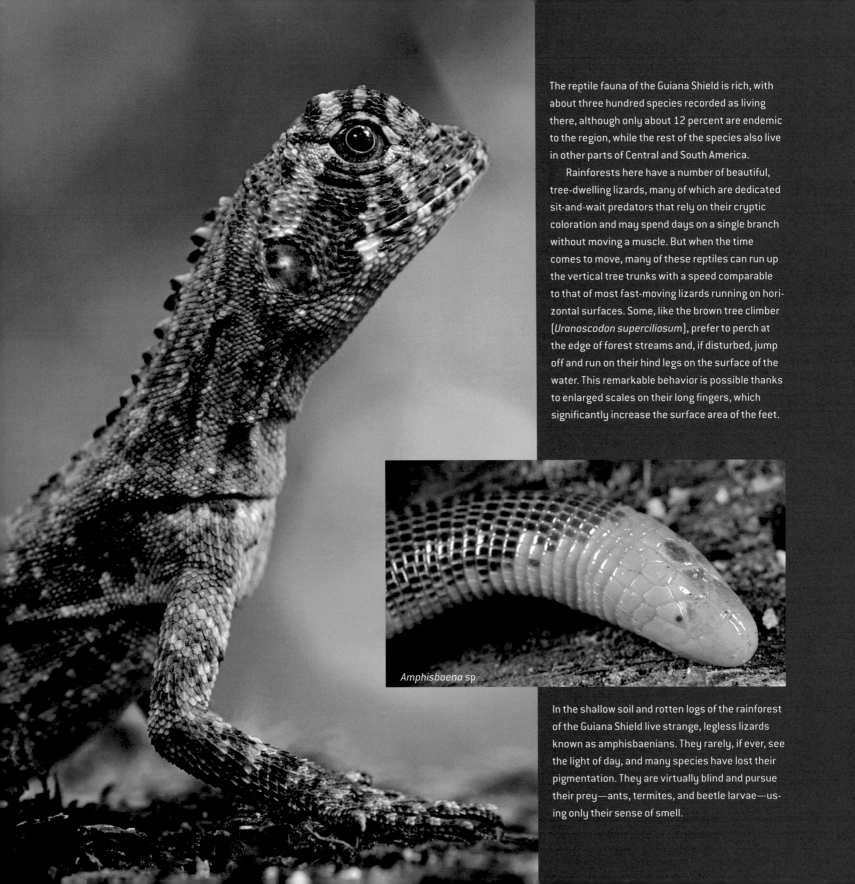

The reptile fauna of the Guiana Shield is rich, with about three hundred species recorded as living there, although only about 12 percent are endemic to the region, while the rest of the species also live in other parts of Central and South America.

Rainforests here have a number of beautiful, tree-dwelling lizards, many of which are dedicated sit-and-wait predators that rely on their cryptic coloration and may spend days on a single branch without moving a muscle. But when the time comes to move, many of these reptiles can run up the vertical tree trunks with a speed comparable to that of most fast-moving lizards running on horizontal surfaces. Some, like the brown tree climber (*Uranoscodon superciliosum*), prefer to perch at the edge of forest streams and, if disturbed, jump off and run on their hind legs on the surface of the water. This remarkable behavior is possible thanks to enlarged scales on their long fingers, which significantly increase the surface area of the feet.

Amphisbaena sp.

In the shallow soil and rotten logs of the rainforest of the Guiana Shield live strange, legless lizards known as amphisbaenians. They rarely, if ever, see the light of day, and many species have lost their pigmentation. They are virtually blind and pursue their prey—ants, termites, and beetle larvae—using only their sense of smell.

The emerald and black mottled treerunner (*Plica plica*) is a large agile lizard that feeds exclusively on ants. Its agility is demonstrated immediately upon hatching from an egg. If, at the end of the eggs' development, which usually takes place in an elevated pile of leaves, a predator disturbs the nest, all eggs immediately hatch within seconds of each other, and young lizards scatter in all directions with blinding speed. This behavior is bound to confuse the predator, and leave it baffled, with an empty eggshell in its mouth.

Superficially similar and found in the same type of habitat as amphisbaenians, another worm-like animal hunts termites and ants in the soils and rotten tree trunks of the Guiana Shield. This is not a lizard, or even a reptile, but a caecilian, a blind and legless relative of frogs and salamanders.

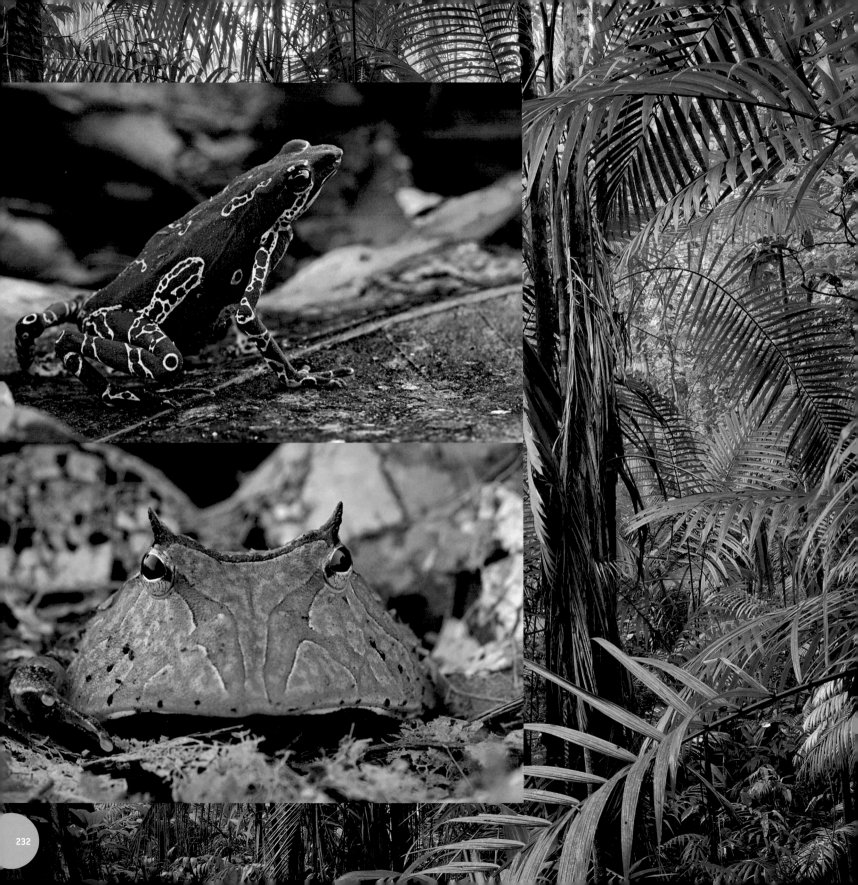

Over 270 species of amphibians—frogs, toads, and legless caecilians—are known from the forests of the Guiana Shield, and over 50 percent of these cannot be found anywhere else in the world. Many of them are highly threatened, and some species, including several harlequin toads (*Atelopus*) have already gone extinct, due to the combined effects of habitat loss and parasitic chytrid fungi that attack the skin of these amphibians. In Suriname's Browns-berg Nature Park the stubfoot harlequin toad (*A. spumarius*) is still relatively common, but in other parts of South America its populations have severely declined or completely disappeared.

The leaf litter of Suriname's rainforests also hides a voracious, large-headed horned frog (*Ceratophrys cornuta*), a sit-and-wait predator capable of swallowing prey nearly as big as its own body, including other frogs and mice.

Shallow, slow-flowing streams and swamps of the Guiana Shield are home to the flat and leaf-like Suriname toad (*Pipa pipa*), a completely aquatic amphibian that exhibits one of the most remarkable forms of parental care known among animals.

During the breeding season, the male calls the female by producing underwater a series of sharp clicks with a hyoid bone in his throat. Once she is appropriately charmed, the pair commences a strange, ritualized dance in the water, during which the female expels the eggs, while the male fertilizes them and then, using his feet, pushes them onto the back of the female. The eggs' sticky coating allows them to stay on her back, and after a few days they become embedded in it, eventually disappearing under the surface of the female's skin, where the entire development of the eggs will take place. Hidden in the mother's skin, the eggs develop into miniature aquaria, each with a quickly growing tadpole inside. Once their development is completed, perfectly formed, tiny toads break the surface of their mother's skin and emerge, ready to start independent life.

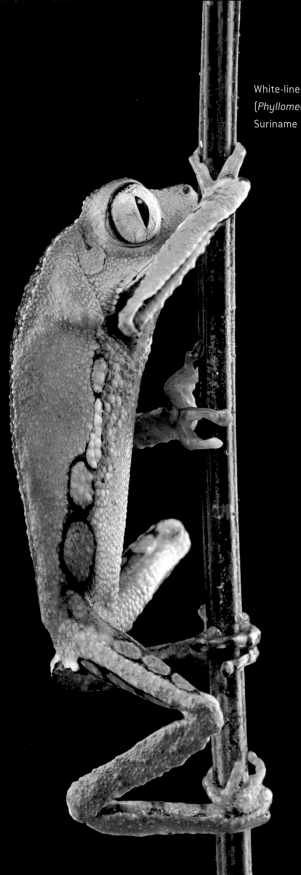

White-lined monkey frog
(*Phyllomedusa vaillanti*),
Suriname

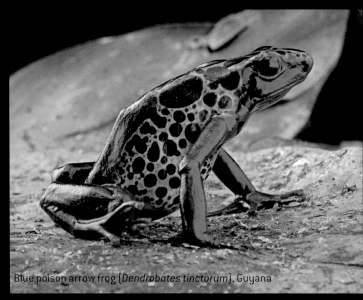

Blue poison arrow frog (*Dendrobates tinctorum*), Guyana

The gorgeous coloration of poison arrow frogs (Dendrobatidae) advertises the toxic properties of their skin, which contains alkaloids sequestered from ants, the primary diet of these amphibians.

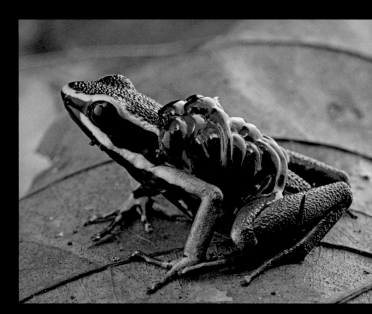

In three-striped poison frogs (*Ameerega trivittata*) from Suriname, the female lays her eggs in the wet leaf litter and, after they hatch, the male carries tadpoles on his back to the water.

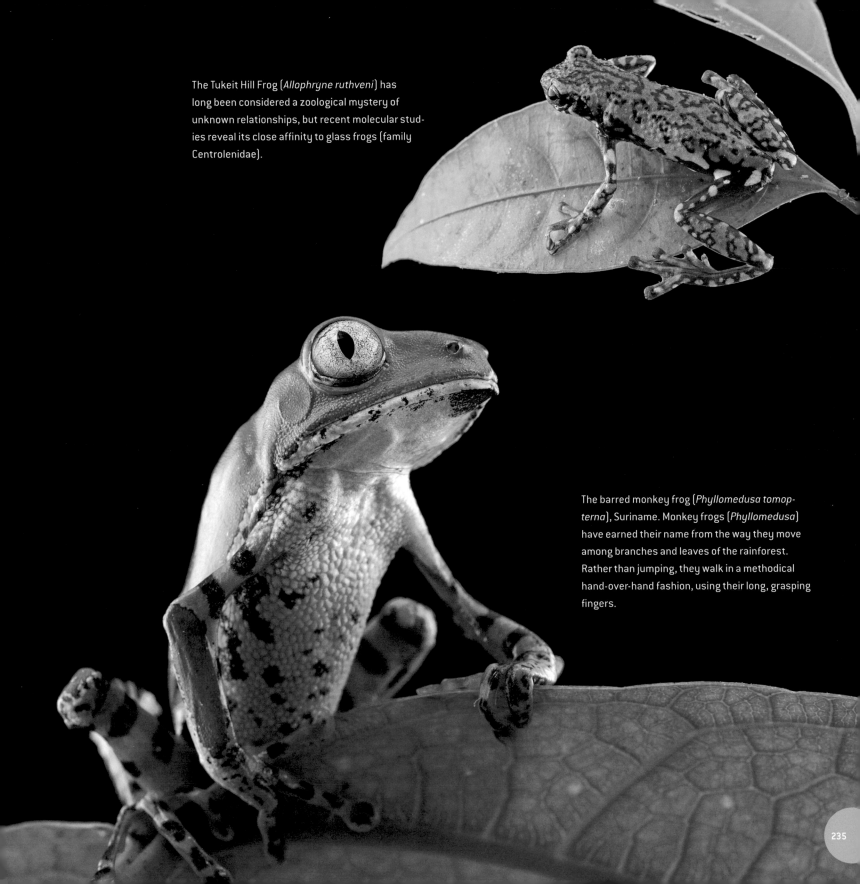

The Tukeit Hill Frog (*Allophryne ruthveni*) has long been considered a zoological mystery of unknown relationships, but recent molecular studies reveal its close affinity to glass frogs (family Centrolenidae).

The barred monkey frog (*Phyllomedusa tomopterna*), Suriname. Monkey frogs (*Phyllomedusa*) have earned their name from the way they move among branches and leaves of the rainforest. Rather than jumping, they walk in a methodical hand-over-hand fashion, using their long, grasping fingers.

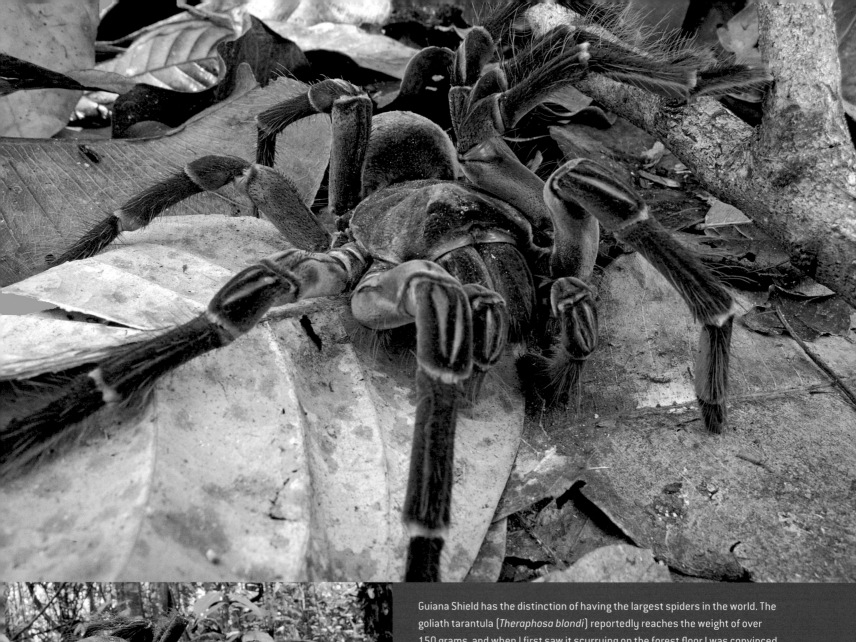

Guiana Shield has the distinction of having the largest spiders in the world. The goliath tarantula (*Theraphosa blondi*) reportedly reaches the weight of over 150 grams, and when I first saw it scurrying on the forest floor I was convinced that it was a small mammal. Tarantulas, despite their size, are generally harmless to humans, and their main line of defense is not their fangs, but the dense hair that covers their bodies. Each hair on the spider's body is equipped with microscopic barbs that easily lodge in the skin and mucus membranes of an attacker, causing painful irritation. Female goliath spiders weave some of their hairs into the silk surrounding the egg sack, a behavior that provides an additional layer of protection for the developing embryos.

Sometimes referred to as bird-eating spiders, tarantulas hardly have an opportunity to catch birds, being active mostly at night among the leaf litter of the forest floor. Their diet consists mostly of invertebrates, and even the goliath tarantula often feeds on earthworms.

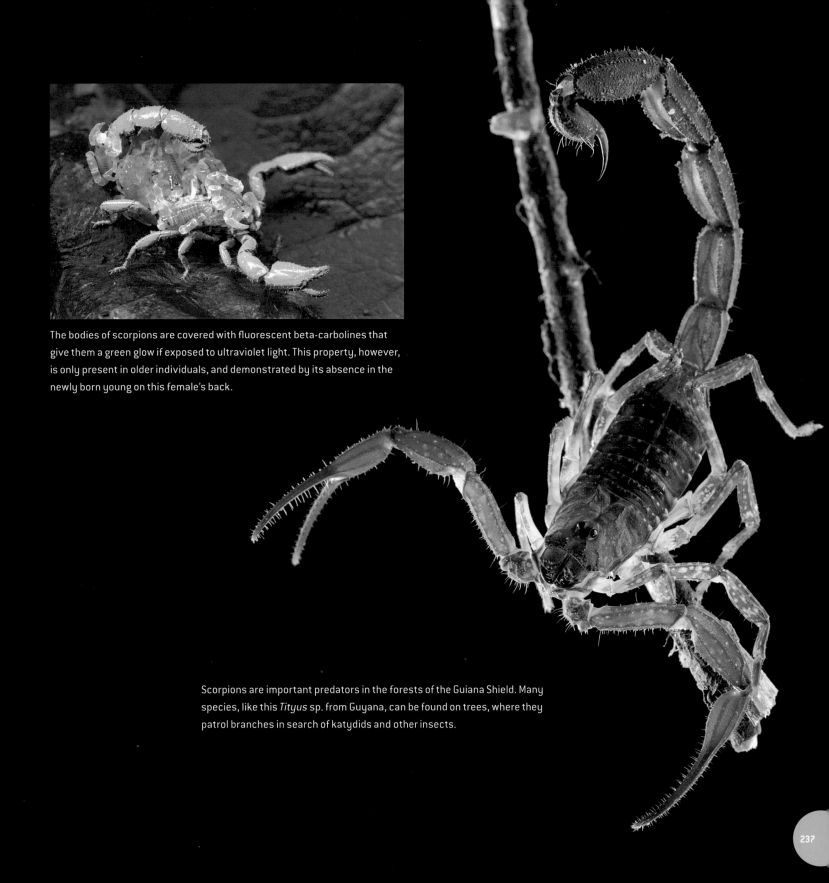

The bodies of scorpions are covered with fluorescent beta-carbolines that give them a green glow if exposed to ultraviolet light. This property, however, is only present in older individuals, and demonstrated by its absence in the newly born young on this female's back.

Scorpions are important predators in the forests of the Guiana Shield. Many species, like this *Tityus* sp. from Guyana, can be found on trees, where they patrol branches in search of katydids and other insects.

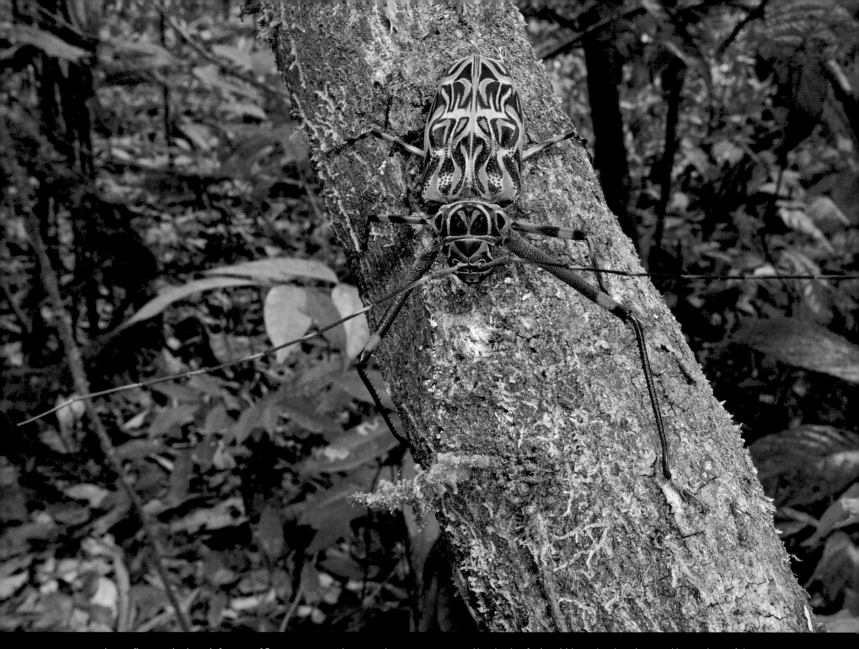

Large fig trees in the rainforests of Guyana serve as hosts to the spectacular harlequin beetles (*Acrocinus longimanus*), which complete their larval development in the wood of these plants. Interestingly, the body of this giant insect is in itself a vibrant ecosystem for several species of smaller animals.

Hundreds of mites hide under the wings and in crevices of the beetle's body, using the insect as a convenient way to move from place to place (opposite, left). This type of behavior, where one animal uses another one solely for transportation, is known as phoresy. The mites also serve as food for another passenger, a pseudoscorpion

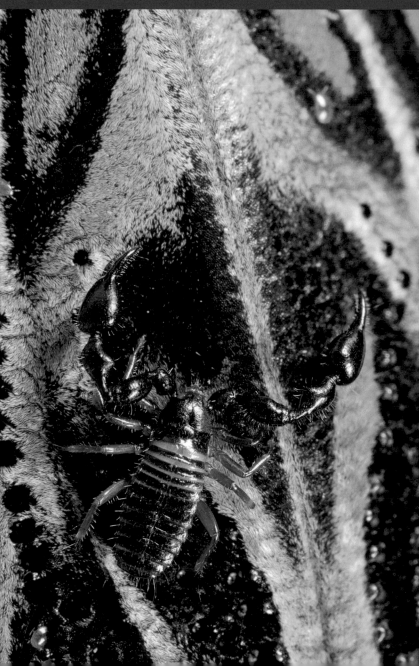

beetle they will end up on another tree of the same species. This also means that the beetle's back is a great place to meet new partners who hopped on it to look for new fig trees to colonize, and a lot of courtship and mating activity takes place among pseudoscorpions under the covers of the beetle's wings. Some male pseudoscorpions never leave the beetle because they know that with each landing on a fig tree new females will embark, giving him more chances to pass on his genes.

(*Cordylochernes scorpioides*; right). But the tasty mites are not the main reason why pseudoscorpions embark on the beetle's back. These arachnids spend their lives on the same fig trees that the beetles need to develop and where they seek mating partners, and thus the pseudoscorpions can be assured that by hitching a ride on a harlequin

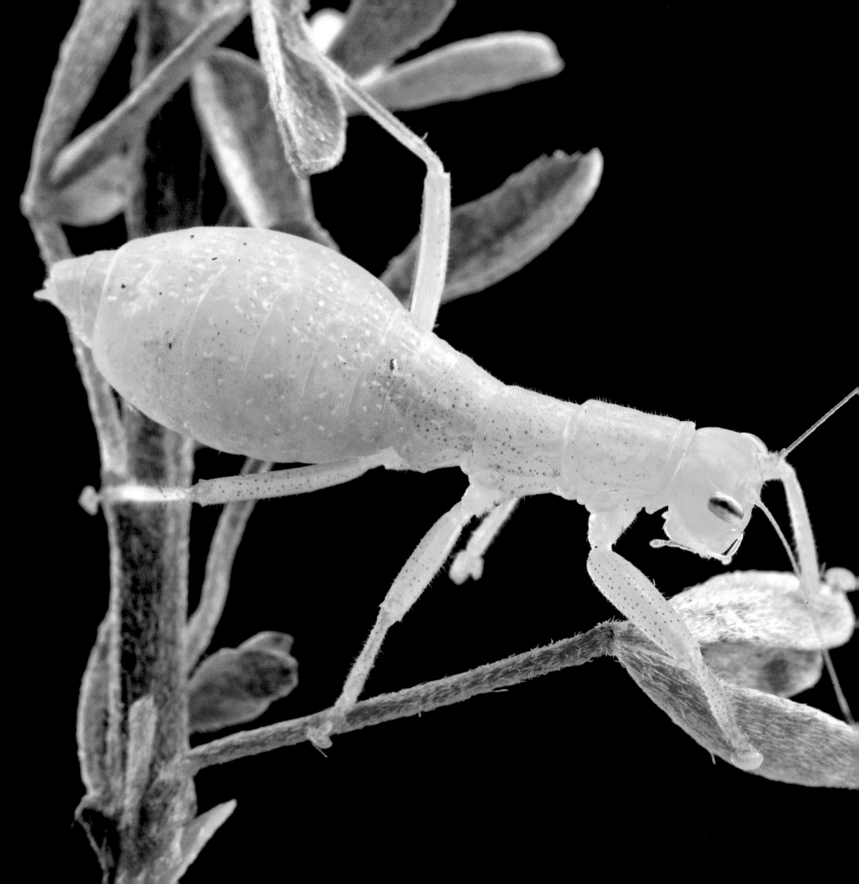

The Yin and Yang of the Notoptera

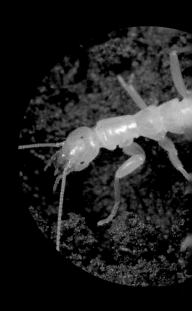

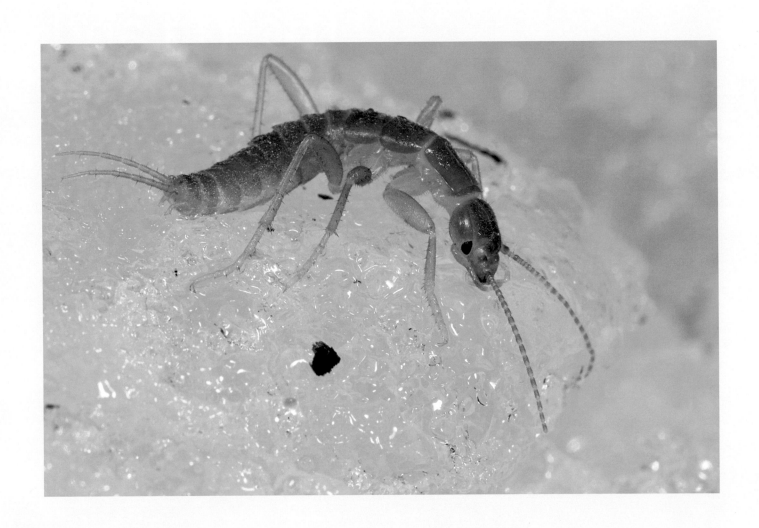

And what *exactly* will you be doing here?" asked the Canadian immigration official at the airport, her icy voice leaving no question of her northern provenance. "Why, looking for ice crawlers, of course," I wanted to answer truthfully, but instead I meekly mumbled something about a professional meeting and visiting a friend. When you carry an Eastern European passport and a case of suspicious photographic gizmos it is better to appear "normal." But in fact I was going to Alberta, Canada, primarily to see one of the world's most fascinating Mesozoic relics, the grylloblattid, also known as the icebug or ice crawler. Shortly before, my friend Derek Sikes, then a professor of entomology at the University of Calgary, had sent me a scintillating photo he took on a field trip near Banff National Park of one of these insects. To the untrained eye these animals appear rather plain—their roughly inch-long, pale brown body is devoid of wings or any exciting appendages—but to an entomologist they are as mesmerizing as a lame squirrel is to a dog.

Ice crawlers were first discovered in 1914 by a Canadian entomologist Edmund M. Walker in a place known as Sulphur Mountain. He immediately recognized their uniqueness, as these insects seemed to combine characteristics of several very distinct lineages of insects into one neat package. Their overall appearance resembled primitive relatives of insects, the Diplura, or two-pronged bristletails, but at the same time they had features reminiscent of both cockroaches and crickets. He created a new family of insects for them, which was soon elevated to the status of a new order, the mellifluous Grylloblattodea. An order is a major grouping of organisms, and

Grylloblatta campodeiformis from Canada

finding a new one does not happen often; elephants, turtles, or flies are examples of some. In fact, this was the last time a new order of insects was ever discovered, or so everybody thought.

The next day Derek took me to the spot where he encountered his ice crawler, which also happened to be just a few miles away from the place where these insects were first discovered nearly a century before. It was late October—fall for Canadians, suicide-inducing frigidity for others—and I soon found myself plowing through knee-deep snow, cursing my naïveté in thinking that any insect could possibly survive in such conditions. We dug in the snow until we reached a layer of cold but unfrozen leaves and detritus. And there, among slowly moving mites and beetle larvae we found the ice crawlers. Entomologists, unlike birders, usually do not keep life lists of insects (with nearly a million described species it would be tough to ever complete one), but seeing my first ice crawler was akin to checking off the first kiwi on a birder's life list. These insects are a strange breed. Only twenty-eight species are known, and they are found only in colder regions of North America and the Far East of Asia. The American species live mostly along the northern coast of the United States and Canada, in the Cascade and Sierra Nevada ranges. There you can find them on northern talus slopes of mountains, as high as three thousand meters or in ice caves. These insects clearly love cold weather. Their optimal temperature of activity hovers around the freezing point, and you can easily kill one by touching it due to the warmth of your hand. And yet they are also not really good at surviving in the extreme cold—a drop in the temperature to below -9°C will also cause them to die. Unlike other cold-loving insects they have never evolved the appropriate levels

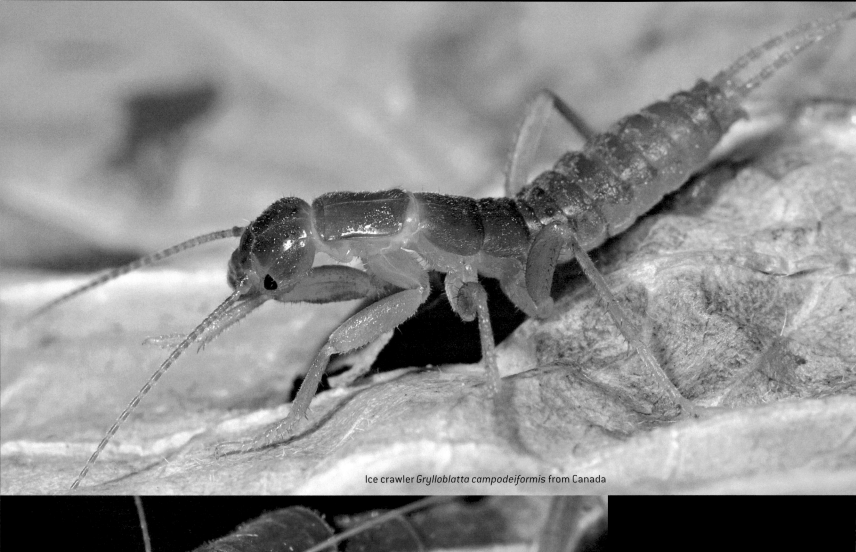

Ice crawler *Grylloblatta campodeiformis* from Canada

Heelwalker *Sclerophasma*
kudubergense from Namibia

of glycerol and other antifreezing compounds in their blood. And so, like tiny, six-legged Goldilocks, they seem relegated to a life in narrow, fleeting ranges of environmental variables, constantly searching for just the right temperature and humidity. But a life like this has its advantages—because of their slow, temperature-dependent metabolism, ice crawlers are surprisingly long-lived (for insects) and may reach the ripe age of ten years. Food is usually not a problem as ice crawlers will eat almost anything, ranging from dead insects blown onto the surface of the ice to vegetal matter found under snow. There is not much competition in the subfreezing layers of the soil, especially if you are the largest insect active in this environment, and most predators, such as shrews or toads, tend to stay away from really cold places. Asian species of ice crawlers have slightly higher temperature tolerance and can safely live in the span of 9–15°C. Because many other animals are also active within this range, Asian ice crawlers escape competitors and predators by hiding very deep in the soil or at the bottom of caves.

But in the beginning, the life of these insects used to be very different. Over 250 million years ago, in the Permian, the ancestors of modern ice crawlers were anything but crawlers on ice. For one, all ancient species were equipped with two pairs of large wings. Based on the analysis of the gut content of some remarkably well preserved fossils we know that they fed primarily on pollen of ancient conifers and some of their now-extinct relatives. For millions of years they flourished in hot, tropical parts of the globe, leading a plant-hopping life, quite likely similar to that of many of today's pollinators. According to some entomologists there used to be as many as 44 families of "ice crawler"–like insects, compared to a single family known today. They are frequently found in rock deposits dating back from the Permian to the Cretaceous. But then, gradually, they disappeared from the fossil record. Strangely, there is not a single ice crawler known from the period after mid-Cretaceous. Their disappearance coincides roughly with the appearance of flowering plants, or angiosperms, and the

nearly concurrent diversification of beetles and other plant pollinators. It seems that rather than allowing themselves to be outcompeted by this new army of more advanced plant-associated insects, the ancestors of ice crawlers found survival in a completely new lifestyle. They shed their wings and entered a chilly, inhospitable niche along the edges of glaciers, in caves, or deep in the soil. This explains the lack of a fossil record; fossilization usually requires the sinking of a dead organism into fine silt at the bottom of a lake or an ocean, and so the environments favored by ice crawler ancestors made fossil formation difficult.

Although they have been luckier than all their winged, plant-hopping ancestors, the luck of modern ice crawlers may soon run out. Their dependence on a very narrow spectrum of low temperatures, combined with their inability to fly and thus quickly colonize new habitats, may soon spell the end of this ancient lineage in our rapidly warming world. As sometimes happens in evolution, ice crawlers have painted themselves into a corner. During the Pleistocene, when most of the North American continent was covered with a thick ice cap, these insects probably survived only on the edges of the glacier or in underground networks of caves. As the ice receded they followed it and colonized suitably cold (but not too cold) places high on mountain slopes or in icy caves. As a result, populations of these insects tend to be small and genetically isolated from each other due to the island-like nature of cold, alpine habitats. This means that when their environment suddenly becomes uncomfortably warm—and there is already ample evidence of the shrinking of North American glaciers—they have nowhere to go. And even if there still existed available habitats, ice crawlers have no way of getting there because of their inability to fly. Some populations in the Sierra Nevada of California, perhaps entire species of ice crawlers, may already be extinct, as repeated attempts to find them during the last forty years have failed. And when the entire genetic makeup of a lineage consists of only twenty-eight species, every one of them is priceless.

After ice crawlers were officially recognized as a new order of insect in 1915, entomologists pretty much assumed that this was it, and no more discoveries of such magnitude were expected. And so it was met with great skepticism when in 2002 another new order of insects was announced to the world by a team of German and Danish scientists. These strange new animals looked remarkably similar to ice crawlers, with their elongate, completely wingless bodies. But in their biology and behavior they could not be more different. The new insects, christened with the catchy moniker Mantophasmatodea, were found on the opposite side of the globe in the scorching deserts and shrubby vegetation of southern Africa. They were fast and agile and, unlike ice crawlers, predaceous and incredibly voracious. They also walked funny, with the tips of their feet held up in the air, earning them the common name heelwalkers. Detailed studies of their morphology and internal anatomy suggest that they might be related to either primitive stick insects or, indeed, ice crawlers. Through a mix of luck and pushiness I ended up on the first expedition to collect live heelwalkers in Namibia, and seeing them there, among scorching hot rocks of the Brandberg Massif was definitely one of the highlights of my life. (I also learned something valuable that time: if you stand in the middle of a dry riverbed and hear some strange noise getting louder, run like hell, it is a flash flood coming.)

In the years that followed many scientists carefully looked at the minutiae of the bodies and genes of the Mantophasmatodea, and both molecular and morphological analyses confirmed their close relatedness to ice crawlers. So close is this relationship that these two orders of insects are considered "sister groups"—two distinct lineages of organisms that diverged from a single common ancestor. As such, and considering how few species each of these orders contains, many entomologists now prefer to combine Grylloblattodea (ice crawlers) and Mantophasmatodea (heelwalkers) into a single order. When such an option was first discussed, I heard at one scientific meeting the name

Gryloblattomantophasmatodea being briefly considered for the combined order. I almost wish it had been chosen, so outrageously long and yet entirely inaccurate it would have been; translated from Latin, the name means "cricket-cockroach-preying mantis-walking stick-like insect," four groups to which neither ice crawlers nor heelwalkers are closely related! In the end, the name Notoptera was adopted to absorb both orders.

But the status of ice crawlers and heelwalkers as distinct orders, or suborders of a single one, is rather meaningless semantics—we know that each group is evolutionarily unique and that both have evolved from a shared ancestor. All higher categories of classification—classes, orders, families, and so forth—are just artificial constructs that help us grasp the approximate relationships among organisms (or the pattern of creation, if one chooses to suppress logic) and have no real biological meaning. What is fascinating is the yin-and-yang nature of these two lineages of insects that share extremely similar genetic heritage but ended up living diametrically opposing lifestyles on opposite sides of the world.

Since the initial discovery of heelwalkers in 2002, more than a dozen additional species have been found, mostly in South Africa where, as it turned out, in some places they were as common as dirt. How and why entomologists overlooked them for so long is a perplexing question, the answer to which appears to be surprisingly mundane. Not long ago I was in South Africa conducting a survey of katydids in the fynbos. My friend Corey and I drove along the coast, stopping every now and then to look for katydids and grasshoppers on the side of the highway. It was the end of southern winter, dry and often cold at night. Few insects are active in this season, and those that you find are often juveniles. But soon we struck gold—first one, then another, and eventually six new-to-science species of small, flightless katydids turned up in the bushes—an entire unexpected radiation of these insects. Entomologists have collected katydids in South Africa for ages; how

could have they missed these? I pondered this question as I slowly scanned the vegetation looking for more insects. Suddenly, I found myself eye to eye with a chubby, green female heelwalker. She sat on a branch at eye height, motionlessly trying to blend into her surroundings. Although I knew she was a fully grown adult, she somehow looked larval. The combination of the lack of wings, stubby appearance, and the fact that she was out and about in the middle of winter, all this seemed to suggest that this insect was immature. And that was it. That was the reason these insects had escaped notice for so many years. Like our flightless katydids, similar to juveniles of species active in the spring and summer months, heelwalkers had been occasionally collected by entomologists but quickly discounted as immature forms of something else and stuffed into the darkest corners of entomological collections. Sure enough, after the publication of the official description of the first heelwalkers, many specimens were discovered in South African museums, some collected more than a century earlier. After Corey and I returned from our field trip, I paid a visit to the (beautiful) Iziko South African Museum in Cape Town, and there, among unidentified immature insects were dozens of the new katydids, some having sat there, unrecognized, for more than seventy years.

Undoubtedly, the coming years will see new species of heelwalkers discovered and volumes of new data on their ecology and behavior published. But we may need to hurry. Like the melting and disappearing environment of ice crawlers, there are signs that heelwalkers' habitats are threatened as well. The ancient, unique, and unbelievably rich South African plant communities of karoo and fynbos, homes of so many plant species that they earned the entire region the designation Cape Floral Kingdom, are shrinking. Development, desertification, and mining steadily strip the precious ecosystem bit by bit, literally pushing it into the ocean. Heelwalkers, with their fifteen or so known species, each restricted to a tiny patch of unique Cape vegetation, may

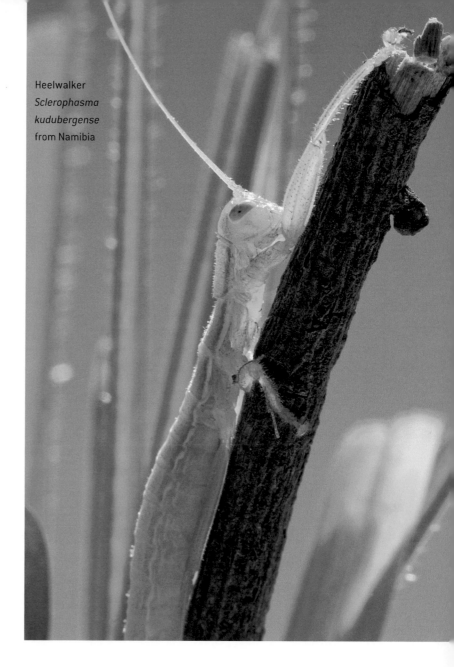

Heelwalker
Sclerophasma
kudubergense
from Namibia

soon be in a serious quagmire. The same Mesozoic forbearer that gave rise to ice crawlers—and their narrow ecological specialization—produced another organism that, although it occupies an entirely different niche, is also dangerously specialized. And this, as the rich fossil record of specialized lineages clearly shows us, is a recipe for extinction.

Cool, shady, and humid subalpine and alpine valleys in the breathtakingly beautiful Chichibu-Tama-Kai National Park not far from Tokyo are an example of the typical habitats of Japanese ice crawlers. As these insects require constant high humidity, they are found under boulders and deep in the soil alongside brooks and streams. The soil temperature in this habitat is always low and fairly constant, never falling below the freezing point, even in the depth of winter. This provides ideal conditions for ice crawlers' development.

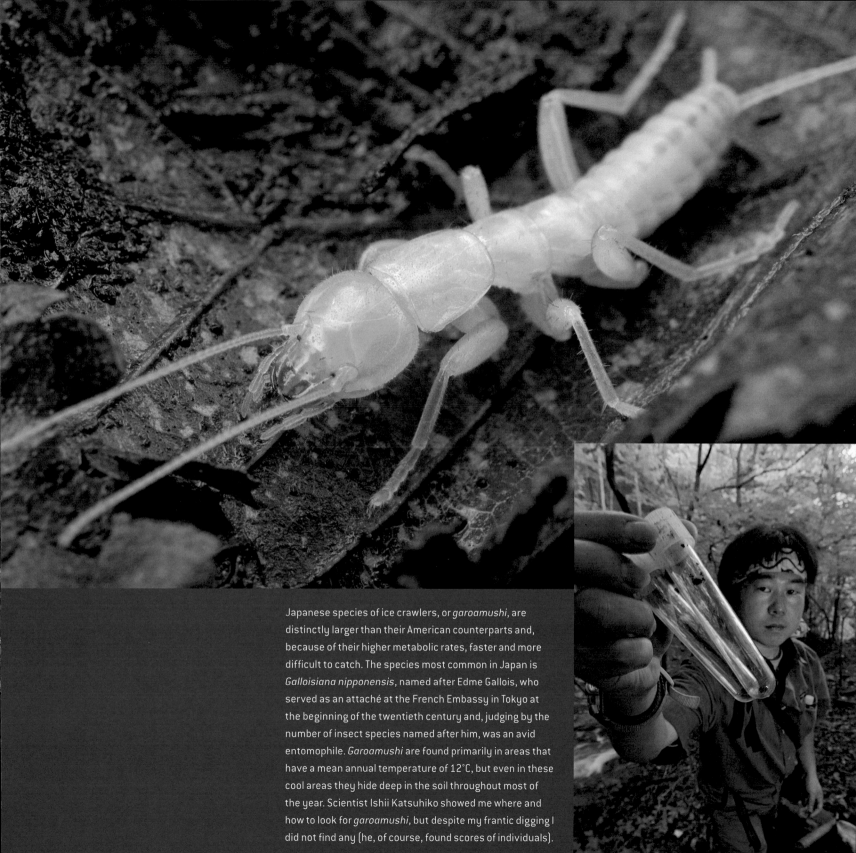

Japanese species of ice crawlers, or *garoamushi*, are distinctly larger than their American counterparts and, because of their higher metabolic rates, faster and more difficult to catch. The species most common in Japan is *Galloisiana nipponensis*, named after Edme Gallois, who served as an attaché at the French Embassy in Tokyo at the beginning of the twentieth century and, judging by the number of insect species named after him, was an avid entomophile. *Garoamushi* are found primarily in areas that have a mean annual temperature of 12°C, but even in these cool areas they hide deep in the soil throughout most of the year. Scientist Ishii Katsuhiko showed me where and how to look for *garoamushi*, but despite my frantic digging I did not find any (he, of course, found scores of individuals).

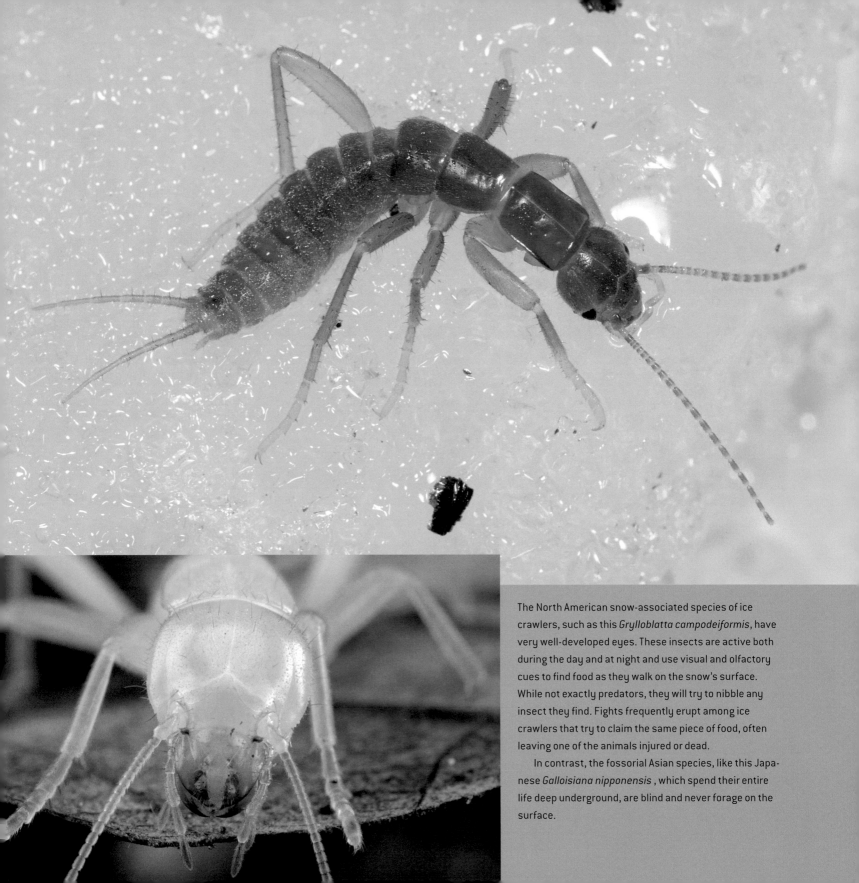

The North American snow-associated species of ice crawlers, such as this *Grylloblatta campodeiformis*, have very well-developed eyes. These insects are active both during the day and at night and use visual and olfactory cues to find food as they walk on the snow's surface. While not exactly predators, they will try to nibble any insect they find. Fights frequently erupt among ice crawlers that try to claim the same piece of food, often leaving one of the animals injured or dead.

In contrast, the fossorial Asian species, like this Japanese *Galloisiana nipponensis* , which spend their entire life deep underground, are blind and never forage on the surface.

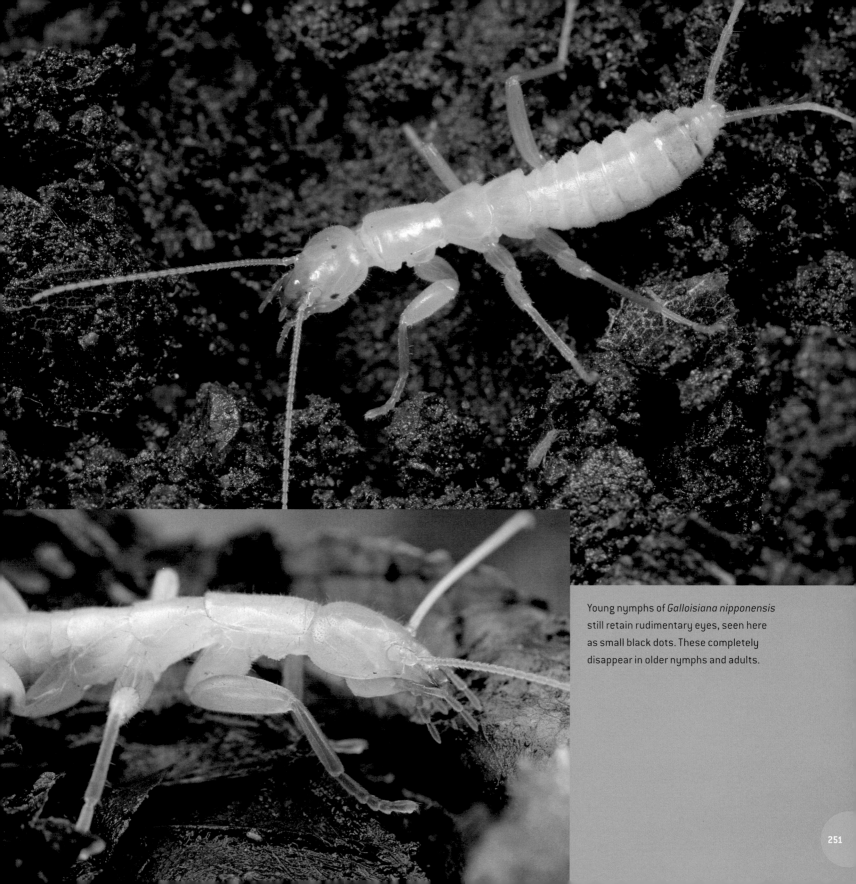

Young nymphs of *Galloisiana nipponensis* still retain rudimentary eyes, seen here as small black dots. These completely disappear in older nymphs and adults.

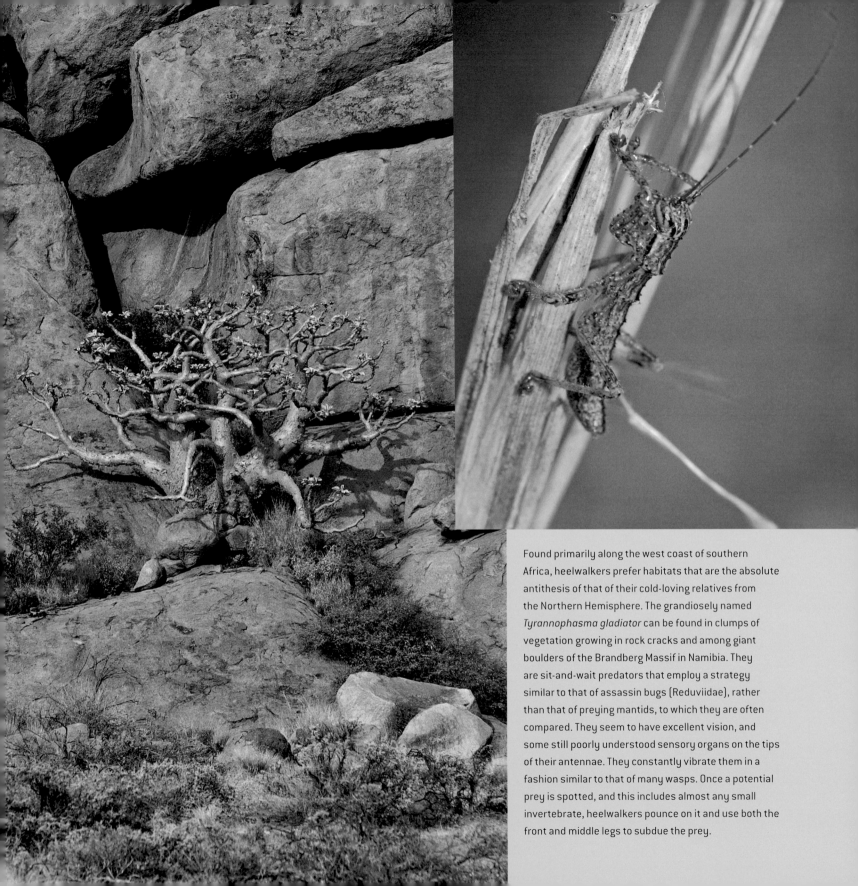

Found primarily along the west coast of southern Africa, heelwalkers prefer habitats that are the absolute antithesis of that of their cold-loving relatives from the Northern Hemisphere. The grandiosely named *Tyrannophasma gladiator* can be found in clumps of vegetation growing in rock cracks and among giant boulders of the Brandberg Massif in Namibia. They are sit-and-wait predators that employ a strategy similar to that of assassin bugs (Reduviidae), rather than that of preying mantids, to which they are often compared. They seem to have excellent vision, and some still poorly understood sensory organs on the tips of their antennae. They constantly vibrate them in a fashion similar to that of many wasps. Once a potential prey is spotted, and this includes almost any small invertebrate, heelwalkers pounce on it and use both the front and middle legs to subdue the prey.

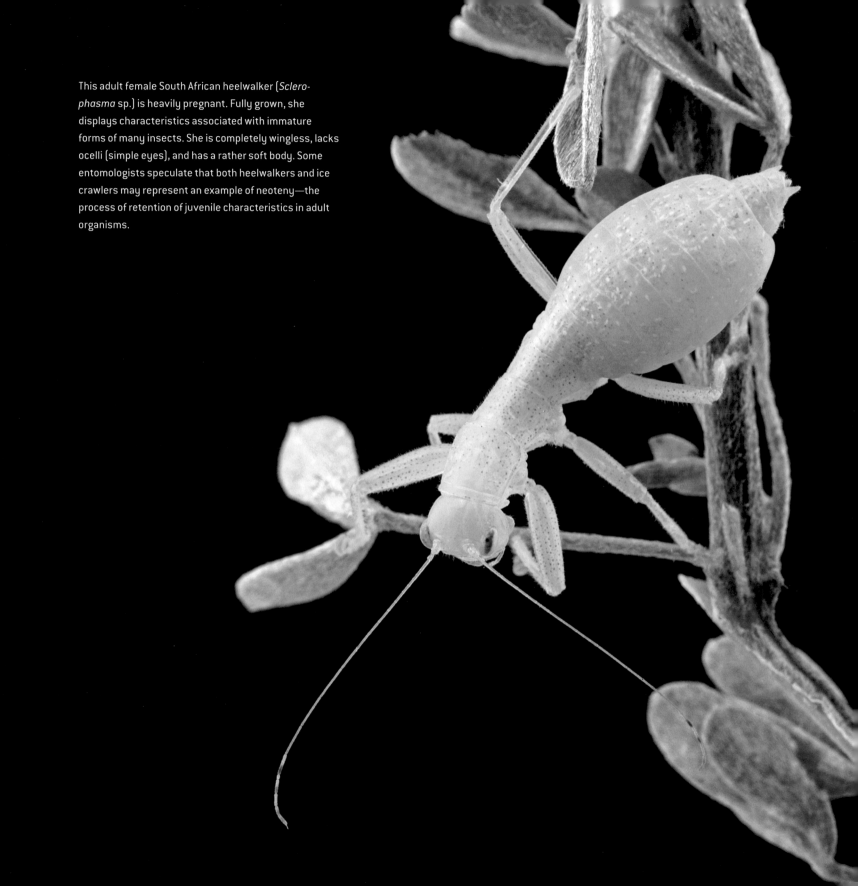

This adult female South African heelwalker (*Sclero-phasma* sp.) is heavily pregnant. Fully grown, she displays characteristics associated with immature forms of many insects. She is completely wingless, lacks ocelli (simple eyes), and has a rather soft body. Some entomologists speculate that both heelwalkers and ice crawlers may represent an example of neoteny—the process of retention of juvenile characteristics in adult organisms.

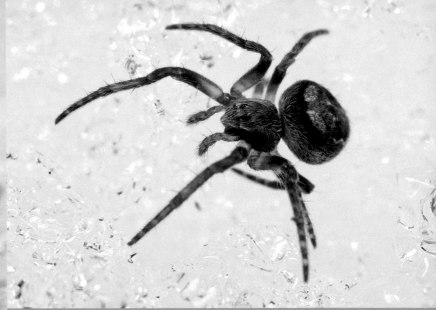

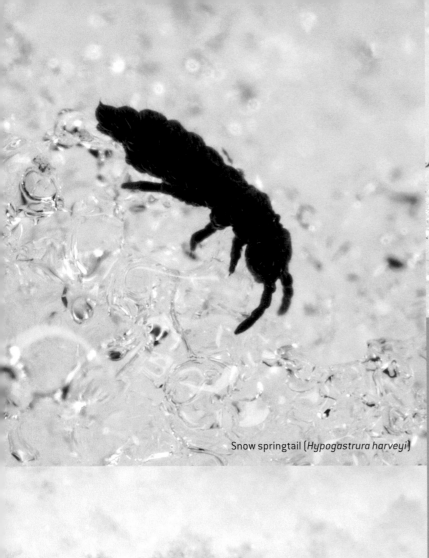

Snow springtail (*Hypogastrura harveyi*)

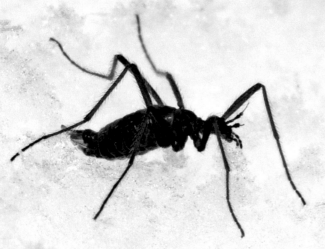

Snow fly (*Chionea valga*)

Bodies of all living cells contain a very high proportion of water, which turns into ice crystals when the temperature falls below 0°C, damaging the cell structure and potentially killing the organism. And yet, surprisingly, even in the middle of winter ice crawlers are not alone on the snow. A number of lineages of arthropods have evolved physiological adaptations that allow them to survive and be active in subfreezing temperatures. As ectotherms, animals that cannot generate their own body heat, winter insects and spiders must possess the ability to supercool their body fluids in order to remain active in subfreezing conditions. Supercooling, a process that allows them to lower their body temperature to well below the water's freezing point and still maintain its liquid state, is achieved by the presence of polyhydric alcohols and antifreeze proteins in their hemolymph and cells. But supercooling works only as long as there are no ice-nucleating agents, particles that promote the formation of ice crystals in body liquids. Fragments of food and gut bacteria act as such, and thus winter-active arthropods rarely feed. They also almost uniformly have dark coloration, which increases their ability to absorb the energy of the sun and warm up their bodies.

Not being able to feed does not sound like a great reason to stay active in the winter, but cold-adapted animals take advantage of one important fact—if they cannot feed, chances are that their enemies also can't. This means that slow-moving, wingless insects, such as springtails (Collembola) or snow flies (Limoniidae), are free to pursue their romantic interests, unafraid of the occasional spider they may run across in the snow. The one group of insects that feed in the snow is ice crawlers. Snow flies, such as this *Chionea valga* from Alberta, constitute a major portion of ice crawlers' diet.

A female snow scorpionfly (*Boreus brumalis*)

Snow scorpionflies (Boreidae) are fascinating insects that can often be found on snow in temperate forests of the Northern Hemisphere. Their relationships are still somewhat mysterious—traditionally they have been considered a family of scorpionflies (Mecoptera), a group of agile, predaceous insects, but recent molecular and morphological studies suggest that they may be in fact more closely related to parasitic fleas. Regardless of their genetic affinities, these peaceful, moss-feeding creatures little resemble either true scorpionflies or fleas. Like other winter-active insects, they take advantage of the lack of most predators in the cold months, and come out during the winter in large numbers to mate. The larger and chunkier female is completely wingless, whereas the male has a pair of strangely modified, scissor-like wings, which he uses to clasp the female's mouthparts and secure her position on his back during mating. After mating the female uses her long, external ovipositor to lay eggs in clumps of moss, where they will stay dormant until spring.

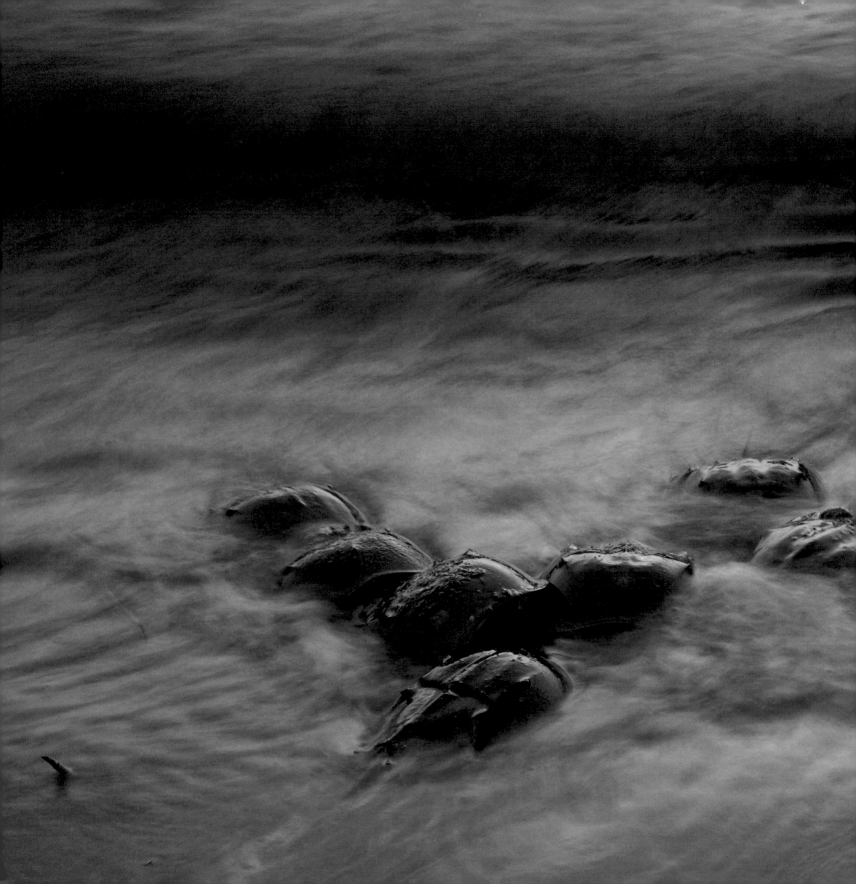

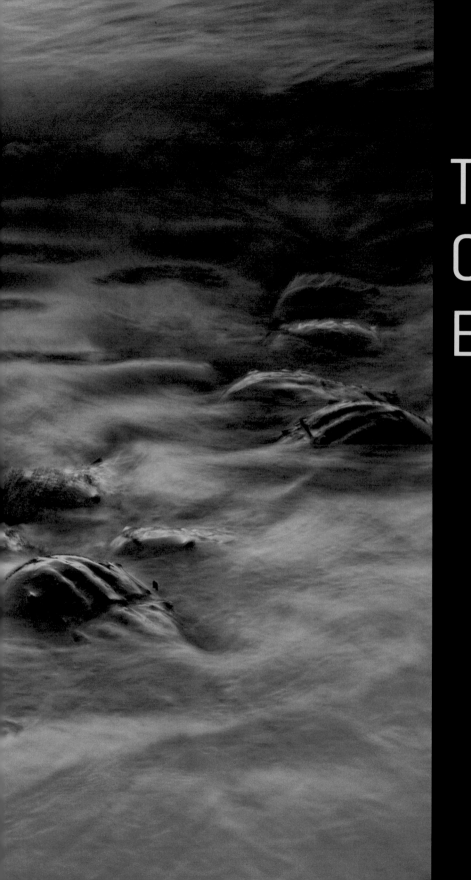

The Great
Ocean
Escape

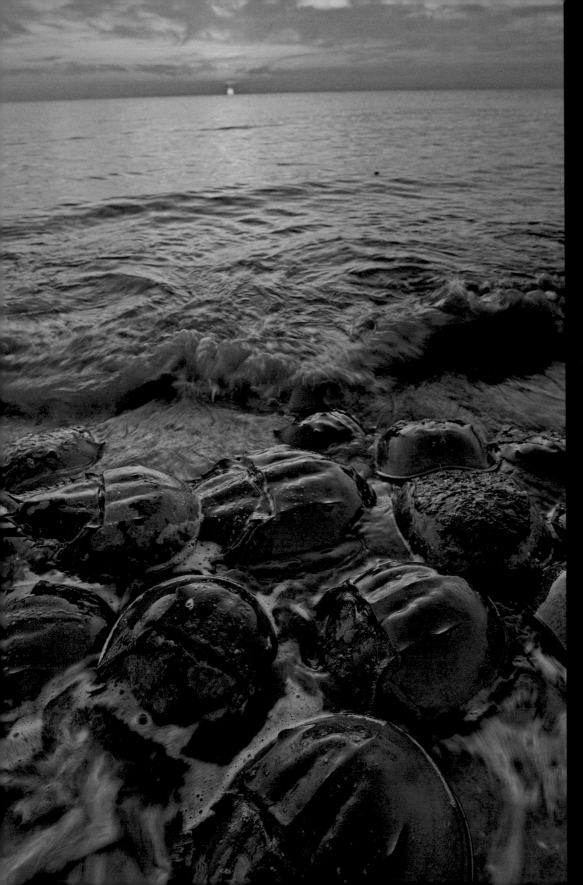

Horseshoe crabs have been around for more than 440 million years. While the currently living species are probably only a few million years old (and have no known fossil record), they retain many morphological and, quite likely, behavioral traits of their long-extinct relatives. The body of a modern horseshoe crab is virtually indistinguishable from that of species that lived in the Jurassic period, giving us a glimpse of what life on Earth might have been like in those days.

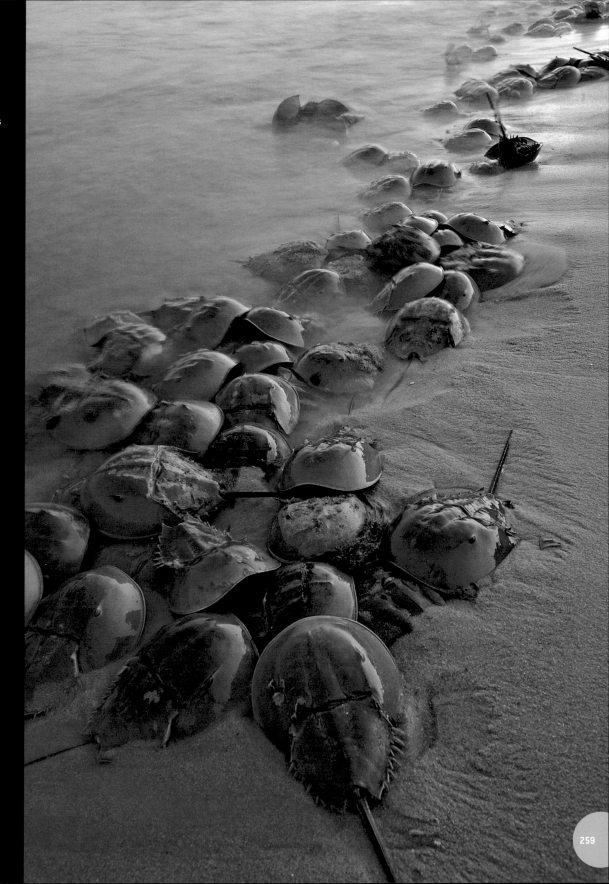

One of the most dramatic natural spectacles in the world, the mass spawning of Atlantic horseshoe crabs in eastern North America is a sight to behold. On a good night it is possible to see over a hundred thousand animals.

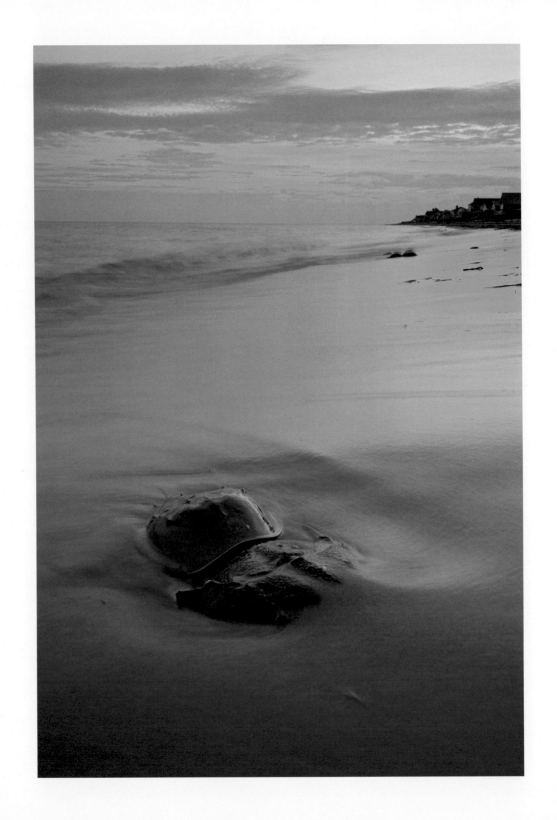

Driving to New Jersey from Boston seemed like eight hours of pure hell. After getting lost in Manhattan at the peak of rush hour and suffering rage-fueled traffic on the New Jersey Turnpike, I distinctly felt that a vein in my brain was ready to pop. I was hot, tired, and so hungry that a potato chip that had fallen on the floor of my car a few weeks earlier began to look positively delicious. But the moment my feet touched the warm sands of Highs Beach, aglow in the long, lazy rays of the late afternoon, all the trials and tribulations of my annual pilgrimage to the Delaware Bay were instantly forgotten. I arrived at my favorite place of worship, a site of affirmation of my faith in the undeniable, physical, and testable forces that created our universe. I came to see a spectacle, possibly one of the oldest on the planet, and one that might have already had over a hundred million encores.

Every year in May and June, during a few nights that coincide with the full and new phases of the moon, horseshoe crabs leave sandy beds of the Atlantic Ocean and enter our world, dry and as foreign to them as their wet and dark domain would be to us. Fighting the pull of receding waves, these extraordinary animals slowly walk toward the beach. Waves thrash them around, flipping them on their backs, and suck them back into deeper waters, almost as if the ocean didn't want some of its subjects to escape its grip. And yet they persist. Slowly but surely horseshoe crabs emerge; risking their lives, they enter a strange and unfamiliar terrain where the lack of water suddenly seems to make the gravitational force stronger. In the water horseshoe crabs are surprisingly graceful, capable of sprinting on the sandy bottom, occasionally enjoying a short, if a bit awkward, swim on their backs. But here, on the beaches of Delaware Bay, they plow slowly. Females are particularly disadvantaged. Not only are they larger and heavier than males, most reaching the weight of nearly six pounds, but also, by the time they get to the shore each female has at least one suitor clinging to her back. In some cases she has to drag not one but two or three males trying to gain access to the eggs she is about to lay.

As hundreds of biting flies did their best to drain us of every drop of blood, my friend and fellow photographer Joe Warfel and I stood on the beach waiting for this spectacle to begin. The sun grew dim, and the high tide was nearing its peak. There were a few people on the beach when we first arrived, but by now they had all disappeared, and we were the only witnesses to what was about to unfold. I started to tell Joe how strange it was that nobody else stayed to watch, but swallowed a fly and decided to quietly enjoy the rest of the evening. The flies eventually got their fill of our blood and left, so nothing spoiled the phenomenal show.

First came the big females. Nearly all had males in tow. In the dimming light we could see spiky tails of hundreds more as they tumbled in the waves, trying to get to the dry land. By the time the sun fully set, the beach was covered with hundreds of glistening, enormous animals. Females dug in the sand, making holes to deposit their eggs, nearly four thousand in a single nest, while the males fought for the privilege of fathering the embryos. Fertilization in horseshoe crabs is external, and often multiple males share the fatherhood of a single clutch. Equipped with a pair of big compound eyes (plus eight smaller ones) capable of seeing the ultraviolet range of the light spectrum, male horseshoe crabs are very good at locating females even in the melee of waves, sand, and hundreds of other males. Scientists studying this

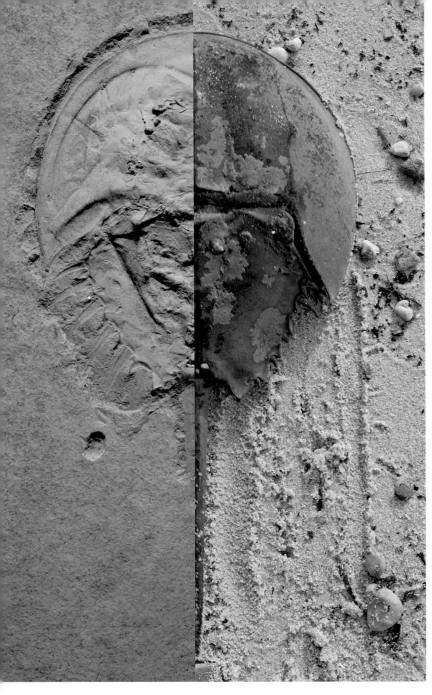

Like twins separated at birth, the 150-million-year-old *Mesolimulus walchi* and the modern *Limulus polyphemus* share a remarkable number of similarities. But each species also has a number of unique characteristics—strong evidence that this lineage of animals has been evolving like all other organisms on Earth.

behavior suspected at first that males might be attracted by female pheromones, but as it turns out they rely solely on their excellent vision. They do make mistakes, however, and it is not rare to find males forming chains, which disperse as soon as a real female shows up.

Watching the drama of the mass spawning of horseshoe crabs is to me as close to a religious experience as I will ever get. My heart seems to slow down and a natural calmness helps me momentarily forget all the ills of the world. As strange and distant horseshoe crabs may seem, these majestic organisms remind me that we share the same evolutionary heritage. Although our paths to what we are now diverged early, humans and horseshoe crabs at some point shared the same ancestor. It was a very long time ago. Horseshoe crabs have been around longer than most groups of organisms that surround us now. In the fossil deposits of Manitoba, the recent discovery of an interesting little creature named *Lunataspis aurora* proves that horseshoe crabs quite similar to modern forms were already present in the Ordovician, 445 million years ago. By the time the first dinosaurs started terrorizing the land in the Triassic (about 245 million years ago), horseshoe crabs were already relics of a bygone era. And yet they persisted. Dinosaurs came and went, the polarity and climate of Earth changed many times over, but horseshoe crabs slowly plowed forward. Yet during this time they changed surprisingly little. Species from the Jurassic were so similar to modern forms that I doubt I would notice anything unusual if one crawled in front of me on the beach in Delaware. Somehow horseshoe crabs had stumbled upon a lifestyle and morphology so successful that they were able to weather changes to our planet that wiped out thousands of seemingly more imposing lineages (dinosaurs and trilobites immediately come to mind). But despite claims to the contrary by creationists and other lunatics, they kept evolving. Modern horseshoe crabs, limited to three species in Southeast Asia and one in eastern North America, differ

in many details from their fossil relatives. We know, for example, that many, if not most, fossil horseshoe crabs lived in fresh water, often in shallow swamps overgrown with dense vegetation, and some might have even been almost entirely terrestrial. Currently only the mangrove horseshoe crab *Carcinoscorpius rotundicauda* from the Malayan Peninsula routinely enters rivers and is the only species to lay eggs in fresh or brackish water.

The morphology of horseshoe crabs, however, has changed very, very slowly. The phenomenon of extremely slow morphological evolution is sometimes referred to as bradytely and is usually found in organisms that are biological jacks-of-all-trades. Being highly specialized, for example, being able to feed only on grass if grass is plentiful, will give you a great advantage over organisms that will tolerate but are not crazy about grass. But come climate change, grasses are replaced by cacti, and all exclusive grass eaters are gone while the generalists are still hanging on. Horseshoe crabs

are very tolerant of many ecological variables—our Atlantic species, *Limulus polyphemus*, ranges from the freezing waters of Nova Scotia to tropical shores of the Gulf of Mexico. It can tolerate extreme differences in salinity, will eat almost anything organic (but prefers young mussels and clams), and if necessary can survive for many days out of water. These are the hallmarks of the ultimate survivor. The powerful armature of the horseshoe crab's body ensures that these animals have virtually no natural enemies (only sharks and large sea turtles occasionally attack adult horseshoe crabs). But the horseshoe crab is a lover, not a fighter. The long, scary looking spike at the end of its body is nothing more than a crutch that lets the animal right itself up if flipped upside down by a wave. Strangely, this spike, known as the telson, carries a row of photosensitive cells, kind of primitive eyes. Their likely function is to help navigate to the beach when the time comes to spawn.

In addition to the thick exoskeleton, Asian species of horseshoe crab protect themselves during the breeding period with powerful toxins in their eggs and soft body parts. Saxitoxin, a compound found in these animals, is one of the most powerful organic poisons known to man. If ingested, the first symptoms of muscle failure occur within minutes, followed by death from general paralysis and asphyxia within the next 16 hours. There is no antidote, and the only rescue is a symptomatic treatment that still may leave the victim with brain damage. It is therefore rather strange that horseshoe crabs are still on the menu in Thailand and several other Asian countries. It is widely known that these animals should not be eaten during their breeding season when the toxins are present in their bodies, but a string of 280 horseshoe crab poisonings in a single hospital in Thailand tells me that the message might have been lost on the good people of Chon Buri.

The American species is not toxic, but peoples of this land must have a more (or perhaps less?) sophisticated palate than seafood connoisseurs of Asia, as eating horseshoe crabs never caught on here. A report from the first European expedition to Virginia published in 1588, alerted Europeans to the existence of these animals and mentioned that native people ate horseshoe crabs but apparently only when no better food was available. In China the first written account of horseshoe crabs dates back to 250 AD, although authors of this and many subsequent books clearly must have only heard of and not actually seen the "hòu-fish" as it was always depicted as a carp with six pairs of legs and a big dorsal fin. It took almost 1,400 years to get the morphology right, and in 1666 a Japanese author, Tekisai Nakamura, published a remarkably accurate picture of a horseshoe crab, and gave it a name *kabuto-gani* (armored crab)—not quite right, but close enough.

As it happens, the English moniker "horseshoe crab," like the Japanese *kabuto-gani*, obscures the true relationships of these animals. Placed in a group of their own, the Xiphosura, they are more closely related to spiders and other arachnids than crabs and other crustaceans. Unlike true crabs, their exoskeleton does not contain large amounts of calcium and is made almost entirely of the polysaccharide chitin. Being strong, flexible, nonallergenic, and biodegradable, chitin obtained from these animals makes a perfect material for such applications as surgical sutures, implants, or well-tolerated contact lenses. Who knows, maybe you are looking at the world through a piece of a horseshoe crab's body.

The following morning Joe and I found the beach covered with horseshoe crab eggs. Well-rested and ready to start a bright new day, the flesh-piercing flies attacked us with renewed enthusiasm. Flailing our arms and swatting dozens at a time, we went about flipping crabs stuck on their backs in the sand and started to look for particularly big clutches of eggs. Although females burry the eggs in the sand, the returning tide washes out many of them. Freshly laid eggs are small, no larger than half a grain of rice. Surprisingly, the eggs grow as they develop, eventually becoming more than

twice as large. This, of course, is impossible. The "growth" is an illusion, the result of the production of an external, thin membrane by the developing embryo. A fully developed egg, which at this stage has spent two weeks in the sand, resembles a tiny glass aquarium, with a petite horseshoe crab twirling inside, impatient to break the walls of its miniature prison. Once free, the larvae (or at least the lucky ones) catch a wave back into the ocean and will spend about a week floating freely before settling on the bottom of the shallow shore waters to begin life akin to that of its parents.

But the question remains—why do these aquatic animals leave their natural habitat and expose their offspring to the risk of getting stuck on land, when they clearly need water to develop? It would be tempting to compare this behavior to that of sea turtles, which also spend their lives in the ocean, leaving it only for one night to lay their eggs in the sand. And yet the reasons for this similar behavior could not be more different. Sea turtles are aquatic newcomers, descendants of terrestrial reptiles who must gulp surface air to live. They cannot stay under water for more than a couple of hours (when resting, even less time when active), and similarly, their eggs must be exposed to atmospheric oxygen for the embryo to avoid suffocation. Horseshoe crabs, on the other hand, breathe underwater, and their eggs must be submerged, or at least frequently washed by waves, to develop. The force that drove them to try such desperate measures as leaving their offspring on land were millions upon millions of hungry mouths waiting in the ocean for the tasty snack of horseshoe crab eggs. When horseshoe crabs first appeared in their present form about 445 million years ago, most of animal life—and virtually all predators—lived in the seas and lakes of our planet. By taking the bold step outside their watery realm, horseshoe crabs outcompeted most of them and gave their offspring a big advantage over other aquatic organisms. They were some of the first organisms, if not the first, to develop what is known as the export strategy in their reproduction. No animal currently living on land is a direct descendant of ancient horseshoe crabs, but it is likely that some of the first terrestrial invertebrates followed a similar path, driven by the selective force of predators waiting for their eggs in the water.

Unfortunately, there was something that horseshoe crabs could not have predicted. Dinosaurs, the gargantuan tetrapods that stomped the land for nearly 170 million years before seemingly disappearing at the end of the Cretaceous, didn't actually go completely extinct. Some of them evolved into one of the most successful lineages on the planet—birds. Birds are smart and have excellent vision. They also have high metabolic rates, which on one hand allows them to maintain a constant body temperature regardless of the environmental conditions, but on the other demands a continuous supply of high-energy food. For some, horseshoe crab eggs are just what they were looking for.

Chock-full of fat and proteins, the eggs of the Atlantic horseshoe crab are an ideal fuel for scores of shorebirds. As reliable as a Swiss clock, horseshoe crabs can always be counted on to spread a delicious smorgasbord of fresh eggs on the shores of Delaware Bay, always there on the morning following the new and full moons of the late spring months. One bird in particular, the rather drab and inconspicuous Red Knot (*Calidris canutus rufa*), owes its very survival to horseshoe crabs. Its migratory route must include a stopover at Delaware Bay, a desperately needed respite from an exhausting nonstop journey from South America. Ever since man started paying attention to such things, they have been amazed by the clouds of Red Knots descending on the shores of Delaware Bay every spring. But a few years ago, as the crabs' population continued to dwindle to a fraction of its former glory, the birds started to disappear as well.

Soon, the ornithological community in the United States was in uproar. Petitions were signed, studies were conducted, and, eventually, laws protecting the birds were enacted. Somebody somehow made the connection that if the crabs disappear, so would the precious birds, and thus we probably

should try to save the lowly invertebrates. In New Jersey, where just a year ago it was okay to drive a pickup truck to the beach and load it with hundreds of crabs for bait and other uses, it is now illegal to collect a single individual. I was threatened with a $10,000 fine for picking up a horseshoe crab (with the intention of immediately releasing it after taking a few photographs) on a beach in New Jersey by an overzealous U.S. Fish and Wildlife Service ranger. He gave me a stern warning but graciously let me go. As he walked away, he tripped over one of a few dozens of horseshoe crabs stuck on their backs on the beach. He kept on walking.

About a hundred years earlier, we probably would have not been able to walk on the beach without stepping on horseshoe crabs. They were so numerous during their breeding season that humans simply had to find some way of using this bountiful resource. Soon they came up with an idea. Between 1880s and 1920s well over a million horseshoe crabs were harvested each year to be killed, ground up, and used as fertilizer and hog fodder. The practice continued until 1970, when the last processing plant closed, mostly because of the complaints about its smell, but also because the harvest dropped to only a hundred thousand crabs per year. But in its place another industry sprung up, this time killing horseshoe crabs to use them as bait for eel and whelk, a kind of edible snail. All this has led to a decline in the population of horseshoe crabs from which it may never fully recover. And then, of course, there is the issue of the horseshoe crab blood.

In the early 1950s researcher Frederick Bang discovered that the blood of these animals was extremely sensitive to endotoxins produced by Gram-negative bacteria. Any exposure of the horseshoe crab's immune system to such bacteria resulted in an immediate and extensive clotting, effectively isolating the microbes and preventing them from doing any damage to the animal's organs. Bang and his collaborator, Jack Levin, quickly realized the potential of this discovery to human medicine. They isolated the active components of the horseshoe crab's blood, the amoebocytes, and developed an extract known as limulus amoebocyte lysate (LAL). Its application greatly simplifies detection of bacterial endotoxins in urine, spinal and cerebral fluids, or any other bodily fluids. But the primary application of LAL is in monitoring endotoxin contaminations in intravenous drugs and medical devices. In fact, if you were ever given an injection, received an intravenous treatment, or had a heart valve replaced, their sterility was almost certainly tested with LAL. Not surprisingly, harvesting of horseshoe crab blood for LAL production quickly became a major industry, which now annually generates hundreds of millions of dollars. Several hundred thousand horseshoe crabs are captured each year, and about 20 percent of their blue blood (their blood contains copper-based hemocyanin rather than red, iron-based hemoglobin) is extracted. Afterward the animals are returned back to the sea. While the mortality of horseshoe crabs harvested for LAL is relatively low (over 85 percent of the animals survive their involuntary blood donation), the industry wreaks havoc on the population structures of these animals, moving and releasing thousands of them hundreds of miles from their place of origin.

What really shocks me is that it took a bird for people to really start paying attention to the horseshoe crabs' decline. In what I can only describe as a phylogenocide, horseshoe crabs have been systematically exterminated for more than a century. This may sound overly harsh, but just think about it—the loss of red knots, as unforgivable as it would be, means the loss of only one-ten thousandth of the genetic pool for birds. The loss of one species of horseshoe crabs would spell the loss of a quarter of all genetic heritage of Xiphosura, one of the oldest living lineages on the planet. And yet we care more about a cute, fluffy animal that contributes little to our well-being than we do about a "strange," "alien" beast that already saved millions of human lives. How shallow we are.

Their extinction is almost complete in Japan, where a local species (*Tachypleus tridentatus*) used to be almost as

numerous as its Atlantic cousin. I went there in the summer of 2008 to see it in the last place in Japan where horseshoe crabs are still supposed to appear in large numbers. With my friend Kenji Nishida, an entomologist and a great photographer, I arrived at Imari Beach on the island of Kyushu. It was a day before the Kabutogani Festival, an annual celebration of horseshoe crabs. We were told that it was a good year—four pairs of horseshoe crabs had been spotted near the beach! Four pairs. Eight individuals. That was it. In the 1980s seeing five hundred individuals at very same spot would not have been unusual. In Japan horseshoe crabs are almost revered, and the Japanese Association for the Conservation of Horseshoe Crabs has been actively fighting for the species' survival. And yet the number of animals continues to decline. There is a bitter lesson here, which I hope we can learn from. There is such a thing as the point of no return in a species' fate. Let's hope we can stop the Atlantic horseshoe crabs from ever reaching it.

Every time I drive back from Delaware Bay back to Boston I cannot help but wonder what I will find the next year. Is it my imagination or are there fewer and fewer animals on the beach each subsequent year I go? Luckily, this does not seem to be the case. There are positive developments in horseshoe crab conservation efforts, and hopefully they will stop the decline of these magnificent animals. A protective zone of no harvesting has been established in the Delaware Bay, named the Carl N. Schuster Jr. Horseshoe Crab Reserve, after one of the world's most prominent horseshoe crab researchers and advocates of their conservation. Restrictions are in place to limit their harvest for eel and whelk bait, and people are becoming more interested in the plight of horseshoe crabs. Each year more and more volunteers come to the shores of Delaware Bay to conduct a census of spawning horseshoe crabs. Recently I saw in a toy store, next to stuffed pandas and orca whales, a plush horseshoe crab. Does this mean that kids now think that horseshoe crabs are cute? Maybe there is hope after all.

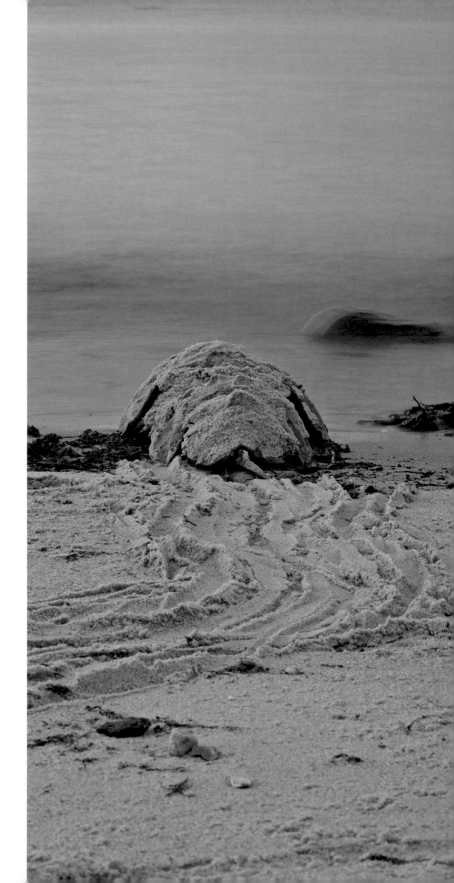

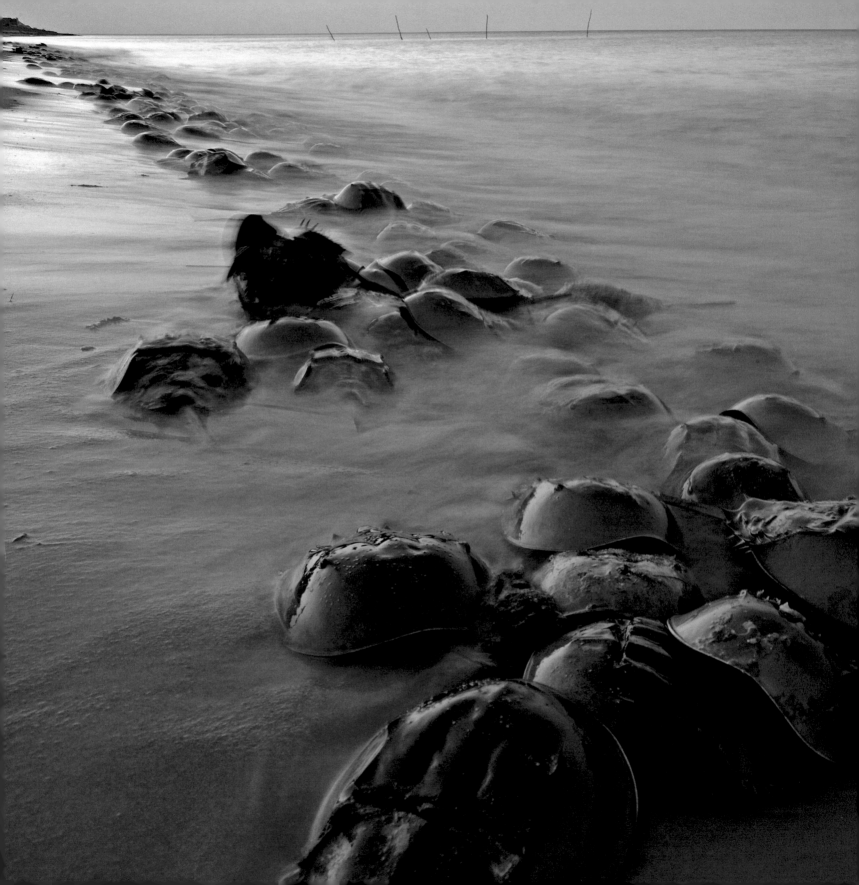

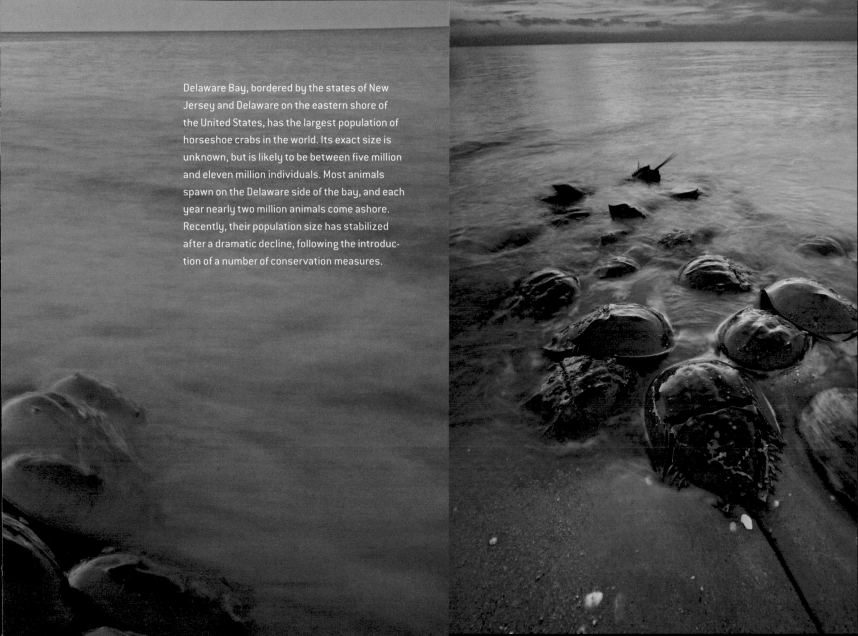

Delaware Bay, bordered by the states of New Jersey and Delaware on the eastern shore of the United States, has the largest population of horseshoe crabs in the world. Its exact size is unknown, but is likely to be between five million and eleven million individuals. Most animals spawn on the Delaware side of the bay, and each year nearly two million animals come ashore. Recently, their population size has stabilized after a dramatic decline, following the introduction of a number of conservation measures.

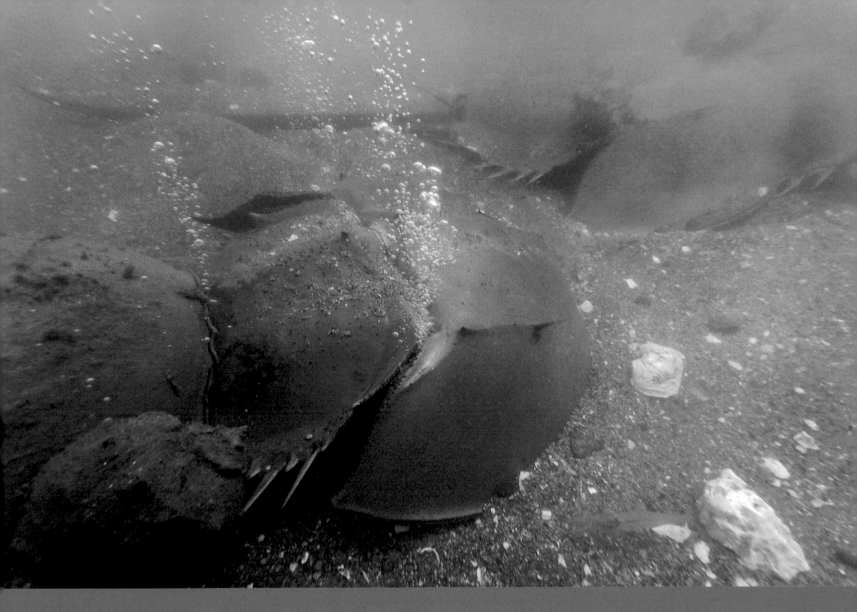

In order to maintain free flow of water around their gills, horseshoe crabs often flush water backward under their carapace, clearing intake channels. This may release gasses trapped in the sediments, producing a twin stream of bubbles emerging from under the carapace of the crab. This behavior is often seen in the female Japanese horseshoe crabs (*Tachypleus tridentatus*), which inhabit calmer waters than their Atlantic cousins.

Japanese horseshoe crabs, or *kabutogani*, have all but disappeared from their native island country. Once very common in the Seto Inland Sea, the development of this area completely wiped out the local population of these animals. Now horseshoe crabs in Japan are restricted to a few sites, the largest two being tidal flats of Kasaoka Bay in the southwestern part of Honshu and the Bay of Hakata in

Fukuoka prefecture on Kyushu. The latter is estimated to have nearly ten thousand crabs, surviving mostly thanks to the efforts of the local government and volunteer organizations. Students in local schools in Fukuoka are actively involved in captive rearing of young horseshoe crabs from eggs, which are released after a few months upon reaching the size that ensures high survival rates.

I photographed these two pairs in the shallow waters of the Bay of Hakata. The large snails hitching a ride on their carapaces are close relatives of the whelk, a tasty North American snail. It is whelk fisheries that are now one of the main threats to the survival of the Atlantic horseshoe crab, fueling the demand for bait made of chopped-up horseshoe crab bodies.

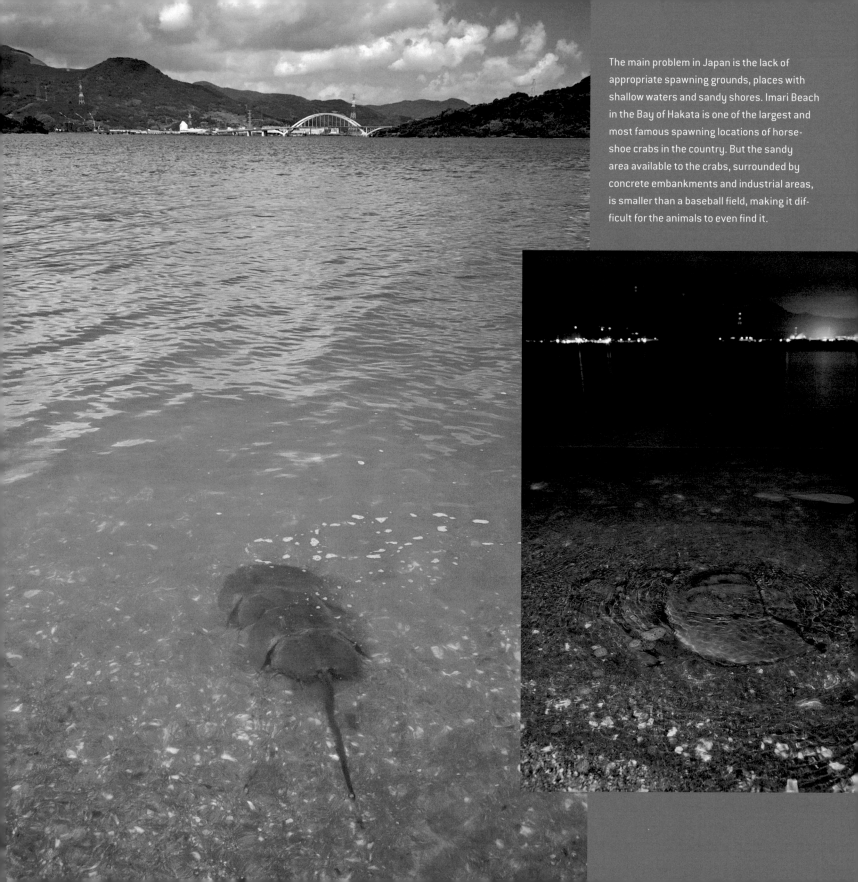

The main problem in Japan is the lack of appropriate spawning grounds, places with shallow waters and sandy shores. Imari Beach in the Bay of Hakata is one of the largest and most famous spawning locations of horseshoe crabs in the country. But the sandy area available to the crabs, surrounded by concrete embankments and industrial areas, is smaller than a baseball field, making it difficult for the animals to even find it.

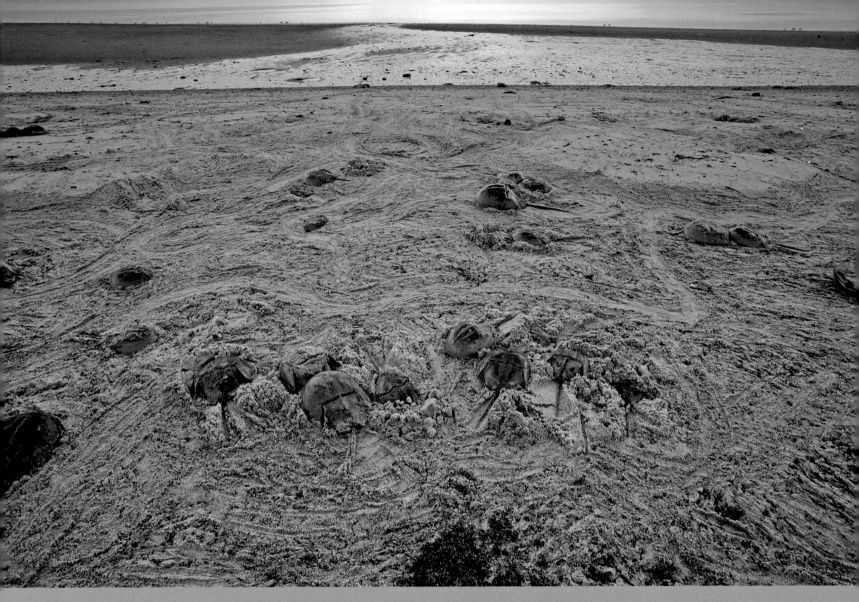

Following a night of mass spawning, sunrise reveals a picture reminiscent of a battlefield. Thousands of tank-like tracks bear witness to the frantic activity from a few hours earlier. Before the sun fully rises, most horseshoe crabs will make it back to the ocean. Those who got stuck in the sand, often on their backs, will have to wait for the next high tide to reach the water. Luckily, these animals are well equipped to deal with an occasional stranding. Their book gills can be closed shut, preventing them from desiccation, and their thick exoskeletons reduce water loss.

Each female can lay up to ninety thousand eggs in a single clutch, divided into several nests and buried in shallow holes in the sand. With hundreds of thousands of females laying eggs simultaneously, this produces an amount of potential food that can overwhelm even the hungriest predator. This strategy of reproduction is known in other organisms, such as periodical cicadas and many fish species. But despite these huge initial numbers, the odds of a horseshoe crab surviving to adulthood are very slim. Only a fraction of the eggs will escape the keen eyes of seagulls and other shorebirds, and of those only a portion will produce a larva lucky enough to reach the ocean. There, millions of hungry mouths await defenseless young crabs. On average, probably only one egg in a clutch results in a horseshoe crab that reaches the reproductive age of eight to ten years old.

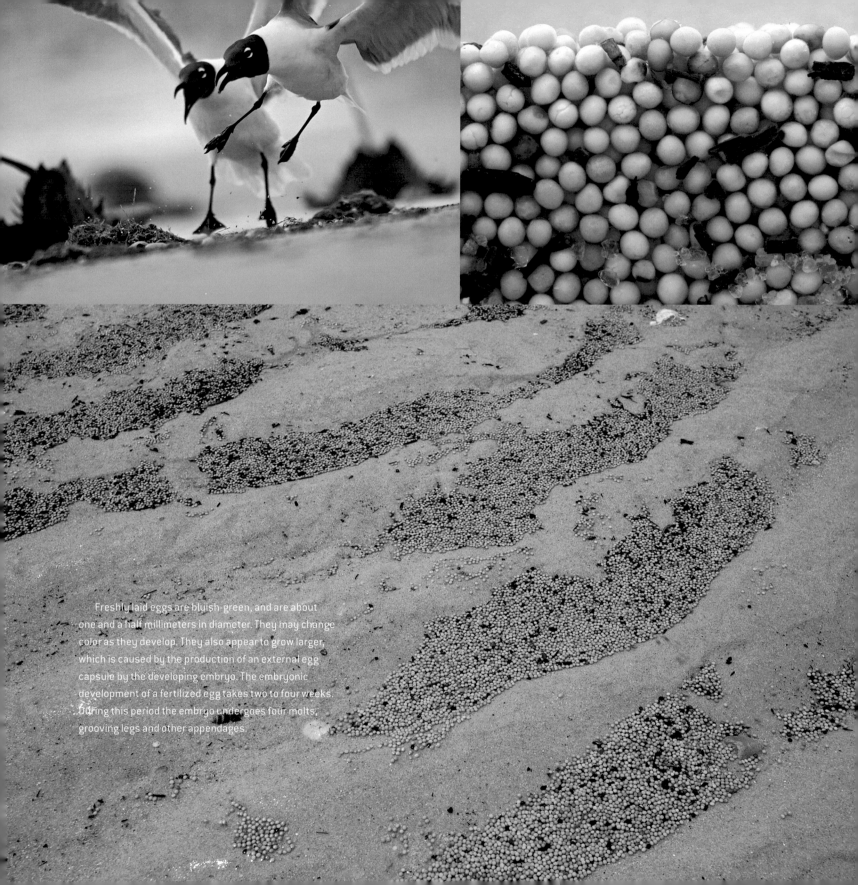

Freshly laid eggs are bluish-green, and are about one and a half millimeters in diameter. They may change color as they develop. They also appear to grow larger, which is caused by the production of an external egg capsule by the developing embryo. The embryonic development of a fertilized egg takes two to four weeks. During this period the embryo undergoes four molts, grooving legs and other appendages.

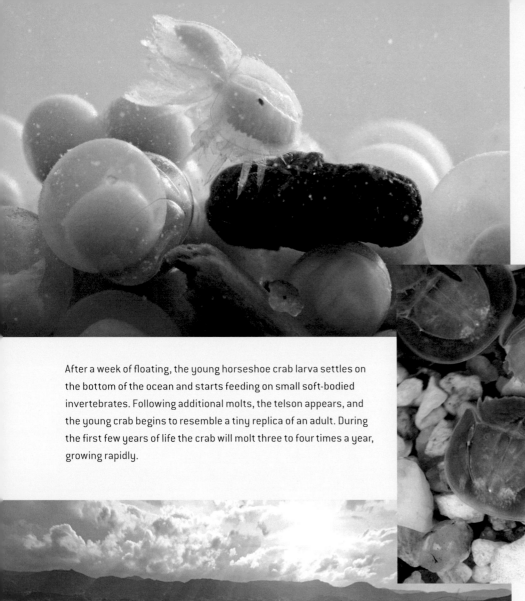

A freshly hatched larva, approximately three millimeters long, lacks the long "tail" (telson) and superficially resembles a horseshoe crab's distant, extinct relative, the trilobite. Referred to at this stage as the "trilobite larva," the young crab will spend five to seven days as a pelagic, free-floating organism. It does not feed during this period of life, relying instead on nutritional reserves in its body, the remnants of the yolk sac from the egg.

After a week of floating, the young horseshoe crab larva settles on the bottom of the ocean and starts feeding on small soft-bodied invertebrates. Following additional molts, the telson appears, and the young crab begins to resemble a tiny replica of an adult. During the first few years of life the crab will molt three to four times a year, growing rapidly.

Young horseshoe crabs spend the first few years of their lives in shallow, muddy waters very close to the shore. They are at this stage still quite vulnerable to predators, as their exoskeleton is not nearly as thick and hard as that of an adult. Perhaps for this reason their bodies carry distinct, sharp spines, which disappear in the adult Atlantic horseshoe crabs (but are retained in the Japanese species).

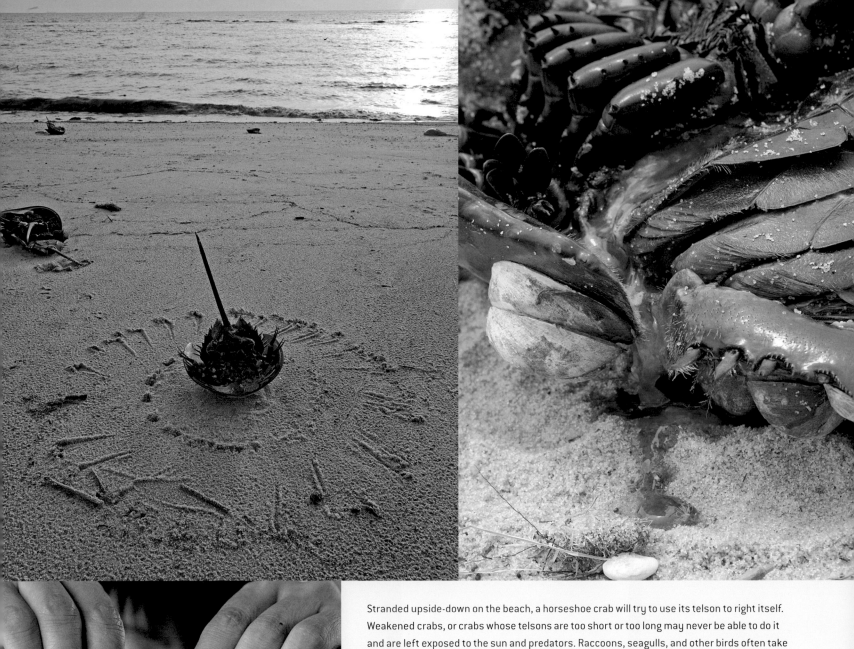

Stranded upside-down on the beach, a horseshoe crab will try to use its telson to right itself. Weakened crabs, or crabs whose telsons are too short or too long may never be able to do it and are left exposed to the sun and predators. Raccoons, seagulls, and other birds often take advantage of such individuals, exploiting the easy access to the vulnerable underside of the horseshoe crab. It is not rare to find injured individuals, whose gills and other body parts have been torn off by predators. Surprisingly, many survive these horrific injuries.

The key to their survival is their blood—blue, thanks to the copper-based hemocyanin. It contains fast-acting amoebocytes that creative massive clots the instant they detect the presence of Gram-negative bacteria. These clots create a very effective barrier that stops further infections and helps the animal recover.

Limulus amoebocyte lysate, a product obtained from their blood, is used worldwide to detect bacterial contamination in medical instruments, drugs, and human body fluids. Peptides found in horseshoe crab blood have also been demonstrated to suppress the activity of HIV.

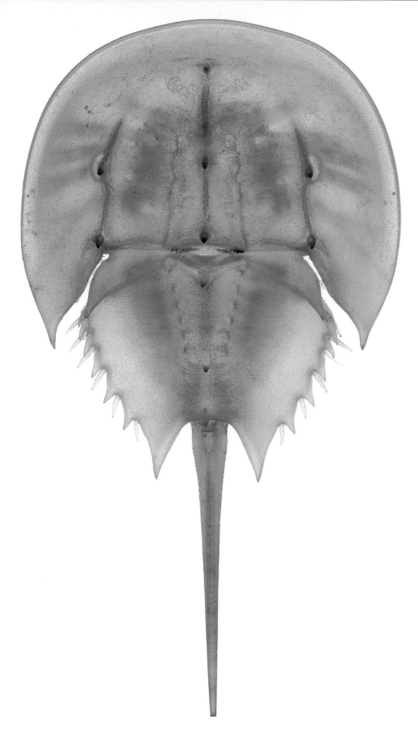

Like their distant relatives scorpions, horseshoe crabs fluoresce a pale green color if exposed to ultraviolet light. Their big compound eyes are sensitive to this part of the light spectrum, which probably helps them find each other in the murky, turbulent waters of the Atlantic coastline.

The thin layer of the fluorescent compound wears off easily and reveals superficial injuries hardly visible in the normal light. The individual in the lower left corner of this photograph has clearly suffered from repeated attacks by an unknown assailant, whereas the blemish free surface of the body of the individual to the right suggests that he has only recently molted.

The old "skin," or exuvia, of a horseshoe crab is fragile and semitranslucent, but it perfectly preserves all external features of this animal. Well known to beachcombers all along the eastern shores of the Atlantic Ocean, these remains, if found frequently, are an indication of a healthy population of horseshoe crabs.

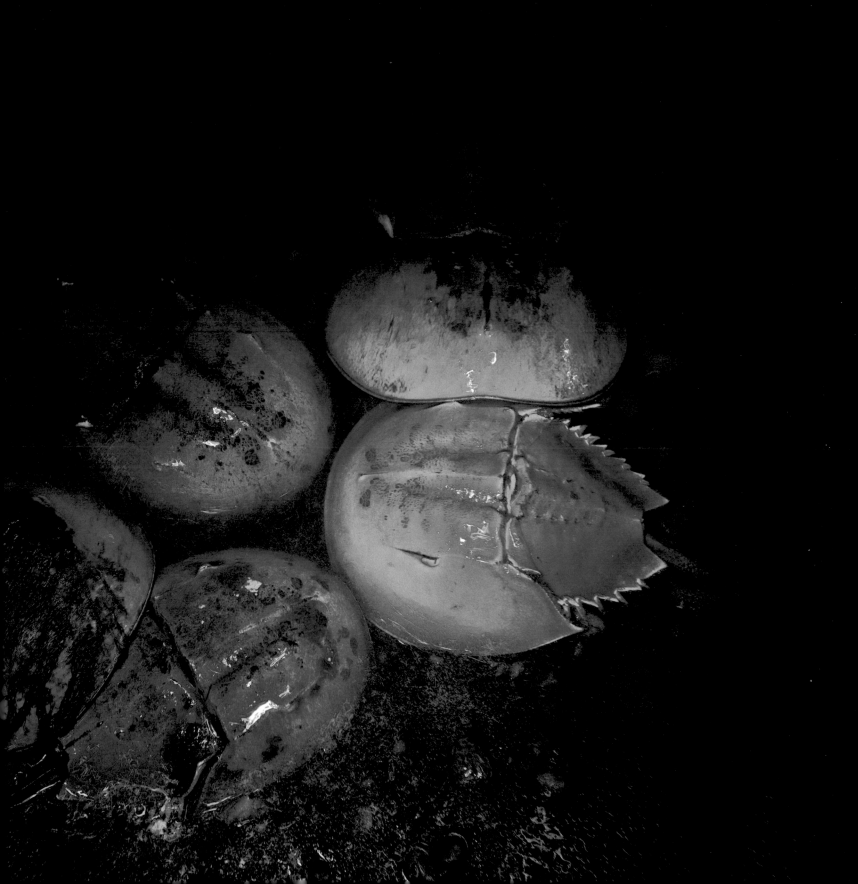

In the Sagebrush

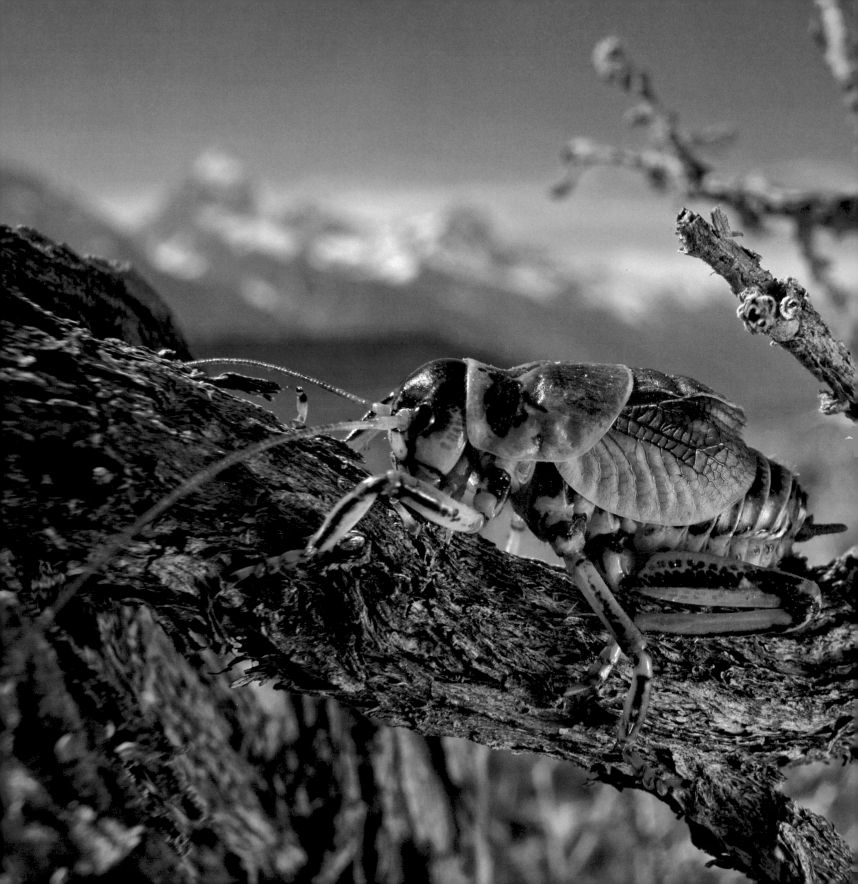

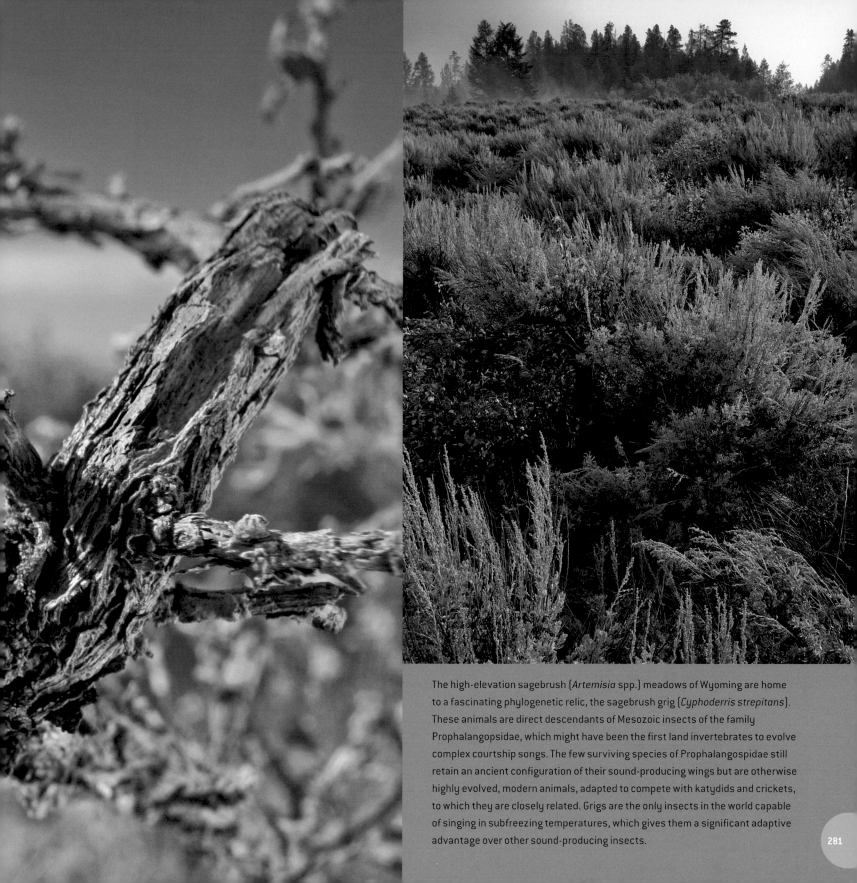

The high-elevation sagebrush (*Artemisia* spp.) meadows of Wyoming are home to a fascinating phylogenetic relic, the sagebrush grig (*Cyphoderris strepitans*). These animals are direct descendants of Mesozoic insects of the family Prophalangopsidae, which might have been the first land invertebrates to evolve complex courtship songs. The few surviving species of Prophalangospidae still retain an ancient configuration of their sound-producing wings but are otherwise highly evolved, modern animals, adapted to compete with katydids and crickets, to which they are closely related. Grigs are the only insects in the world capable of singing in subfreezing temperatures, which gives them a significant adaptive advantage over other sound-producing insects.

281

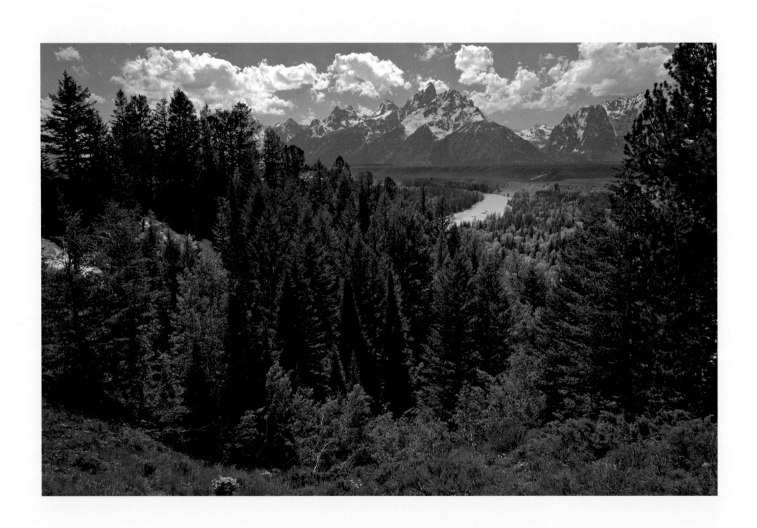

One of the most alluring aspects of time travel is the possibility (however unlikely) that the lucky individual who somehow managed to go back to the long-gone epochs of Earth's history would be able not only to see the ancient life forms but also to hear the sounds of organisms we now encounter only as mere imprints in old, sedimentary rocks. Solitary appreciation of night symphonies of a tropical forest or listening to the ambient concertos of an African savanna is to me the pinnacle of a naturalist's experience, and I cannot even imagine how exhilarating it would be to be privy to similar soundscapes of the Permian or the Cretaceous. Sadly, while we can make reasonable guesses as to what the denizens of the ancient worlds might have looked like (their shapes, that is; we will never know the colors of most creatures of the bygone eras), their aural footprint is gone forever. In a few rare cases it may be possible to recreate the physical sound-producing apparatuses of some particularly well-preserved extinct animals and plausibly reconstruct the overall frequency parameters of the sound they produced, but all nuances of the call's temporal pattern, the complexity of its harmonics, and the interplay of vocal duets of extinct singers will forever remain a mystery.

Nobody really knows who the first singers were. Chances are that the first acoustically active animals were aquatic—grunting placoderm fish, stridulating trilobites, or perhaps pincer-snapping eurypterid sea scorpions—they all have modern equivalents that produce sound underwater. But on land the first organisms that broke the silence were almost certainly small arthropods, whose bodies, encased in rigid plates and tubes of the chitinous exoskeleton, were perfectly suited to become percussive instruments (of the washboard variety, rather than that of a drum). The simplest form of sound production, still common among modern insects and arachnids, involves rubbing two parts of the body against each other, for example, scraping the back of the head against the thorax. The sound produced in this way is simple, with a broad frequency range, and its function is usually to warn a predator of the caller's unpleasant ability to inflict some kind of bodily harm on the attacker. It is quite likely that the defensive sound production was the initial reason for the evolution of animals' acoustic behavior, but it did not take long for them to start using sound as an effective attractant during courtship, and then greatly increase its complexity.

The unquestionable leading voices of invertebrate love chorus are, and probably have always been, the orthopteroid insects, known in the present time as crickets, katydids, and grasshoppers. Their Permian and Triassic ancestors already had quite sophisticated sound-producing organs on their wings and must have dominated the soundscapes of the Pangean supercontinent. Wings of these fossil insects are often preserved with exquisite detail, allowing us to speculate about the kind of sound they made, and who their modern successors might be. A handful of direct descendants of these ancient singing arthropods, members of the largely extinct Mesozoic family of insects called the Prophalangopsidae, are still alive today. Among them, none elicits more excitement in entomologists than the mysterious insect known as *Prophalangopsis obscura*, whose specimen, only one of two ever collected, is carefully guarded in the Natural History Museum in London. Its geographic origin used to be a puzzle to entomologists, and it took 140 years after the first individual was described in 1869 to find another one at the

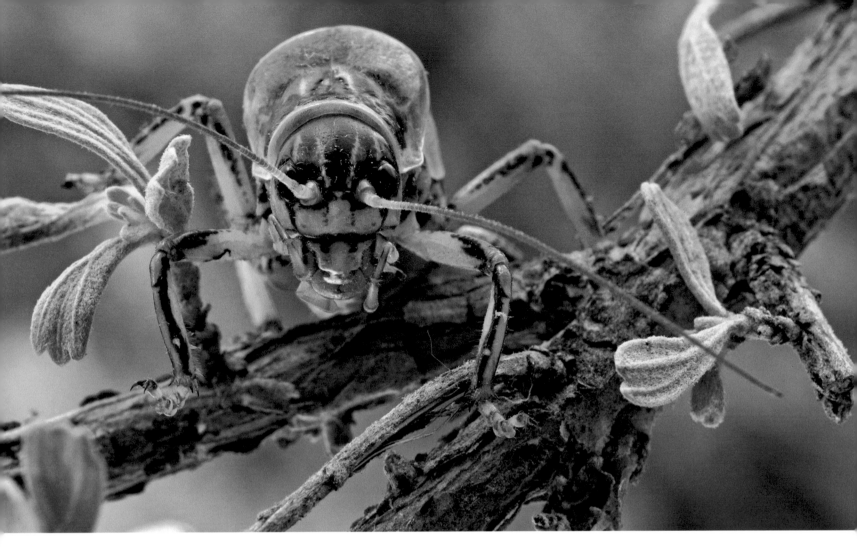

foothills of Tibet. This insect, with big, somewhat tattered wings, and some body parts gone missing in the century and a half since its collection, resembles a big, chunky cricket. Most entomologists agree that *Prophalangopsis obscura* is a phylogenetic relic and possibly the closest modern relative of the common ancestor of all living crickets and katydids. While a living *Prophalangopsis obscura* has yet to be studied, a handful of additional species of its ancient family are still surviving in sometimes inhospitable, often cold places of the Northern Hemisphere. There is one species in eastern Siberia, and four enigmatic species were recently found in central China. Three additional species still live in the Rocky Moun-

tains of the United States and Canada. Virtually nothing is known about the Asian species, but the North American ones, called grigs or hump-winged crickets, have inspired research for decades, and we now know more about their singing behavior than about that of almost any other insect on the planet. And what fascinating behavior it is—these small, innocent-looking insects combine a love of freezing weather, singing, and cannibalism with a lust for virgins. So when an opportunity presented itself for me to see and listen to the grigs in their natural habitat, I jumped at it.

I arrived in the small town of Jackson, Wyoming, in early June, a time when most snow in the Grand Teton National

Park had already melted but nights were still freezing cold, and few insects could be seen during the day. Visitors come here to witness a fragment of the North American continent as it appeared before Walmarts and Shell stations conquered most of this land, but few realize that the glorious landscapes of the Grand Teton hide an organism, the sagebrush grig (*Cyphoderris strepitans*), that can give us a glimpse even deeper into the past life of the continent. Before coming to Wyoming I had read almost every article on this animal's biology and behavior and knew well what to expect. And yet it felt wrong to go out at night to look for a singing insect when the temperature hovered near the freezing point (I had grown to associate insect songs with steamy tropical nights), and I wished for a pair of thick, wool gloves. For some reason grigs relish cold weather; in fact, they have been recorded singing at -8°C, well below the comfort zone of most cold-tolerant invertebrates. This ability to survive and reproduce in harsh and icy conditions may be the reason they are still able to compete against modern crickets and katydids, which largely replaced grigs and their relatives in the Tertiary.

As the night approached I drove slowly along a winding road toward the sagebrush plains on the banks of the Snake River. I passed a group of cars stopped to admire a mother moose with her calf grazing plants in a shallow pond but was too anxious to find the grigs to be sidetracked by some common mammal; there would be time for roadside attractions during the day, when grigs are asleep underground. I checked with the park's management if it was okay for me to be out and about at night (it was), but I still tried to be as inconspicuous as possible—experience had taught me that there is nothing more suspicious than a single man doing something strange at night in a remote place. By the time I got to my destination, a particular patch of sagebrush where many observations of the grigs' behavior had been recorded, it was dark and, at the elevation of nearly seven thousand feet, very cold. The one thing I didn't know was the sound of the grig's call, and so I sat in silence in the middle of a beauti-

fully fragrant sagebrush meadow, shivering ever so slightly, waiting for the concert to begin. Just in case, I brought with me an ultrasound detector, a device that allows human ears to perceive the sound of frequencies that are too high for us to hear unaided, such as ultrasonic calls of echolocating bats. As it turned out, I didn't need it—suddenly I heard a soft trill coming from nearby sagebrush, then another one, and after a while I started hearing it all around me. I slowly crept toward the nearest source of the sound. And there he was, oblivious to my presence, lost in his love soliloquy, a male grig and the closest thing to the first insect singers that graced Earth with their courtship serenades. Trying to be as quiet as possible I pointed a microphone at him and recorded the sound, a high-pitched but rather pleasant warble, somewhat akin to the ring of an old-fashioned telephone, if it were slightly muffled and heard from a far distance.

I spent the next hour recording and photographing the grigs, until it dawned on me that all the individuals I had seen so far were males. I knew well that I should not expect to hear singing females, as they are completely wingless and incapable of producing loud courtship calls, but they should be here. But each plant invariably had only one singing male (they are fiercely territorial), although a few also had small juvenile individuals feeding on the buds of the plant. Another hour had passed before I found the first female, emerging from her underground hideout far from the nearest bush; it was almost 11 p.m. when the females started coming out in large numbers. Lacking wings and with big, shiny heads, female grigs looked more like some giant, solitary ants than relatives of long-legged, graceful katydids. There was clearly a purpose in their stride as they walked toward the clumps of sagebrush that hid the singing males. Unlike us, grigs' ears are not on their heads but on their front legs, right below the knee. Because their ears are so widely spaced and finely attuned to the particular frequency of the male's call, female grigs are very good at detecting the direction of the caller they are interested in. But their interest in males is of somewhat different

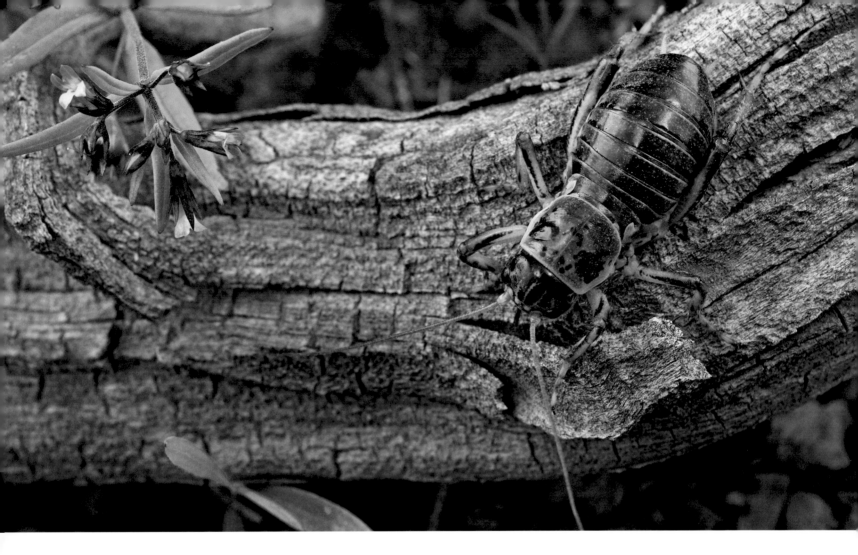

nature than one would expect. In the majority of the animal kingdom the male provides little more than reproductive cells that inseminate the female's eggs, and hence the profusion of elaborate displays of masculine strength and virility designed to convince the female of the male's good genes, rather than his suitability for lasting partnership or shared investment in offspring. Usually, all the gullible female gets is a brief, entertaining show and the knowledge that she will never see the guy again. Not so in grigs. The females in these animals want to take home more than just a memory of a good time; they also demand a decent meal, something that will significantly contribute to the production of eggs. Because grigs literally

live in their food, a male offering a piece of sagebrush, no matter how fresh and tasty, would certainly be given a cold shoulder. Having nothing else to give, the males are forced to make the ultimate sacrifice—they offer females parts of their own bodies to dine on.

Like most insects, male grigs have two pairs of wings. The first pair, slightly hardened and modified into sound organs, is used to produce courtship songs. The second pair, however, is somewhat dispensable, and it has evolved into a pair of big, fleshy organs filled with the male's blood (hemolymph), and this is what the female grigs lust for. Once a female locates an interested male, she climbs on his back and immediately starts

devouring his wings. While she is busy with her cannibalistic hors d'oeuvre, the male attaches his reproductive organs to those of the female and transfers a packet of sperm. He also leaves with the female a package of nutritious carbohydrates and proteins, known as the spermatophylax, which the female consumes after mating. It seems that the role of these nuptial gifts is to ensure that the sperm he delivered has enough time to get where it needs to in the female's body, and it also precludes her from mating again with another male, at least until she is done eating. More importantly, his edible wings and the spermatophylax provide the female with nutrients that she will be able to use to produce her eggs, making the male an active and invested participant in parenthood.

Although both the male and the female will soon be ready to mate again, the male now has a problem—he is not ready to retire quite yet, but he no longer has the tasty wings that attracted his first partner. Luckily for him females are not very good at distinguishing the song of an unmated male from that of one who has already lost his virgin wings (but there is evidence that the females preferentially mate with virgin males). And once she climbs the back of a male and realizes that he no longer carries the tasty snack, it is too late. Male grigs have evolved an ingenious, if somewhat insidious, device on their abdomen, appropriately called the gin trap, which effectively locks the female in place and gives him extra time to transfer his reproductive cells. It takes a female a considerable amount of effort to disengage from the male, and there is plenty of time for him to pass on his genes.

I watched the drama of the grigs' lives for hours, and it was well after 1 a.m. when I decided to head back. I wanted to stay longer but all I could think of was a thick sweater that I had foolishly left in the hotel room. I also suddenly realized that I was all by myself, unarmed, at night, in the middle of bear country. A loud crack of a breaking branch (a deer, I thought—I hoped) was all the motivation that I needed to say goodnight to the grigs and run for the car.

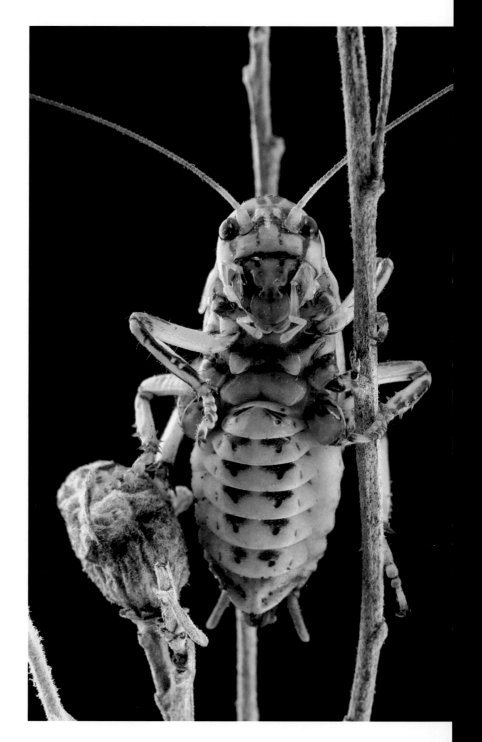

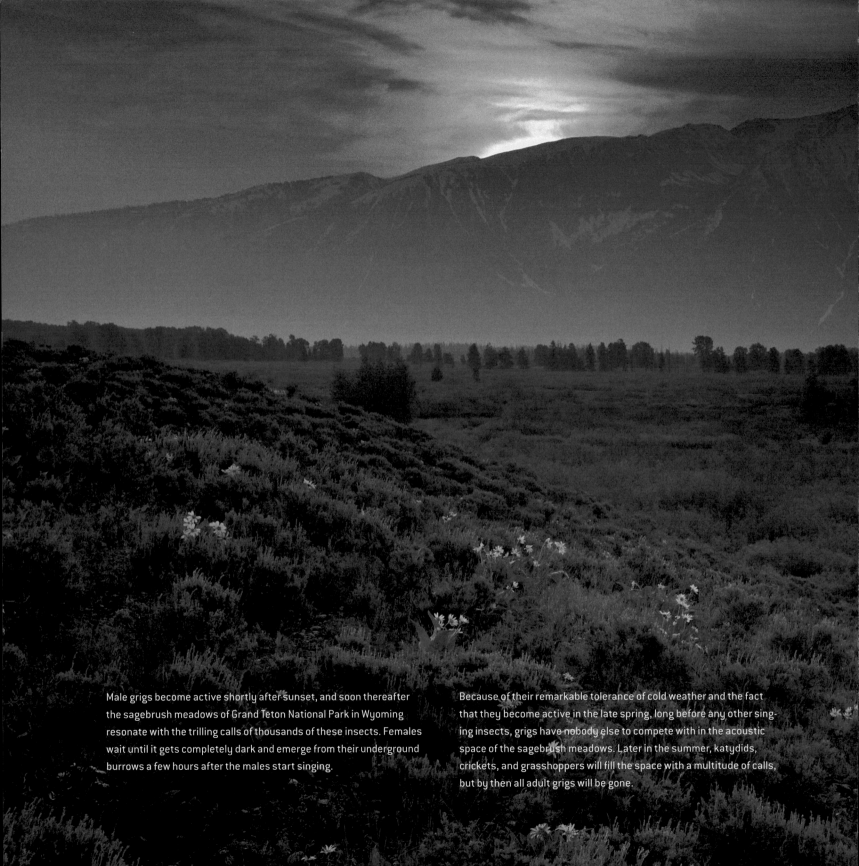

Male grigs become active shortly after sunset, and soon thereafter the sagebrush meadows of Grand Teton National Park in Wyoming resonate with the trilling calls of thousands of these insects. Females wait until it gets completely dark and emerge from their underground burrows a few hours after the males start singing.

Because of their remarkable tolerance of cold weather and the fact that they become active in the late spring, long before any other singing insects, grigs have nobody else to compete with in the acoustic space of the sagebrush meadows. Later in the summer, katydids, crickets, and grasshoppers will fill the space with a multitude of calls, but by then all adult grigs will be gone.

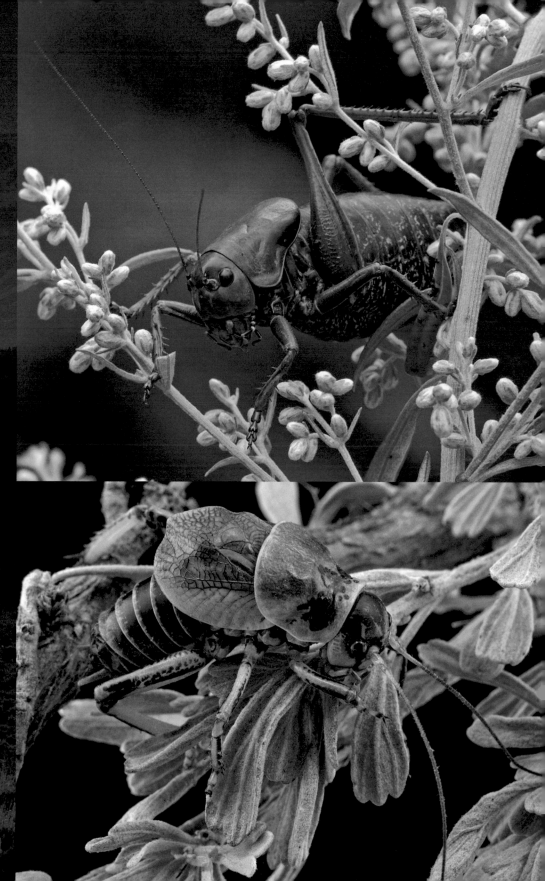

Somewhat similar to the sagebrush grig, a Mormon cricket (*Anabrus simplex*) can be seen and heard in sagebrush meadows starting in late July. Like the grigs, these katydids (despite their common name, Mormon crickets are not true crickets) cannot fly, and their wings are used only for sound production.

The wings of a male grig are mirror images of one another. This means that they can produce sound with either wing. Their cousins, katydids and crickets, have more specialized sound producing wings, and can make calls only with the left or the right wing, respectively.

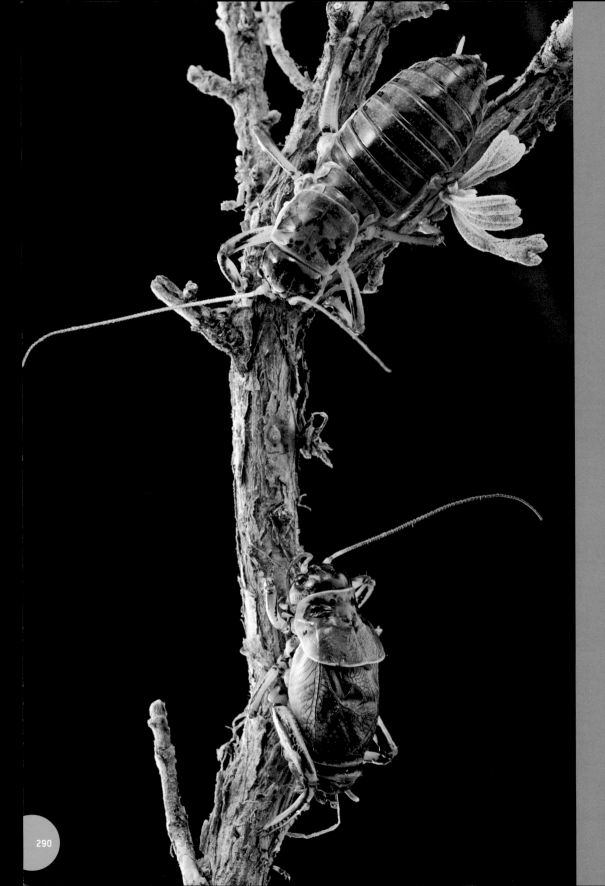

The wingless, somewhat larval-looking female sagebrush grig gingerly approaches a singing male. She is looking not only for a father for her offspring but also for somebody who can provide a nutritious meal that can help her produce eggs. Studies have shown that females preferentially mate with virgin males whose second pair of wings are still intact and can be devoured by the first female that mates with them. The male's investment in offspring is not limited to the sacrifice of his wings. During mating he also produces a spermatophylax, a nourishing package of carbohydrates and proteins that the female eats after copulation.

The male's energetic and material sacrifice during the first mating takes a significant toll on his future reproductive success. Weakened by the production of the spermatophylax, he has less energy to sing; he also no longer has the second pair of wings with which to entice females. Luckily, male grigs have another way of ensuring the fatherhood of more than just one clutch of eggs—these insects have evolved a special abdominal organ known as the gin trap, which allows them to secure the female firmly to their abdomen during mating. Even if the female wants to leave immediately after discovering the lack of tasty virgin wings, she has to struggle to disengage her reproductive organs from those of the male. This usually gives him enough time to produce a packet of sperm and ensure passing of his genes on additional progeny.

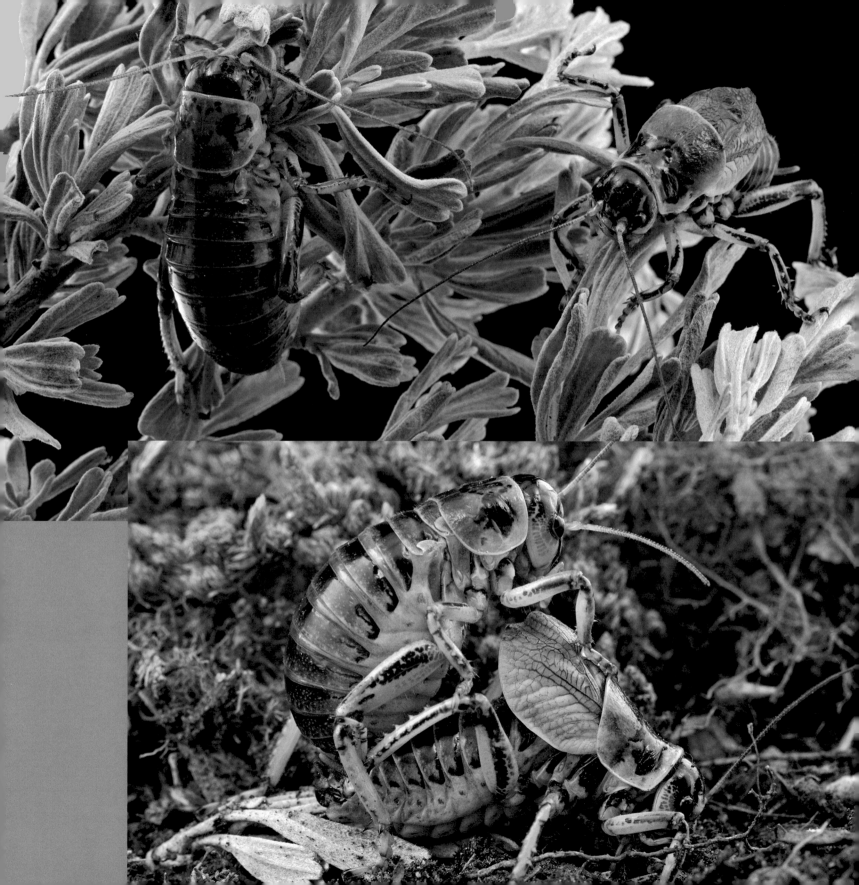

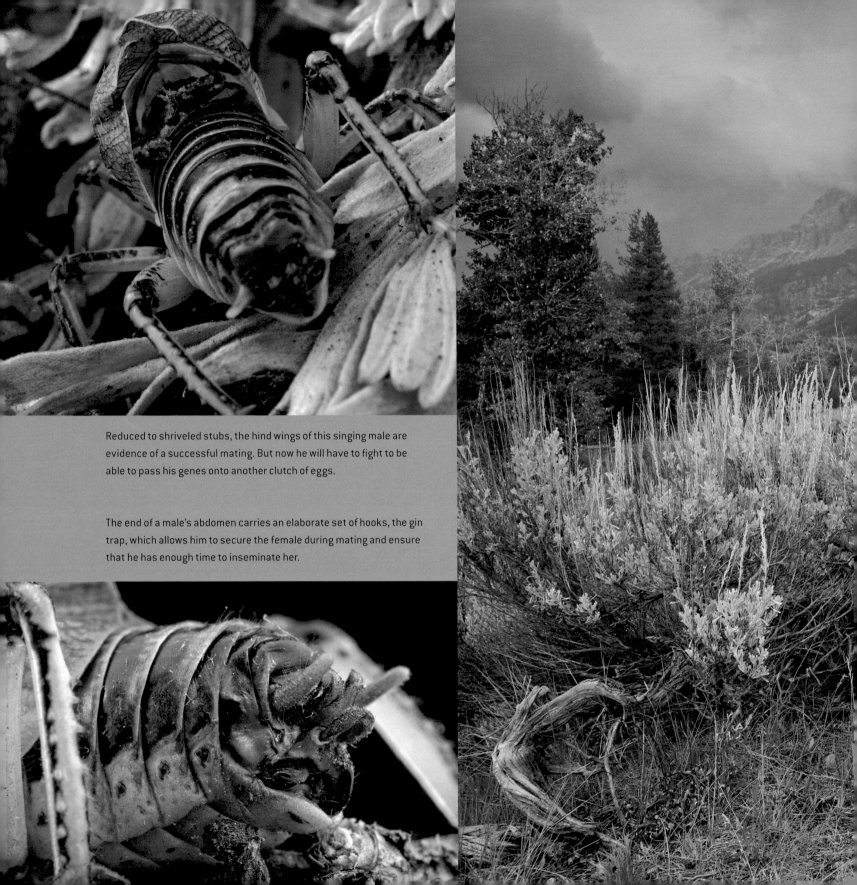

Reduced to shriveled stubs, the hind wings of this singing male are evidence of a successful mating. But now he will have to fight to be able to pass his genes onto another clutch of eggs.

The end of a male's abdomen carries an elaborate set of hooks, the gin trap, which allows him to secure the female during mating and ensure that he has enough time to inseminate her.

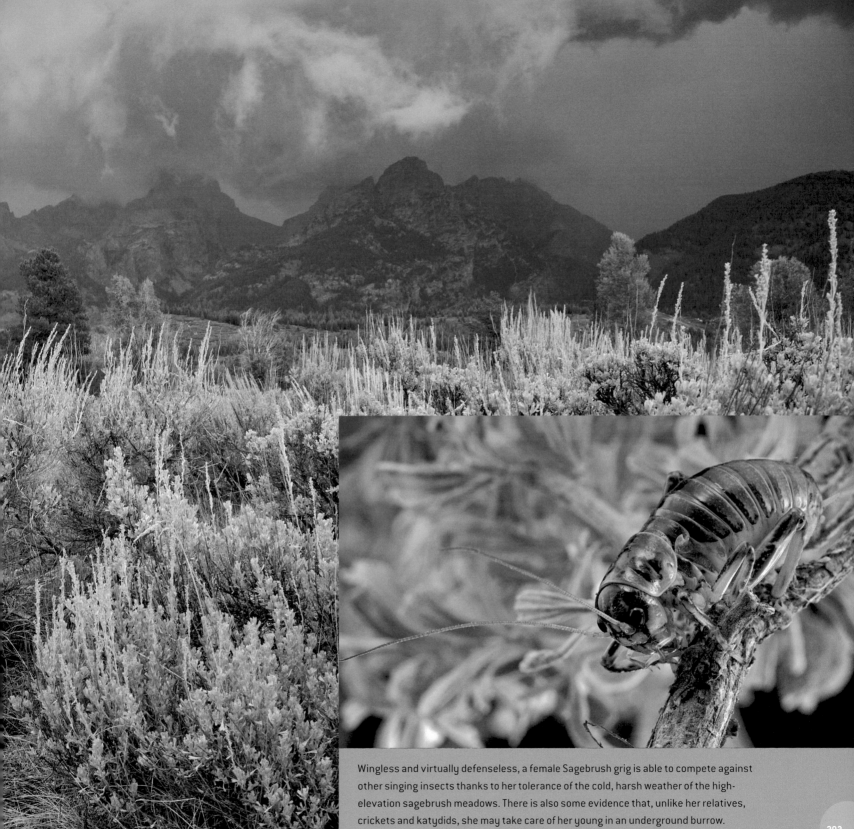

Wingless and virtually defenseless, a female Sagebrush grig is able to compete against other singing insects thanks to her tolerance of the cold, harsh weather of the high-elevation sagebrush meadows. There is also some evidence that, unlike her relatives, crickets and katydids, she may take care of her young in an underground burrow.

293

A Walk in the Estabrook Woods

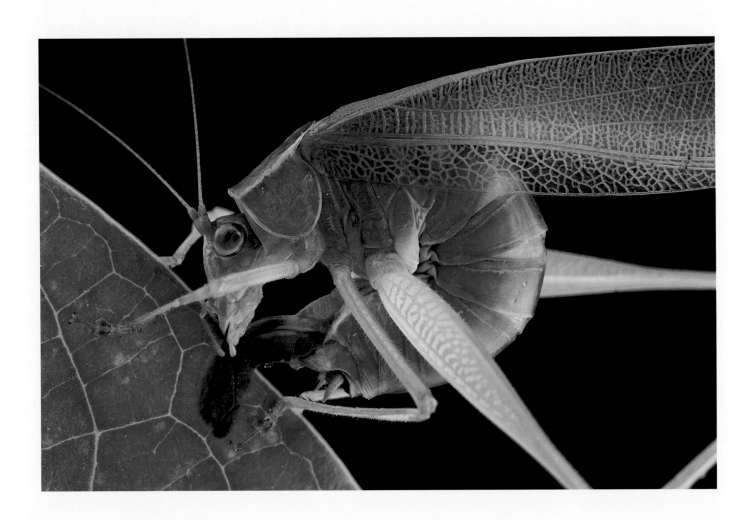

Not far from Boston, and just a few miles from Walden Pond of Henry David Thoreau fame, lies a small track of woodland and swamps known as Estabrook Woods. Although it covers less than two square miles, it is nevertheless the largest contiguous and undeveloped patch of forest within thirty miles of the city and, not surprisingly, it attracts many visitors from the metropolis and the suburbs. One thing about this place is particularly appealing to many—and this is how I first learned about its existence—dogs are allowed to roam freely along its many trails, and one may get the impression that on some days the canines outnumber human visitors by at least an order of magnitude. I have been taking my furry children to Estabrook for years now and, while greatly enjoying this small enclave of nature, I never thought much about its biological composition. Many parts of the forest are secondary growth, and the presence of lichen-encrusted stone walls hidden among the trees betrays its not-so-distant past as an area once covered by pastures and agricultural fields. Chipmunks love hiding among the walls' rocks, and their high-pitched squeaks drive my dogs into frenzy, which in turn makes me foam at the mouth as I try to get them to listen to me and come back on the trail.

But the more time I spent in Estabrook, the more I noticed how incredibly diverse the variety of its life forms was. Under every fallen log colonies of ants conducted their busy and mysterious activities, often accompanied by red-back salamanders and a great variety of beetles. Katydids sang from bushes and trees, and flowers of amazing shapes and colors dotted the leaf litter of the forest floor.

A female katydid (*Scudderia furcata*) laying eggs inside a leaf

Garter snakes sunning in patches of sunlight tested the bravery of my dogs, proving (as I had always suspected) that they were all bark and no bite. I learned that Estabrook Woods was home to a surprising number of rare organisms, including an endangered dragonfly known as the ringed boghaunter (*Williamsonia lintneri*), the spotted turtle (*Clemmys guttata*), and the Mystic Valley amphipod (*Crangonyx aberrans*). Then, on July 4 in 1998 and 2009, Peter Alden, a renowned local naturalist and author, rallied a massive group of amateurs and professional biologists, 330 in all, to conduct a census of life of Estabrook Woods and several adjoining natural areas. These Biodiversity Days, as they were called, revealed an astounding variety of organisms. During these two 24-hour-long events, 2,579 species of plants and animals ranging from mosses to a moose were recorded. I was blown away.

And so it was only natural that as I began to compile ideas for this book, the thought occurred to me that Estabrook might be as rich in ancient, relict lineages as the most remote and exotic lands I had been scouring for years in search of members of prehistoric groups. And indeed, it soon became apparent that some of the most common plants and animals found in Estabrook have hardly changed in their morphology from their primordial ancestors, now immortalized as faint, fossilized embossments. All I needed to get a glimpse of a fragment of the world as it might have appeared hundreds of millions of years ago was to follow my dogs through the underbrush of the forest, with a mind finally prepared to see what I had been looking at for years, but had never truly comprehended.

At the edge of a small meadow in the center of Estabrook

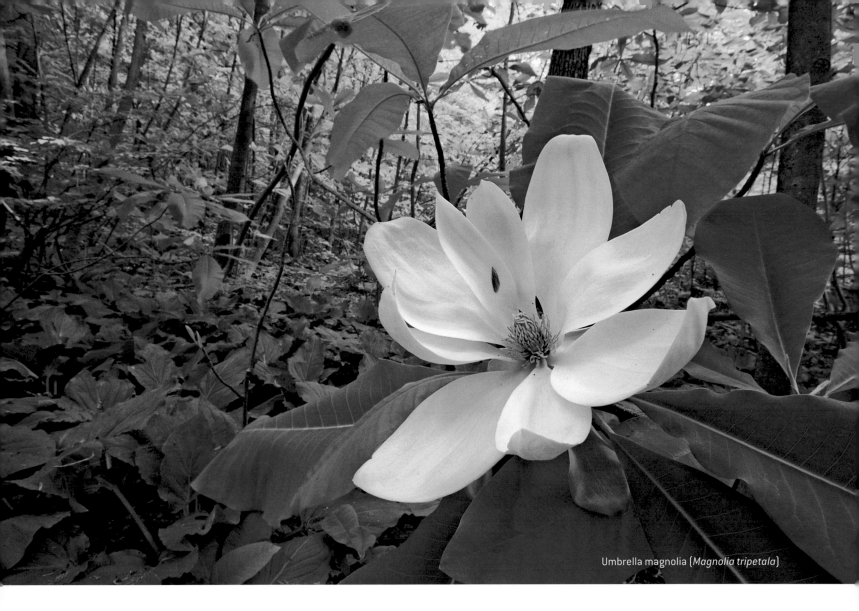

Umbrella magnolia (*Magnolia tripetala*)

stands a group of magnolia trees, southern arrivals that seem to be testing their ability to survive nasty Massachusetts winters. For the longest time magnolias were thought to hold the key to Charles Darwin's "abominable mystery," a baffling evolutionary problem that had preoccupied the great thinker until the very end of his life. That mystery was the extremely rapid (from a geological point of view) origin of flowering plants, a question so puzzling that he even confessed in a letter to his friend and supporter Joseph D. Hooker that he

"fancied that perhaps there was during long ages a small isolated continent in the S. Hemisphere which served as the birthplace of the higher plants—but this is a wretchedly poor conjecture." Truth to be told, it is.

Evidence for the existence of flowering plants, known to botanists as angiosperms, first appeared in the fossil record of the Early Cretaceous, about 136 million years ago. They differed from other plants of that period in having remarkable new structures: flowers, reproductive organs that often

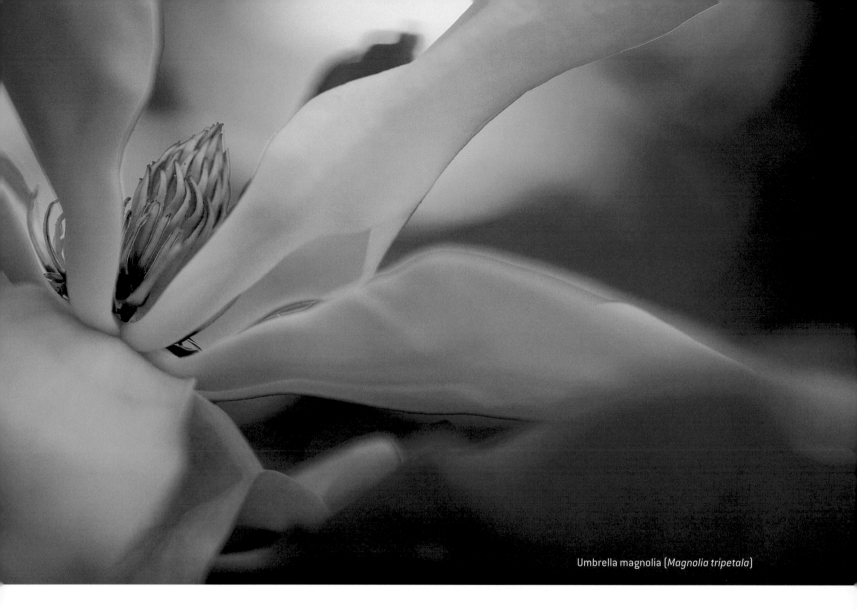

Umbrella magnolia (*Magnolia tripetala*)

combined both male and female elements into one handy package. But even more importantly, unlike their ancestors, the gymnosperms, whose eggs grew into seeds pretty much exposed to the elements ("gymno-" = naked), the newcomers carefully protected their developing seeds in ovaries, and surrounded the embryo in a nutritious tissue known as the endosperm ("angio-" = vessel). Often the entire wall of the ovaries grew fleshy and thick, turning them into delicious objects we now know as fruits.

What happened next profoundly changed the world. Within 10 million years of the first appearance of flowers, all main lineages of modern plants were present and, by the middle of the Cretaceous, flowering plants became the dominant group of the world's flora. Today, nearly 300,000 species of flowering plants, including virtually all plants that humans rely on for their very survival, inhabit every terrestrial and many aquatic ecosystems of the globe. By comparison, only about 870 species of gymnosperms, the ancestors

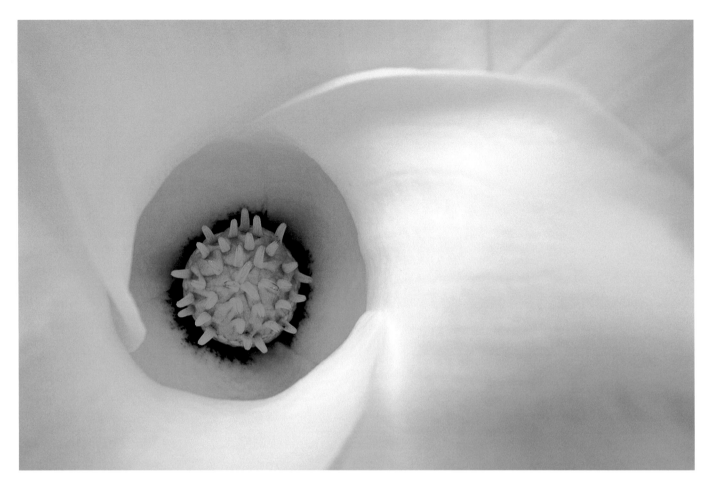

Bigleaf magnolia (*Magnolia macrophylla*)

of flowering plants, a group that includes all conifers—pines, spruces, and the like—still survive. It was this rapid explosion of angiosperm diversity that perplexed Darwin, whose idea of the evolutionary change assumed slow, steady selection and accumulation of variation in organisms. Now, of course, we know that evolution can proceed in a very rapid fashion (once again, from a geological point of view), and a dramatic shift in the composition of the entire Earth's flora within a single geologic period is not an unexpected event. But what drove this sudden success?

Darwin suspected that the process had to be related to the almost concurrent diversification of insects in the Cretaceous, but in his time solid evidence for that was lacking. But now, armed with a rich fossil record and powerful corroboration from molecular phylogenetics and evolutionary developmental biology ("evo-devo"), biologists are certain that it was the intricate, mutually beneficial relationship between insects and angiosperms that drove the increasing specialization and diversification of both lineages. The results of this process can be plainly seen today—insects

dominate the animal world, while angiosperms dominate that of the plants. Through their symbiotic relationship each group gained something that phenomenally increased its chances to survive and compete against other organisms. Flowering plants, by using insects as carriers of their reproductive cells, increased the efficiency and range of the dispersal of their genes. No longer did they need to rely on unpredictable winds to propagate their pollen, and the amount of energy spent on the production of huge amounts of reproductive cells could be diverted elsewhere. Sending pollen away from the parent plant on the wings of insects, combined with hiding the eggs in ovaries, also reduced the risk of self-fertilization, which, in turn, led to a higher genetic diversity of plants and a rapid emergence of new forms. For insects, visiting flowers provided them with a wide range of benefits, including food (nectar, pollen, or both), convenient (and romantic) meeting sites for reproduction, and free heating (yes, some flowers generate heat that insects use to warm up their bodies). Flowering plants were not the first ones to engage insects in their reproduction—some early gymnosperms were also insect-pollinated—but they perfected the liaison. Over millions of years these plant-insect interactions have become increasingly more specialized and efficient, and now the majority of plants simply cannot exist without insects and vice versa. Flowers of many plants can only be pollinated by certain species of insects, and their morphology precludes others from gaining access to nectar or other rewards. At the same time insects have evolved structures and behaviors that serve no other purpose but to gain access to flowers. The long, extraordinarily modified mouthparts of butterflies and moths that perfectly fit the long, nectar-filled corollas of flowers are a good example of such a reciprocal evolutionary change, or coevolution.

A closer look at the cluster of umbrella magnolias (*Magnolia tripetala*) in Estabrook Woods gave me a glimpse of one of the early chapters of this remarkable spectacle. The magnolia's exuberant, huge flowers, which start opening in late spring, are vortices of insect activity. But, strangely, the insects I found inside were not those that we usually associate with plant pollination. No butterflies approached the resplendent blooms, and a lone bee seemed confused by the huge structures in the center of the flower and stumbled aimlessly among its giant stamens. Almost all insects inside were beetles, and the rest were tiny, comma-sized thrips. When magnolias first appeared in the early Cretaceous, well over a hundred million years ago, many pollinator insects that are dominant today, including bees and butterflies, simply did not yet exist. Thus, magnolias were forced to attract and form alliances with insects that already had some experience as pollinators of other, older plants, such as cycads and some of their now-extinct cousins, and those alliances have managed to survive to this day. Beetles, with their hard bodies and chewing mouthparts, are remarkably unsophisticated as pollinators, rolling and tumbling in the flowers, in the process getting covered with pollen, which earned them a rather unflattering designation as "mess and soil" pollinators.

Until quite recently botanists believed that magnolias were some of the very first of flowering plants and that their relationship with beetles represented the initial stage of one of the most successful and fruitful (pun intended) examples of coevolution. The morphology of magnolia flowers, with spirally arranged reproductive structures, had been assumed to represent the ancestral condition of the flower morphology. But recent molecular studies of the relationships of basal ("primitive") plants revealed that magnolias were not the earliest of flowering plants, and that their relationship with beetles, while indeed extremely old and one of the earliest ones, was not the very first of its kind. It appears instead that the first flowering plants might have looked more like *Amborella*, a short, inconspicuous shrub from the remote Pacific island of New Caledonia, whose minute, simple flowers are pollinated by the combination of wind and rather unspecialized insect visitors, such as tiny midges and other assorted flies. This type of pollination was followed shortly by a more

advanced kind, represented by another plant growing in the Estabrook Woods that bears a striking resemblance to its Cretaceous ancestors—the fragrant water lily (*Nymphaea odorata*). These beautiful aquatic plants that cover the surface of almost every pond in Estabrook employ quite a sinister pollination strategy that often results in death of the unlucky visitor. The large white flowers of the water lily first develop female structures, which quickly become submerged in a sweet-smelling, but not at all nutritious, liquid. Insects, attracted by the seductive fragrance, enter the flower and fall into the liquid, which washes off any pollen that may have clung to their bodies after an earlier visit to another water lily. Many drown in the process, while others leave wet and confused, which is why this type of deceitful behavior by the water lily is known as "exploitative" pollination.

Nowadays, most flowering plants treat their pollinating insect partners with greater respect, and biologists agree that their relationship is the key to both groups' success. The story, however, may have an additional dimension. Recently, some ecologists have argued that the key to flowering plants' triumph may lie not so much in their innovative reproductive strategy but rather in a physiological advantage over their gymnosperm ancestors in processing nutrients contained in the soil. Their faster, more efficient metabolism of certain elements, particularly nitrogen and phosphorus, allowed them to colonize very quickly areas vacated by slow-growing gymnosperms and ferns (for example, after being trampled by dinosaurs), and, once there, they radically

Despite their name, water lilies (*Nymphaea*) are not close cousins of the lilies that grow in our gardens. They are related to some of the earliest flowering plants, placed by botanists in an informal assemblage called ANA (Amborellaceae-Nymphaeales-Austrobaileyales, named after the oldest flowering plant lineages), a group of plants united by their primitive flower morphology and pollination methods.

changed the physical composition of the soil, removing once and for all the possibility of the gymnosperms growing back.

It's an interesting hypothesis, one that certainly warrants further research, but I don't really believe it. Although most of presently living plants are of the flowering type, when my dogs happily roll in dead raccoons and chase chipmunks in Estabrook Woods, they do so surrounded by thousands of giant, towering gymnosperms—pine trees and hemlocks. These conifers still dominate certain ecosystems, despite over a hundred million years given to flowering plants to finish their coup d'état. Pines (*Pinus*), in a form remarkably similar to white pines (*P. strobus*) now growing in Estabrook Woods, first appeared in early Cretaceous, approximately 130 million years ago. Like many other old survivors, they have managed to hang on by being able to weather countless climatic and geological transitions the world has gone through, and their individual species adapt well to a wide range of environmental variables, such as the temperature, humidity, or soil type. They also cope remarkably well with low temperatures, and this is why their reign has never been challenged in high mountains and subarctic regions, where conifer forests have always been the dominant type of vegetation. By comparison, many flowering plants tend to be more specialized and do well only within a relatively narrow spectrum of environmental conditions. Give them warm, constant weather, and soon they will cover the land with an impenetrable blanket, but come the ice age, conifers move right back in. The one thing the gymnosperms have learned how to do well is to outlast others. And yet below their massive crowns, Estabrook Woods shelters organisms whose roots go even deeper in time.

By the end of May, after a couple months of warmer and humid weather, the forest undergoes a remarkable transformation. In place of wide stretches of ground covered with nothing but dry leaves and fallen twigs from the winter months, a thick layer of fresh, green foliage of new plants has sprung up. In wetter areas, if you squint your eyes a little,

all traces of the flower revolution seem to vanish and all you can see is a thick mat of plants that are virtually indistinguishable from their Triassic ancestors. Ferns of the genus *Osmunda* are known from 240 million-year-old fossils, but they still dominate the undergrowth of Estabrook Woods. Their appearance has hardly changed since—a recently found fossil species from Triassic rocks of Antarctica was christened *O. claytoniites*, because in its morphology, which included the minutest details of its reproductive structures, it was indistinguishable from a modern form known as the interrupted fern, *O. claytoniana*.

Needless to say, such amazingly similar physical appearance of the two species does not mean that ferns' evolution has stood still in all those years; far from it. Ferns have been around a mind-boggling 370 million years. They are one of the oldest lineages of organisms on the planet, and one of the most successful ones. Although flowering plants receive all the press these days and take up most of the space with over 250,000 currently living species, ferns are the second-richest group of plants, represented now by over 10,000 distinct forms. This may not sound like much, but this is four times as many species as all other nonflowering plants combined. In many habitats, including large stretches of the undergrowth of Estabrook Woods, it is ferns, not flowering plants, that are the most abundant, dominant type of vegetation. Why haven't ferns shriveled into near oblivion, like so many other ancient plant lineages that could not compete with those Cretaceous whippersnappers, the flowering plants?

Reading almost any general account of the paleontological history of the animal life on Earth may give you the impression that after the first appearance of dinosaurs in the Triassic all invertebrates simply vanished. From that point on there is hardly any mention of crustaceans, arachnids, or snails, as if the writers of such descriptions, having plodded through all the geologic periods that had nothing but "bugs" were finally relieved to find a more exciting subject. This, of course, I find unfair, if not unexpected, knowing

Common polypody
(*Polypodium virginianum*)

quite well that it was the arthropods who have undergone an even more stunning diversification since the Triassic than the vertebrates. But I was quite surprised to discover that paleobotany suffered from a similar bias. Although you will be hard-pressed to find any mention of it in many paleontological books, it turns out that after the spectacular, explosive radiation of flowering plants in the Cretaceous, in the shadows of these new rulers of the plant world, ferns underwent an extraordinary development. Initially, ferns, which, alongside the gymnosperms, had dominated the land before the arrival of the flowering plants, were hit hard by the new competition. The number of their species plummeted in the fossil record of the Cretaceous. But then, unexpectedly, they started to diversify again. Many gymnosperm lineages never fully recovered from the shock, some even perished altogether, but the ferns bounced back. Major new lineages of ferns started appearing at the end of the Cretaceous, *after* the flowering plants had established themselves as winners of the big, green race. How did they manage to pull it off?

During the reign of ferns, a period of time stretching more than two hundred million years, from the Devonian until the Jurassic, the environment in which they lived was rather simple. Other groups of plants that at the time co-existed with ferns had straight, narrow trunks, and their leaves were thin and often needle-like. That is to say, they did not have much to cast a shadow with. But flowering plants, with their wide, often very large leaves and multi-branched body structure created an environment where light was at a premium, especially for plants trying to grow below them. A recent study, which brilliantly combines data from paleontology, molecular phylogenetics, and plant physiology, pinpoints one critical innovation that appeared in Cretaceous ferns after the rise of flowering plants and made it possible for them to adapt to the new circumstances. This innovation was a photoreceptor known as phytochrome 3 (PHY3) that evolved in their cells, which allowed ferns to take advantage of a part of the light spectrum unavailable to other plants. It

Although these three-hundred-million-year-old fossil leaves look very much like modern ferns, they are members of a mysterious lineage known as seed ferns (Medullosales) that probably gave rise to cycads and became extinct during the Permian. These beautifully preserved impressions well illustrate the fact that the fossil record should be interpreted with great caution, as many unrelated groups of organisms may converge on similar morphological features.

increased their ability to orient their leaves and chloroplasts toward the light and gave them the capacity to survive and grow in low-light conditions, such as shady forest floors under the canopy of broad-leaved flowering plants. The higher spatial complexity of the angiosperm-dominated plant communities also allowed ferns to diversify into new niches, and they began to climb trees to become epiphytes on leaves and branches of flowering plants. Ferns found an opportunity in the initial defeat and went on to exploit the abundance and diversity of new plant communities created by the angiosperms. In other words, if you can't beat them, join them.

Let's now go back for a moment to the Triassic fossil fern found in Antarctica. Because one of the currently living species, the interrupted fern, is almost indistinguishable from

it, it would be tempting to call the modern species a "living fossil." But what the discovery of PHY3 demonstrates is that although ferns have retained their ancient appearance, they have completely reworked their physiology and behavior, a process that required a tremendous amount of evolutionary change. In fact, studies have shown that the rate of ferns' molecular evolution exceeds that of the significantly younger flowering plants. Unfortunately, things like that simply do not fossilize. Morphology is all we have for extinct organisms, but morphology is just one of many attributes of living things that determine their survival. And if a body plan that works well under a wide variety of environmental conditions has evolved, chances are that it will be preserved by natural selection, even if major biochemical and physiological changes are taking place on the inside. And here lies one of the many problems with the concept of "living fossils," organisms that appear to have changed little or not at all from their extinct predecessors. We make judgments about such organisms' presumed lack of change (stasis) based on very limited number of pieces of information, ones that happen to preserve well in prehistoric rocks, while being unaware of countless, invisible changes that must have taken place on the molecular level. Conversely, most organisms, humans included, employ biochemical pathways and physiological mechanisms that are almost as old as life itself, but we don't call such organisms "living fossils" because they don't *look* like their predecessors. Every organism living today, including those we call relics, belongs to a modern, recently evolved species, even if in its external appearance it resembles a long-gone prehistoric ancestor. "Relic" organisms are relict only in the sense that they are members of a genetic line that originated a very long time ago and still resemble their ancestors' morphology. Such genetic (or, more precisely, phylogenetic) lines may wither through time and turn from roaring rivers of species to a trickle before disappearing altogether. Others, like ferns, gain momentum again and keep their ancient appearance. They give us clues as to what ancient organisms

and ecosystems might have looked like and how they functioned, but they are not "living fossils."

On the shores of a small pond in Estabrook Woods, where for years my dogs have been exercising their frustration by trying, unsuccessfully, to catch even a single frog (giving a great testament to the effectiveness of the amphibians' masterful use of a cryptic coloration and powerful legs), another group of short, inconspicuous plants faintly echoes the once-dominant Carboniferous plant communities. These are horsetail ferns, sometimes also known as scouring rushes or simply horsetails. Until recently botanists were unsure of their relationships to other plants, but new paleontological and molecular data have placed them firmly as an early offshoot at the base of the evolutionary tree of modern ferns. Horsetails (categorized by botanists as the class Equisetopsida) have been around since the Devonian, or about 380 million years ago, and were then one of the dominant elements of the world's vegetation, with hundreds, perhaps thousands of species. But, like so many other ancient lineages, following the advent of flowering plants horsetails faded into the background and their line is now continued by a lone genus of small, herbaceous plants. *Equisetum*, the only survivor of the lineage, is now represented by only 15 species of a nearly cosmopolitan distribution. Yet back in their heyday horsetails were tall trees, growing in vast numbers in tropical swamps of the Carboniferous. It was their fossilized remains, alongside those of other ancient ferns and giant clubmosses, that propelled the human race into the industrial revolution and allowed us to achieve the technical sophistication we now enjoy. We know these remains as coal, the result of over 300 million years of oxygen-free compression of billions of dead plants under thick layers of sedimentary rocks. Our civilization would not be where it is now if it wasn't for the ancient horsetail ferns but, unfortunately, by digging out these antediluvian corpses we are also reconstituting, bit by bit, the hot, Carboniferous atmosphere. With each piece of coal burned, we re-release carbon dioxide that had lain bur-

ied until now after being sequestered from the Carboniferous air by the ancient plants. No matter where one stands on the issue of the global climate change, we cannot escape the simple fact that our planet has a certain, finite amount of carbon, a large proportion of which used to be buried underground, but now it is once again becoming a part of the gaseous layer that envelops Earth and traps solar radiation with an increasing efficiency.

Modern horsetails have little chance of playing a similarly essential role in human affairs, but they are not entirely useless to us, either. One interesting characteristic of these plants is their ability to sequester and concentrate certain chemical elements, especially silicon. In fact, they are the only plants that actually require silicon to grow, and they use it in a way surprisingly similar to what we and other vertebrate animals do with calcium—they build a skeleton out of it. Of course, you will not find silicon bones inside the hollow stem of a horsetail, but strips of silicon-based crystalline compounds, or silica, reinforce the stem and give it remarkable rigidity. As an added bonus, silica works wonders filing down teeth and mandibles of grazing animals, and hence few animals feed on these plants (although a number of fly species manage to develop inside the plants' tissues). Stems of horsetails are covered with hard silica granules, which makes them perfect for polishing metal objects. Before the invention of washing detergents, stems of horsetails were commonly used to wash dishes, but even more interestingly, because of the finesse of their abrasive action, horsetail stems were used by the Stradivari family to polish the wood of their famous violins. Gold is another element that horsetails reputedly accumulate in their tissues. For years gold prospectors had considered these plants good indicators of the presence of the precious metal in the soil. Unfortunately, this exciting property of horsetails did not withstand the rigors of scientific enquiry—research has shown that they do not hoard gold in their tissues any more than other plants. But the myth may have a rational basis after all. As it turns out, horsetails ac-

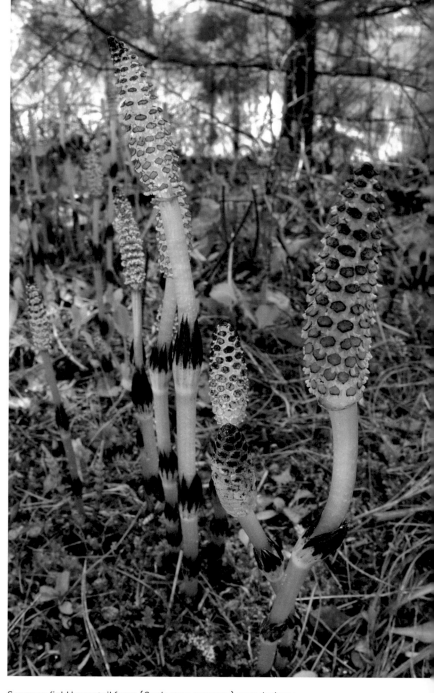

Common field horsetail ferns (*Equisetum arvense*) spend winter underground, and in early spring produce white, chlorophyll-free reproductive shoots, each topped with a spore-producing strobilus. Once the spores have been dispersed, the shoot dies, and green, photosynthesizing stems take its place.

cumulate arsenic, an element that is usually associated with gold deposits, and as such may indirectly point to their presence.

As the first sunny days of March in Estabrook Woods begin to melt away the frozen remainders of winter, members of another ancient lineage get ready to spring back to life. They survived the cold months hidden in the leaf litter in the form of minuscule cysts, waiting for a signal to wake up. Throughout most of the year their habitat is as dry as a bone, but when the last patches of snow turned into water, leaf-packed depressions on the of the forest floor suddenly transform into small, ephemeral ponds. Known as vernal pools, these fleeting bodies of water will be gone again by the time summer comes, but for now they create a unique aquatic ecosystem. Stirred by the wetness, the cysts hidden in the soil begin to hatch. Soon, the water is filled with thousands of tiny animals, at first not much larger than the period at the end of this sentence, but within a few weeks reaching the length of nearly a half of a pinky finger. Fittingly, their bodies are pink or light brown, and you can clearly see their big eyes as they swim among dead leaves in the shallow water. They are the fairy shrimp (*Eubranchipus vernalis*), members of a lineage older than that of any vascular plant now growing in the forest of Estabrook. They belong to a group of crustaceans known as branchiopods, animals that were already present in the Cambrian seas half a billion years ago, before any plants even considered leaving water for terrestrial habitats. Looking at the delicate, soft body of a fairy shrimp, it is hard to imagine how a lineage of organisms so seemingly fragile could have survived for so long. Take one out of the water, and it is dead within seconds. Let the oxygen level in the pond drop, and the entire population is wiped out. Given a chance, a single fish could probably do away with them all in a day, but luckily fish don't do well in ponds that last for only a few months of a year. But fairy shrimps' frailty is an illusion; where it counts they are as tough as nails.

If you live in a place as transient as a vernal pool, here now but gone in a few months, an environment of unpredictable duration and often uncertain arrival, you better have a solid survival strategy to build your life around. First, once the right environment appears, you must develop very quickly and reach reproductive maturity before the changing conditions kill you. Second, you need a method to keep your genetic line alive, even when the only habitat in which you can survive is gone. And third, plan for the unforeseeable cataclysms, such as sudden evaporation of the pool before you are ready to produce a new generation. Because, if you fail on any of these counts, your species will not last past the first generation. Fairy shrimp, despite their unassuming physique, are master survivalists in the most hostile and unstable of habitats and execute the three-step action plan flawlessly.

As soon as the vernal pools form, cysts containing fully formed shrimp embryos from the year before break open, and minute, swimming larvae emerge. They immediately start feeding on microscopic algae and bacteria already present in the water, and grow like crazy. During the first few days of their lives, baby fairy shrimp, known as nauplii, increase their length by a third and nearly double their weight every day. In about a month the animals are fully grown. One pair of the males' antennae develops into giant, antler-like projections that help them catch and grasp their mating partners, while females grow big egg pouches on their abdomens. A few days later females start to lay at the bottom of the pool large clutches of cysts, eggs with embryos already developing inside, and die shortly after. Soon the water level in the pool begins to drop, and by June all traces of the once vibrant aquatic habitat are usually gone.

But inside the cysts, hidden under a thin layer of soil, the embryos are very much alive. They slowly continue their development but can remain in the dormant state, out of the water, baking in the sun or being frozen in ice, for many years. Their outer shell is nearly waterproof and quite

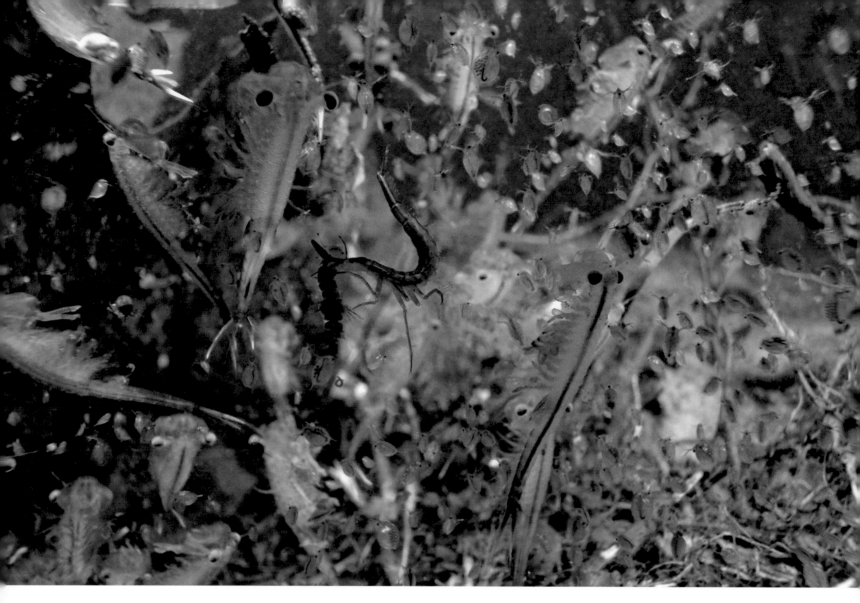

Within a few weeks of the first appearance of a vernal pool, aquatic life virtually explodes. In addition to fairy shrimp, other invertebrates take advantage of an environment free of the principal aquatic predators—fish. Assorted crustaceans, water mites, flies, and predaceous diving beetles (center, eating a mosquito larva) race to reach maturity before the ephemeral body of water disappears.

sticky. This stickiness explains the sudden appearance of fairy shrimp in the most unexpected places, including old tires filled with water, after hitching a ride on the legs of birds and other animals.

The following spring, if everything goes as planned, wa-ter of the melting snow awakens the dormant embryos, and within a few days they break the shell of their tiny survival capsules. But not all of them. Only a portion of the cysts re-sponds to the first appearance of water, while others continue their slumber. If the pool dries prematurely, as sometimes

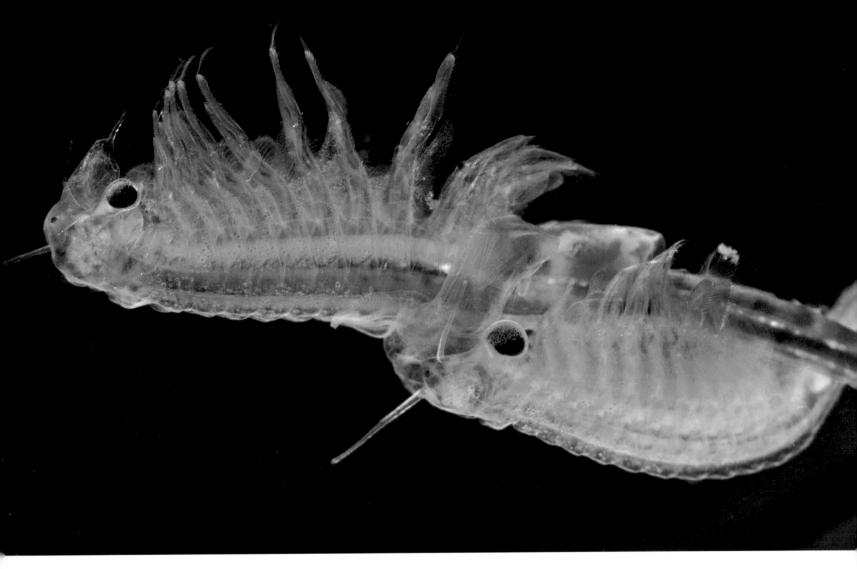

The second pair of antennae on the head of a male fairy shrimp is modified into powerful claspers that allow him to hold the female and prevent her from mating with other suitors.

happens during a particularly warm spring, all early hatchlings die, and a second batch of larvae will emerge only if the pool fills up with water again. It has been shown that some cysts in a clutch will wait through eight cycles of wetting and drying before finally deciding to hatch. Fairy shrimp have evolved this ingenious strategy of hedging their reproductive bets in response to the erratic nature of their habitat, and it clearly serves them very well.

In other parts of the world, fairy shrimp and their relatives are able to survive in the most extreme of environments. I once witnessed a rare downpour in the Namib Desert, one of the harshest habitats in Africa. Within a few

days following the rain, in tiny pools of water accumulated on top of scorching hot rocks, thousands of fairy shrimp appeared as if out of nowhere. They quickly produced their eggs, and as the water evaporated, they vanished. But their eggs, some stuck to the rock, others swept away by wind, will ensure that the species continues to thrive, even if the next rain comes many years later. The Great Salt Lake of Utah, a body of water saturated with salt to a degree that makes it uninhabitable to most organisms, is home to trillions of brine shrimp, close relatives of the fairy shrimp found in Estabrook. They are able to survive in an environment that would instantly kill most aquatic creatures thanks to their ability to regulate the osmotic pressure of their hemolymph and increase the amount of hemoglobin in response to low oxygen levels caused by the high salinity. Their eggs can live through being dipped in boiling water ($100°C$) and liquid air ($-194.35°C$), temperatures so extreme that these organisms are being used by NASA to test the survival of life in the outer space. No wonder their lineage has managed to stick around for so long.

Last weekend, on the first official day of spring, Kristin and I took our dogs to Estabrook Woods again. Vernal pools glistened among the trees, and the raucous sound of wood frogs could be heard in the distance. My wife pointed to me a small plant creeping on a rock. "This looks like something you will probably like," she said. It was a clubmoss, a member of Lycopodiophyta, the oldest lineage of vascular plants on the planet. Relics, it seems, are really all around us.

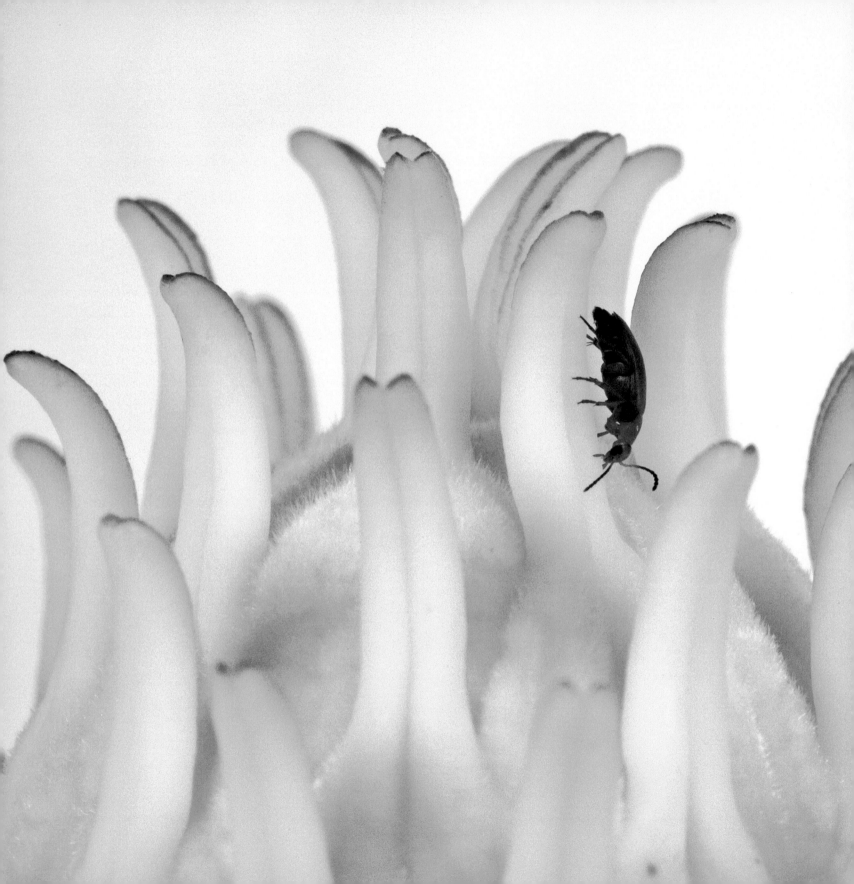

Giant, robust flowers of the bigleaf magnolia (*Magnolia macrophylla*) are well adapted to unsophisticated pollinators, such as beetles. The top part of the flower consists of female reproductive organs, or stigmas. On the first day after the flower's opening they are ready to accept pollen from any wanderer that may visit them, such as this tiny beetle, *Anaspis rufa* (left). The next day the stigmas become unresponsive to pollination, and the male organs (anthers) at the base of the flower start producing pollen. Such separation in time of female and male organs prevents the plant from self-pollination and reduces the risk of inbreeding.

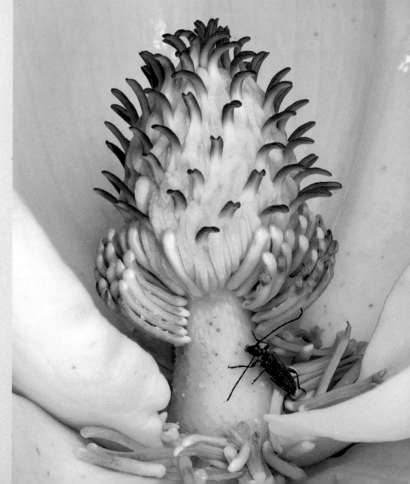

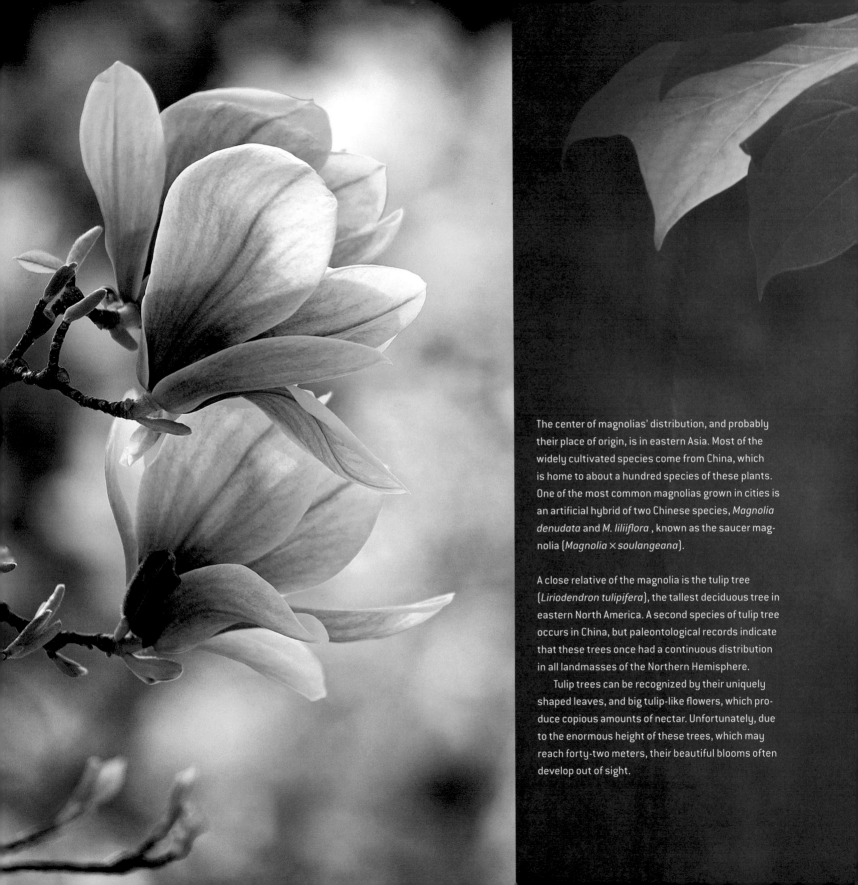

The center of magnolias' distribution, and probably their place of origin, is in eastern Asia. Most of the widely cultivated species come from China, which is home to about a hundred species of these plants. One of the most common magnolias grown in cities is an artificial hybrid of two Chinese species, *Magnolia denudata* and *M. liliiflora* , known as the saucer magnolia (*Magnolia* × *soulangeana*).

A close relative of the magnolia is the tulip tree (*Liriodendron tulipifera*), the tallest deciduous tree in eastern North America. A second species of tulip tree occurs in China, but paleontological records indicate that these trees once had a continuous distribution in all landmasses of the Northern Hemisphere.

Tulip trees can be recognized by their uniquely shaped leaves, and big tulip-like flowers, which produce copious amounts of nectar. Unfortunately, due to the enormous height of these trees, which may reach forty-two meters, their beautiful blooms often develop out of sight.

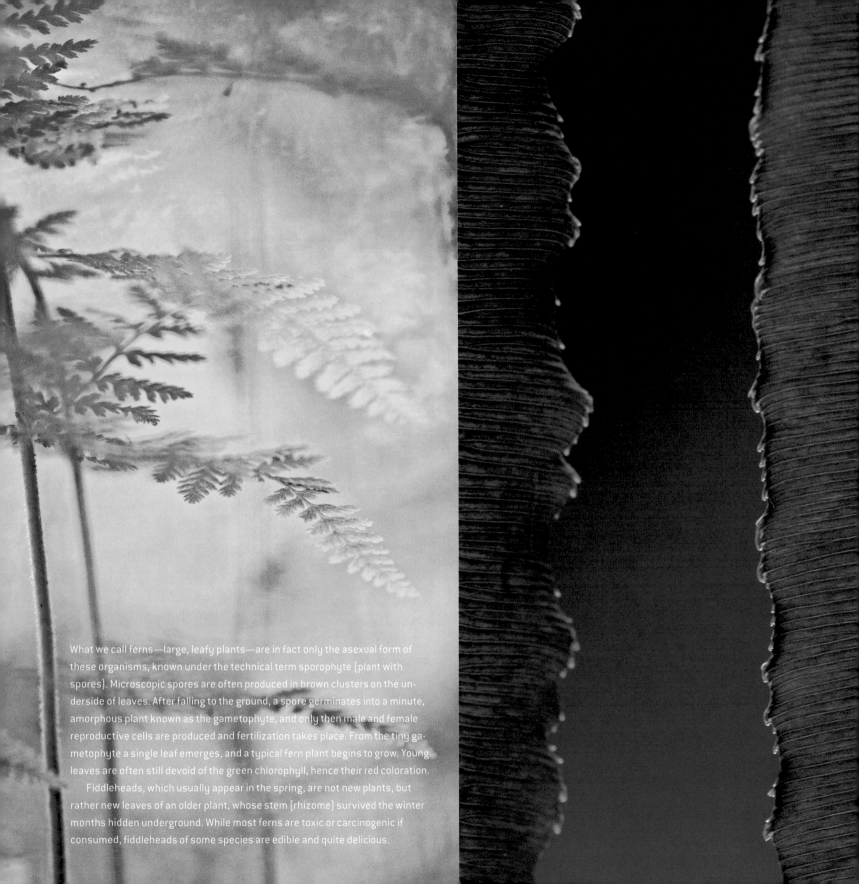

What we call ferns—large, leafy plants—are in fact only the asexual form of these organisms, known under the technical term sporophyte (plant with spores). Microscopic spores are often produced in brown clusters on the underside of leaves. After falling to the ground, a spore germinates into a minute, amorphous plant known as the gametophyte, and only then male and female reproductive cells are produced and fertilization takes place. From the tiny gametophyte a single leaf emerges, and a typical fern plant begins to grow. Young leaves are often still devoid of the green chlorophyll, hence their red coloration.

Fiddleheads, which usually appear in the spring, are not new plants, but rather new leaves of an older plant, whose stem (rhizome) survived the winter months hidden underground. While most ferns are toxic or carcinogenic if consumed, fiddleheads of some species are edible and quite delicious.

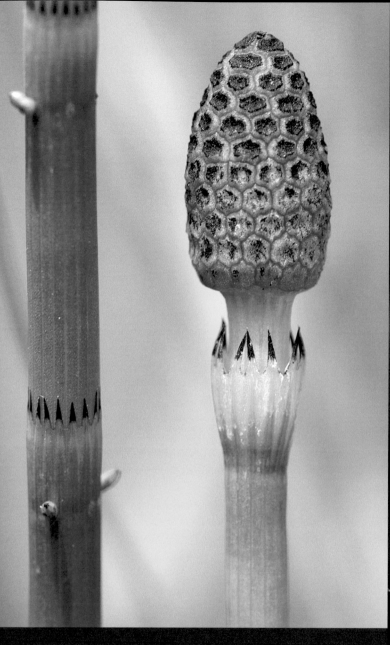

Horsetail ferns (*Equisetum*) are some of the few plants that do not develop green leaves. Vestigial leaf remnants can be seen as dark rings at the base of each segment of the stem, and they are the largest in newly sprouting plants, when they protect the developing strobilus—a cone-like structure that carries the spores of the plant.

Photosynthesis in horsetail ferns takes place only in the stem, and some species increase its efficiency by producing multiple, leafless side branches in whorls around the base of each segment.

Microscopic spores of the field horsetail fern (*Equisetum arvense*) leave the strobilus when the plant shakes in the wind

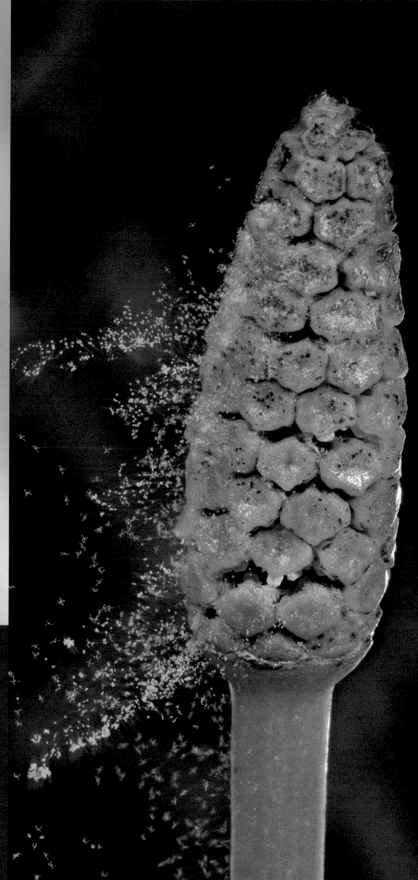

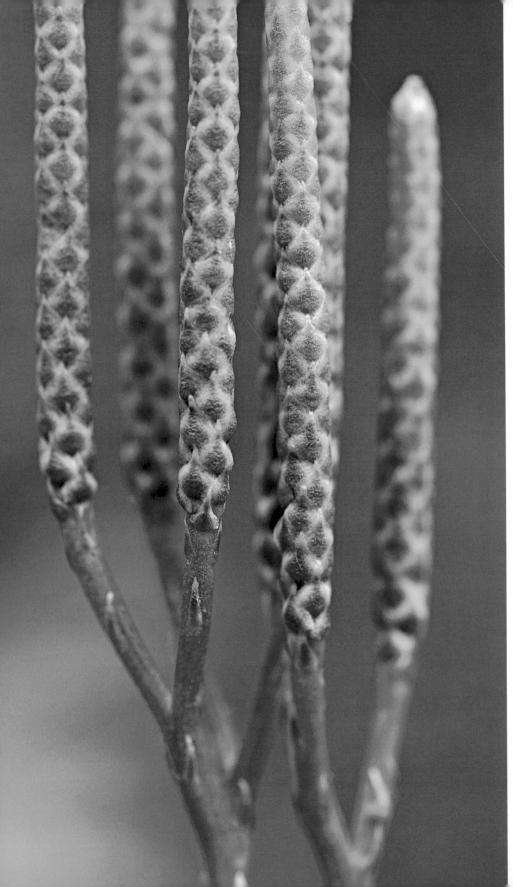

Until about 480 million years ago, nearly all life on Earth was still confined to the oceans and lakes, despite having been there for more than 3 billion years. Dry land was barren, waiting to be colonized, but the first pioneers took their sweet time coming out of the water. At that time land was not a pleasant place to be; ultraviolet radiation was bombarding its surface with great intensity, and it took a while for the ozone layer in the atmosphere to accumulate in quantities sufficient to block the deadly radiation.

When the first plants made their initial foray onto dry land, they were not quite prepared to deal with the fact that they could no longer rely on water to support their flimsy structure. Rather than grow up, like modern plants do, they were forced to spread horizontally, hugging the ground. They also lacked a vascular system, a network of vessels needed to efficiently distribute water and nutrients to different parts of their bodies, something that was not an issue for plants living submerged lives.

The first plants to develop such a system, which allowed them to lift up from the ground and grow tall and large, were clubmosses, a group of plants known as the Lycopodiophyta. Their distant grandchildren still thrive in humid underbrush of temperate and tropical forests, but they are but a shadow of the former glory of their ancestors, which formed dense forests of giant, treelike plants. Alongside ancient ferns and horsetails, their fossilized remains now form vast deposits of coal.

In Estabrook Woods several species of clubmoss can be found peeking through leaf litter, most visible in early spring before taller ferns and flowering plants cover the bottom of the forest with a thick, green blanket. Some, like the prince's pine (*Dendrolycopodium dendroideum*), resemble miniature trees, while others send long, creeping stems alongside fallen tree trunks and rocks. Like ferns, clubmosses reproduce through spores, which form on leaves gathered in a cone-like structure known as a strobilus. Clubmoss spores are exceptionally rich in fat, which makes them highly flammable, even explosive. In the nineteenth century, before the invention of modern photographic lights, clubmoss spores (known as Lycopodium powder) were used to create the first flash strobes for photography.

Diphasiastrum digitatum and *Dendrolycopodium dendroideum*

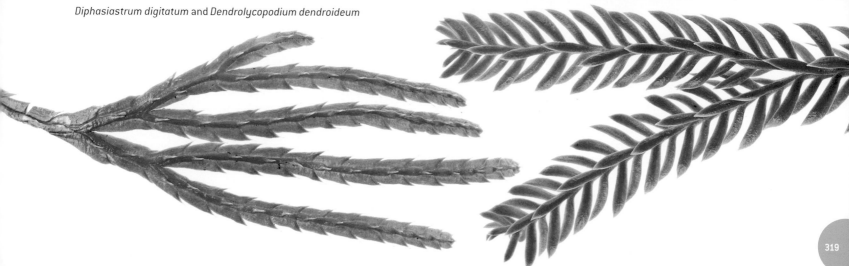

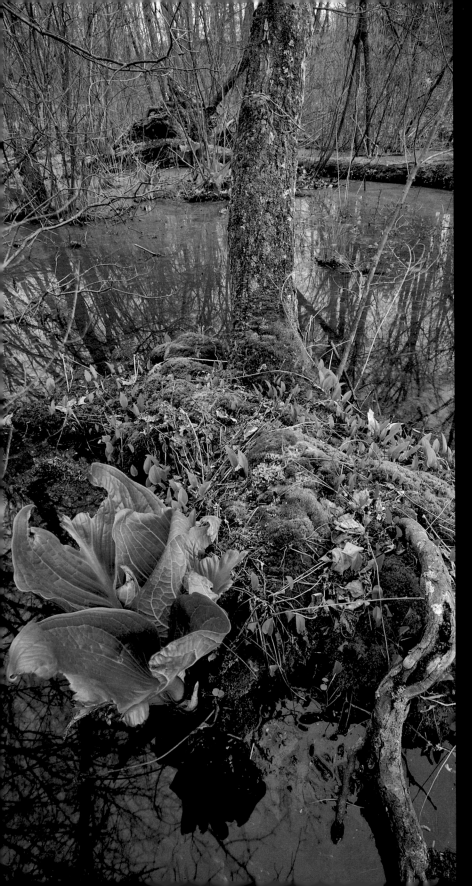

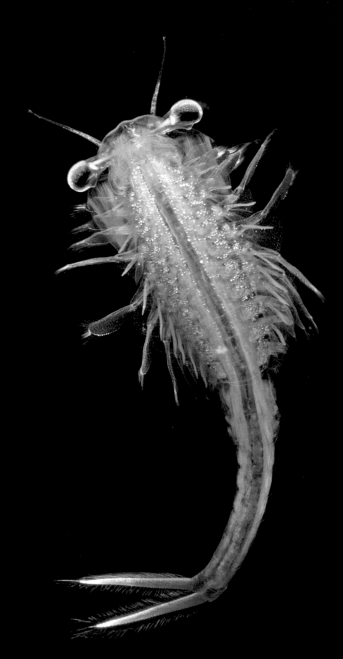

Although at first glance it may appear that the vernal pools of Estabrook Woods are devoid of animal life, they are in fact bursting with activity. Fairy shrimp (*Eubranchipus vernalis*) are some of the first animals to appear, but they are quickly followed by other crustaceans and insects. Eventually, larvae of salamanders and frogs join the rich community of aquatic organisms—and often decimate the invertebrates.

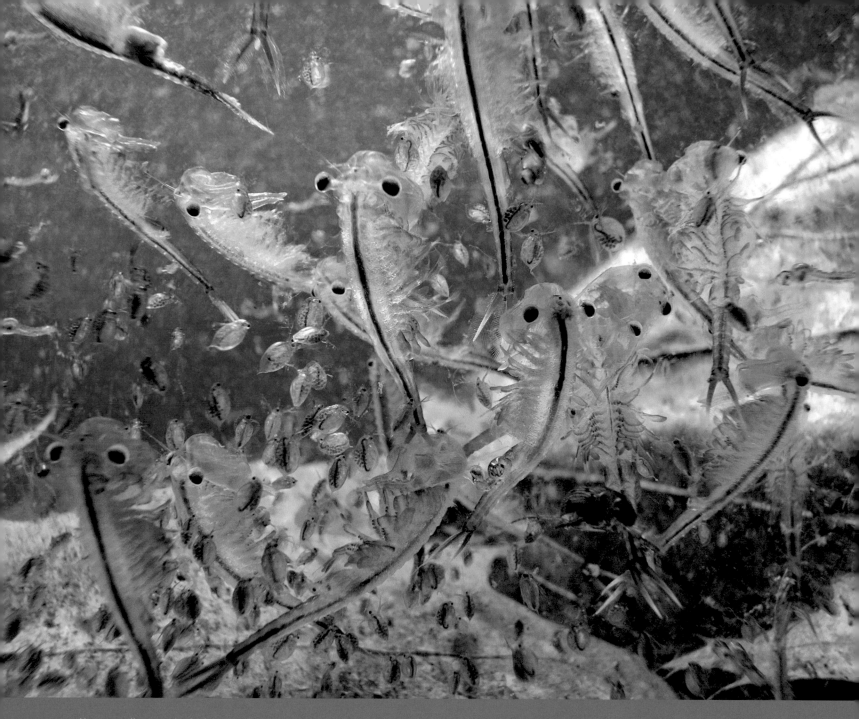

Almost as vibrant and colorful as tropical coral reef communities, the vernal pools of New England offer a glimpse of life forms of ancestry older than almost anything that can be found in terrestrial habitats. Fairy shrimp come from a lineage that was already teeming in the Cambrian, over five hundred million years ago.

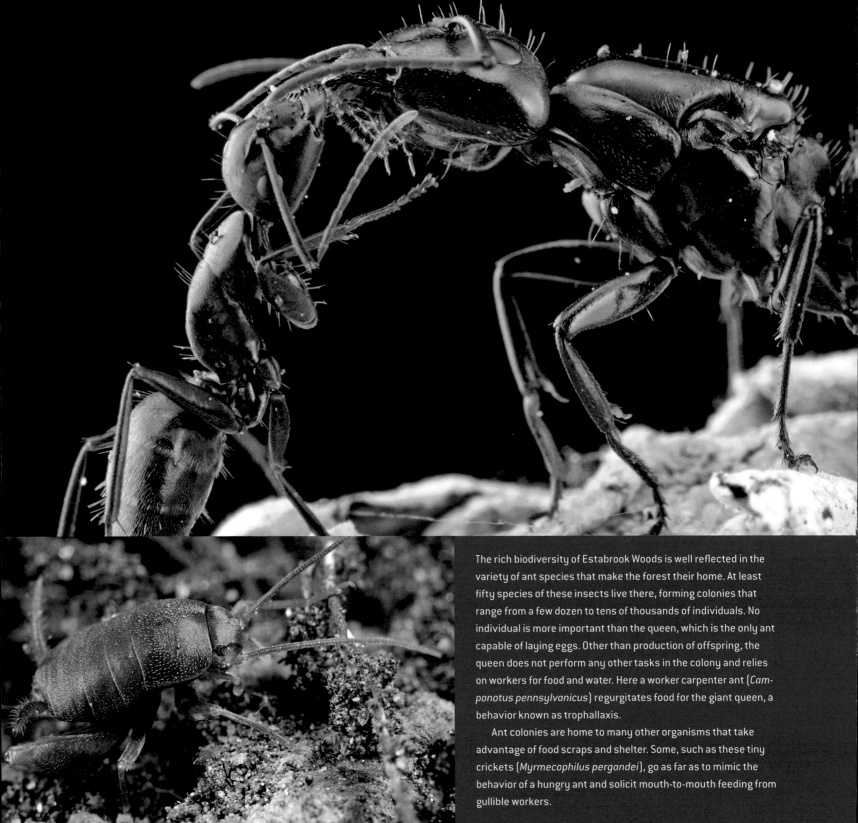

The rich biodiversity of Estabrook Woods is well reflected in the variety of ant species that make the forest their home. At least fifty species of these insects live there, forming colonies that range from a few dozen to tens of thousands of individuals. No individual is more important than the queen, which is the only ant capable of laying eggs. Other than production of offspring, the queen does not perform any other tasks in the colony and relies on workers for food and water. Here a worker carpenter ant (*Camponotus pennsylvanicus*) regurgitates food for the giant queen, a behavior known as trophallaxis.

Ant colonies are home to many other organisms that take advantage of food scraps and shelter. Some, such as these tiny crickets (*Myrmecophilus pergandei*), go as far as to mimic the behavior of a hungry ant and solicit mouth-to-mouth feeding from gullible workers.

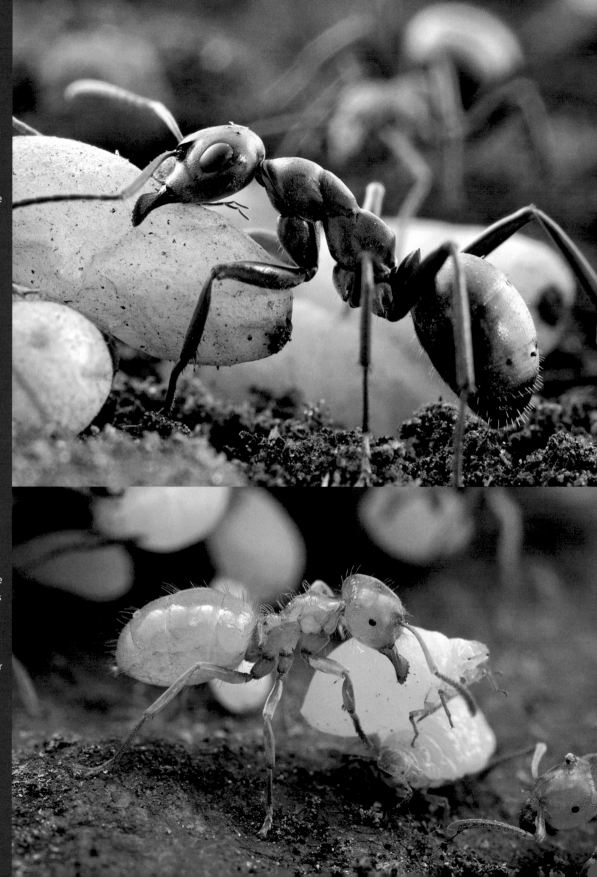

Lifting a rock in Estabrook Woods often reveals a colony of ants busily moving around large, egg-like objects. These are silken cocoons that enclose a pupa, the last stage in an ant's development before adulthood. Workers like this digging ant (*Formica subsericea*) often move them closer to the surface to take advantage of higher temperatures of the upper layers of the soil and accelerate their development.

Yellow citronella ants (*Lasius claviger*) are extremely common in Estabrook but are rarely seen due to their entirely subterranean lifestyle. They never need to leave the nest to forage, as they farm their own food source—white aphids (*Geoica*) that feed on plant roots within the colony. But the ants do not eat the aphids. Rather, they drink honeydew, a sugary excretion produced by the aphids, and take a good care of their "cattle," often moving them to better underground pastures.

Estabrook Woods clearly demonstrates that even in places adjacent to busy metropolitan areas nature can thrive in an astonishing variety of species. But Estabrook is not special in any significant way, and similar sanctuaries of nature can be found in and around every major city. Each of them shelters organisms that come with a pedigree that goes back millions of years before humans first appeared and began to alter the planet's ecosystems. They all deserve our respect and protection, if for no other reason than they were here first.

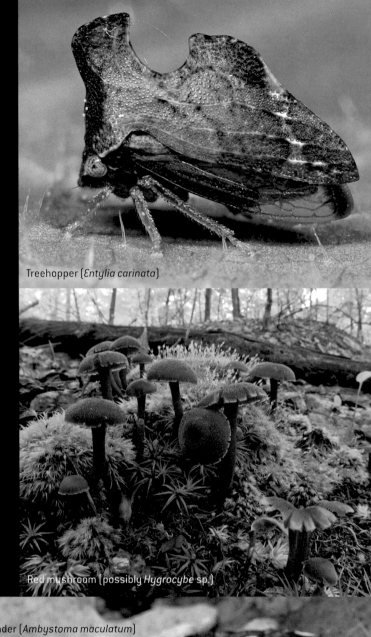

Treehopper (*Entylia carinata*)

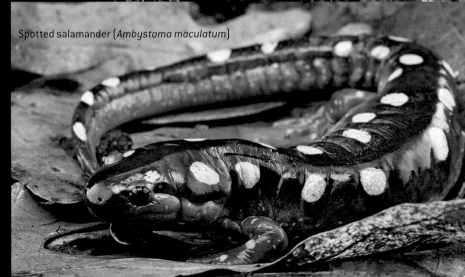

Red mushroom (possibly *Hygrocybe* sp.)

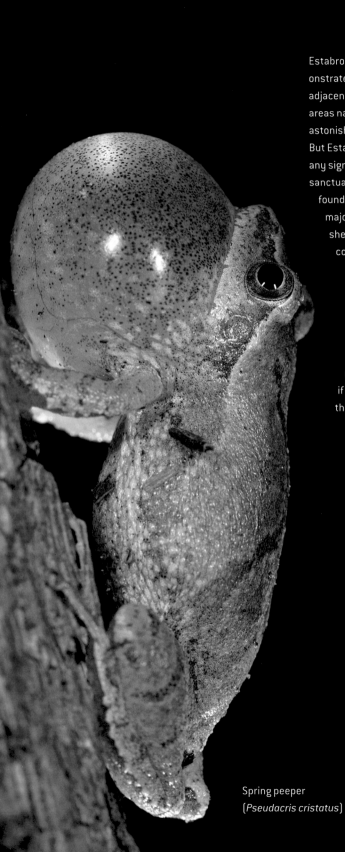

Spring peeper
(*Pseudacris cristatus*)

Spotted salamander (*Ambystoma maculatum*)

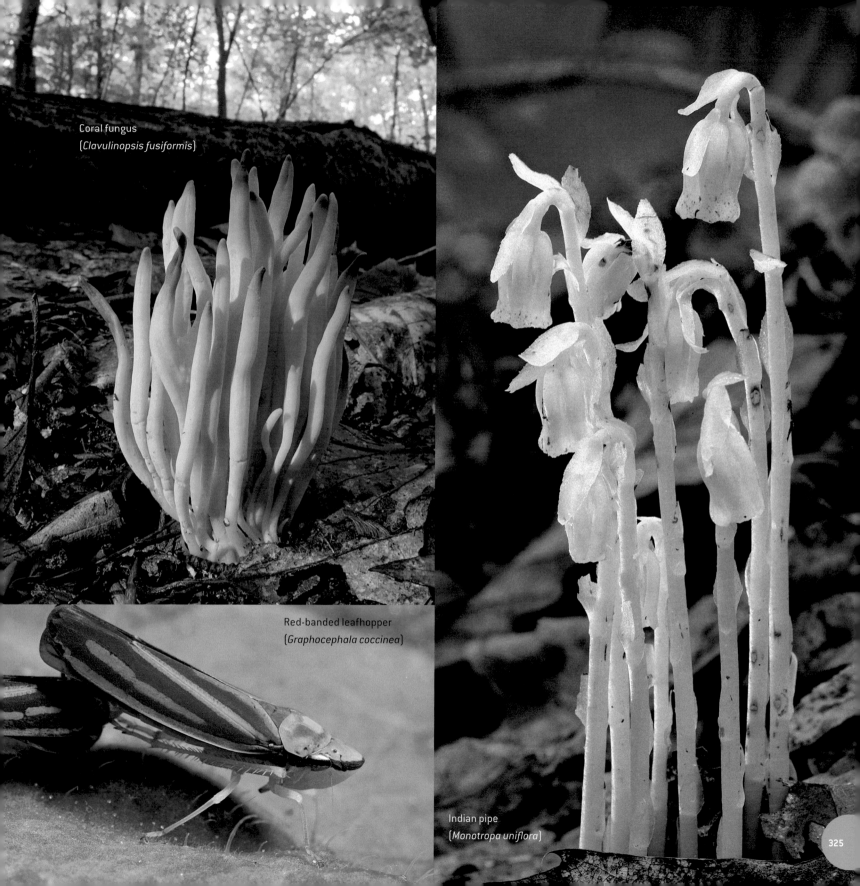

Coral fungus
(*Clavulinopsis fusiformis*)

Red-banded leafhopper
(*Graphocephala coccinea*)

Indian pipe
(*Monotropa uniflora*)

325

A WORD ABOUT PHOTOGRAPHY

W hat kind of camera do you use?" This is, by far, the most common question I receive when giving lectures or presentations where I show some of my photographs. And, invariably, my answers tend along the lines of the irrelevance of the particulars of the equipment and that what matters is the knowledge of your subject, a great deal of patience, and some basic understanding of the principles of exposure, depth of field, and proper illumination. Camera equipment constantly improves and becomes more affordable; and the technology that was cutting-edge and prohibitively expensive a few years ago can now be found in a cell phone camera that is given away free with a two-year contract. But sometimes I need to remind myself that while all these statements are absolutely true, often it is the specifics of the techniques and equipment used to obtain a particularly striking image that are more informative and valuable, especially to those who already have a decent understanding of the fundamentals of photography. During public appearances by photographers, myself included, there is usually not enough time to go into the minutiae of how individual images have been taken, which may—and probably sometimes does—leave the audience with the impression that there exist some secret tricks of the trade that photographers are unwilling to share. In my experience, there is nothing further from the truth; if anything, photographers love to brag about the details of their captures. I, naturally, am no different, and therefore I decided to close this book with a few details of how I was able to capture some of my favorite or particularly difficult-to-obtain images that appear on these pages. I hope that this information will help other nature photographers in their pursuit of documenting of our beautiful, one-of-a-kind, natural world.

To capture this image of a lantern bug (*Enchophora sanguinea*) expelling droplets of honeydew on a tree trunk in the Costa Rican rainforest (above) I needed to be able to illuminate both the skittish nocturnal insect, and the tiny translucent drops, which were flying with the speed of about two meters per second. I placed a flash (Canon 580EX) on a tripod behind the tree to highlight the drops and used a 100mm macro lens and macro flash (Canon MT-24EX, mounted on the Canon 1Ds MkII camera) to illuminate the foreground. The macro flash acted as the "master" that triggered the background flash, which was set to fire short pulses of light with the frequency of 199 Hertz.

Leaf-cutter ants (*Atta cephalotes*) are small and move really fast, making focusing on an individual ant quite difficult. To be able to photograph a worker carrying a piece of leaf I needed to find a spot where I knew the ant would always be in focus. Luckily, a thin vine intersected the trail of these insects, and every ant going back to the nest had to walk on it. I prefocused my tripod-mounted camera (Canon 1Ds MkII, with a Canon MP-E 65mm macro lens) on a particular fragment of the vine

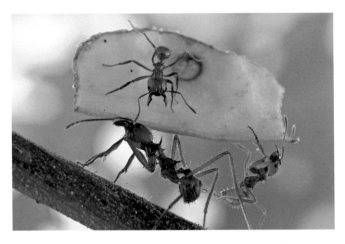

and waited for the right moment. After a few misfires I got my shot (above). To illuminate the scene I used three flashes placed on small tripods around the vine, each diffused with a large piece of white fabric to reduce the glare reflecting from the shiny bodies of the insects.

Trophallaxis, feeding of one individual by another, is the type of intimate behavior that would be very difficult to witness in the wild, especially if it takes place deep in an underground nest. To capture this behavior in carpenter ants (*Camponotus pennsylvanicus*; below) I kept a small colony of these insects for a few weeks on a table in my basement, and strategically placed four diffused flashes around it. Every now

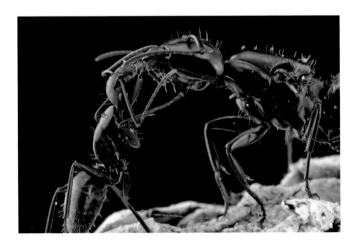

and then I could lift a piece of wood that covered the colony and, if I was lucky, get a peek of their hidden activity. My patience was rewarded with an image of a worker feeding the queen, a photo I took with a Canon MP-E 65mm macro lens mounted on a Canon 1D MkII.

This photo of fairy shrimps (*Eubranchipus vernalis*) in a vernal pool near Boston (above) was probably the most technically difficult of all the photographs that appear in this book. I wanted to capture the richness of life as it truly appeared and so decided to photograph them right there, underwater, and not in an artificial setting of an aquarium. I placed my SLR (single-lens reflex) camera (Canon 5D) in an underwater housing (Ewa-Marine U-BXP100) at the bottom of the pool. The SLR was equipped with a tiny remote video camera attached to the viewfinder, and the video signal from the viewfinder was then fed into a small monitor (ZigView S2) through a long cable, which allowed me to see what was in front of the lens (Canon 16–35mm with Extension Tube EF 12 II), while sitting (somewhat) comfortably at the edge of the pool. To illuminate the scene I positioned two flashes (Canon 580EX) on tripods standing in the pool, while a third flash, acting as the master (trigger), was in the underwater housing. Even I was surprised by the beauty of the scene I was able to record with this setup.

I discovered this male of yet-unnamed frog (*Oreophryne* sp. n.) guarding his eggs on a low plant at night in the middle

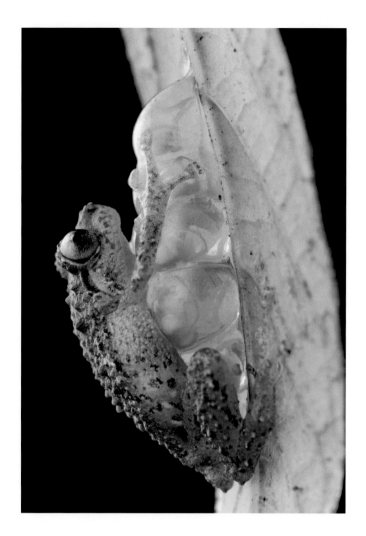

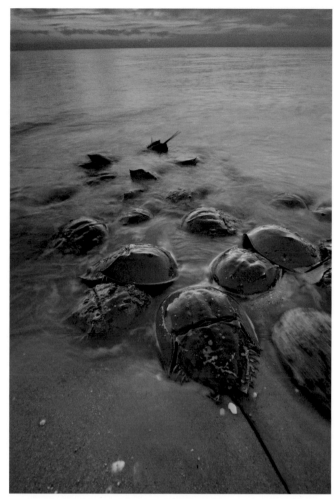

of a remote rainforest of Papua New Guinea (above). I had to be extra careful not to scare off this tiny animal, but at the same time I needed to place several flash heads around it to get a soft, diffused light that would show the translucent quality of the eggs. I placed two flashes (Canon 580EX, each with a large white diffuser) on small tripods behind the animal, about a meter away, and another, also a meter away, in front of the frog. The flashes were controlled by a small infrared transmitter (Canon ST-E2), which gave me the freedom to move my camera (Canon 1Ds MkII with a 100mm macro lens) whichever way

I needed without the risk of bumping into anything with a protruding flash.

To photograph spawning horseshoe crabs (*Limulus polyphemus*) on the New Jersey beach of Delaware Bay (above) I placed my camera (Canon 1Ds MkII) on a tripod and used a wide-angle lens (Canon 16–35mm) equipped with a graduated neutral density filter, which allowed me to darken the sky while keeping the foreground light. With a half-second-long exposure, the relatively slow-moving animals still appear sharp while the water around them achieves a beautiful, silky quality.

ACKNOWLEDGMENTS

This book would have never seen the light of day if not for the support and encouragement from a small army of people who over the past few years have helped me with various aspects of its preparation and writing.

My wife, Kristin M. Smith, deserves the most heartfelt thanks and credit for being not only the first reader and an insightful in-house editor but also for putting up with my frequent absence, both physical and in spirit, as I collected the material for and worked on this book. Invaluable comments and corrections to various parts of the manuscript were also provided by Ingi Agnarsson, Leeanne Alonso, Corey Bazelet, Angelica Cibrian, Stefan Cover, Ann Downer-Hazel, Rob Dunn, Jiri Hulcr, Andrea Lucky, David Rentz, Stephen Richards, Derek Sikes, and David Wagner.

I would not have been able to visit and work in the places mentioned in this book if not for the help from many individuals and organizations, and I am particularly grateful to Leeanne Alonso and all past and present members of Conservation International's Rapid Assessment Program team, Eustace Alexander, Vincent Awotwe-Pratt, Corey Bazelet, Paul Grant, Nicholas Jengre, Susan Keall, Edward Lohnes, Nicola Nelson, Kenji Nishida, Daniel Otte, Ishii Katsuhiko, Yaw Osei-Owusu, Stephen Richards, Derek Sikes, Joseph Warfel, Heather Wright, and the entire Wai Wai community of the Konashen district of Guyana, as well as Banak Gamui, Michael Kigl and the rest of the wonderful group of people from the Papua New Guinea Institute of Biological Research in Goroka.

I thank all experts who helped me identify animals and plants appearing in this book: Ken Aplin, Kyle Armstrong, Charles Bartlett, Dick Brown, Csaba Csuzdi, Milan Janda, Ada Kaliszewska, Adam D. Leaché, Wayne Maddison, Philippe Magnien, Stuart McKamey, Geoff Monteith, Kenji Nishida, Darren Pollock, Stephen Richard, Nikolaj Scharff, Ted Schultz, Celsi Señaris, Gregory P. Setliff, Bill Shear, Wayne Takeuchi, and Michael Wall.

I also thank Rosemary Monahan and Stefan Cover, who allowed me to visit and photograph their splendid collection of magnolia trees; and Charles Marshall and the Museum of Comparative Zoology at Harvard University, for giving me permission to photograph and reproduce in this book a fossil specimen of a horseshoe crab from its collection.

And last, I am grateful to Dr. Winnie Ooi and the staff of the Travel and Tropical Medicine Clinic of the Lahey Clinic in Burlington, Massachusetts, for helping me recover from assorted tropical diseases (five different ones at last count) that befell me in the process of working on this project.

NOTES

The Land of the Unexpected

Page 11. An excellent comprehensive review of the history of biological exploration, geology, and biology of New Guinea can be found in a monumental two-volume work *The Ecology of Papua*, edited by Andrew J. Marshall and Bruce M. Beehler (Singapore: Periplus Editions, 2007). Although concentrating primarily on the Indonesian part of the island, most of the information there applies also to Papua New Guinea. For a less rigorous, but infinitely more entertaining account of a biologist's life and work in Papua New Guinea I cannot think of a better book than Vojtech Novotny's *Notebooks from New Guinea* (Oxford: Oxford University Press, 2009).

Page 13. The number of species on this planet is still a matter of debate among biologists, and only about 1.7 million have been officially recognized by science. The first really high estimate of 30 million living species was presented by American entomologist Terry Erwin in 1982, based on his studies of beetles in the rainforest canopy ("Tropical Forests: Their Richness in Coleoptera and Other Arthropod Species," *The Coleopterists Bulletin* 36 (1982): 74–75). Some scientists claim that there may be as many as 100 million species sharing the world with us, including no fewer than 10 million species of nematode worms in the oceans. Novotny and his colleagues significantly temper such enthusiastic calculations in their article Vojtech Novotny, Scott E. Miller, Jiri Hulcr, et al., "Low Beta Diversity of Herbivorous Insects in Tropical Forests," *Nature* 488 (2007): 692–95. But even if they are wrong, and the number of currently living species is very high, the extinction rate due to human activity will quickly take care of the inconvenient surplus.

Page 13. Vojtech Novotny, Yves Basset, Scott E. Miller, George D. Weiblen, Birgitta Bremer, Lukas Cizek, and Pavel Drozd, "Low Host Specificity of Herbivorous Insects in a Tropical Forest," *Nature* 416 (2002): 841–44.

Page 21. Since its publication, Daniel Janzen's article "Why Mountain Passes are Higher in the Tropics," *American Naturalist* 101 (1967): 233–49, has generated a number of studies that tested its interesting assumptions. A recent review by Cameron K. Ghalambor, Raymond B. Huey, Paul R. Martin, Joshua J. Tewksbury, and George Wang, "Are Mountain Passes Higher in the Tropics? Janzen's Hypothesis Revisited," *Integrative and Comparative Biology* 46 (2006): 5–17, appears to confirm many of original Janzen's predictions.

Travels in the Meddle Earth

Page 59. Among modern reptiles, crocodilians retain two good temporal openings (fenestrae), and most lizards still retain the upper openings (snakes, techni-

cally a group of lizards, generally have lost both temporal bars), but no group has both pairs of the openings as well developed as those of the tuatara.

Page 67. Jennifer M. Hay, Stephen D. Sarre, David M. Lambert, Fred W. Allendorf, and Charles H. Daugherty, "Genetic Diversity and Taxonomy: A Reassessment of Species Designation in Tuatara (*Sphenodon*: Reptilia)," *Conservation Genetics* 11 (2010): 1063–81.

Page 67. Nicola J. Mitchell, Fred W. Allendorf, Susan N. Keall, Charles H. Daughert, and Nicola J. Nelson, "Demographic Effects of Temperature-Dependent Sex Determination: Will Tuatara Survive Global Warming?" *Global Change Biology* 16 (2010): 60–72.

Page 68. A recent extensive review of the problem of invasive species in New Zealand is *Biological Invasions in New Zealand*, edited by Rob B. Allen and William G. Lee (Berlin: Springer, 2006).

Page 69. The failed experiment of the Whitaker's skink recovery and other examples of problems facing conservationists trying to eliminate invasive species in New Zealand are reviewed by David A. Norton in "Species Invasions and the Limits to Restoration: Learning from the New Zealand Experience," *Science* 325 (2009): 569–71.

Page 71. The New Zealand Ministry of Agriculture and Forestry Biosecurity was a service established in 2007 (after a merger of two services that dealt with quarantine of potential biological hazards). Its role is to prevent new, unwanted biological agents from entering the country and develop policies and methods of dealing with those already established in New Zealand. MAF Biosecurity employs about a thousand people and has an annual budget of NZ$500 million (approximately US$355 million).

Mother's Care

Page 94. Blattodeans are only some of the many visitors who take advantage of the honeydew produced by lantern bugs; other organisms, including moths, ants, and snails, come to feed on the sugar-laden droplets (Piotr Naskrecki and Kenji Nishida, "Novel Trophobiotic Interactions in Lantern Bugs [Insecta: Auchenorrhyncha: Fulgoridae]," *Journal of Natural History* 41 [2007]: 2397–402).

The Southern Kingdom

Page 100. The most recent comprehensive overview and classification of South

Africa's plant communities is presented by editors Ladislav Mucina and Michael C. Rutherford in "The Vegetation of South Africa, Lesotho and Swaziland," *Strelitzia* 19 (Pretoria: South African National Biodiversity Institute, 2006).

Page 101. The curious case of the dominance of relatively few plant families in the flora of the Cape region is discussed by Peter Goldblatt and John C. Manning in "Plant Diversity of the Cape Region of Southern Africa," *Annals of the Missouri Botanical Garden* 89 (2002): 281–302.

Page 102. An analysis of the origins of South African plant communities is provided in a series of articles in a special issue of the journal *Molecular Phylogenetics and Evolution* entitled *Origins and Evolution of a Biodiversity Hotspot, the Biota of the African Cape Floristic Region* (vol. 51, no. 1 [2009]).

Page 103. The "clean slate" and alternative hypotheses of the origin of fynbos vegetation are discussed by H. P. Linder and C. R. Hardy in "Evolution of the Species-Rich Cape Flora," *Philosophical Transactions of the Royal Society B* 359 (2004): 1623–32.

Page 106. An overview of the correlation between the species richness of plants and insects in fynbos is presented by Serban Proches and Richard M. Cowling in "Insect Diversity in Cape Fynbos and Neighbouring South African Vegetation," *Global Ecology and Biogeography* 15 (2006): 445–51.

Page 109. Although the Cederberg katydid (*Cedarbergeniana imperfecta*) is the only katydid known to live in large groups in caves, a few katydid species show a similarly gregarious behavior outside of caves. Mexican *Eremopedes colonialis* has been seen forming groups of up to fifty individuals on a single large bush, whereas Mormon crickets (*Anabrus simplex*) occasionally form migratory bands thousands of insects strong (despite a misleading common name, these insects are katydids, not crickets.)

Page 113. Wendy Foden of the South African National Biodiversity Institute and her colleagues published their findings on the impact of climate change on quiver plants: Wendy Foden, Guy F. Midgley, Greg Hughes, William J. Bond, Wilfried Thuiller, M. Timm Hoffman, Prince Kaleme, Les G. Underhill, Anthony Rebelo, and Lee Hannah, "A Changing Climate Is Eroding the Geographical Range of the Namib Desert Tree *Aloe* through Population Declines and Dispersal Lags," *Diversity and Distributions* 13 (2007): 645–53.

Page 115. Although cacti do not occur naturally outside of hot, dry areas of North and South America, human interference has allowed some species of these plants to colonize other continents. Prickly pear (*Opuntia*) is a cactus that now thrives in vast areas of Africa, Australia, and even warmer parts of Europe.

The Rain Queen's Garden

Page 151. The history of the Rain Queen, and even an account of a personal audience with the fifth Rain Queen, are described by Ann Jones in *Looking for Lovedu: A Woman's Journey through Africa* (New York: Vintage, 2002).

Page 154. A good general overview of cycads and a beautifully illustrated account of the world's species is David L. Jones's *Cycads of the World* (Washington DC: Smithsonian Books, 2002).

Page 155. There is a significant body of literature that describes the pollination of cycads by beetles; a concise overview is provided by Dietrich Schneider, Michael Wink, Frank Sporer, and Philip Lounibos in "Cycads: Their Evolution, Toxins, Herbivores and Insect Pollinators," *Naturwissenschaften* 89 (2002): 281–94.

Page 155. The fascinating case of the "push-pull" pollination of cycads was first described by Irene Terry, Gimme H. Walter, Chris Moore, Robert Roemer, and Craig Hull in the article "Odor-Mediated Push-Pull Pollination in Cycads," *Science* 318 (2007): 70.

Page 159. Neurologist Oliver Sacks explored the story of the Chamorro of Guam and their mysterious ailments in *The Island of the Colorblind* (New York: Vintage Books, 1997). A few years later Sacks and ethnobotanist Paul Cox presented a theory that linked the Chamorro people's diseases to the consumption of fruit bats, animals that have been shown to accumulate BMAA (β-methylaminpropionic acid) toxins in their bodies ("Cycad Neurotoxins, Consumption of Flying Foxes, and ALS-PDC Disease in Guam," *Neurology* 58 (2002): 956–59). Even after several years of debate since the publication of this theory, there is still no conclusive evidence linking cycads and the diseases of the Chamorro. John Steele and Patrick McGreer recently stated, "This hypothesis falls short of the minimal criteria needed for further serious consideration" ("The ALS/PDC Syndrome of Guam and the Cycad Hypothesis," *Neurology* 70 [2008]:1984–90). This, however, does not in any way negate the fact that all cycads remain extremely toxic and should not be consumed.

Page 161. "Operation Botany," conducted by the U.S. Fish and Wildlife Service, which was meant to thwart an international ring of cycad smugglers, concluded with the arrests of Rolf Bauer, Jan Van Vuuren, and Peter Heibloem, who were charged with conspiracy, smuggling, and making false statements. They ended up receiving modest fines, credit for time served, and probation. Heibloem is a renowned expert on cycads and author of the definitive field guide to cycads of Central Africa. His case clearly demonstrates the lack of finesse and difficulties of enforcing international laws that govern the trade in endangered species—as a cycad expert and commercial grower, Heibloem has a vital interest in the cycads' survival and propagation, as opposed to somebody caught smuggling pelts of endangered snow leopards or other products that require an organism's death. But his actions were illegal, and it is a troubling possibility that such fanatic, often-unlawful aficionados may in the end provide the last refuge for species whose natural habitats no longer exist. We may soon see the disappearance of tigers in the wild, with only about 3,200 individuals left, but the fact that there are at least 5,000 tigers in captivity in the United States alone means that the species' genetic survival is assured. The most tragic aspect of it is that even if we could release them into the wild, there are probably not enough wild habitats left to accommodate the animals, and the same may be soon true for cycads.

Page 173. The jury is still out on the effects of ginkgos on human health, and every year clinical trials produce new, often contradictory findings. The independently funded study that failed to show any significant effect of ginkgo

extract on human memory was conducted by Beth E. Snitz, Ellen S. O'Meara, Michelle C. Carlson, Alice M. Arnold, Diane G. Ives, Stephen R. Rapp, Judith Saxton, Oscar L. Lopez, Leslie O. Dunn, Kaycee M. Sink, and Steven T. DeKosky ("*Ginkgo biloba* for Preventing Cognitive Decline in Older Adults: A Randomized Trial," *JAMA* 302 [2009]: 2663–70). It was quickly counterpoised by a study funded by two major ginkgo producers, which made claims about the beneficial effects of ginkgo extract (Joseph A. Mix and W. David Crews, "A Double-Blind, Placebo-Controlled, Randomized Trial of *Ginkgo biloba* Extract EGb 7611 in a Sample of Cognitively Intact Older Adults: Neuropsychological Findings," *Human Psychopharmacology: Clinical and Experimental* 17 [2002]: 267–77). Based on my experience with ginkgo extract and its effect on my memory, I am strongly inclined to agree with the findings of the former study.

Atewa

Page 180. Although we are now in the warming part of the last glacial cycle, this does not mean that the climate change we are experiencing now is entirely natural. Human-produced greenhouse gases dramatically accelerate the process, which normally is only the result of natural variation in the amount of solar radiation that reaches the surface of our planet and, to a lesser extent, a side effect of Earth's tectonic activity. Based on the studies of previous glacial cycles, we should be able to predict where and when climatic changes should occur. Yet enormous amounts of man-made carbon dioxide, methane, and other gases trap more solar energy than unaltered atmosphere would, thus throwing wrenches in the natural equation of heat exchange of Earth, making it warm up faster, and in a more unpredictable way. Up-to-date information on the scientific findings about our rapidly changing climate can be found at the website of the United Nations' Intergovernmental Panel on Climate Change, http://www.ipcc.ch.

Page 182. For a detailed report on Atewa's history and the results of our survey, see Jennifer McCullough, Leeanne E. Alonso, Piotr Naskrecki, Heather E. Wright, and Yaw Osei-Owusu, eds., "A Rapid Biological Assessment of the Atewa Range Forest Reserve, Eastern Ghana," *RAP Bulletin of Biological Assessment* 47 (Arlington, VA: Conservation International, 2007).

Page 183. Bushmeat, or wild meat hunting is a serious problem that impacts many highly threatened species of mammals and other large animals in tropical parts of Africa, South America, and Asia. Often hunters target species that are protected by international and national laws whose populations are already in severe decline from the habitat loss (for example, the great apes of central Africa.) *Consuming Nature* by Anthony L. Rose, Russell A. Mittermeier, Olivier Langrand, Okyeame Ampadu-Agyei, and Thomas M. Butynski (Palos Verdes, CA: Altisma, 2003) is a shockingly honest, very graphic photo essay on bushmeat hunting in Africa. Information about bushmeat hunting and its impact on the world's forest biodiversity can be found on the website of the Bushmeat Project, http://bushmeat.net.

Guiana Shield

Page 220. The description and history of the Konashen Community-Owned Conservation Area and the results of our survey with the Wai Wai can be found in Leeanne E. Alonso, Jennifer McCullough, Piotr Naskrecki, Eustace Alexander, and Heather E. Wright, eds., "A Rapid Biological Assessment of the Konashen Community Owned Conservation Area, Southern Guyana," *RAP Bulletin of Biological Assessment* 51 (Arlington, VA: Conservation International, 2008).

Page 223. Allan K. Gibbs and Christopher N. Barron, *The Geology of the Guiana Shield* (Oxford: Oxford University Press, 1993).

The Yin and Yang of the Notoptera

Page 245. For those interested in learning more about this fascinating group of insects, a somewhat outdated but still informative volume, *Biology of the Notoptera*, edited by Hiroshi Ando (Nagano: Kashiyo-Insatsu, 1982), provides a range of articles on ice crawlers' biology and behavior. For the most recent overview of their phylogenetic relationships, see Karl J. Jarvis and Michael F. Whiting, "Phylogeny and Biogeography of Ice Crawlers (Insecta: Grylloblattodea) Based on Six Molecular Loci: Designating Conservation Status for *Grylloblattodea* Species," *Molecular Phylogenetics and Evolution* 41 (2006): 222–37.

Page 246. Shortly after their discovery, the most frequently used common name for the order Mantophasmatodea was not the now-accepted "heelwalkers" but "gladiators." Most people assumed that this name had something to do with the ferocious nature of these predaceous insects, but the true reason appears less insightful. I asked Oliver Zompro, the German scientist who discovered these insects and christened them "gladiators" about the origin of the name, and he said, "I had just finished watching the movie *Gladiator* with Russell Crowe and thought that 'gladiator' would make a cool name for an insect. But it had nothing to do with their behavior as at that time I had never seen a live one."

The Great Ocean Escape

Page 261. Although Delaware Bay has the largest population of horseshoe crabs in North America, their spawning behavior can be witnessed all along the eastern coast of the continent, from Nova Scotia to Gulf of Mexico. The best places to see them are sandy undisturbed beaches, preferably adjacent to shallow coastal wetlands. The peak of their breeding activity falls on the nights of the full and new moons in May and June. It is a good idea to check a tide chart for your area beforehand to see what time the peak of the high tide takes place. There are many Internet resources that make it easier to find places to watch horseshoe crab spawning; a good place to start is http://www.horseshoecrab.org, a website run by the Ecological Research and Development Group, a nonprofit horseshoe crab conservation organization.

Page 264. The case of an epidemic of horseshoe crab poisonings in Thailand is described by Jirasak Kanchanapongkul in "Tetrodotoxin Poisoning Following Ingestion of the Toxic Eggs of the Horseshoe Crab *Carcinoscorpius rotundicauda*, A Case Series from 1994 through 2006," *Southeast Asian Journal of Tropical Medicine and Public Health* 39 (2008): 303–6.

Page 266. An extensive overview of the horseshoe crab fertilizer industry, along

with a wealth of information on the animals' physiology and ecology, is presented by Carl N. Schuster Jr., H. Jane Brockmann, and Robert B. Barlow in *The American Horseshoe Crab* (Cambridge, MA: Harvard University Press, 2004).

Page 266. William Sargent, *Crab Wars: A Tale of Horseshoe Crabs, Bioterrorism, and Human Health* (Lebanon, NH: University Press of New England, 2006), provides an interesting—if not always unbiased—insider's view of the industry of the production of limulus amoebocyte lysate from horseshoe crab blood.

In the Sagebrush

Page 283. Based on a well-preserved fossil specimen, Jes Rust, Andreas Stumpner, and Jochen Gottwald reconstructed the dominant song frequency of a fifty-five-million-year-old katydid in their article "Singing and Hearing in a Tertiary Bushcricket," *Nature* 399 (1999): 350.

Page 287. The literature on the reproductive behavior and parental investment in grigs is quite extensive; an article that explores females' interest in virgin males is J. Chadwick Johnson, Tracy M. Ivy, and Scott K. Sakaluk, "Female Remating Propensity Contingent on Sexual Cannibalism in Sagebrush Crickets, *Cyphoderris strepitans:* A Mechanism of Cryptic Female Choice," *Behavioral Ecology* 10 (1999): 227–33.

A Walk in Estabrook Woods

Page 297. You can find more information about Biodiversity Days at http://www.waldenbiodiversity.com.

Page 298. The mystery of the origin of flowering plants has spawned a huge body of research. A recent summary of our understanding of this process is presented in a special issue of the *American Journal of Botany* 96, no. 1 (2009), entitled *Darwin Bicentennial: "The Abominable Mystery."*

Page 302. The alternative explanation for the angiosperms' radiation was proposed by Frank Berendse and Marten Scheffer in "The Angiosperm Radiation Revisited, an Ecological Explanation for Darwin's 'Abominable Mystery,'" *Ecology Letter* 12 (2009): 865–72.

Page 304. The role of PHY3 in the evolution of ferns was researched by Harald Schneider, Eric Schuettpelz, Kathleen M. Pryer, Raymond Cranfill, Susana Magallón, and Richard Lupia in their article, "Ferns Diversified in the Shadow of Angiosperms," *Nature* 428 (2004): 553–57.

Page 307. The relationship between horsetail ferns and gold deposits was evaluated in a study by R. R. Brooks, J. Holzbecher, and D.E. Ryan, "Horsetails *(Equisetum)* as Indirect Indicators of Gold Mineralization," *Journal of Geochemical Exploration* 16 (1981): 21–26.

INDEX

*Page numbers in **bold** refer to images*